A Handful of Ashes
One Mother's Tragedy

Victoria C. G. Greenleaf, M.D.

Cypress House

A Handful of Ashes: One Mother's Tragedy
© 2001 by Victoria C. G. Greenleaf, M.D.

Cypress House
155 Cypress Street
Fort Bragg, CA 95437
Tel. 707-964-9520
Fax. 707-964-7531
www.cypresshouse.com

ISBN 1-879384-37-X

Cover design by Colored Horse Studios

Library of Congress Cataloging-in-Publication Data

Greenleaf, Victoria C. G., 1927-
 A handful of ashes : one mother's tragedy / Victoria C.G.
Greenleaf.– 1st ed.
 p. cm.
 Includes bibliographical references.
 ISBN 1-879384-37-X (hardcover : alk. paper)
 1. Greenleaf, Daniel–Mental health. 2. Conduct disorders in
children–Patients–Biography. 3. Antisocial personality
disorder–Patients–Biography. 4. Conduct disorders in children. 5.
Conduct disorders in adolescence. I. Title.
 RJ506.C65 G74 2001
 618.92'8582'0092–dc21

 00-021976

Manufactured in the USA
2 4 6 8 9 7 5 3 1
First edition

Dedication

To all parents who, like 'Tommy's mother', ask themselves,
"After all my love and care and good intentions,
how could my child have turned out like this?"

Contents

Foreword

THIS IMPORTANT AND MOVING BOOK, *A Handful of Ashes: One Mother's Tragedy*, was originally written as a therapeutic activity of the author as she struggled with the frustration, anger, guilt, and anxiety of living with a disturbed son. It is much more than a diary. It represents the flashing amber light, the caution about the vicissitudes of the psychiatric treatment of our out-of-control adolescent children with character disorders. Because of the development of our laws, customs, insistence on "privacy" for adolescents, our educational system is shackled and the legal system operates counterproductively in the nurturance of our young people towards the goal of mature, fulfilled adulthood. Thus, barriers are erected between the adults to whom their welfare is most precious—schoolteachers, administrators, and their own families.

As William Glasser pointed out twenty-five years ago in his book, *Reality Therapy*, the probing, understanding, and insight-oriented approach to the treatment of character disorders in adolescence is often ineffective and even inappropriate. To treat out-of-control youths in traditional ways of psychotherapy deters them from their need to develop internalized control and provides an apparent *carte blanche* to pursue their self-destructive ways. Thus psychotherapy may become an agent of failure—perhaps one of the most compelling points of his book.

In the current age of scientific psychiatry, a more integrated approach is to be found in exploring innate biological mechanisms affecting temperament and behavior. This book emphasizes the need for even more research in this area. It also points to the changes in society which have led to the environmental impact on growing children, i.e., at an earlier and earlier age contemporaneous children, rather than families, exert more impact. Paradoxically, at a time when our society has become increasingly hedonistic and intrusive into the lives of our young people, parents are blamed and blame themselves for their children's problems. Thus, as their authority is eroded, only love, feelings of responsibility and impotence are left.

This book takes a critical look at what has been a traditional focus of psychiatric social work, i.e., psychotherapy for the parents. In it we witness and share the parents' pain and guilt for being somehow responsible for what has gone so horribly wrong. The story is told with compassion for all the characters in the drama.

Most psychotherapists will be tempted to comment on the family dynamics that are revealed in the course of the history. How unfortunate that the family was not involved in a family therapy approach, which could have taken into account at a much earlier time the father's seeming passive compliance with the misbehavior, the denial that existed in the family system, as well as the deep gulf that developed as a result of the trauma of dealing with a disturbed adolescent. Family therapy for all involved would be the preferred treatment. Nonetheless, the social and other forces conspiring against the treatment could have resulted in the same type of frustration, perhaps at an earlier time. It is clear that all the forces of our society need to be mobilized, including the legal and judicial forces. More work needs to be done in reversing the process of the "psychiatrization" of the judicial process, an area that has become a very important topic in contemporary American psychiatry.

I believe *A Handful of Ashes* is an important book. No other book that I have recently read cries out for public attention as does this one. In some respects it is much more of a drama than a first person case study. It needs to be read by serious readers who are concerned about how society is going, by parents, educators and concerned citizens from all walks of life. In this sense, the author's self-stated therapeutic endeavor in writing the book will have helped not only herself but countless others as we approach disturbed young people and their families in the next decade and beyond.

Robert O. Pasnau, M.D.
Past President of the American Psychiatric Association
Los Angeles, California

Preface

THESE ARE DIFFICULT TIMES TO BE A PARENT. We love our children and do our best for them. We worry about what will become of them. We are concerned about their character, their safety, their associates, their happiness, and their prospects.

Until the twentieth century, children were considered part of a family's economic operation—usually a farm—and feeding, clothing, and sheltering them was all that was expected of parents. Passing along skills and knowledge that would help them as adults was a bonus. Expressions of parental affection were all to the good and brought harmony and happiness to the family hearth.

"Give us a child to the age of seven," boasted the Jesuits, "and he will be ours for life." Other voices, notably Sigmund Freud's, postulated that children's early years are vitally important to their outcome. It was soon incumbent on parents (mostly mothers) to ensure their children's psychological success. One formula for success was for parents to provide their children with the three A's: Acceptance, Affection, and Approval: "They want me, they love me, they think I'm OK."

The downside to this laudable injunction, however, came when everything did not turn out well. A society that a generation earlier had sympathized with families shamed by "black sheep" began blaming parents for their children's negative character traits, reprehensible behavior, and criminal activity. Child guidance experts were kept busy ferreting out what parents did wrong, could have done better or should have done differently. Well-intentioned, guilt-stricken parents asked themselves the same questions. It didn't take long for irresponsible adolescents with nimble minds to seize the issue, blackmailing their parents for their own shortcomings, misdemeanors, and malfeasances.

At the same time, as the century rolled forward, population increased, becoming more urban and crowded. With education compulsory and more years of it, children were spending more time with one another. Families in which both parents worked, and families headed by single parents, were no

longer anomalies, and "peer pressure" leapfrogged over parental input in molding a youth's character.

Meanwhile, the pendulum had swung away from an emphasis on responsibility, obedience, and duty (like "work", a dirty four-letter word), toward a demand for individual rights and personal freedom, with devastating effect for those who had not learned to value moderation, accountability, responsibility, and morality. In a single generation, society did an about-face from belief in working for rewards to the idea of entitlements by virtue of being alive. Unrestrained, adolescents moved in a few years from childish dependency to access to a glittering array—more aptly, a poisoned smorgasbord—of destructive options.

In a culture characterized increasingly by easy access to drugs, virtually unlimited access to "information", and popular music emphasizing sex, violence, and irresponsibility, the role of parents in child rearing has declined precipitously. Reassessing the old nature/nurture controversy regarding whether, and to what extent, biology or environment molds a child into an adult, the role of parents has plummeted while the influence of peers and society has escalated, regardless of biological contributions. One important and pernicious social force has been television programming. Reprehensible in its stimulation of violence in the young, it is even worse for the egregious taste it fosters.

What about "nature" in the equation of what contributes to a child's development? In recent years, studies of monozygotic twins (twins from a single egg and, therefore, with identical inheritance), separated at birth and raised separately, have shown that genetic inheritance is more important than previously credited. A possibility from which we recoil in horror is that some persons (or everyone to some degree) carry seeds of evil, including the bad traits of forebears. "Is heredity so determinative?" we may ask, forgetting that only recent generations of parents have believed in their own powers of good and evil.

Conscientious parents are worried as never before. Schools are armed camps. Delinquency statistics are frightening. A majority of inmates in federal prisons are incarcerated on drug-related charges, while local jails are filled with those arrested for violent crimes. The number of young women being incarcerated is rising at an even faster rate than that of young men. What did these felons look like five years before they were convicted? In our confusing world, what adolescent misbehavior could be explained as "harmless experimentation", and what conduct demanded immediate and decisive action because it presaged serious damage, bodily harm, or legal confinement? What intervention was called for? Can we save our children and, if so, how? What authority provides reliable leadership? Is discipline abusive? Is lack of control abusive? How can we reverse the frightening social trends? A recent, astonishing study by Donald Black (*Bad Boys, Bad Men*) shows

that delinquent youths who do a little jail time turn out better, on average, than delinquents who escape punishment. The leading central question is: How can we inculcate in our children the character, morals and values we wish them to exhibit as principled adults?

These issues, worries, and questions are addressed in this book, which looks at a troubled youth from a good family in a typical American community. The usual antecedents of delinquency are not present here. Poverty, neglect, broken family and substandard schooling commonly associated with at-risk children are mercifully absent. As a result, the story you are about to read is all the more tragic and frightening—tragic to the family involved and frightening because the same story is unfolding in towns and cities across the country—with devastating consequences to our society's future.

Yes, we love our children, and in all our human imperfection we do our best, but authority has been wrested from us, and we no longer have rights as parents. The deck is stacked against us in our efforts to bring out the best in our children.

In this book, I share my family's struggles with our eldest son, including conflicts with my husband over how to proceed with rearing him. I have faults in common with other mothers (and fathers) and perhaps some flaws that are unique to me. In my repeated efforts to understand, avoid, correct and redirect my son's downhill course, I have failed. And I am a psychiatrist.

Yet, what went into my son's upbringing does not account for what came out.

As an author, therapist, and parent, it is my hope that my experiences will offer insight to parents, mental health workers, educators, and lawmakers into the complex problems we face with today's youth.

Victoria C. G. Greenleaf, M.D.
August 1999

Acknowledgments

I WISH TO EXPRESS GRATITUDE to those who helped complete this long, arduous project:

To 'Aletheia', my elder sister in sorrow, who grieved with me over my eldest son while I grieved with her over her only daughter. Despite what is said, the pain is truly worse when the disappointing child is your only one. Aletheia also read drafts of my manuscript and was my original source of encouragement.

To Robert Pasnau, M.D., Warren Boroson, Charmaine Severson, William Sones, and James Walker, for reading and commenting empathically on an early draft.

To Ted Schwarz, my mentor, who showed me that I needed to abandon the academic style in which I had written scientific papers and that I must write from the viewpoint of what the reader needs to know. He warned me that for a book like this, reporting what happened is not enough—the author has to "bleed on the page", and it is the hardest kind of writing. I did my best to follow his teaching, while he walked a fine line between indicating what needed changes and traumatizing an already suffering author.

To Donald Black, M.D., a leading expert in antisocial personality disorder, for reading and validating my conclusions in my final draft.

To John Fremont and Joe Shaw, my editors, for their patience with my deficiencies and for their advice and skill in preparing my book baby for birth. And they, too, did it with compassion, which I appreciated.

And finally, to 'Peter', who, though opposing my project from the start, respected my decision to pursue it and did not put roadblocks in my way despite the costs to family life caused by the inelasticity of my time. He has not influenced the content or read a single line.

Necessary changes in names, places, and identifying data to ensure privacy for my family, particularly 'Daniel's' younger brothers—and even 'Daniel' if he should ever know and care—have not affected the essence of what I have written.

V. G.

1999

One

A Night to Remember

AT 11:30 ON LABOR DAY NIGHT the call came. Tired from attending the annual air show with their father, our two younger sons, Jonathan, twelve, and David, eleven, were long asleep. My husband Peter was watching the end of the news, and I was already in bed reading. But our eldest son, Daniel, sixteen, was still out, making the most of his fast-dwindling summer vacation. Peter took the call, then, ashen-faced, came upstairs to tell me:

"That was the Glencoe Police Station. Daniel is at their headquarters."

"What did they pick him up for?" I gasped, visualizing a scene of drinking and drugs around a driftwood fire on the beach.

"Breaking and entering," was his appalling answer.

I was shocked, yet not surprised, since this was the kind of outcome I had been trying to prevent for the better part of a year. Every day we hear of rebellious teenagers graduating to more serious acts of delinquency. Yet I was dumbfounded because Peter and I were not talking about an anonymous name in the news. Daniel was our beloved eldest son.

"Do you want to guess who was with him?" Peter asked.

"Probably those awful characters we've been trying to keep him away from."

"Kevin Wilson," Peter replied. While I was reeling under the news of another unlikely delinquent, he added, "I have to go down to the police station."

"Why?"

"Because they said we—or I—have to. He's our minor son."

"Why don't we just not go? Why not let them just do whatever they do to

people who break and enter? Why not just let him feel the weight of the system rolling over him, not jump to keep him from feeling the consequences of his behavior? What good does it do to run in, like the cavalry, to the rescue?"

"I can't do that. He's my son, and he's only sixteen. I can't turn my back on him when he needs me—he's my son. Besides, since he's a minor, they told me that at least one of us has to be present for questioning. We can take a lawyer if we wish."

"You know how we've been escalating from one strategy to another for months to avert something like this. He hasn't learned anything from everything we've tried. Now I think the time has come to change from 'helping' and talk and arguments and therapy to something with teeth. Let the police work their will on him—do whatever they do to people who are caught breaking and entering."

"I can't do that. He's my son, and I can't abandon him."

"That's not abandoning him. It's an intelligent way to make the point that society and we are trying to make. What about just waiting a while? Don't just race right over to get him out of their clutches. After all, he got himself their without our help. Let him sit there and think for a couple hours and feel what it's like to be on the other side of the law. It would be better for him. The system is wrong that immediately tries to mitigate the offense by shifting responsibility to the parents. Daniel consciously put himself above the law and morality, everything we've spent sixteen years modeling and teaching him. Now let him feel what it's like to be detained in a police station. I think the time has come to rethink what it means to be a truly good parent. The time has come to be counterintuitive. After all, we've done all the standard 'good parent' things and they haven't worked."

"I have to go," he said. "I take it you don't want to come along."

By this time I was sobbing on Peter's shoulder, and he was kissing my hair and rubbing my back. "I'm glad my mother didn't live to see this," I said. "She loved him so. At least make him wait. When the police call back, tell them you thought you had a terrible nightmare and went back to sleep."

"I have to go now," he said again. And he kissed me and went, alone.

I was left with my pain. And not only pain but also rage. And rage not only against the son who had betrayed our loving and thoughtful upbringing, but also against his father, my husband, whom my friends envied as loving and devoted to me, but who had, in my view, failed as a father, not because he did not love our sons at least as much as I did, but because he was passive, ineffectual, and gullible. As Dorothy Parker so wittily put it, [Peter] could speak seven languages but couldn't say "no" in any of them.

2

Two

Family Life at the Greenleafs

As I awaited Peter and Daniel's return, I reviewed again the tale of our life together, with our three sons. Our family had not just happened. I had an abnormality requiring more than one plastic surgery in my pelvis. Even conceiving had not come naturally; I had had to keep a temperature chart, calculate the most likely time for ovulation, make love on demand several days each month, struggling with the ambiguous squiggles on a temperature chart, choke back sadness with each month's failure, and finally rejoice in the telephone call informing me that the rabbit had said "yes". Even after this, our first three pregnancies had failed, with bizarre and heartbreaking complications, demonstrating that I could not carry a baby normally. But we wanted to savor the richness of a full family life, "to work and to love" as Freud had called the important things of life. And so, with medication to relax my quicksilver uterus and by lying like a bloated queen termite at bed rest from time of diagnosis, I had finally been able to break new ground getting my fourth pregnancy six months along. Even so, my own life was under threat and, like a soldier in combat who may not live to know his unborn child, I wrote my baby a love letter, lest Roger, my obstetrician/friend, might lose me but be able to snatch the baby.

The letter ended, "I loved you before you were born, and if there is such a thing as loving after we die, I love you still."

At long last I got that pregnancy to term, and the high-risk team saved us both.

"You, Victoria, are a mother!" announced Roger, raising the baby for me to see.

"And you, Roger, are a miracle worker!"

Daniel was that pearl of great price. Having carried him in my womb, I finally carried him in my arms. When Peter and I carried him home, even Cleo, the adorable, intelligent, mostly spaniel stray puppy that we had taken in, assessed the situation and moved her living quarters from beside the outer door to under his crib to assume her role of protector. My mother called Cleo "the nurse's aide".

Peter, Victoria, and Daniel Peter. Our new family.

Just four years later, after six months' bed rest (following two months during which Roger denied that I was pregnant), we welcomed a brother for Daniel—Jonathan—and nineteen months later, after another eight months in bed (that time Roger believed me), the final Greenleaf child, little David. Further efforts were never rewarded with another child, maybe a girl to replace our stillborn, but I had my four wonderful "men".

Our family consisted of two professional parents, Peter, a biochemist/physician who ran his own research lab and thereby avoided the all-too-common complaint about physician fathers attending to patients seventy or eighty hours a week to the neglect of their families. No, Peter displayed the unbeatable combination of tenderness and intelligence, worked regular hours and was devoted to his family—joining Indian Guides with each son as the child became old enough, and later assuming the adult responsibilities of Boy Scouts.

I was a psychiatrist, not full-time in my own practice, for the most part an hourly worker in clinics. When Daniel was born, I had a few more months of training left to complete, and each noon I pumped and refrigerated breast milk for his caretaker to give Daniel the next day. By the time I was a fully trained psychiatrist, I worked evenings, giving Peter precious father/son time. Later I worked several half-day clinics a week and jokingly billed myself as: Psychiatrist—Have Couch, Will Travel.

I remember as if it were yesterday my first lesson in suffering vicariously the disappointments of my child. Daniel had made friends with little Aaron in the nursery. I suggested that we invite Aaron and his mother over for a day, to play and have a picnic under the scarlet maple. Daniel was delighted. We planned the lunch and the toys and games the boys would play with. For an hour before the scheduled arrival at ten, Daniel became more and more excited, following the big hand on the clock. But ten o'clock came and went, and Daniel became increasingly upset and begged to know when they would come and why they were late. My calls produced no response, and we never learned what happened to break their promise and mine.

The years passed quickly, like pages fluttering off the calendar in old-fashioned movies.

We had not considered early entrance into first grade, but Daniel's preschool teacher strongly recommended it. "This is the brightest child I've ever worked with," said this middle-aged, seasoned teacher. "At least have him tested."

The psychologist's report confirmed his intelligence, but he drew my attention to something atypical in Daniel's Draw-a-Figure test. "Look, he drew the hands without fingers."

"So what? Maybe he's not much of an artist, like me."

"Lack of fingers goes with low self-esteem," said the psychologist.

"Why in the heck should he have low self-esteem?" I asked. I had never seen evidence that Daniel thought there was anything he couldn't do.

Peter reminded us that one of the older boys in the neighborhood had teased him by pretending to throw him a ball and then threw it somewhere else. This trick worked only once with Daniel. Nobody else had any other explanations for the self-esteem.

And so Daniel went early to first grade. Over the years the possibility that early entrance may have been an irreparable mistake, with or without low self-esteem, returned to haunt us. But Mrs. Stein, at the first grade teacher conferences, confirmed what excellent work he was doing, as did other teachers for several years.

However, two incidents occurred in Daniel's early years that alarmed me, because they were outside the scope of normal childhood misbehavior.

The first occurred when he was five and Jonathan just beginning to toddle. Somehow Daniel was out of my direct observation, and when I went into the living room I was appalled by the scene of destruction: one large, heavy overstuffed chair was overturned, and dozens of books and slides were strewn. The books, both Daniel's and ours, including an atlas, had pages torn, most of them about two-thirds of the height of the page, so they were hanging in place.

Slides had been punctured with a pencil, leaving the rest of the film intact. Daniel told us that Jonathan had done it. I believed him and got Peter to spank Jonathan, but I was wrong. Then Peter asked Jonathan to push over the chair, which was obviously impossible. We told Daniel the serious wrongness of his behavior, and I required him to watch as I taped the book leaves back together.

When Daniel was in second grade, the second such incident occurred, the furtiveness of which worried me. The principal called me: "Did you give Daniel thirty dollars?" he asked.

"Of course not. What would I do a thing like that for?"

"He has thirty dollar bills and is showing them around to the kids."

Since neither of us had a clue about their origin, Peter and I questioned Daniel. His explanation was that he had found them down at the cul-de-sac where the school bus picked him up. I didn't think to ask about a container.

This raised a worry because I had noticed that an occasional car would turn around there at night, sometimes waiting five minutes or so. I had wondered what they were up to, and at the back of my mind I worried about drug transactions. I talked to the police and got no help. I searched the weedy turnaround at the abandoned farmhouse and found nothing. But I began to walk Daniel to the bus, the fringe benefit being enjoyable mother/son time. I let him believe it was news to me when he said, "The *sun* is a *star!*"

Then Peter and I talked again. On this occasion he was uncharacteristically suspicious. He asked how much money I had in my wallet.

"How would I know? When I get low, I get more out of the bank."

"Count what's in your wallet every day," he suggested.

Dubious that it would show any discrepancy, I kept track. To my astonishment and shock, I found an occasional deficit of a dollar or two. We interrogated Daniel again, and he finally admitted taking the money. I cannot remember any kind of explanation for the behavior. But we worked with him, impressing him with the wrongness of such behavior, and put the incident behind us. There was no recurrence.

Was this a harbinger of future trouble? I have to admit that this was a sophisticated sting for a six-year-old to come close to pulling off. Years later I compared it to an analogous, normal, yet diametrically opposite incident. David came howling to me that all the money was gone from his piggy bank. Jonathan freely admitted taking it and explained why: "What does that little kid need with all that money?"

Just a few months later we had to leave that idyllic place for raising children, with woods to explore, a stream for wading, and adventures to be had, and move to a city for Peter's new job running his own laboratory. I have often wondered how our lives might have turned out had we not had to leave our *Little House in the Big Woods*.

Of course we all have 20/20 hindsight. At the time, however, I could not or did not differentiate the multitudinous misdeeds of childhood, in that broad category of more or less normal—each dealt with at the time and a learning experience for child and parent alike, then left behind like outgrown toys—from other misdeeds that presage something ominous for the future. Only in retrospect did I realize that there were crafty and secretive misdeeds, usually discovered only by accident, and, when traceable at all, they always pointed to Daniel. One such was the shoplifting of a candy bar; it was detected by the store manager and brought to the attention of Peter, who returned home white and trembling with Daniel. We worked with this, one of the most common of childhood misbehaviors, and thought we put it behind us. In truth, there was never a repetition. Daniel never threw the same problem at us twice. And there never was an example of either of the two truly portentous misdeeds of childhood, fire-setting or cruelty to animals. Rather than the fact of and the nature of such relatively normal misdeeds, it was the accelerating pace and tempo that began to cause me vague, intermittent, later constant, discomfort, waxing and waning with events.

Through all this and many years subsequently I was held hostage by the then current folk wisdom, almost an article of faith, that parents could always teach and instill virtue in their children by upbringing and example. Sometimes this can be done, but not always. It is not as I had believed, that if you do whatever the occasion warrants, your child will necessarily respond with the desired behavior.

Peter and I always attended parent-teacher conferences together, but fourth grade was when they took a downward turn. On the verge of tears, Daniel's teacher complained of his silly attention-getting behavior, intended to get the class to laugh and disrupting what she was trying to accomplish. We all worked on that and it improved, marginally, for a while.

On the other hand, Daniel was becoming cavalier about simple rules, such as coming directly home after school, changing into play clothes, being punctual, attending to chores that I tried to assign all the children on an age-and-ability basis. When I bore the children over such terrible obstacles, I was aware of the pitfalls of a too-wanted child and the temptations of "spoiling" him. I was determined to hold the children to fair and reasonable standards, helping them to mature into considerate and responsible people because I wanted others to love my children as well as I loved them myself.

Whining, demanding, and self-centeredness would not endear them to anyone. When David was not getting his way, he would ask, incredulously, "Don't you want us to love you?" I would reply, "Not by giving you something that's not good for you." Many times I explained to the children that motherhood is not a popularity contest but a special relationship of love and responsibility.

After years of a close-to-ideal marriage (including the years we were trying to get our family and the years when the children were very young), our marriage showed its first crack. This was hardly a surprise because no persons and no relationships are perfect. What was surprising was not the fact of the developing trouble, but its nature. From the outset, Peter was always giving, in the caring, nurturing parts of parenthood (like pacing with a colicky baby), and he taught and played with the children from the start (that was my favorite part of parenthood too). But parenthood is more than being a playmate. The trouble spot was discipline. I had entered into parenthood with the tacit belief that by becoming parents we had taken on not only the love and happiness a family should bring, but also the dreary, less-than-fun, no-nonsense, nitty-gritty aspects of child rearing. I felt that both parents had assumed responsibility for joint training of the children regarding manners, morals, consideration for others, and what used to be called "deportment". Parents were, after all, adults with a modicum of maturity, wisdom, and authority, which should be used judiciously for the benefit of the growing, loved child.

I began my parenthood career with many naive ideas. I had never wanted to take a hard line or be a staff sergeant any more than Peter did. As a singleton girl, living out in the country and yearning for a sister, I had romantic ideas about having a "big family" in which we would all live, love, and work together. We would each make our contributions, large or small, depending on age and ability, and we would all reap our rewards. It would be on the order of the old family farm. But I quickly learned that Daniel Greenleaf was not Christopher Robin.

My rules were so simple and logical that I thought they didn't warrant debate. They related to safety, punctuality, responsibility, reasonable care of personal property (one's own and others'), realization that funds spent one way cannot go for something else, respect for the rights and needs of others, nobility of character, and *sagesse oblige*, or accepted obligation to use one's gifts to benefit others as well as oneself.

I visualized that whenever a significant infraction occurred, the three of us (Peter, the culprit—who would be Daniel at first as eldest—and I) would get together, clarify the issue, and outline consequences. I thought this was too obvious to have to be spelled out, but when Peter didn't get my idea, I tried on several occasions to explain and enlist his cooperation. I thought that sooner or later he would see these things my way, and that we would work

together to implement them. Therefore, for the first few small incidents, I would say to Daniel, "When your father gets home, we'll discuss this and decide what needs to be done." The upshot of several of these was my realization that Peter saw no need to punish minor infractions or take any action, and refused to back me in any way. I hated to think that Peter was shirking his duty, but that is how I saw it. Even that I could have tolerated had I not gradually come to perceive as a corollary that Peter's negligence was cheating Daniel out of a chance to become the noble gentleman I visualized.

"Half an hour late isn't so bad," he would say. "Why are you so rigid?"

"The time is important. The issues are responsibility and safety. I need to know where Daniel is after school. Children need to change for play so as not to ruin their school clothes."

But Peter's gentle virtues were obviously not up to this. It was his tragic flaw, and a costly one for our family.

Ironically, one of the traits I had loved in Peter was that he was not materialistic, though coming from a family where money was never in long supply. One of his lines was, "It's only money." Yet he carried it too far, writing off not only legitimate accidents but also carelessness and imprudent use of personal property. "Of course I'm glad it was only a ruined sweater and not a broken arm," I would agree, "but because something is 'only money' doesn't mean it's worthless. Besides, that sweater had sentimental value. Daniel's honorary aunt, Dorothy, knitted her love into it."

One incident when Daniel was twelve, trivial in itself, nevertheless raised the hackles on my neck, from fear of the psychologic import. We took the boys camping in Alaska, a trip that created marvelous lifetime memories for all of us and even gave Peter an idea for a research project that has brought him recognition in a field other than his own. In one campground word went around that in a nearby stream there were grayling, a fisherman's prize catch, and a fish of the North no longer found in the lower forty-eight, although a town in Michigan bears their name. Daniel went off to try his luck and returned with two small, unimpressive-looking fish, which we nevertheless acknowledged as having admitted him to the fraternity of grayling-catchers. Later on the trip, Daniel volunteered that another boy had given him the fish.

"But Daniel," I lamented, "why did you let us think they were your catch? Wouldn't you rather be an honest person without that ridiculous distinction than to know internally that you were a fraud?"

Another example of Daniel's failure to incorporate the values we were trying to instill came the autumn when Daniel was twelve and both he and his brothers protested that they were too old for a baby-sitter for the hour after school until I would be home from my clinic. So I gave Daniel a chance to earn a little

money by sitting his brothers. I spelled out the rules very clearly: no Greenleaf child off the property, no non-Greenleaf child on the property, and all three spending the time playing quietly or reading. Daniel was to keep his time for later pay. The system seemed to work well until one day I arrived home unexpectedly early. I found Jonathan and David playing quietly as agreed, but Daniel and a friend were skateboarding down an elderly neighbor's driveway, thereby breaking all three rules at once. Instead of sharing my outrage, Peter criticized me for refusing to pay Daniel for work he wasn't doing that day and may never have done. I avoided putting his brothers in the position of informers.

Another character trait I tried to correct in Daniel was impulsiveness. I had made a point to teach him street crossing behavior when we moved to the metropolitan area. Still, I would hear from friends that they had seen him dart across a busy thoroughfare or even a train track. Fortunately, he had only one relatively mild pedestrian accident.

After several such incidents in which Peter undercut my efforts at a joint stand with just enough teeth in the punishment to promote learning and ensure that the incident would not be repeated, I realized I couldn't go along with his laissez-faire approach and would have to handle matters myself. I did this fairly easily for several years, though I became uncomfortably aware that the hoped-for learning and character development in Daniel were not meeting my expectations. Years later I noticed that the "easy" younger boys responded well to my teaching and my similar mild punishment without pitting Peter against me.

My response, when I was disappointed in my suboptimal results with Daniel without the help I considered my right to expect from Peter, was to feel that I must try harder, explain better, assume the firmness required by the juvenile testing of a strong-willed child.

"Why do you always want to punish him?" Peter would ask.

"I don't. That should be the second line of defense, the first being preventive. And it could be, if you'd back me up."

But Peter couldn't, wouldn't, or didn't do it that way. Ever.

Peter's stand was, at best, neutral; more often it reinforced behavior I was trying to correct. I felt Peter owed it to me to be part of the solution, not more of the problem. I began to resent having to carry the Daniel burden and the Peter burden as well. Faced with the problem of a lax and a strict parent, I would not abrogate my responsibility to my child, and so took on the discipline by Peter's default. I dealt with infractions as best I could, trying for consistency and fairness, using rewards and punishments as judiciously as I could, in a carrot-and-stick manner. I never had to spend nearly as much thought and time, nor perform such a balancing act, with the younger boys, nor did I ever elicit from them more than an occasional quibble or grumble.

Peter didn't even back me in my efforts to teach respect and consideration for adults, parents, and those with a handicap. Once when I asked Daniel to give his seat to Peter, who has an old polio disability from childhood, Daniel did jump up promptly, but Peter opposed me, saying, "Stay there, Dan. I don't need the seat."

"But *he* needs to give it to you. You are an adult, his father, and have a special problem. He should show consideration almost as a reflex."

Playing one parent off against the other is a standard technique of childhood. Early on, all the children learned that their father was a pushover, would agree to anything.

But Peter," I would have to protest, "you don't know the whole agenda. There is nobody who can pick him up that day."

I could understand, at first, why Peter might just agree to whatever was asked, innocent as it appeared. I myself have never liked to leave things dangling, and for years I thought it was like playing footsie to answer, "We'll see." It took me incredibly long to learn that a wiser way is to postpone decisions a bit. Not every request is entitled to an instantaneous answer. After all, the requester has had time to think matters over and frame a plan, and it is only fair that the responder should have time, too.

Worse than going directly to the "easy" parent would be Daniel's strategy to go to Peter after getting a "no" from me. I would then have to overrule him on the basis of a dental appointment or uncompleted work, such as cutting the grass. It seemed to me that Peter should have caught on eventually, but he never inquired into implications or complications. I eventually concluded that an appeal to a second parent after refusal by the first was in itself not only cause for denial but justification for punishment for manipulative behavior. When it worked otherwise in Daniel's case, it was on-the-job training in manipulation. Its first negative effect was the wedge it drove between Peter and me.

For years I puzzled over why Peter, who was such excellent husband material was less-than-good father material. For years there had been nothing for the two of us to disagree about. In life's major non-child-related matters, we had the same goals and objectives, and we worked together to accomplish them. I quickly learned to deal with problems raised by his being a pushover with tradesmen, paying for work not done. Before we had the children, there was only one matter in which I was unable to overrule Peter's impulsive generosity. When my father proposed a kind of loan, I opposed it, warning Peter that my father was unreliable and would come up with a dozen rationalizations for not repaying us. Not only did this scenario play out just as I had predicted, but my father asked Peter again, and Peter insisted on advancing another loan over my objections. We never saw any of the money. Peter is a genius who is a slow learner.

On the matter of the children, I don't believe, as one might suspect, that Peter was trying to buy their love. He didn't have to. Everybody loved him, children, patients, colleagues. His humor was gentle, not caustic. But of course it's easier to be a physician to frightened patients than a father to difficult children. It also helped Peter's image with the boys that over time I had had to evolve into the "heavy", who made sure that everyone toed the line. But all Peter's virtues of tenderness and nurturing were not enough to make him a good parent. To this day I cannot explain why Peter was held hostage to Daniel.

I have observed that Peter's brother and nephew are also both passive and ineffectual in interpersonal relations. Peter is like them, and possibly more so because of the psychologic trauma of dealing with a wasted leg from polio in infancy, making him uncompetitive in those areas of sports that males hold so dear. For whatever reason, Peter is unlike his father, who, a man of high intelligence, though uneducated, had and used both intelligence and strength where needed for the good of the family and for immigrants who came after him in a time when "greenhorns" were considered fair game and cheated by the locals. And his father was generous. On the other hand, Peter's mother was easily gulled by sharpsters: she once bought "unbreakable" dishes from a peddler, then proudly demonstrated her good deal as she dropped them to the floor. Like his father, Peter is "generous to a fault" and like his mother, gullible. It is ironic that two people like Peter (with excessive trust and generosity) and Daniel (with excessive manipulativeness and ability to deceive) should have been in the father/son relationship, with me as mother linking the two. Daniel and Peter fit each other like a template.

I hasten to add that most of my experiences with the children were very happy ones. Daniel was special in many good directions. He had talents and precocity in spades, and many memories of him are so charming, delightful, and tender as to take away my breath and bring a tear to my eye even now. He wrote a "book" in the form of the diary by Moby Dick about being hunted, bound it by hand, and gave it to me (it is still in the attic). He created a "museum" in the backyard with objects he had been given or brought back when we traveled. He arranged treasure hunts for his little brothers, with plays on words and double-entendres for clues, and using as prizes books I had bought in great supply when a publishing company moved south and sold out very cheap. One summer he made books for his brothers, containing many words beginning with each child's initials. His brothers have long forgotten this, but I have them with my "treasures".

Worse than Peter's failure to shoulder the less-than-pleasant parental discipline responsibilities, was his laggard recognition that Daniel was developing something evil. I admit my fault in beginning the parental phase of our lives

with the assumption that Peter's judgment was as likely to be right as my own.

Nowhere, including in the family, did I "pull rank" with the fact of my training in the understanding of human motivation and behavior. I somehow equated high intelligence with psychologic intuitiveness, but they do not go together. Time demonstrated that despite Peter's scientific acumen, his psychologic interpretations were unsophisticated, and he was in denial for many years. If, like Sleeping Beauty's fairy godmother, I could have given Peter just one gift, it would have been psychologic sensitivity. But since he lacked it, I take blame for not becoming a detective sooner than I did. If I had, I might have realized sooner that Daniel was developing into some kind of deviant.

Finally came Daniel's academic slide. While there was never a question in anyone's mind about Daniel's ability to learn anything, he began to arrogate the right to decide what work he was willing to do. I remember his fifth grade teacher's remark: "I think he should do an assignment for no reason other than that I gave it to him." What could be more obvious? In sixth grade his work was again perfect, and we thought the point had finally hit home, and Daniel was once again performing at the level we all knew he was capable of. But in seventh his slide back was even worse, and he was thrown out of honors math. In eighth all his grades crashed, even while his standardized tests showed his achievement at high school level in all areas where it wasn't at college level. Could this disparity be explained as "immaturity" and result from that terrible mistake in putting him into first grade early, when he drew the figure without fingers on the hands?

Perhaps it would have been different had Jonathan and David come first, and had I been confirmed in my belief that what I expected from bright children was in no way unreasonable. They always did the work of childhood, school, very well, as expected, and enjoyed it, as also expected.

A solution to the Daniel problem suggested itself. Peter was entitled to a sabbatical, and one possible venue was the Australian National University in Canberra, working with a friend he had known back at one of our universities. The timing was such that the children would have three summer vacations, Daniel would spend part of a semester in the Australian program, and return to the same grade he had left, one year behind his former classmates. Maybe a little more time to grow up would help our son's Peter Pan Syndrome. All three children could experience life in a foreign capital, enriched by learning about the special marsupial fauna down under, Australian and English literature, and the history of an erstwhile convict colony.

The plan worked beautifully for the four of us. I found summer vacation activities for all three boys, a day camp for the little ones and a drama group for teenagers in which Daniel, who had been in dramatics all the way through

school back home, was given a role. Whenever we had a few days of free time, we would travel to another part of Australia, such as the Great Barrier Reef, to see and learn. By February the children went back to school. I gave the two appropriate schools the children's birth dates and asked that they be treated as Australian children of those ages. I got them all school uniforms. David came home the first day and reported, "They put me ahead into third grade," and Jonathan arrived a little later and announced, "Guess what. They told me to go upstairs into fourth grade." Daniel was in "third form", the equivalent of ninth grade, and moved from class to class.

But wonderful though it was for all of us, the Australian experience did not solve our problem with Daniel. We were often invited as a family to colleagues' homes, which gave me an opportunity to observe Daniel with other adults. I did not like what I saw. I was shocked at his incivility, arrogance, and general obnoxiousness. He also ran away one weekend when denied permission (at fourteen) to go hitchhiking with some friends from school. Forty-eight hours later we finally found him at the drama school where the twenty-two-year-old director had taken him in, swallowed unquestioningly Daniel's tale of mean parents, sympathized, and declined to notify any responsible adults of this runaway. That director did suggest a psychiatrist, a Dr. Herman, who was said to be very good with teenagers. Dr. Herman's paradigm was that teenagers misbehave at their parents' instigation. He expressed the opinion that Peter and I must be sending Daniel covert messages to misbehave so we could enjoy it vicariously. I was ready to give up on this psycho-babble when the time had come to board ship and return for a fresh start in the new ninth grade at Evanston High.

Years of seemingly isolated, trivial, and explainable-away incidents had now become a pattern. And another worry surfaced in my mind. Was there more to this than I knew? How much was Daniel, with his innate secretiveness, able to keep under wraps, mostly submerged, like the proverbial iceberg? Did my vigilance result in his becoming more secretive and crafty? I had read, years earlier, that an observant family could sometimes keep a socially dysfunctional child under wraps longer. But my ever-escalating vigilance had to fail, sooner or later, and later might be counterproductive. Sooner might be better so as to address the situation definitively, before the mid-teenager would be almost beyond the age of legal control by his parents.

Three

Victoria
Becomes Detective

THE FIRST HALF OF DANIEL'S REPEAT freshman year progressed unremarkably, though I noticed that he did not make friends in his new class but continued to hang around with the now-sophomores he had known. His grades returned to perfect, and he participated in forensics. His coach said he could do much better with greater effort, but in any case he went to the state tournament. He continued in Scouts and worked on his Eagle rank project.

It was in the second semester that my worries increased in intensity and tempo. While I knew that something was wrong, it took me longer to know what was wrong.

I became uneasy about the looks of some new boys Daniel was hanging around with. They were seniors and recent graduates or dropouts, and their voices were deeper than his. They were old enough to drive, which he was not. He seemed attracted to them for the wrong reasons, such as their free-wheeling life style. I questioned why they bothered with him.

I must admit I didn't know any of these boys well. I would see them, if at all, for a moment or two, from a distance, or they would say a few words in passing. If they telephoned, they were superficially civil, but they came across as furtive, not forthright and boisterous. Then too, I noticed that more often than usual, the phone would go dead when I picked it up. Rightly or wrongly, I related this phone pattern to these boys.

They were too quiet for one thing—*that's* a new complaint from a mother— and didn't act noisily excited about classes or school sports or anything else. They didn't seem to have much to do with school, though some apparently attended classes and some had what I surmised were part-time jobs. One or two sounded as if they might be in school/work programs, but other than that, they didn't seem really integrated into school activities.

Strangely, though involving himself with these frequently changing boys on the fringes, Daniel was earning grades at honor level. Even that didn't really delight me because he showed no spark of enthusiasm for his work. This academic improvement seemed odd in light of the fact that he had dropped band and showed little interest in extracurricular activities. It had given me goose bumps when, on the football field, he had crashed the cymbals at the perfect moment in "The Star-Spangled Banner". Peter and I, who had both been champion debaters, succeeded in pressuring him to continue with fo-rensics, in hopes that this would enhance his speaking and reasoning abilities as well as his social poise. As in other areas, his performance at meets was erratic, occasionally very high, sometimes bombing. Peter and I would have been happier had Daniel made friends of the forensics students. I learned later that he was cutting classes in such a way that his absences went unde-tected by the school. How could that have been?

Had there been just one or two boys of the nonacademic type, I would have understood that they were an enjoyable counterpoint to the hard-study-ing, nose-to-the-grindstone, cutting-loose-on-weekends high school students with whom I hoped Daniel would share a life. But he had only two friends who were motivated, academic-type, honors students whom I really liked and thought he liked too. Those other shifty fellows were almost his entire cohort, and he was beginning to look and sound like them.

I called Boris Vargo, Daniel's advisor at school, with a question about a name that was sometimes left for him on my answering machine, "Richie Blackmore".

"I can help you with that," said Vargo. He told me that they had no such student, and he surmised that since it was the name of a popular rock star, someone was probably using it as an assumed name. That jolted me. Why would a teenager use an alias? When I asked Daniel, he did not deny the deception but smirked at the duplicity.

The only other contribution Vargo could make was that at school dances Daniel acted like a "mascot". What did that mean? Vargo said, "He clowns around."

Daniel was coming home late more and more often, and while he could explain each such lateness, more or less, I was left with a not-quite-satisfied feeling about the whole pattern. Anyone can occasionally miss a bus, or change plans in the middle of the evening, but not as often as Daniel invoked such

alibis. When I tried to talk to him about these things, his vague answers left me feeling more unsettled. It was as if he and I were on different wavelengths, talking past each other. Several months later, when I finally got him to Dr. Gilbert Perez, an adolescent psychiatrist, he called these interchanges "communication problems". Such jargon was nonsense. Daniel was lying to parents who loved and believed him.

When I expressed my concerns to Peter, he could never see anything wrong with all these not quite right late-comings. Often he would quote his favorite line, "You just don't understand boys. You obviously never were a boy and didn't even have brothers." Even more than before, Peter's "reassurances" didn't reassure me. In our love for Daniel we were 100 percent together, but our interpretations of our son's behavior had been pulling us farther and farther apart.

Daniel evolved a pattern: he would appear to be going to a school function on Friday night, but on Saturday he would be vague about his destination, making me apprehensive; yet I did not feel justified in making a rule that he could go only to school events. Therefore, as I found myself eaten away with doubts and misgivings, I made belated efforts to keep closer surveillance.

In my first fumbling effort to keep better tabs on Daniel, I instituted my "weekend plan" system, which precipitated the next phase of the problem. By Thursday of each week, I expected a plan for Friday and Saturday. I asked for this in writing because we never remembered things alike when we only discussed matters verbally. Therefore, Daniel was expected to list persons, places, times, and phone numbers. He could be out both nights provided one was for a school-sponsored function, like a football game or dance.

"That way I'll know in advance where you are," I explained, "and I'll need a call should there be a change during the evening."

None of the three of us liked the "weekend plan" system. I didn't because it was a constant reminder of the erosion of what had once been a normal, loving family relationship. Love is easy when life is going well, but when it's not, one test of love is doing whatever needs to be done, no matter how disagreeable. This task was not nearly as unpleasant as many things I had to do—just mildly so—but was nevertheless one more thing to remember and do.

Peter made some not-very-vehement protests. "You shouldn't make him follow that weekend plan," he objected. "Kids like freedom on a Friday night—to let down their hair, go where the spirit moves. I know I did."

"The trouble is that our kid needs not less structure, but more."

That was one of my problems with Peter. His global standard of reference was his own background, and he equated our sons' adolescence with his own. But Peter had grown up in a small steel town in mid-century. No one had a car where he grew up, and the blue-collar workers all walked to work.

Everyone knew one another and worked together, and nobody had any way to get very far from home base. Young people were always close to the watchful eyes of other adults who had known the family for a generation. In those days any adult could reprimand any child and expect to be listened to. And Peter had, of course, been trustworthy. As Daniel's father, he was not making allowance for these differences in time, place, and person.

Daniel's reaction when presented with the "weekend plan" was to sigh, shrug, and accede grudgingly, rolling his eyes with a mothers-are-a-pain look. At the time I was relieved that a battle had not ensued. Retrospectively, I can see that Daniel's passive acquiescence meant that he had no intention of abiding by the rules, so why make an issue?

The "plan" system seemed to be working for a few weeks, but I was never really comfortable with this stopgap measure. And then the realization came over me that it proved nothing about Daniel's whereabouts unless he was actually honoring it. How could I know he was not listing acceptable activities on his "plan" and then doing anything he pleased? In that event, I was living in a dream world. I knew I would need to assure myself whether Daniel was doing whatever we had agreed upon. Was Daniel's word his bond?

My apprehensions increased, until finally, one unseasonably warm Friday night in February, my suspicions reached floodtide. Much as I wished for this unnamed fear to ebb like the outgoing tide, it did not do so. Whatever it meant, I had to confront it. And so I began my odyssey.

Shortly after Daniel left the house, I put on raincoat and boots, and marched out into the pouring rain. He had listed "Northside Bowling Lanes with Marc" on his plan, Marc being one of those two classmates/friends of Daniel's whose personality and interests I liked.

As I left, I called over my shoulder to Peter. "I have a few errands over at the Northside Mall. Maybe I'll stop at Vanessa's afterwards, so don't worry. I'll be home no later than 11:30."

Snow that had fallen the previous weeks was sooty and fouled by dogs. Slush carrying dirty debris was eddying down storm sewers. Mounds of snow were slowly melting in the shopping mall's handicapped parking spaces, where they had been shoveled prior to that night.

It would have been a perfect night for the family to share popcorn in front of a fireplace, but the weekend had begun, and adolescents like Daniel had tossed aside their books and were meeting their friends at each other's homes, at school dances, basketball games, malls, movie theaters, and recreational facilities. Accordingly, I left my comfortable, dry home to assume a new role,

that of detective investigating my eldest son. It was the first of the terrible changes made in and by a mother who, rightly or wrongly, no longer trusted her child.

By 7:30 I had parked my station wagon several double lines of cars away from the lanes, with the entrance in my line of vision. With my station wagon partly shielded from view by a small truck, I doubted that Daniel would spot me, but in case he did, I planned to wave and go on into a department store. What a heaven-sent gift it would be, I thought, if I could just see him enacting the agreed-upon plan, letting my tide of suspicion turn and start receding.

Then, as I sat pondering, I realized that the answer would not be that easy. Even if I should see Daniel enter the lanes, it would prove nothing more than that he had followed his plan on that particular night. It would reveal nothing about other Fridays or other plans, and would not prove his trustworthiness in all circumstances.

I wondered how many more such expeditions I might need to put myself through to allay my fears. How many times would I have to reassure myself that I could trust Daniel's behavior when he was out of sight? What is the cost of reestablishing trust once it is jeopardized? At best, one validation of Daniel's reliability could only be a start.

8:15, and no sign of Daniel. 8:30. 8:45. I realized then that in the inevitable confrontation with our eldest son, when I would accuse him of not having been at the lanes, he might counter with the explanation that he and Marc had entered by another door. I would have blown my cover and still not have my question answered.

I went into the bowling alley, a surprisingly dark, smoky, smelly establishment, considering its location at the edge of a family-oriented mall. It was not the well-lighted place where boys in Daniel's junior high gym class used to go for extra credit. It was like the ones my mother had kept me out of as a child, before bowling had become a family affair and most owners had cleaned up their lanes.

From one end to the other I searched in vain for Daniel before returning to the car. At 9:30 I made another fruitless circuit of the lanes. On my way out I almost bumped into Bruce, my friend Marie's son, who had driven his mother frantic by dropping out of school and spending his days roaming the streets, drunk, stoned, or high. His blank look of nonrecognition as I said hello verified that he was impaired that night. Adding to my fears was the fact that he did not look out of place in that sleazy establishment. Was pain like Marie's the price women must pay for being mothers in the late twentieth century?

Seeing Bruce made me confront a fear from which I had tried to shield myself: I was afraid even to say the word, but "drugs" kept creeping into my thoughts.

As I watched the door, a memory intruded itself of the single incident that linked Daniel and drugs. Eight months earlier, during our summer vacation, I was looking for Daniel on the beach where he had every right to be, but what I found was Daniel's shoulder bag. On impulse I opened it and discovered pot paraphernalia, including a hookah. I was upset, and in the confrontation that followed, Peter and I stressed his intelligence, his almost limitless options, and the importance of avoiding behavior like pot smoking, which jeopardizes motivation. I tried to show him that he could and should be the master of his future.

Although Peter sat in on this discussion, he did not take the strong, angry, father-to-son stand I wished, although there was no question that he felt the same way I did about drug use.

I thought the matter was behind us and saw no more evidence of marijuana use. But the sight of the glazed-eyed Bruce reactivated my worries.

I had no choice but to consider the possibility that Daniel and Marc were using drugs, just as I had no choice in the matter of the whole evening's foray. I was angry as I thought how my options were being eliminated, one by one. Sooner or later, I would discover the truth. Bad as it might be to know, not knowing was even worse.

I made another circuit at 10:15. I did not find Daniel, nor by then did I expect to. My mounting terror regarding my son was by then overshadowed by my fury with Peter. Why should Peter be sitting home, warm, dry, and comfortable while I was out doing our dirty detective work? Of course I hadn't asked him, but why should I have had to ask? Why couldn't Peter see what was so clear to anyone with half an eye, that we had legitimate and increasing cause for alarm about Daniel?

My reaction to how Peter was sharing only the good and joyful and loving parts of being a parent had reached rage level. What moral right did Peter have to enjoy life as a father but to shirk the hateful parts of fatherhood? Now that the chips were down, there I was alone. As I sat in the car for three hours watching the entrance to the lanes, I pondered again my intensely conflicting sets of attitudes and feelings about Peter, about the radical difference in the ways he handled his two major family roles of husband and father.

I had a loving and considerate husband, and yet there I sat in the parking lot, bitter and enraged because he had not met my expectations as a father, too. I should have anticipated that his being a close-to-perfect husband did not guarantee his being a perfect father as well. A different set of traits and skills is required. Yet what I expected from him seemed so simple, and he seemed to be going the other way so wrong-headedly. How could he be so incompetent? Why couldn't he see what a pushover he was with the children? Why wouldn't he ever probe anything beneath the surface of their explanations? Why didn't he ever discipline the boys, or cooperate with me in discipline,

or see a need for it, or back me up, or even just keep out of my way? Why couldn't he have been like his father—not only loving and giving, but also running a tight ship? Why, when I tried to administer discipline fairly and consistently, would he sit in judgment on the two of us as peers, then always rule with the child? Why couldn't he see that Daniel was manipulating him, and learn to take evasive action?

I was boxed in with a man I loved dearly as a husband, but was coming close to hating as an inadequate father. I berated myself for ingratitude to Peter, questioning my right to my resentful feelings, yet Peter was failing me as the father to my children. I sat in the parking lot feeling angry with Peter, and guilty because I was angry, and, underneath it all, horribly scared about Daniel. It was a hornet's nest of emotions, all painful.

Then another terrifying thought assaulted me. Maybe Daniel wasn't even with Marc. I hurried to a nearby phone booth and dialed Marc's number. "Mrs. Prendergast, this is Victoria Greenleaf, Dan's mother. What time did the boys leave this evening? . . . You haven't seen Dan? . . . Dan wasn't at your house tonight? . . . Marc has been home with the flu all week, you say? . . . He didn't plan to go somewhere with Dan? . . . No, I understood they were bowling."

I leaned against the booth for support as she snapped, "Please don't call here again about Daniel."

I knew she had a chronic condition of some sort, an illness that may have left her tired, in pain, and short-tempered. At least that was what Daniel had told us, but that could have been another in his tissue of lies.

I felt demeaned by her remark. I tried to use her probable illness as an excuse for her treating me with scorn. But I blamed Daniel for somehow being the cause of her contemptuous remark, the like of which I have never made to anyone in my life, nor had I ever before been on the receiving end of such an insult.

I was so stunned that I did not think until after I had hung up to ask what she knew about Daniel that had made her say that.

11:00. I made my last circuit. The sleazy proprietor unctuously inquired whether he could do anything for me. He said he didn't know Daniel Greenleaf.

I headed for home, hoping to get there before Daniel.

21

Four

Confrontation
with Peter

I RETURNED, RAINCOAT DRIPPING, as the eleven-o'clock news came on. "Peter, turn that thing off and listen to me," I began. "You have to help me. Daniel wasn't with Marc tonight, and he wasn't at the bowling lanes. I don't know where he was—or is. Daniel is deceiving us, and I'm sure it's not the first time."

"It's only 11:15. He'll be home soon."

"I repeat, he's not at the bowling lanes and Marc has been home all evening."

"How do you know he's not at the lanes?"

"I've been parked over there since before eight, watching the door. I checked inside the lanes from one end to the other four times in case the kids had gotten in some other way. Even the proprietor of that crummy establishment got suspicious and asked what I wanted."

"Why were you checking on Dan?" Peter asked accusingly.

"Because the house of cards has come down. I finally decided I have to know what is really going on with him."

"You worry too much. Kids like to feel free on Friday night, and let down their hair. He just didn't follow your plan."

"But the purpose of the weekend plan was to discourage just that kind of drifting around. Our kid doesn't need more spontaneity, he needs less. He needs structure."

"They just went somewhere else. What's so terrible about that?"

"No, that's not right either. You're not listening. I said Dan *isn't with Marc*. I called Marc's house about nine. His mother told me Marc was home with the flu, and they hadn't seen Dan. This was the first time either of them heard about Dan's supposed plan for tonight. Dan never had any intention of seeing Marc tonight. His mother got annoyed with me, asked me not to call there any more. I would have been glad if Dan had been somewhere else with Marc—he's the kind of boy I like, a nice, soft-spoken, well-mannered kid, not like those new friends of Dan's."

"Yeah, I like Marc too, but you're too rigid about all this. You can't pick Dan's friends for him. And teenage boys like to go where the spirit moves them."

"I never wanted to pick Dan's friends, until those new creeps showed up. I wish Dan would just focus on school things, the way we did. But that's not the problem tonight. He lied to me, and I suspect it's not the first time. Where was he all those other times when I assumed he was doing whatever his plan called for? Did he actually go to that school dance last week? Why do we get those calls from a kid who thinks it's cute to call himself Richie What's-His-Name?"

We went over the same ground for several more minutes and then heard the front door open. Our handsome, auburn-haired sixteen-year-old son had arrived and half-apologized, "I know I'm late, Mom. I'm sorry."

As Peter had so often said, half an hour late wasn't "the end of the world", but lateness was no longer the issue.

"You know how time gets away from you when you're having fun," he continued, looking me straight in the eye, as if to remind me that it was no big deal.

"Where were you, and what were you doing?" I asked calmly, intending to see how far he would try to carry the deceit.

"At the Northside Lanes, bowling with Marc."

"That's a lie!" I said, my voice conveying the anger I felt. "You weren't at the lanes and never meant to be!"

"How do you know that?" he asked, instantly aware that he would need to tread cautiously, that the tissue of lies was unraveling.

"How I know it is none of your business!"

"That's not fair!" His sense of justice centered on my strategy and deception, completely overlooking his own.

"Don't shift the focus from you to me. When you lie to me, I don't owe you fairness. So where were you and with whom?"

"Well, maybe we went for a burger first."

"I'm giving you one more chance. What did you do tonight and with whom?"

"We rode around."

24

"You and Marc?"

"Yeah—"

"Then how did it happen that Marc's mother told me Marc was home sick with the flu?"

"So you've been calling there again!"

"Damn' right! I've been calling there again! You expect me to be up front with you and tell you the truth when you lie to me? That's fighting with one hand tied behind me. All right. It wasn't Marc. Who were you with?"

"Blaise and Scott Duncan."

"Those nineteen-year-olds again!"

"Mom, why can't you leave me alone?"

"Because you're my son and a minor, and society makes parents the legal guardians and representative of law for minor children....Besides, I love you. If I didn't love you, I'd leave you alone. I shouldn't have to tell you that I care very much about what happens to you. I'm worried because I have a kid who lies. And while I know that everybody does that now and then, what's worse, you make yourself the judge of your own behavior, and you see no law higher than yourself."

"But Mom, don't you remember? You've always *said* I could do anything I wanted in my free time if I did well in school."

"Of course I said that, but I must have said a billion things to you in your lifetime and that's the only one you always remember and quote. Yes, I said that, but I meant and assumed that 'anything' would consist of wholesome enriching extracurricular things in and out of school, like that whitewater canoe trip we sent you on last summer with the Y. Yes, I said that, but in your case you can't be the measure of all things and make your own rules as you go along. You are avoiding the real issue. When I put in the plan system, it represented the other side of the coin, the responsibility that goes with freedom. You have to live in an orderly world with rules, and at your age they have to come from your family. Besides, what's the matter with hanging around with Marc and the forensics kids?"

"You can't have any fun with the people you like." (I didn't think to ask why not.)

"Well, one thing's certain. There are going to be no more nights like this, and you are grounded for tomorrow and Sunday, until Monday morning. Go to bed!"

Peter, as usual, sat silent through this interchange. But after Daniel left, I opened up the subject of what we should do about him. Then I realized more

25

than before how far apart Peter and I really were. He was, as always, willing to hear what I had to say about the inconsistencies of the evening, about Daniel's infractions of several rules. Yet he was also, well, he was Peter, and that meant that while he didn't excuse Daniel's lying, he was unable to see anything wrong with the pattern that Daniel was displaying. By contrast, my vague and nebulous but increasing worries and suspicions had finally snapped into crystal-clear focus.

The facts I had discovered about Daniel that night weren't so bad in and of themselves, but they represented the first time I "had the goods" on him. What I had learned sickened me because it confirmed that I had been 100 percent right to be suspicious. I no longer had to apologize to anybody, even in my mind, about going on my stakeout. I would never again feel called upon to defend myself to Peter or myself or anyone else for trusting my own judgment, following my intuition and ignoring Peter's namby-pamby, almost willful blindness.

That night I reviewed with Peter the string of incidents, each of which had gripped me in the pit of my stomach, yet each of which Daniel had explained, more or less plausibly. There was the pile of clean, stiff, unopened, unread Alistair McLean paperbacks that Daniel claimed someone had "loaned" him, but that looked more likely to have been freshly stolen from a newsstand. There was a chemical balance in his study carrel that looked like the scales used in high school laboratories. Daniel alleged to have bought it as "surplus", but "surplus" is usually army materiel, not school equipment. In Daniel's defense I knew that he had always, even as a small child, been particularly aware of concrete mercantile matters. He knew where to find whatever item someone needed at the best price. My mother, Daniel's Grandmother Gray, loved to quote the story of how she and Grandpa were discussing buying a watermelon. Eight-year-old Daniel piped up that they were for sale for a dollar out of the back of a farmer's truck at a particular corner they had driven past. It was possible that Daniel had acquired the scale and the paperbacks by some honest means. Just as Peter always said, "It could have been."

I reminded Peter of the shoplifting. I recalled many other incidents, each one of a kind. There was the time Daniel withdrew $186 from his savings account and later replaced it. He said it was to help a friend deceive the boy's parents, which was itself wrong. He refused to explain further.

There was another time when Daniel volunteered that he had been accused of stealing a gym key at school. I didn't think to inquire whether it was for a locker, entry, or security door, but whatever the truth of the matter, it sent a chill down my spine that he actually bragged that the school authorities couldn't pin anything on him. He even acted haughtily superior to the only other suspect, who had broken down and cried while protesting his

26

innocence under questioning. I wished that Daniel would have acted afraid and been the one to cry instead of presenting such a tough facade. I wished that they had gotten at the truth and that Daniel, if guilty, had been made to accept responsibility and show remorse. The school never called us, but I realized later that I should have called them.

Even after the lies of the bowling night, Peter was willing to accept Daniel's explanation for each of these cases, arguing "It could have been." He was unable to see that one by one they could have been, but the accumulated pattern *couldn't* have been normal.

I recalled to Peter the only time when he recognized that there was anything wrong in his relationship with Daniel and that his behavior bespoke subconscious anger with Daniel. Peter repressed the trivial triggering incident from his mind but remembered the horror of finding himself suddenly so enraged that he had lost control. My usually passive husband slammed the provocative, smart-mouthing adolescent Daniel against the refrigerator, pinning him by the throat, cutting off his breathing and turning him purple for a few seconds. I was not afraid of long-term harm to Daniel, but as I watched, I wished for the thousandth time that Peter could had reacted sooner with firmness, controlled anger, and true discipline, as I had been asking for years.

When we discussed it later, a shamefaced Peter took the blame on himself. "I don't know what made me do it. He just kept egging me on. I kept telling him that sticking out his jaw that way and acting so cocky, someday he would get someone so mad they'd kill him." To Peter's horror, he realized he might have been the one.

Later, too mortified to think of himself as violent even when provoked beyond endurance, he put it out of his mind.

I had half a dozen reasons for wishing I could be spared another round of psychiatric consultation. Understandably, I was ashamed and embarrassed over having to display to a colleague my child who, despite my best efforts, was going so strangely wrong. But I was willing to take my lumps, for the sake of my child.

Worse was the fact that I had no illusions about securing cooperation from Daniel for such an effort. If Daniel could lie to me on a twenty-four-hour-a-day basis, I did not expect him to be forthright with the doctor, a new adult and stranger. I remembered how Daniel's scoutmaster had told me he had tried to get close to Daniel, without success, had tried to "be his friend", but Daniel had maintained his loner position (with which I had become increasingly uncomfortable) except for the questionable recent acquaintances.

Furthermore, I did not trust my own colleague, whoever that might be. I had no confidence that, beginning, as he must, from a stance of neutrality, he would give sufficient weight to my vague hunches and dissatisfactions and discount my intuition that there was more than we were seeing. He would probably say, "So the kid lied to you—they all do that now and then." I was afraid he would evaluate Peter as the "good guy" (everyone else did), Daniel as close to normal, and me as a persnickety mother with too-high expectations. After all, it had taken me years to crack through Daniel's deceit. What could the doctor do, one hour at a time, which the wily Daniel could sit out or use to hone his skills at deceit. I believed then—and believe now—that despite Peter's laxity and my high expectations, we provided a family environment in which most of the world's children would thrive, as Jonathan and David were doing. Any "mistakes" we made going in with Daniel were not commensurate with what I was seeing and sensing coming out. Still, I would have welcomed a new revelation if it offered a realistic strategy of redirecting Daniel into the path I thought he should be following.

This is, admittedly, an odd position for a psychiatrist to take, when most of the population thinks that once you get to a psychiatrist, he or she will solve the problem. I had good reason to know better, that psychiatry is not magic, that, just as there are physical disorders that are fatal despite state-of-the-art treatment, so there are psychiatric disorders for which we don't have a cure. I was afraid Daniel might have one of those, a disorder that causes grief to those around but not to the proband himself, who would not wish to change, or wish to confer with a doctor, and the doctor would have little ability to effect change. One of my biggest concerns was that, besides what I had come to recognize as talent at deceit, and now criminal behavior, Daniel showed no signs of psychologic pain, hence had no internal reason to wish to change, certainly not just because I wished it. The Australian sabbatical had not fulfilled its purpose for Daniel. My worry was that Daniel was already unchangeable.

What was the disorder I feared most? It is now called antisocial personality disorder (formerly psychopathic, later sociopathic personality) and occurs preponderantly in males. The noun for the afflicted person can be "psychopath" or "sociopath", but "antisocial personality" is clumsy, and therefore I have chosen to use "sociopath". These people ride roughshod over others, even those in their families, whom they could be presumed to love. In the words of the old joke, they don't get ulcers—they give them. They have no qualms about dishonesty. They are confidence men. They dance through life engaging in outrageous, often shady or downright illegal enterprises, and rarely getting caught. They are glib and often charming and, surprisingly, they usually inspire confidence, and it takes unbelievably long to get wise to them.

28

As one author put it, "You take their check." I might add that I had evidence that you take a second check, even after the first one has bounced.

Current thinking is that this disorder is always preceded by conduct disorder in childhood, but conduct disorder does not always lead to antisocial personality. According to one expert, the adult diagnosis should be made before the patient is sixteen, and Daniel had passed that milestone. It was possible that my efforts to keep strict tabs on Daniel in childhood had worked but had thereby been counterproductive by preventing earlier diagnosis—and intervention. One hope was that although these persons are notoriously impervious to treatment, possibly Daniel's relative youth might make him more treatable, the condition being less engrained. The only tool in the therapist's armamentarium is somehow to persuade such people that good conduct is in their own best interests, because they don't do "right" for reasons of conscience. In fact, they have a conscience like Swiss cheese.

To seek psychiatric help, someone must be in psychologic pain. In the case of antisocial personality disorders, the one in pain is never the person himself but the significant other, usually the wife. And usually she is frantic and at her wits' end. She relates incident after troubling incident in a marriage filled with endless frustration, chaos, uncertainty, and desperation. Usually her spouse has her persuaded that the problems are her fault.

When I have treated such wives, I have had to be the bearer of bad news to the effect that their husbands will not change, leaving them the choice to tolerate it or cut their losses and bail out. Parallels to our case included the fact that while Daniel gave no evidence of psychologic pain, he was hurting both of us, now that Peter was in pain over the arrest. But a child cannot be divorced, like a husband. Would our only option be to tolerate it?

Occasionally I had fallen into the trap of getting the husband into the office with the wife. Soon I realized that diagnosing his condition was easier without seeing him. In a brief encounter I would find myself drawn in by the man's charm and plausible manner. Astonishingly, the husband's condition was easier for me to diagnose from what the wife told me than by getting the husband into the office for a face-to-face encounter. I would catch myself discounting, minimizing, or rationalizing what the wife had told me over weeks or months. Accurate diagnosis rested on the man's long-term pattern, often consisting of one-of-a-kind incidents, all displaying the individual's insistence on going his own way regardless of the cost to his wife, children, and anyone else he was presumed to love. When such marriages end in divorce, it is astonishing how well the husbands come off in the settlement, regardless of the laws in the state, and how they subsequently wriggle out of obligations for alimony and child support, without legal reprisal. It is as if they have the system in their pocket.

In evaluating Daniel for this kind of disorder, his life had not been long enough for there to have been a problematic marriage or unstable work history to assess. If adult males with personality disorders of the antisocial type present this picture, how would an adolescent with a nascent condition appear? Would he look the way Daniel was looking? If Daniel was afflicted with this condition, at least we were getting to him earlier than usual.

Furthermore, we still had legal control over Daniel and could make medical decisions for him until the age of eighteen, at which time the Twenty-sixth Amendment defined him as an adult. It was time to get him to the doctor, but would it do any good?

Over the months before, but especially after, Daniel's arrest, I had been fighting the fear that I was watching the childhood and evolution of an antisocial personality. Yet, whenever this diagnostic possibility raised its ugly head, it was not from comparison to the wives of patients I had worked with. Such an idea came from Daniel's similarity to someone much closer to me, more influential in my life, and a lifelong, walled-off abscess. Was I watching the rerun of a life I had grown up with fifty years earlier?

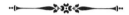

"Can you think of anyone Daniel reminds you of?" I asked Peter the night of the bowling incident.

"No. Who?"

"My father."

"Don't say that!" he said shakily, turning a little pale. It was the first isolated flash of gut-level concern I had seen in Peter. "I don't think it's that. I sure hope not, but let's see what the new psychiatrist says."

I was alluding to my newest fear, that, allowing for the differences in our society in the fifty years between their adolescences, Daniel was like my father. The father I had grown up with was not always fair or honest, although his dishonesties, by the time I could observe them, never brought him into direct confrontation with the law. Only as a seventeen-year-old, convicted of auto theft before the days of "juvenile justice", had he served six months in a reformatory. My mother tried to keep this from me, afraid that I would feel stigmatized. That part didn't bother me, since my father had grown up in another city. It was his adult behavior that I was ashamed of, knowing that he frequently operated at or over the edge of the law, getting away with schemes that were at best questionable, closer to fraudulent or criminal. I found my-

self envying girls who could be proud of their fathers. In our small town he was known as a hustler, a small-time operator at first, buying and selling low-cost housing, not exactly a slumlord, but offering cheap apartments to unstable tenants. He also ran a bingo game on weekends, and I am still embarrassed at class reunions when a debate partner of mine, who worked for my father as a caller, alludes to the old bingo game. Later my father also bought and sold stock, buried certificates in fruit jars, amassed a modest fortune, and left it to me by default of never writing a will. (Now I am putting it into a foundation for the study of antisocial personalities with drug-abuse problems.) My father suffered from three separate eye disorders and was legally blind from his mid-thirties. It is to his credit that, plagued with a handicap that would have put many persons on public assistance, he supported my mother and me well.

In family life, however, the best way to describe my father was "unpredictable". I learned early on that I could never have any confidence in any promise because he would find many rationalizations not to keep it—he always changed the rules while the game was being played, and he didn't even seem to know he was not trustworthy. There was the money he never repaid Peter and me, and that he talked Peter out of the second time. He ended up thinking he didn't owe it to us.

Once when I was in grade school, he promised me a "surprise" if I would be very good. I was tired of being manipulated, and resented being asked to work for something undefined, would not buy a pig in a poke, and made no effort to do whatever he wanted. It turned out that my "surprise" happened anyway—he knew that my name would be mentioned on a radio program, for reasons that had nothing to do with my father. Another time he had promised my mother and me a trip to Alaska and then backed out for no apparent reason.

In his own way he was tender to me and inordinately proud of my accomplishments. In something he said as an old man with Alzheimer's disease in a nursing home where I had had to put him, I recognized an old, commonly held folk belief to the effect that the father plants the infant, and the mother provides the earth in which it grows. "Just think!" he said. "Isn't it wonderful that once long ago you lived inside me!"

His manipulations and threats to control me usually involved money for something I held dear, such as tuition for medical school, which he could well afford. (In contrast, Peter's father, knowing that his sons needed intelligent, educated wives, paid part of Peter's brother's wife's tuition for music school. He offered to pay my tuition for medical school when my father threatened not to pay if I married Peter, but he didn't have to because my father came through.) As a teenager I determined to become self-sufficient so as never again to be dependent on either my father or anyone else—or be under their

control—and with my mother's help I escaped and studied for my profession and career. Thereafter I never again had to counter-manipulate. I tried to be a good daughter, tried to get my father recordings to circumvent the blindness. But I was never again manipulated or shamed.

Before and after the arrest night, I was developing the clammy fear that Daniel was showing the same type of character disorder I had lived with in my father. It suddenly came to me that I was the daughter and mother of sociopaths.

But if this was the case, I had to ask myself whether my father's mother and I had both done something occult and destructive to our sons, to create that kind of character disorder. I couldn't believe that there was anything atypical or cruel about my father's mother and father, who were in the mainstream of recently immigrated citizens, and whose two daughters became normal, upstanding citizens, one a teacher. Nor had Daniel ever spent enough time with my father to incorporate from his grandfather the kind of character pattern I was seeing. He was exposed more to my mother, who would come to our house in a different state to help care for our sons when we needed her. She foresaw trouble in Daniel before I did. She said, once only, "Isn't it too bad that he doesn't have a nice personality?"

And then with a surge of insight, I realized what had happened. If I did not have to accept responsibility for being some kind of poor mother, I was, nevertheless, responsible for Daniel's disorder, but not in a way I had considered. It was, in the terms of the old "nature-nurture controversy", in the area of nature. I was the link between my father and my son. I had innocently passed some kind of bad seed from my father to my son without displaying it myself, just as I had passed my father's severe myopia on to Jonathan and David, despite normal vision in myself—and in Daniel.

At the time, views that traits of a mental/psychologic nature can be rooted in biology were just beginning to be voiced. Hereditary components of schizophrenia were being studied, and personality traits in identical twins separated at birth were sometimes seen to be astonishingly concordant. But I had not—and still have not—heard of an analogous assertion being made for character disorders.

For several months I kept from Peter the fact that I had come to believe myself to be the unwitting cause of Daniel's disorder. This was because I had observed that whenever I admitted to anything less than perfect or in need of change in myself, Peter and I would always be in perfect agreement (in contrast to his defensive justification of himself whenever I suggested a flaw in him). I was not prepared for him to agree that I was to blame for Daniel.

Identification of the first glimmerings of something bad developing can be constructive if it permits taking evasive action. In the case of Daniel, had I

realized this sooner, known what was in store and sought professional help early, and had I been able to persuade the experts of the nature of Daniel's antisocial personality disorder, some professional opinions hold that intensive efforts might have altered the outcome. Others believe that no matter when diagnosed, the sociopathic personality is unalterable with our current treatments, although it ameliorates with age. As a psychiatrist working in another area but familiar with studies and the outcomes I have seen in personal life, I believe the latter. Although I live with tormenting uncertainty, I believe the die was cast when the sperm penetrated the egg. Whatever the reality, the question is moot because I delayed.

Five

Mountain-Climbing School

PETER, THEN AS ALWAYS MORE THAN WILLING to do whatever was needed for the children, deferred to my selecting a colleague who worked with adolescents.

I picked Dr. Gilbert Perez, a balding, bespectacled man in his forties, a man I knew only from professional meetings. He was young enough to relate well to a teenager, yet old enough to be seasoned in his difficult subspecialty of adolescent psychiatry.

For the first appointment, Peter and I went together to give Daniel's history, as psychiatrists prefer for children living with their parents. Then, because Daniel's history was so involved, I went for a second hour. Peter would have gone again but had to attend one of his infrequent out-of-town conferences to give a paper in his specialty.

During those first two meetings, I tried to make clear to Dr. Perez how I always felt off-balance with Daniel. He was so slippery, nothing ever coming together quite right. Two plus two always seemed to equal about three and a half. I told the doctor about the $186 dollar withdrawal, the "surplus" scale, the gym key, and the bowling night, as well as the two childhood incidents beyond the pale of normal misbehavior.

Yet telling the doctor this made me feel a little guilty because mothers should not be bad-mouthing their children. Besides, I had always considered

myself a very fair person, giving everyone, especially my own child, his due. Therefore I tried to be a fair reporter, including the many good and praise-worthy facets of Daniel's life, his academic success, his work as a junior curator at our nature center, and his being just a stone's throw from the rank of Eagle in Boy Scouts. Dr. Perez began seeing Daniel weekly, almost always alone, occasionally with Peter and me.

The only out-of-the-way incident during the next several months involved Daniel's unexpectedly late return from an out-of-town forensics meet. As I learned months later, Daniel and other boys (not from forensics) had taken those two hours to vandalize the beach house of the family of a friend of Daniel's who was away at boarding school. They made rings on furniture with wet whisky glasses and let embers roll out of the fireplace onto the white carpet.

As winter melted into spring, I faced the problem well known to working mothers: what the children would do over the summer, to have time for exploration and adventure and just thinking and loafing, all in a setting of supervision and safety.

We had offered Daniel a two-week mountain-climbing school in the Wind River Range, in Wyoming, but only if his grades held at no more than one B. Similar to the YMCA's whitewater canoe trip that we had let him take the previous year, this adventure was sponsored by a camping equipment store. I liked the fact that Daniel was at the upper end of their age range and all but one participant would be younger. Peter went to the organizational meeting to hear about arrangements—all new, unused ropes, for example. I talked by phone with Dennis, the young man in charge, to explain that Daniel's partici-pation was not yet assured, being contingent on his grades, but that we wouldn't ask for a refund. If Daniel's grades didn't qualify him, the money would come out of his account. I told Dennis I wanted my son to do wholesome and fun things, but I admitted to worries about him. I asked what Dennis would do if climbers brought drugs.

"If I found out when we were still in the vans, I could put them on a plane back home. But there's not much I could do if we were a day's backpack from where we leave the vehicles. To let you know where I'm coming from, I get all the highs I need on clean, fresh mountain air," he concluded. He impressed me as a reliable leader.

Certainly the mountains were a more wholesome setting than the metro-politan area, and I liked Dennis' openness in sharing with me that he suffered juvenile diabetes, which presents a special problem to a climber, due to energy requirements, altitude, and dryness. He related that he had lost his chance at conquering Mt. McKinley (now Denali) because a fellow climber, entrusted to carry some of his insulin, had not kept it close to his body but ruined it by letting it freeze, making Dennis turn back to base camp for life-

support. I was shocked. "That was irresponsible to the point of cruelty, to destroy your opportunity when it would have been so easy for the fellow just to do what he had promised!" I sympathized.

When June arrived, Daniel's only B was in Latin, so the trip was on, and he had to stay overnight with another boy for an early start. As he packed, he looked in vain for his camera. "I'm sure I had it right here on this hook," he said.

"Then what could have happened to it?" I asked. "You must have put it someplace else."

"Mine is too good for you to bang around on the rocks," said Peter. "This is awful—to go on such an adventure and not bring back pictures. Kids!"

But the time had come for us to leave for the boy's home. It was the last time the five of us ever went anywhere together as a family. At the host's house, Daniel ignored their son and looked out of place, scowling, sitting hunched in front of a television set, wearing the Australian slouch hat he had brought back, looking a little grimy, but maybe O.K. for a mountain climbing adventure, I tried to reassure myself. "Have a good time and a safe trip," I said, "and don't fall off a cliff!" We jostled him in farewell because you certainly don't kiss a boy that age in front of others.

On Monday afternoon David came into the kitchen as I was preparing dinner, with word that his bicentennial coin collection was missing.

"Oh, you've just forgotten where you put it," I said, then remembered the camera.

Jonathan went to investigate and reported his coins gone too. By then David was wailing, and the pork chops were burning. I promised to help replace his coins, but I had been giving the little boys every one of these circulating quarters I came across, so I could hardly be said to be replacing the lost ones.

When Peter arrived, I confronted him with these developments.

Peter also noted the absence of his collection, mostly foreign coins of little value brought home when we traveled, but also three older ones of some worth, which could have been sold to collectors.

The inference was mine to draw. "Daniel must have taken them. It wouldn't be the first time a kid stole from his own family. Or it could have been those scruffy buddies of his."

"But they've never even been in the house," he objected.

"Not when we were home, but who knows what goes on when we're not? It's ironic that no sooner is Daniel off enjoying himself than we are left under this black cloud of uncertainty that can't be resolved until he gets back."

We called the police, who could not tell me what I hoped to hear, that there

had been a rash of similar neighborhood break-ins. I told Peter he could call our insurance man, since our homeowners' policy covered this kind of loss. I didn't intend to, because I felt violated and ashamed. Peter never called either.

I was, naturally, the one to have to point out to Peter that the time had come to institute a search. As soon as Jonathan and David were in bed, we started with Daniel's study carrel in the basement, formerly a workshop, full of crannies, cupboards, nooks, and shelves. There, in full view on the desk blotter, was a pink Gibraltar banknote worth twenty shillings, which, for lack of a better place, had been with Peter's coins. Even Peter had to admit that this linked the missing coins with Daniel.

And then, on impulse, I lifted the blotter. Under it were two letters and a fragment in Daniel's writing.

> *Dear Fione,*
>
> *What's happening? I have been having some real hassles with my parents lately. They were really hassling me so last Fri. night I went to 55th St. Beach and hassled the rangers there. They were on the top of a hill shining their lights on me so I got really rowdy and started shouting Fuck you pigs and stuff like that. They really got pissed and came down to the beach to look for us, but we got away. Sat. night my old lady said there was no way I was gonna go out, so I went out my bedroom window. I cut my thumb on the way down and broke my new beer mug which I had never used before. We went into Chicago down to 55th St. beach and hassled some pigs in boats. I was really wrecked and I was jumping around on a pier screaming "Fuck you pigs. Ranger Rick and his dick." People couldn't believe how wild I was and left. We went garaging then and ripped off about 5 gallons of gas for the car. I went home at 2 and opened my bedroom window, then the mother-fucking dog started barking and my old man woke up. I was really drunk and I fell asleep on the roof until 3:30, woke up, and came in the window and slept on my bed.*
>
> *I am being a real freak and my hair is longer than ever. I got it cut about 7-8 months ago. It is well past my shoulders. I am about 5-8" now and weigh 135 pds.*
>
> *Say hello…to everyone I used to know and…tell everyone to write if they can, and the chicks too!*
>
> *Be cool,*
> *Daniel Greenleaf*

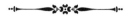

Eddie,

What's happening. Want to buy a bag? I got 12 oz.'s last Friday and I'm trying to unload them by the end of the week.

My parents are going to Baltimore this Thursday and my aunt is gonna be here. She lets me do anything I want, so Fri. night me and some dudes are gonna see Bob Segar in concert.

On Sat. night I'm going to a bag party. (Remember Pete Anderson's and yours birthday party. I got really wasted at that one.)

School is a real bummer. I take some fuckin' hard classes. But usually I get high before school. I've been dealing a lot lately too. I can get 7 grams of Lebanese blond for 35 bucks. I paid $185 for those 12 ounzes.

My friend went to Florida and so did his parents so me and some mates had a party over there. Fri. night Kevin had some dudes and chicks over but I was home. He took them upstairs (from the basement) and they partied up there. This house is a real mansion, marble all over and expensive wood furniture too. Well, they really fucked it up, black ash stains on white rugs, whiskey stains, wet beer cans on the wood, a log rolled out of the fireplace, and they ripped off the liquor supply.

Sat. night I had some dudes (freaks only) over to party. We were comfortable getting fucked up in the basement, not wrecking anything. Some jocks showed up and I kicked em out. Well, some freaks drove in and the neighbors saw em and turned on the outdoor lights and called the pigs. Everyone split while me and Sawyer (another freak) quickly (really quickly) cleaned up the emptys and on the way to the door, some pigs started knocking. Me and this dude hid upstairs and a closet and the pigs walked by saying - I wonder where those kids are? I almost pissed my pants and I was shakin' like a leaf. We got away.

I used to have some cool friends, but they turned into dicks and now I don't hang with them anymore. Real dicks! Poofters! They used to be cool too.

I'll write again sometime.
Dan Greenleaf

I turned to Peter and said, "All right, now what do you say about the $186? I know he put it back into the account because he showed me the passbook. He had no honest way to get that money. He's not just a kid who smokes a joint or two. And what about that Saturday? Remember that time I found a dried blob of blood on the front porch? That must be the night he's talking about. And the line about the $186 for the Lebanese blond—that must be some kind of pot. Now you have to face having a child who deals in drugs!"

Even in the face of such overwhelming evidence Peter weaseled, saying he didn't know which Saturday Daniel was referring to and calling the talk about marijuana "braggadocio". He did agree to another consultation with Dr. Perez in light of these new developments. But even before I called the therapist, out in the backyard over the edge of the cliff above the lake, I saw a bright piece of paper caught in some weeds. By lying on my abdomen I was able to retrieve several bits of multicolored paper—scraps of torn-up Gibraltar banknotes. They had been left over after I had bought, at free port prices, a collection of Beatrix Potter for the little boys.

Dr. Perez had no happy explanation for the coin collections, the Gibraltar money, the $186, or the letters. What to do about all this was another matter. Putting Daniel into a psychiatric ward would only buy time, and not very much of that, given patients' rights to be let out in three days unless you could prove they were about to kill someone. Dr. Perez was dubious about my idea of a local boys' school called Winslow, which a teacher had recommended as working miracles with three brothers she knew. The doctor suggested that we investigate a local drug-abuse program called Ad Astra and a therapeutic community in Maine by the name of Nova.

"Are you sure a hospital or 'therapeutic community' as you term it wouldn't be overkill or put Daniel in with even worse influences? Who are the rest of the patients? You know what they taught us in medical school: *Primum, non nocere.* First, do no harm."

"According to these letters, your son deals in drugs," he reminded me gently, a conclusion he had not reached in the months of working with Daniel.

We parted, agreeing that I would look into all three possibilities because we all realized, even Peter, that we could no longer contain Daniel at home.

Peter and I went to Winslow to meet the admissions officer and arrange an interview and testing as soon as Daniel returned from Wyoming. I also sent off for Nova's material, and I contacted Dr. Hyatt, the physician in charge of Ad Astra. I quickly rejected Hyatt's program since it operated in an open setting, with the residents placed with other families whose kids were further along in treatment. As slick as Daniel was about hiding his activities from me and covering his tracks, we could not let him be in an open community. He needed to be held still in one place, with walls, surveillance, treatment, and

redirection. I also had no reason to trust the ability of other parents any more than my own. I had no reason to believe that he would respond to their reasoning, appeals, threats, or whatever. Months ahead I could not imagine myself taking on someone else's child when I couldn't manage my own. Nor did I, as mother of two younger children, want them jeopardized by exposure to someone like Daniel or even worse.

I also made mental note to start watching Jonathan and David more closely, less trustingly. As a mother, I had lost my innocence.

Six

Deeper into Quicksand

Daniel's homecoming, with bags of dirty clothes and hiking boots, was a bitter reunion. I was aghast at having to face the Mr. Hyde part of Daniel, a child who could lie, deceive, betray, and steal from his family or help someone else do so. I was tired even at the thought of what lay ahead.

Even more than on the "bowling" night, I planned my moves carefully against this slippery customer, starting with one of the lesser discoveries. "Tell me about your brothers' bicentennial quarters," I said.

"What about them?" he snapped.

"They're gone, as you know. Not only that, but alone or with someone else you were in our bedroom and took part of your father's coin collection," I accused.

Daniel did not defend himself, argue, or offer any excuse or explanation. Instead, he went to the basement to do his laundry and take care of his gear.

I was relieved to have him out of the room but confronted Peter for not presenting a front with me. Instead, with Daniel out of earshot, Peter was telling me a story Daniel had related in the car on the way home from the drop-off point. It illustrated the polarities in Daniel, endlessly whipsawing my emotions.

Like any other diabetic, Dennis needed the protection of others in his environment knowing what to do in emergency. Therefore he had taught Daniel and Chuck, the other climber older than Daniel, what to do in the event of Dennis' becoming unconscious from the insulin overshooting his needs. At such a time he would need glucose, a form of sugar, and immediate action

43

could be lifesaving. He showed the boys plastic tubes of glucose and taught them how to force these tubes behind his clenched back teeth to administer the sugar. Then nobody gave it another thought.

Dennis was an experienced and careful climber, but the combination of high altitude, dry air, and strenuous activity produced the insulin/sugar imbalance he had feared.

The first time Dennis lost consciousness, Daniel and Chuck were able to revive him with the glucose. Dennis thought the problem was behind him and continued to work with the rock-climbers. A few days later, however, a second emergency occurred. This time the boys' best efforts failed to restore Dennis to consciousness. Daniel and Chuck made a quick, intelligent decision. Chuck stayed, continuing to work with the glucose tubes, while Daniel found his way back to the nearest village to bring medical help.

Daniel loped eight miles up and down unknown mountain trails with only moon and stars for illumination. He found the doctor, who provided horses for both of them, and together they rode back to camp in time to save Dennis' life. They then triaged Dennis back to the hospital in the village, leaving Daniel and Chuck to supervise the younger boys.

In this way my son, the thief, was also my son, the hero. It was exactly the kind of courage and intelligent, quick thinking that I had hoped and expected from Daniel, whenever a need would arise. It was a story any mother could remember with pride to her dying day.

It made me all the angrier. My son, the heroic punk.

The following day Daniel announced that he didn't intend to talk to me any more. He indicated that he would be responsible for his own comings and goings and in no way obligated to include me in his plans, associations, behavior, life. He considered himself an adult, he said, able to make his own decisions without interference from me. I saw no reason to argue or discuss the thefts any further because my hope and plan was to get him as soon as possible to Nova, though I had not heard from them.

As time slipped past, Daniel came and went soundlessly through the house. I would look up and he would have left, only to return hours later, sometimes smelling of alcohol, sometimes with bright pink dots on his cheekbones, like rouge on a clown. I have since heard that these dots are a hallmark of LSD, but I have no idea whether that was what put them on Daniel. His appearance was beginning to change by imperceptible increments, like a portrait of Dorian Gray, reflecting accretions of corruption. During some of his absences from home, my flesh would crawl because I sensed that evil was abroad.

Occasionally I would try to talk to him, to reassert some kind of control over this out-of-control child. "Daniel, you seem to be headed for the door. Where are you going and what are your plans?" I would ask.

"Out and I don't know where. Maybe I'll see if Kevin's home."

"Why don't you call him first and make plans, and then your father and I will know," I would plead.

"Mom, I just don't want to do it your way," he would retort with mounting irritability. "Look, I'm sixteen and old enough to come and go without this third degree. What difference does it make where I'm going? Everyone else's mother isn't trying to check on them all the time. And I'll tell you one thing—I'm not going to stand for it any more."

"Parents of sixteen-year-olds who care do check on them." But Daniel would be out the door.

Hours later I would say to Peter, "You saw what happened. It's 11:45, and that kid isn't back yet."

"What do you want me to do?" he would ask.

"I don't know yet. You think of something I haven't thought of yet. I don't have a reply from Nova, but I plan to call them tomorrow. This whole mess doesn't seem to be bothering you the way it does me, but I can't stand my sixteen-year-old running amuck. I don't think we should have to be staying up to let him in, but you know he never remembers his key, and I don't want to go to bed with the house wide open. I'm not sure I could sleep anyway. He'd probably climb in through some window, but if he were to wake you up, you'd never get back to sleep. We work tomorrow and we can't keep going without sleep, always at his mercy, with him calling the shots."

"You go on up to bed, and I'll wait for him. I can read awhile," Peter offered. But Daniel came in soon thereafter, this time smelling of alcohol.

"Daniel, you've been drinking," I said angrily.

"No, I haven't."

"I can smell it."

"So what if I have?"

"Daniel, you're sixteen. It's against the law, but much worse, it's against you and your character."

"Can the sermon. I'm going to bed." And he did.

I wandered back to the kitchen where Peter was drinking tea. "Why did you accuse him of that?" Peter wanted to know.

"Because he reeked!"

"I didn't smell anything."

"You never had a sense of smell. He smelled just like aftershave. Besides, he's the one who said, 'So what if I have?'"

45

As that terrible summer dragged on, and I continued struggling to find a solution for Daniel, one good thing happened. I made a new friend. Iris Wilson was the mother of Kevin, a classmate and friend of Daniel's. Kevin too was on a destructive course. But unlike Marc's mother, Iris was happy to cooperate with me in trying to keep track of our sons and brainstorm what to do about them.

Iris' husband, Irwin, had tried to maintain a semblance of control over Kevin, but Irwin was even more passive than Peter. Irwin would ground Kevin, but no sooner than Kevin would start badgering, Irwin would roar, "Do anything you like. Just leave me alone and give me some peace!"

Kevin's deterioration was in some ways slower than Daniel's. He still dressed and looked better than Daniel. With blond curly hair trimmed short, he had an innocent, charming, almost cherubic look, the opposite of Daniel's furtive, sly, and sneaky demeanor. Kevin still spoke middle-class English, not the kind of street slang that Daniel was affecting. Kevin also came and went at all hours, the difference from Daniel being that Kevin had always cajoled Irwin's "permission" first.

In other ways Kevin was worse than Daniel. Iris told me he had come home stumbling drunk more than once. His school grades had plummeted, and he had been randomly dropping courses, without his parents' permission or approval.

We had had Iris and Irwin over one evening while Daniel was still out climbing in Wyoming. A few years older than Peter and I, they were approaching retirement from their teaching jobs at a nearby community college. They were gentle people, like Peter, distraught but largely paralyzed in their efforts to control their son. Kevin was their younger child, and they had had milder problems with his older sister. Coping with Kevin was their last gasp of parenthood. Whenever I had time and energy to divert from my preoccupation with Daniel, I reflected about my new worry: never having expected trouble like this from Daniel, might I now be facing it also in his two younger brothers?

All else being equal, Kevin was a boy I preferred for Daniel to spend time with, if for no other reason than that Iris was a mother who would work with me in trying to help keep tabs on the boys, unlike Marc's mother's haughty rejection the night of the bowling fiasco. Daniel never mentioned Marc after that night.

I had the distinct impression that Kevin was following Daniel's lead, and Daniel was following "Richie Blackmore" down the garden path. Still, not knowing Blackmore's true identity, I had no way even to look for his mother, who, for all I knew, might also be willing to reach out for help.

Late one evening when Daniel was "out", I called Iris to ask whether Kevin was with him and whether she had any clues about where they went.

"All I know is that Dan came by about 7:30, and the two of them went off

somewhere together. Kevin wandered back alone about 10:30."

"Had Kevin been drinking? Last night Daniel came in about midnight smelling of booze."

"Kevin went right up the stairs and to bed, which of course he does so I won't know. I didn't smell anything, but I wasn't that close. . . . You mean that now Dan is drinking too? This is the first I heard of that. . . . I guess he didn't tell you where he was going."

"Of course not. He never does." And I told Iris how I had just become aware of the drinking myself, not having any reason to look for it, and how Daniel refused to answer my questions, and how Peter never asked any.

She filled me in on the details of a story from the previous winter, that I had heard only from Daniel's end. One evening Kevin had pushed all of Irwin's buttons, threatened to run away, and got his father so distraught that Irwin roared for him to go ahead and run. So without a jacket or even a sweater, Kevin threw himself out into a snowstorm.

Knowing about our sons' association, Iris had called frantically to see whether Kevin might have come to our house. He hadn't, and if he or anyone else had ever arrived in his shirtsleeves in a snowstorm, I would have immediately called the parents anyway, unlike the young drama coach in Australia. While Iris waited on the line, I went to inquire what Daniel knew, which was nothing. But when I got back to the phone, Iris was relieved to report that Kevin had just walked in, cold but safe.

I told her about Dr. Perez's idea of Nova's residential treatment for Daniel, and the possibility of Winslow Academy, although I had doubts the latter could contain him. I also recounted my disenchantment regarding Dr. Hyatt and Ad Astra.

Iris said they were considering a military academy for Kevin, even though they were repulsed by martinet-like strutting and saluting and posturing.

"That kind of reflex obedience is the opposite of the appeal to reason we have always preferred, too," I agreed, "but spit-and-polish and snapping-to-attention may be just what some teenagers require, I'm afraid."

"Let me know what you find out about Nova," she asked before hanging up so I could call them.

Nova's secretary said that she had mailed the literature and applications two weeks earlier. "It should have been there long ago, but I'll put another packet in the mail today. Meanwhile, can we help you? Our director is sitting right here. Would you like to talk to him?" She had him on the line before I could think of an excuse to get out of talking about Daniel.

"This is Dr. Franklin," he said. "The secretary tells me our material has gone astray. Do you have any questions I can help you with? What kind of youth are you considering Nova for?"

Slumped over in shame and despair, I felt a blush creeping up my neck as I replied in a low voice, "It's my son."

"I'm sorry. I'm not hearing you," he said. "Maybe this is a bad connection."

"No, the connection is O.K. ...It's my son, Daniel. He's out of control, comes and goes at all hours, drinks, uses and sells drugs. He conned a child psychiatrist for four months, before we found letters he had written about selling drugs. That psychiatrist recommended you. Daniel is only sixteen, extremely bright, heroically saved a man's life last month, and is just too good to lose."

"Dr. Greenleaf, come out to visit us, talk about Daniel, and see what we have to offer. Anything I could say can't assure or reassure you in the way that seeing our program with your own eyes and talking to our residents would."

"Residents? Are you training psychiatric specialists?"

"No. In therapeutic communities we use the term 'resident' for those here for correction and reorganization of their lives," he explained. It was my baptism in the terminology of delinquents, offenders, and new ways to work with the antisocial young.

"You don't understand, Dr. Franklin. It's all I can do to hold things together with me here full time. I have two younger sons. I don't care what your facility looks like. I want to get my son to you. Please see that I get the application forms."

"I would like to meet you and show you Nova. We are geared for children like Daniel, obnoxious but not crazy. We have children of other psychiatrists. Parents of children like Daniel are always desperate and confused, ambivalent and guilty—"

"Guilty!" I exploded. "What right do you have to call me 'guilty'?" His word choice outraged me. I already knew he must have a pretty good idea of what Daniel was like—Nova was, as he said, full of Daniels—and what he was referring to in parents were 'guilt feelings'—often inappropriate ones at that—that conscientious parents have been programmed to feel for anything that goes wrong with their children.

I went on, "I haven't done anything to be or feel 'guilty' about! It's that creature that should feel 'guilty' and doesn't know how. If there's anything to Karma, it's another life I sinned in. I never sinned that much in this one.

"I don't think I can come out to Nova, or at least not until we bring Daniel, but please see that the forms get sent. On second thought, you'd better send them to my office. Daniel may have stolen the first batch. As far as I know, he's never taken any of my mail, but whatever he does is always a first."

"I'll give you back to the secretary for your office address, but think about what I said, and come out to Nova."

We had several visitors that summer, and at last I stopped concealing from some relatives and close friends my concerns and fears about Daniel. Among the first to hear were my paternal aunt and her husband, Gretchen and Willard, who were close to Peter in age and like older cousins to me. Gretchen was being treated for breast cancer by a specialist to whom Peter had referred her in our medical center, so they stopped to see us when they came to town for her quarterly appointments.

Willard and Gretchen were aghast at my revelations, having considered Daniel normal within the longhair limits of our times. While we talked upstairs, Daniel was in the basement reading *Les Misérables* for honors English in the fall.

Willard, a junior high teacher with a lifelong history of working with adolescents, went downstairs to talk to Daniel, urging him to find new and better friends. He was half-pleased to report that while Daniel bragged that he would probably run away, he nevertheless promised that, if so, he would run to Willard and Gretchen's. Even Willard acted dubious, the more so when Daniel came upstairs and angrily told us all he was going "out" in that haughty tone of contempt I had come to hate, which said, "Get off my back!" to both me and his great-uncle Will.

"Now you see what I mean?" I asked rhetorically.

A few days later my cousin Esther, also from a different state, called from the airport on her way through. I quickly adjusted my schedule so as to have lunch with her between planes. She was the third person on whom I tried my eye-opening explanation of the tango I had been dancing with Daniel. Instead of feeling comforted by our time together, I ended up feeling humiliated by Esther's reaction. "We always sent ours to private schools," she said. "That way they met 'better people'."

"But more money doesn't mean 'better'," I retorted angrily. And several months later Esther herself suffered one of the terrible parental griefs almost unique to our times. One of her private-school-educated sons who had been associating with all those 'better people' vanished and was never heard of again, alive or dead, as if he had dropped off the face of the planet.

My relatives' reactions confirmed my earlier observation that the average person just could not get a feel of Daniel from my stories. Not even Gretchen, with a lifetime of experience with my father, understood, and so I gave up trying. It was just what I had experienced when, as an adolescent and young adult, I would try to explicate what my father was like. Without experiences with an antisocial father, my friends' responses to me would be irrelevant and tangential. They could relate only to their own concept of "father". Now, similarly, intelligent, concerned people seemed capable of relating only to their own concept of "son".

49

Finally Nova's packet arrived in my box at the hospital. Included with the brochure and application blank were many photocopies of letters and newspaper stories detailing recent accusations, charges, and investigations of the facility. It was apparent that the director needed to be up-front with parents and professional referral sources.

Included in the articles were accounts of how correctional authorities of another state that had used Nova for some of its delinquents had investigated the treatment the juveniles received. The first line of defense in dealing with day-to-day disciplinary problems was done by longer-term residents who had progressed to levels of responsibility in Nova's program. New arrivals, particularly, often reacted with hair-trigger outbursts to perceived insults or epithets from other residents. Such newcomers usually showed more-than-usual levels of denial, and the system was geared to address immediately whatever problems they caused. Therefore, when explosions occurred, residents would call a hearing immediately, listen to evidence from witnesses, and mete out punishment under staff control.

It was something like the system in traditional boarding schools where upper-level students play an unofficial role in governing lower-level students. The difference from our ordinary court system was immediacy. Nova's "court" could be convened in minutes, minimizing the distortions, evasions, and denial that would otherwise muddy the process.

Punishment was creative and could fit both the offense and the offender. Sometimes additional work details were assigned. Sometimes, when a resident's rage was volatile, he would be restrained long enough to be brought under control, then permitted to work out his hostility in controlled ways, such as the "boxing ring" in which matched youths would spar according to standard rules enforced to protect everyone from injury. This "boxing ring" was one disciplinary measure questioned by the juvenile authorities but retained. They also objected to use of "electric sauce" (a mixture of garbage and dishwater) poured over out-of-control juveniles to bring them down to earth. I was appalled that the out-of-state authorities raised objections to the most trivial of the punishments: restriction of television privileges. I thought it strange to be embroiled over the perceived right of delinquents to be entertained.

Investigations by both the state authorities and neutral, outside specialists in juvenile treatment brought in to assess Nova were in the main supportive. Only the "electric sauce" treatment had been discontinued.

This disagreement among juvenile experts about the management of delinquent youths underscored a question both practical and philosophical: how to get the attention of out-of-control youths who, for years, have tuned out talking, reasoning, and attempts to deal fairly and rationally with them. These were juveniles who seemed impervious to everything but force. The disagreement

illustrated how antisocial adolescents are able to provoke many normal adults, even correctional specialists, to fight over them.

The manner in which correctional authorities put Nova on the defensive on the subject of punishment reminded me of what I had been through with Peter. Not only did we disagree about the need for discipline in a given situation, but also we never could see eye-to-eye on the nature of acceptable punishment. I quickly observed that verbal disapproval never had any effect on Daniel, nor would he work for praise. I had to find concrete punishments. But, beginning with the basic proposition that no physical harm could be inflicted, what was left? To be sent to bed without dinner seemed to me relatively mild and trivial, yet illustrated to the erring child that not living by family rules brought exclusion from family activities. But to Peter, food in the form of three meals a day was a birthright, deprivation inappropriate regardless of circumstances. In truth, we had little to "take away" because whatever we "gave" was given for its good and wholesome benefits to the child. The frequently used "taking away television" didn't apply because we allowed only worthwhile programs (the children saw plenty of junk television at their friends'), and even Peter made no argument about restricting what little non-educational television I permitted.

For most of our time as an allegedly intelligent species on planet Earth, children had no rights. For centuries our society lived by the unquestioned assumption that fathers had absolute power over their children (and wives), including power of life and death. Belatedly, in historic perspective, our civilization has finally assessed this behavior as abusive, and has slowly and painfully moved toward protecting children.

With great difficulty, we have finally achieved legal methods to take children from abusive parents, though the methods are often so difficult as to make such "protection" too little and too late. Laws mandating compulsory education, though often flouted, are intended to protect children against their own and their parents' shortsightedness regarding choices affecting their lifelong needs. Child labor is also limited and regulated. Efforts to safeguard the young extend to mandatory immunization, legal driving, drinking, and marrying age, and regulation of dangerous chemicals, house paint, asbestos, and the like.

Where we have fallen short is on the other side of the balance: ensuring that the young gradually assume the rights and responsibilities needed to mature into moral, productive adults. In most cases this happens more or less naturally as the young respond to judiciously applied rules, sanctions, and rewards under the loving guidance and encouragement of parents, teachers and other adults. But, when in the growing child, we do not see the development of socially constructive behavior, we have little in the way of backup

strategy. We need a Plan B, and I thought that Nova offered it. I knew of no one else who did.

It is ironic that when something has gone wrong in the socialization of the child, as in the case of Daniel and thousands others like him, the rest of us—parents, juvenile experts, and the rest of society—don't know how to confine them with needed controls. Instead, we argue and fight among ourselves, taking strong stands about whether someone is encroaching on the rights and privileges of such obstreperous teenagers, who seem to have little regard for the rights and privileges of others. These adults get squeamish about allowable, acceptable, legal punishments, even down to whether it is justified to restrict amusement. If the caretakers' hands are tied over such trivialities, how can adults in the mainstream get the attention of the antisocial young, not to mention re-socialize them? I sympathized with Nova over its recent beleaguerment and appreciated their honesty with me.

I filled out Nova's twelve-page application form, with its totally predictable questions. As I worked, I doubted whether many of their applicants were honors students. Just typing these answers felt to me like wading deeper into the icy waters of Daniel's redirection and not looking back to shore. As bad as it was, I was able to take comfort in the fact that at least I was actively doing something, not sitting passive and helpless, waiting for the next development. I drove to the post office to drop off the big envelope.

That night I called Iris again. She was disgusted with Irwin's wishy-washy ways but did not take active steps on her own, as I was trying to do with Daniel. Where were those old-fashioned, Victorian-style fathers whose wives threatened misbehaving children with their return from work, and whose presence caused their adolescent sons to snap to attention with respect if not fear? Just that evening, as Iris described it, the latest Wilson donnybrook had again ended with Irwin throwing up his hands and letting Kevin go off with Daniel.

Iris had important new information for me, however. The boys were probably with Kurt Duncan, one of the two older boys Daniel had been hanging around with. Kevin, in a rare communicative mood, had told his mother that Kurt was the boy who went by the "handle" of "Richie Blackmore", and "Richie Blackmore" had called Kevin that evening, leaving a message asking Daniel to call him.

Iris and I compared our hurt, angry, ambivalent feelings toward our children. Besides all our disappointment with them, we did not like what their behavior was doing to our own characters and behavior. In our battle to save them, we had acted in ways we would have scorned in the past. We had

become eavesdroppers, as Iris had done that night, and spies, as I had on Daniel's "bowling" night. Yet what was our choice? These were the lesser of the evils. These were situational ethics with a vengeance.

At 1:15 A.M., after my hours-long conversation with Iris, Daniel strolled in, looking, again, like a painted clown with the telltale pink spots on his cheeks. It seemed too hopeless to pursue.

The next day Peter, Daniel, and I had an appointment at Winslow, which I thought we would be wise to pursue pending an acceptance from Nova, not to burn any bridges. Daniel reluctantly took the hand Mr. Lipka, the admissions officer, extended to him. Then Lipka took Daniel alone to his office for an interview and testing.

Back home again, Daniel for once told me where he was going, to spend the afternoon riding his bicycle in the Metro parks. That was why, later in the day, my heart did a flip-flop when a man's telephone voice identified itself as Sergeant Fredericks of the Parks Police. But my fear of an accident was quickly relieved. The officer said he was spot-checking bicycles and had called to verify the make and description of Daniel's bicycle, since it wasn't registered. Why didn't Fredericks ask me instead of telling me the make and color of the bicycle Daniel was riding? My own interrogation method with the children always involved getting information from them without giving them what I knew. A competent officer would have had me describe the bicycle, since I could have simply agreed with anything Fredericks said if I had wanted to shield Daniel. With public officials like Fredericks, it was no wonder Daniel could get into so much trouble without getting caught.

That very afternoon Charles Lipka phoned. "I'm afraid I have bad news for you," he began. "It was the opinion of our committee, myself included, that Daniel isn't the kind of student we prefer at Winslow. To be honest, his speech is street language, and I think the possibility that he would bring in drugs is too great. I don't say we've never had such problems, but we do have to protect ourselves when we foresee such a situation developing. I might add he performed very well on the tests. He has great potential but sounds bored with school and uninterested in Winslow. . . . I'm sorry."

"I understand. I can't say I blame you. Thank you for your time." I hung up and cried.

"So that leaves us with Nova," I concluded, as I told Peter the story that night.

"You mean they really think from talking to him that he would bring in drugs?" he asked incredulously.

"Peter, you haven't detected the change because of your being with him. It's the way parents don't see their own child grow, though out-of-town grandparents, seeing him at longer intervals, can easily spot changes. If Daniel

came to you for a job in the lab, you wouldn't hire him. He speaks 'Street', not middle-class English. He runs syllables together, drops the ends of words, and all with a kind of built-in growl. This isn't what he was taught, but it's the way he is now. This call from Lipka really clinches it. Now we're left with Nova, and the problem is, how will we transport an unwilling, obstreperous sixteen-year-old a thousand miles?"

Seven

Logistics Problems

I MULLED OVER OUR STAGGERING TRANSPORTATION PROBLEM. Two middle-aged parents would be no match for Daniel, who would have no reason to cooperate. We would need two, preferably three, strong young men flanking Daniel. The only relative who fit this description was Peter's nephew Steve. But Steve's mother Vera told us he was on a job in Venezuela and wouldn't be home until Labor Day. She thought he would be willing to help and promised to mention it when he called home. Still, we needed help sooner than fall.

I dismissed almost immediately my idea of advertising in the paper for strong young students. After all, not knowing Daniel and not having a parent's perspective, they would probably be sympathetic to him and could very well outflank me and release him.

I called on a local judge to ask for help. This man was very close-mouthed, suggesting only the Juvenile Department. He probably considered that helping me would represent some kind of conflict of interest, I thought bitterly.

I was left with asking for help from the authorities, and I gave Peter the chance to go with me, but he declined. I envisioned asking the police for something like a bucket brigade, passing Daniel from state patrol to state patrol at each border from Illinois to Maine. While waiting my turn at our Evanston Juvenile Department, I sat cowering miserably in the waiting room, hoping I wouldn't see anyone I knew. Then in walked one of their juvenile officers, Heidi Cunningham, a former counselor at junior high when Daniel was there. She saw my distress, got me coffee, listened to what I was asking,

and indicated that from seeing Daniel on the street she could tell he had hit the skids since his junior high days.

"If you saw that, why didn't you call me? Whenever I have seen a problem in anyone else's child, I have brought it to the parent's attention. Why didn't anyone do this for me?"

Heidi had no answer for those questions, but she said that since she ranked at a lower level, I would have to talk to her boss. I made an appointment for the next day.

Peter decided to go along the next morning. Under Mr. O'Donnell's questioning in the Juvenile Unit, we named the boys with whom Daniel had been associating. As each boy was identified, Mr. O'Donnell would respond with something like, "Oh, yes, we know him—he's involved in drug pushing." Or, in the case of Scott Sawyer, "Oh, he's a real beauty—an 'adult' of nineteen—we hope to send him up some day. He's the worst influence on youth in this end of Cook County. Very smart too—he attended Science High in New York and has a juvenile record out there. He's very slippery—we haven't been able to nail anything on him since he moved here with his mother and sister."

Peter's face blanched with each revelation that Mr. O'Donnell so casually tossed out. Like Heidi Cunningham, he was sympathetic to our plight but knew of no precedent and no way to implement the sort of help I was asking. All he could suggest was that we contact the juvenile referee—and that we take a lawyer along.

"Why a lawyer for me to explain to, so he can explain to the referee?" I asked incredulously.

My frustration was mounting, along with my worry and despair. In difficult situations I have observed that whatever I need to do, it seems I have to do something else first. I have to back up one step, and then another and another. To get Daniel to Nova, I had to get help first, and I needed help to get help, getting farther and farther behind the starting point. Nevertheless I made the next appointment—for a week later, when the only court referee for our end of the county, Mr. Hadigan, was due back from vacation. Our system moves with glacial speed.

Starting that day, I began something new, keeping a log of incidents relating to Daniel, their dates and times, recording my observations in as objective language as I could. It was obvious that generalizations and retrospective descriptions simply did not convey the wobbles of Daniel's increasingly eccentric orbit around the family. Who could tell when I would need documentation? Short of being accused of fabricating the whole thing, I could not imagine such evidence not carrying weight.

8/12 (Friday)—Stood outside kitchen and listened to his father and me discussing plans for Nova. Then asked by his father to go willingly and voluntarily. Left home without permission; returned some time after midnight. (Champagne found in overflow refrig.)

8/16 (Tues.) 9:30 A.M.—Gone already without permission. Wandered home at noon and asked for money for a haircut. Gone at 12:15; still gone at 3:45. Returned at 5:15, had spent $7 for no apparent shortening of long hair. (Receipt for $5, claimed he had spent $2 for lunch—told it would come out of allowance since lunch food was here.) Told to stay home in evening. Left at 8:15 without permission. Home at 11:45.

8/18 (Thurs.) Gone about 12:30. At 6:45 call from Iris. Neighbors saw Kevin and 3 other males (one with long hair) in alley. Then neighbor found 1 1/2 cases of beer missing from garage. Gloria [Kevin's sister] saw Kevin and other boys beside garage. When she arrived a few minutes later, they were gone. Iris predicts return with smell of beer. Kevin never out through dinner hour. [Neither had D been.] D home at 7. Smells of alcohol. Surly. Says he drank beer that they found on beach. Loud mouth and arrogant manner. Says we are taking things from him, i.e., drinking privileges.

8/19 (Fri.) Permitted out in afternoon for "bicycle riding". I suggested that he deliver letter from Chicago Pub. Lib. (re taping books for the library for the blind) and other forms for Eagle application to Scoutmaster. Didn't do this. At dinner his father strongly suggested that he usher at Shakespeare Festival tonight. Refused. I told him I don't want him out tonight, but if he's out, home by 11. Gone by 6:40. Peter came to bed at 2 and D not home yet. I was awakened at 3:30. D in his room. That whole end of house reeked of alcohol.

8/24 (Wed.) I asked D to help move a dresser and he said "Not unless I get my clock-radio back. Otherwise fuck it." So Mrs. I and I moved it. Gone by 12:30. Home ca 4:30. Vanished by 7:00 P.M. In at 1:30—says he was on the beach and fell asleep. No strange smells.

8/26 (Fri.) Away in afternoon—intended to take Eagle application to Scoutmaster. (Bottle of champagne I found early in August in basement refrigerator and had put into little-used cupboard now gone.)

During all this coming and going on Daniel's part, interspersed with my phoning, letter-writing, and appointments concerning Daniel, I tried to protect the lives of the rest of us from being swallowed up in his. My strategy

has always been that, having done everything possible on the big problem, you must make certain not to stop living your daily life. My summer schedule was light, which helped, and the little boys went to camp for part of the summer, which also helped.

During that long hot summer, Iris and I continued our alliance against entropy. But it was a laughable fight we waged. We were like children armed with lollipops, out to do battle against the Mafia.

That summer Iris assumed the role of information-gathering contact for me because Daniel would usually go first to the Wilsons' to pick up Kevin. The boys would talk quite openly in front of Iris about their plans, somehow not considering that she would then report to me. Kevin vacillated between secrecy and communicativeness with his mother, while Daniel refused to talk to me, as he had threatened. Iris, in fact, complained that Kevin had a nervous habit that would drive her wild. He would talk in a torrent of words, his productions often inconsistent and contradictory. The result was a smoke screen, obscuring what he intended to impart, but at least Kevin's intent was communication. Iris commented on another difference between the two boys. She sensed that when Kevin caused pain to his parents, it was an unintended side effect. At times he even seemed genuinely sorry and apologetic for his increasingly erratic behavior. Daniel projected to Iris a much less wholesome attitude. He seemed to her to relish hurting us—me in particular.

In another way Kevin's case looked less ominous. As best his mother could tell, Kevin had apparently developed normally until a year or so earlier, giving him a normal base to which to return, and not so far back to go before going forward on track. I despaired in the realization that Daniel had been showing signs of antisocial personality much longer, since even before Australia.

I broached a new concern to Iris. I asked her about a girl named Kim Levendula, a name Daniel had dropped. Iris had heard the boys mention her, offered to point out her home, and added that her father was a policeman. Iris and I found no phone listing for that unusual surname, and we could appreciate that a policeman might need an unlisted number. And so I called the police station and left my name and number with the desk sergeant, implying that while not an emergency, my call was medical in nature, which of course it was, dealing with Daniel's mental health. Kim's father lost no time returning my call. I explained that I was not comfortable with Daniel, who apparently spent time with his daughter, and asked whether she had introduced Daniel to him. He indicated that he had been trying to get his ex-wife, a nurse who worked evenings, to tighten up controls because she had kept a pretty loose rein on Kim. He said he would look into her relationship with Daniel and get back to me. He never did.

I was not reassured: apparently there was little supervision at Kim's.

One terrible night in early August, while the birds were still twittering in the wild cherry trees in the melon-colored dusk, Peter and I were in the kitchen when we heard a swift rustling sound in the dining room. I leapt to my feet in time to see Daniel disappearing around the corner into the hall. He had obviously been eavesdropping, and what we had been discussing was the transportation bottleneck for getting him to Nova. Thus the advantage of surprise was no longer on our side, compounding the original problem. Attempting to help, Peter chased Daniel and forced him to return to the kitchen where he again pleaded with him to go voluntarily to Nova.

"Isn't there some healthy part of you that sees how crazy, how deranged, how out of sync you are?" Peter asked. "Can't you trust us to have better judgment of what's better for you five, ten years down the road? We know you're not happy, and we love you and want you to be happy in a normal way. Remember how you've even told me yourself you don't know why you do some of those crazy things? They'll help you with them at Nova."

"Yeah, but I know somebody who knows kids who've been there. It's no fun."

"'Fun' isn't the point! It's your health." It was wasted breath.

I did not think then to ask Daniel how he would happen to know of delinquents who had been sent to Nova. Peter's appeals for Daniel to forego immediate gratification for his long-range benefit were predictably futile. When Peter's quiet, rational appeals to reason failed, he broke down into impotent rage. Daniel responded in kind before heading out the door. Peter and I held each other wordlessly, lovingly, as in the earlier days of our marriage, a pattern that was becoming rarer as the troubles with Daniel intensified. More commonly I would try to force Peter to look at the reality of what needed to be done about Daniel, and Peter would hang onto hope that it wouldn't be necessary.

Iris reported the next day that the boys had gone to the library to read up on Nova.

I was asking for help from everyone but the right person. I should have involved Dr. Franklin again. He had received my material and indicated that the Nova program was appropriate for Daniel. He had also mentioned that Nova sometimes sent staff to pick up recalcitrant youths. What I did not know was that they typically sent out a small plane. I visualized a station wagon with three or four male staff members driving from Maine to Chicago and back again, taking turns driving and overseeing the youth, who, I feared, would be shouting for police at every turnpike entrance and exit.

I also remembered our procedure for admitting teenagers to an adolescent unit on which I had had part of my psychiatric training. Our chief expected that a family should arrive together, the adolescent admitted by court order, and the history given by the parents.

Even without knowing about their available plane, in retrospect it would have been a wiser decision to take whatever Nova had to offer, such as the station wagon I visualized. But there was yet another consideration. Once I made contact with the juvenile referee, I hoped the judge would make Daniel a temporary ward of the court, tell him he had to go to Nova for his own good, and his future in the system would be reconsidered at intervals, depending on his progress. Years earlier when I worked on that same adolescent ward, that same chief had by bitter experience come to insist on such an arrangement before he would admit an adolescent. This was to preclude the kind of ineffectual efforts he had made in his early days with ordinary admissions signed by the parents of minors. Under such terms, parents would be figuratively beating on the doors to get help for their child, who would be unmanageable and out of control. Then, within a few days the child would be on the phone, manipulating the parents' ambivalence and feelings of guilt, with promises to "be good". Parents are often putty in the hands of out-of-control minor children, usually swayed by the fear that their child will stop loving them. Under such blackmail, they would often sign their child out of the hospital. Within a few days they would be back, begging for re-admission, and the cycle would begin again. My chief worked out the temporary custody system to interpose a higher authority between child and parent, so that child, parent, and therapist could just get on with the work at hand. I knew that with an admission signed by Peter and me, I would have no trouble withstanding Daniel's expected badgering, but I had no confidence in Peter. I wanted us both to be relieved of parental authority, temporarily. I had not allowed for evolution of juvenile rights since my training.

When I look back over the years of disappointment at our failure to reach Daniel and somehow transform him into a normal, socially responsible adult, my grievous misconception about Nova's ability to provide transportation is my deepest regret. The common phrase "problems of communication" never applied more tragically than it did to my failure to understand that Dr. Franklin really could have transported Daniel to Nova that summer had I given the go-ahead. Why didn't Dr. Franklin suggest his plane? Given my misunderstanding, it was back to the transportation drawing board.

My memory of that nightmare summer is a blur of hot, humid days, with Daniel using our home for little more than shower and fridge. One hot Sunday, soon after we all came home from church, Daniel was into cutoffs, out the door, and off on his bicycle. That was fine with me. But just as with the mountain-climbing school, no sooner was he off enjoying himself somewhere than I was left spinning in a whirlwind he had set in motion. As I changed my

clothes, the phone rang, and an adult man's voice asked for Daniel.

"Who is calling, please?"

"I'd rather not say."

"In this house no one is called to the phone for a caller who won't give his name, not even my husband or myself, but particularly not the children. Do you want to tell me your name or not?"

"Aw' right. The name's Frogner. Now will you call Dan?"

"I am Daniel's mother, Mr. Frogner. Maybe you'd better tell me what the problem is," I said, my heart thudding.

"Look, lady, if you don't want the police involved, you'd better get Dan on the line."

"Police involved for what?"

"Dan promised to return some stolen stuff to me, right? Somebody broke my window and took a hi-fi. Dan knows who done it, and I won't make no waves just so's I get the hi-fi back and the cost of the window. Dan said he'd get it for me."

"Did Daniel steal it?"

"Naw, it wasn't Dan, but he knows who done it. All's I want is my money and my hi-fi."

"How do you know that Dan knows?"

"He told me."

"How does he know?"

"I'd rather not say."

"Well, he's not here now. I'll take your number for when he comes back." I was learning to interrogate, to get information out of people, and to seem to make promises I was not making to do things I certainly did not intend to do.

"It's 313-4544, and I know you don't want no publicity."

"Mr. Frogner, I could interpret that as a threat. Anyway, I'll take it up with Daniel when he comes home."

I checked the phone book for "Frogner". There was one listing with the number the man had given me, with only an initial. From the address he apparently lived in a large apartment complex, a hard place to steal from through a window. I described the interchange to Peter and ended with, "So Daniel is somehow involved with this creep whose social conscience extends no farther than to get his property back."

"What do you mean?"

"What do you *mean* 'what do you mean?'? Dan associates with people who prey on, exploit, and victimize one another. Here is a slimeball who doesn't care that a young person stole from him, if he just pays it back. Daniel is somehow in the thick of things—just what we've been seeing all along lately, always on the periphery of trouble, like with the gym key and the scale."

61

"What are you going to do?"

"Question Daniel. What else?"

By mid-afternoon Daniel breezed home on his bicycle. "Daniel, what do you know about Mr. Frogner?"

"Oh, yeah, I have to go there."

"Why?"

"It's an errand of mercy—I have to keep somebody from getting into trouble."

"What kind of talk is that? What kind of trouble, and is it you?"

'Now, Mom, you know I wouldn't tell you that, would I? But I know who stole his hi-fi, and I said I'd get him to give it back. Nothing wrong with that, is there?"

"Daniel, if some young person is stealing hi-fis, somebody responsible should know, like a parent. Also, this Frogner, how did you meet him?"

"We were walking down the street one day, and he asked us in to listen to records."

"Does he work?"

"How would I know?"

"Dan, can't you see that he's no fit companion for teenaged boys? Daddy and I wish you wouldn't associate with so-called 'adults' who don't care about the morals or principles of their young friends, so long as they don't get ripped off in the process."

"Mom, you just don't understand," snarled Daniel.

"Daniel, what do you *do* all the hours you're away?"

"You'll never know," he mocked. "You wouldn't understand."

"I understand one thing, that the situation is past the point of no return. Regardless of what you want or don't want, or how you feel about us or we feel about you, I assure you that we take our obligations to our children seriously. Your father and I will do everything in our power to get you the treatment, help, and correction that your conduct is crying so loudly for. Even you admitted to your father you need it."

"Bullshit!"

"I don't like that language, either."

That night Peter asked Daniel to watch *Sixty Minutes* with us, but his only response was to growl. Then Peter asked him, again, about ushering at the nearby Shakespeare Festival, where Daniel had ushered for all five plays the previous season. "Some other time," he replied, in a tone that implied that he was no longer interested in ushering or Shakespeare.

As the front door banged, Peter and I looked helplessly at each other. "I hope he can reach Nova before it's too late," I sighed. "And I hope that Nova can reach him."

Finally the day arrived for my appointment with the referee, Mr. Hadigan.

Peter declined to go. On Hadigan's desk was a letter. I recognized it as one Dr. Perez had sent at my request, a copy of which I had received. In it were summarized Daniel's problem areas and strengths.

For the twenty-eighth time, I told my story. With no authority to implement Nova for us without a formal hearing, Mr. Hadigan suggested that I file a charge of "unruly child". This charge would be heard by another referee, and he offered to select the individual most likely to cooperate with my Nova plans. In the several weeks all this would take, if we worked out something else, I could always drop the charge.

I felt as if struggling in quicksand. Whenever I tried to extricate one foot, the other was sucked deeper. I had taken yet another step backward before going forward in getting my son to Nova, i.e., getting legal backing in hopes of getting logistic backing in the form of transportation plans involving the help of more than one husky young man.

And so I filed a charge on my own child.

As I glanced up from the endless phoning, my eye rested on a red and white papier-mâché bracelet on my dresser. Daniel had made it for me in an art class, and we agreed it looked better over my navy sweater than my bare scrawny wrist. Where, oh, where had that Daniel gone?

One evening as I wandered around the house trying to think of what I needed to do next, I surprised Daniel in our bedroom. He knew he was not to be there without express permission, for reasons of our privacy, and he knew that using that telephone extension was against the rules. I overheard mention of "Skippy" and then "See ya', Brett". As soon as he was out the front door, I recalled the only Brett I had ever heard him mention, picked up the suburban phone book, and looked for an uncommon surname, Lamb. There was only one in Evanston.

Mrs. Lamb confirmed that Daniel had come by for Brett a few minutes earlier, but sounded wary as she denied knowing "Skippy" or anything about our sons' plans.

She hung up, but ten minutes later she called back. "Mrs. Greenleaf, isn't Daniel that terribly smart kid?" she asked.

"You could say so, I guess, but with all those smarts, he's a slow learner. He hasn't been learning what we've been trying to teach him about living and values. Why do you ask?"

"I knew Daniel when he was in band and I would chaperone on the bus to away games. One time while we were waiting to get started, Dan took off his uniform pants—he had gym shorts on underneath—and stuck his bottom out

the bus window. He was always doing something like that—wouldn't conform."

"That's crazy! Why didn't anyone tell me about it?"

"I don't know. Daniel was always yelling, hard to quiet down. My older son Chuck told me to keep Brett away from Daniel because he was 'Trouble with a capital T'. Last year or so he said that Daniel runs with the worst crowd in Evanston."

"Who are they?"

"Kurt Duncan and Blaise and Scott Sawyer—especially Scott. Do you know him?"

"Not really, but I keep hearing that name. A few weeks ago that Sawyer kid was here but instead of knocking at the door, he started around the house to the back yard. Why? We didn't like that or his looks that thumbed their nose at the Establishment. My husband ordered Scott off our property loud enough to be heard all over Evanston—one of just two times I've ever heard him raise his voice. Do you know where Brett and Daniel are tonight? Are they with Kurt and Scott?"

"I don't know."

"If you learn anything, I'd very much appreciate your letting me know. We're trying to keep tabs on Daniel, and it's been getting pretty difficult. I'll be happy, if you like, to keep you informed if I see Brett or hear anything about his comings and goings."

"All right. I'll help you. I feel sorry for you." (Another first. No one had ever said that to me before, and it wounded my pride.)

"Why do you say that?"

"For trying to keep up with Daniel. I always thought he had a family that didn't care." (We have all been brainwashed to believe that a "bad" child proves a "bad" parent.)

I did not hear the surname Lamb again for eighteen months.

It had been my dearest hope to have Daniel settled in Maine by September, but we were butting our heads into one stone wall after another. A hearing with the second referee had not even been set yet. We had not had our call about Steve's return from Venezuela, but still nursed the hope that somehow he could find two young, strong, reliable men to help with our mission. Meanwhile, since Daniel was still in the community, he would have to return to Evanston High for the opening of school.

On Labor Day afternoon, Peter, Jonathan, and David went to the air show. Daniel and I were home alone together when the tension erupted. I can't remember what caused it, something trivial, like, "What are you doing, Dan?" and his retort, "Mind your own business" or "You'll never know", both stock phrases of his. Without knowing how it happened I lost control and heard myself screaming horrible things at him. Then, somehow, I found myself

trying to hit Daniel with a high-heeled shoe while he laughed at my futile efforts. I told him he was not going "out" this time, and I locked him in his bedroom. The next thing I knew, he had left by shimmying down a spout from the second floor.

Daniel returned within minutes by the front door, evidently for something he had forgotten. I managed to lock him in the basement but he left again, this time through a window well. I saw his bicycle round the corner, and I tried to follow on my own bicycle, reasoning that it was more maneuverable than the car. I lost him in seconds, but in reality I had lost him months before.

Eight

Initiation into the Legal System

DURING THE FOUR HOURS PETER SPENT at the police station with Daniel that Labor Day night, I tried to read but could only think, "So now we have a genuine police-certified juvenile delinquent." How could Daniel stigmatize himself forever in a couple hours? What about his family? How could he betray us so? Amidst my welter of cruel emotions—pain, hurt, shame, rage—a new thought surfaced. With the authorities involved, this could mean snarling of my cherished hopes for Nova. Where would this ever end?

And then another idea seized me. Maybe he had been breaking and entering all summer, and this was just the first time he got caught. Most criminal offenses go unsolved, and Daniel was crafty and sly. I remembered his boast that I would never know what he did in his long hours of absence.

Once more I cried.

I did not see Daniel when he and Peter returned, because Peter directed him to go straight to bed.

"Well?" I asked Peter.

"They picked up the boys at that little diner on a side street in Glencoe where Daniel was apparently acting as lookout. The police caught Kevin coming

out. Somebody broke a window, and they think others were involved. They questioned Daniel and Kevin separately, so the boys couldn't get together on a story."

"Did Daniel admit anything about anybody else?"

"Not a word. He played it close to the vest, answered only the minimum of what was asked and then only after long thought."

"Were Iris and Randall both there?"

"Oh, yes. The police took Dan and me first, then Kevin and his parents, then us again. Then they let us come home."

"What was there to ask? You said they caught the boys red-handed."

"They went over and over the details of who did what, how the boys got there, and so on. It was from this incident that they connected them to breaking and entering earlier in the evening. It turns out they are charged with two burglaries. Are you ready to hear about the second?"

"As ready as I'll ever be. Tell me about that one."

"First they robbed the Nature Center."

"The *Nature Center?*"

"Yes, they took some jewelry from the gift shop. But the police didn't question Dan about that one because the Nature Center is in the Metroparks jurisdiction. Tomorrow their detective will be over to question Dan and get a statement."

"The Nature Center," I gasped. "The Nature Center, where they taught him and tried to help him grow. And this is how he repaid their love?"

"I'm afraid so."

That night I had just one thing to be grateful for: there were no arguments about what to do next in the Daniel-engendered crisis. I cried, and Peter held me. I mumbled something about what a beautiful baby Daniel had been, like a little boy doll, and how he used to call us in the morning by cooing like a mourning dove. I suggested we try to get him to Nova before the hearing in juvenile court, but Peter was afraid of what they would do to us and him. I was afraid too. They could surely demand that he be returned.

"What a way for all this to end," said Peter.

"It hasn't ended. It isn't even, in Churchill's words, the beginning of the end. But it is the end of the beginning. And we are all on the losing side."

I was downstairs before daybreak, leaving the sleeping Peter undisturbed. Then Daniel came down and started to make toast, just as if it were an ordinary morning.

"Daniel," I began, "Daniel, you know that what you've done has hurt us all

very much, but yourself a thousand times more. And just a few days ago you bragged that I'd never find out what you were up to in all those unaccounted-for hours."

"That was the first time I ever did anything like that, Mom," said my son, in a subdued voice, the closest I ever heard to remorse.

"Maybe. I wish I could believe that."

"Don't worry; I won't ever be arrested again," Daniel promised. He intended to be reassuring, but it would take much more than a few words to reassure me. Did he mean to imply that he had learned his lesson or that he had learned not to be so inept?

I realized with bitterness that I had too long believed some of the old, saccharine maxims about children, i.e., if you show faith and trust, your child will be trustworthy. Instead, the time was overripe for Daniel to prove to *me* that I could trust *him*. To do so would take a mountain of good, proper, moral behavior on his part—and a long time.

When Detective Peron questioned Daniel in our living room that afternoon, I noticed a complete absence of "why" questions. There was nothing about motivations or intentions, just who, what, where, when, and how. After all, the law had a crime to solve, not a life to save. "Who drove the car?" "What time was that?" "Where did he pick you up?" Over and over the same questions, and each time Daniel took an unbelievably long time to answer before responding as briefly as possible, all the while biting his nails.

Finally I posed my question: "Daniel, if you're telling the truth, why does it take so long? If you're just telling us incidents less than twenty-four hours old, why should it take five minutes every time the detective asks you something?"

"Don't interrupt. Detective Peron is doing this," said Peter, this put-down conveying the idea that I was Daniel's peer, and Peter helping the official.

"Let him take all the time he needs," said the detective.

"But that's just it. He shouldn't need all this time if he's just telling what happened just last night." Was this detective being taken in by Daniel? Or could he be trying to elicit an inconsistency that would incriminate Daniel—or someone else?

The story that Peron dug out of Daniel was this: Scott, the third boy involved that night, gave Daniel and Kevin some beer. Then shortly after nine Scott drove the younger boys out to the Nature Center in his blue Firebird. All three boys circled the building and climbed the fence of the wildflower garden. Daniel believed it must have been Kevin who broke the Nature Center window, near the kitchen where Daniel had prepared animal

rations when he worked as assistant curator. Kevin reached through the broken window to open the door, and both younger boys entered. Scott remained out in back while they went to the gift shop where Daniel took a bracelet and necklace, which he later threw away in the woods where the police found them. The boys hoped to find money, according to Daniel. He denied entering other parts of the Center or having knowledge of doors that the authorities had found ripped off cabinet hinges or merchandise strewn on the floor. (To my astonishment, the detective focused only on the break-in, and no authorities dealing with Daniel ever pursued these acts of vandalism. Nor was the diner break-in pursued by anyone other than the owner, who called us months later. We made Daniel pay all the repair costs.) Daniel estimated that they had been in the Center ten or twelve minutes, then left by the same door, out through the wildflower garden and over the fence where Scott was waiting. Scott drove them to McDonald's in Glencoe for a burger, and finally, according to Daniel, dropped them off near the diner where the Glencoe Police apprehended them.

Over and over, Detective Peron returned to the precise involvement of Scott Sawyer, the nineteen-year-old "adult" whom Mr. O'Donnell in the Evanston Juvenile Division had called the worst influence on juveniles in Evanston. Over and over Daniel tried to avoid answering questions about Scott and gave as little information as possible. "I have to be very careful," he said. "I'd hate to have it on my conscience to help send anyone to prison."

Daniel's associating "conscience" with helping someone wiggle out of punishment flabbergasted me. "You have a conscience on behalf of *him*?" I screamed. "You have to be protective of that predator? You owe loyalty to that creature who needles kids like you and Kevin to show how macho you are by betraying the good and wholesome and worthwhile things you have been taught? You owe something to him but nothing to your father and me who cared for you and loved you since before you were born? Don't you owe *us* anything?"

Daniel did not respond. Peron and Peter calmed me down.

Over and over the detective questioned; over and over Daniel dragged his feet. He would sit with head rigid but eyes flickering from side to side, a mannerism his Aunt Vera had commented on. Finally Daniel's statement, pulled out of him by the detective's questions and pushed out of him by Peter's constant prodding ("Answer the question," Peter would say, over and over; "tell him what happened.") established to the detective's satisfaction Scott's presence in the garden, but not in the interior of the Center, and also Scott's transporting the younger boys in his blue Firebird. Then Daniel was instructed to write the incident out in narrative form in his own words and sign that it had been "voluntary" without any promises other than that he would be credited for "cooperating".

Daniel was required to appear Friday, three days hence, at a preliminary hearing, called only to determine whether there was sufficient evidence to file charges against Scott, legally an adult.

By the time the detective left, I was wrung out. Daniel's "voluntary statement", his so-called "cooperation", had been the cooperation of an animal, cornered but wily. It was obvious to me, if not to Peron, that Daniel was laundering the truth, but the detective's apparent gullibility may have been his way of trying to trap Daniel in an inconsistency. He had not succeeded.

Even more than the incident itself, the fact that Daniel was not guilt-stricken shocked me. He had not acted as if he had been tempted and fallen. Given the heart-breaking circumstances, I would have wished for him to confess humbly, to align himself on the side of right, to show remorse and throw himself on the mercy of the solid, law-abiding community. Instead, he acted as if playing a giant chess game, in which he would now need to proceed warily since he had already carelessly lost a pawn.

The following day was the first day of school, a day I had always loved as a child, as I returned to my three-room country school, goldenrod tablet in hand. One of the joys of parenthood I had looked forward to was vicariously enjoying watching my bright children troop back to school. And I did, with Jonathan and David. We made trips to a discount store for binders and to the music store for new reeds for David's clarinet. Not settled yet at Nova, Daniel had to go off to high school too, and he did. But unlike in earlier years, he left home without notebook or pencil to take down assignments and supply lists. He had finally finished his summer honors reading of *You Can't Go Home Again*.

Whenever I could, during that abbreviated school week, I maneuvered to be alone with Daniel to talk about our recent bombshell and its repercussions for all of us. I alternated between doing what needed to be done privately and leveling with Daniel. "I want you to know, Daniel, that I've been keeping in log form how you've been coming and going at all hours, drinking with other juveniles, and, I'm pretty sure, using drugs."

"So you've been playing detective," he sneered.

"I didn't 'play detective' until you proved to me, more than I ever wanted to know, that you weren't growing up the way you were taught, that you refuse to make friends with motivated young people, and that you run with older kids already in trouble."

"I'm old enough to pick my own friends, and I won't have you picking them for me."

"I didn't try until it turned out you were picking the wrong ones. I always just assumed that my children would develop good judgment and be inclined to make friends with people of good character. With you it didn't work."

"I won't spend time with those fags you like. My friends all know you're the one who's crazy," he said, in a haughty and arrogant tone, outrageous coming from someone who, three days before, had been booked in a police station.

"Your friends with whom you get in trouble apparently have similarly flawed judgment. You all somehow seem to miss the point that normal people aren't 'busted' for B and E."

"I've told you before, I'm never going to be the kind of person you want me to be, so you can forget it."

Though I realized that it was hopeless, I tried to enlist Daniel's cooperation for treatment, but I had little chance to counter my sixteen-year-old's omnipotent belief that he should be captain of his own ship. Then, to demonstrate his adult, peer status, he told me that he had smoked cigarettes for six months, but quit at fourteen of his own volition, all without my knowledge. This he offered as evidence for his good decision-making ability.

I was not impressed. I let him know that I would continue to work toward his treatment at Nova. "I want you to go there, be cured, and come home for your senior year at Evanston High, living with the family."

"I don't need Nova, and I won't go. I know a kid who knew somebody there, and he said it's no good." Again I didn't think to ask how he knew one of their delinquents.

"People with something wrong often can't see the need for the bitter pill that works the cure. Nobody who needs Nova ever asks or wants to go."

That same night Peter talked Daniel into ushering for *Macbeth* at the Shakespeare Festival, as he had done earlier summers. They were a handsome pair, father and son, setting off together. They left home early enough for Daniel to usher, and both presumably saw the performance, Peter in the audience, and Daniel down in front with the other ushers. But doubts rankled me. Suspicious as I had become, I questioned whether he had actually stayed with the other ushers. He could have slipped out during the witches on the heath, gravitated to unsavory persons, and found Peter after the final curtain. I saw myself changing from one who accepts things at face value to a person in a limbo of uncertainty verging on paranoia, the list of unanswered questions getting ever longer.

The next morning, when Daniel should have been settling in for his third year of high school, he, Peter, and I made our sad way to city hall for the prelimi-

nary hearing for Scott Sawyer, the adult of nineteen summers whom the police hoped to get out of Evanston and away from their youth. After an argument with Peter, Daniel tucked his shirt over his navel and changed into his new Converse sneakers, which proved a wrong strategy on our part. We should have let him look like the street.

We arrived no earlier than necessary, and were kept outside the closed courtroom. As we waited in the hall, Eileen from my Great Books group passed on her way to pay her sewage assessment, and I waved and tried to smile and look casual. I was furious over being thus exposed to humiliation, an invasion of privacy of the innocent.

I had never before seen Scott, but when I saw a handsome blond boy with drooping mustache, I knew it had to be he. The young man curled his lip into a sneer when he figured out who I was.

On one of the uncomfortable wooden benches along the wall sat a woman in her mid-twenties with another woman, older than I. Lean and haggard, her hair pulled tightly back, her jaws clenched, she reminded me of Grant Wood's American Gothic farm woman. I have wished since that I had gone up to say "I'm sorry" to Scott's mother and sister.

Kevin arrived with his mother and father. Randall was ashen and walking with an unsteady gait, unlike the jaunty, recently retired economics professor we had chatted with while Daniel was in Wyoming.

Too late to spare me Eileen, the bailiff opened the chambers. Kevin paced nervously, then approached a small dark man I had never seen before, lounging around the back of the courtroom. Kevin told him something we could not hear. Iris blanched, leaned over, and whispered, "I bet Kevin is trying to change his testimony."

The dark man, who turned out to be the assistant prosecutor, called Daniel and us out into the hall and told us privately, "Kevin wants to change his testimony. Now he denies that Scott Sawyer was at the scene of the Nature Center break-in. He says that he just said that before because he was scared."

"Being scared should have made him tell the truth, it seems to me," I said.

"Let me talk to him alone," Daniel offered.

"Why can't you talk to him in front of us?"

The swarthy man said to me, "That's all right. Let them talk alone. This isn't Russia." I took that to mean that a free society tolerates two apprehended lawbreakers getting together on their story, if it offers hope of nailing a third. The prosecutor correctly appraised that while Kevin was retrenching, for whatever reason of truth or falsity, Daniel was sticking to his earlier story, for whatever reason, and Daniel carried weight with Kevin.

Daniel and Kevin strolled down the hall together, and when they returned, court was ready to begin. We rose as Judge McDervott, the same judge I had

talked with during the summer, took his place.

A littering charge was heard first. The bailiff then called for the case of Scott Sawyer.

Scott sat silent, never questioned during the proceedings. Detective Peron gave a brief account of the events of Labor Day evening. Then Kevin was called to the stand. Tremulously, he took his place, and I wished I could have seen similar evidence of fear in Daniel.

Judge McDervott's questioning revolved only around Scott's involvement. Kevin indicated first that Scott had been on the Nature Center grounds, then that he had not, and then again that he had. Scott's lawyer smiled.

After a few minutes of this confusion, the judge asked Kevin, "How old are you, son?"

"Sixteen, sir," said Kevin.

"Do you go to school?"

"Yes, sir."

"What grade are you in?"

"Eleventh, Your Honor."

"Do you know how to read?" (Kevin had babbled incoherently.)

"Yes, sir."

"All right, now. Let's start again. When Scott said 'Let's go to the Nature Center', what did you think he intended to do?"

"I don't know, sir."

"Well, was it to play cards at ten o'clock at night in a dark park?"

"I don't know, Your Honor."

"What do you mean, you don't know? You must have had some notion of what you were going there for."

Kevin insisted that he had ridden off into the night with no idea of the purpose of the trip. Then he was excused as a witness.

Daniel took his place on the stand, looking nonchalant. Acting like the judge's peer, he admitted going to the Center intending to break in. Daniel's unruffled conduct on the stand struck a chill in me. I wished he had burbled the way Kevin had.

Judge McDervott stopped in mid-sentence, looking as if an insight had suddenly come to him and interrupted Daniel. "Just a minute, son. I have another question for you first. Is your mother a doctor?" So he remembered my visit.

When Daniel answered in the affirmative, I felt somehow less contaminated for knowing that the judge remembered my efforts to prevent this. (Only much later did I realize that I should have returned to that judge that day for help in the Daniel matter. I was laboring under the delusion that illegal matters are dealt with only in front of all the participants, in court. Extracurricular conferences with anyone supposed to be neutral felt like sub-

orning a witness or bribing a juror.)

"All right. Go on." The questioning and Daniel's answers confirmed consistently and unequivocally his earlier signed testimony for Detective Peron that Scott had been on the property but not in the building with Daniel and Kevin. Scott's lawyer frowned. The assistant prosecutor smiled. The case was sent for trial. Detective Peron from Metro Parks also smiled and looked pleased.

So Daniel was the hero of the day, provider of usable testimony, although the very minimum they required. It seemed obvious to me that he knew more than he told, and later Iris told me that Kevin had told her that other delinquents were at the Nature Center and at the Glencoe diner break-in, too.

We drove Daniel back to school for the rest of the day. I thought his "excuse" that the school required should have been from the detective, but Peter wrote it, and I don't know what he said. I told him to include the time, lest Daniel lose another couple hours before reporting. I don't know whether he ever made it to school.

Peter left for the hospital. Instead of going home, I went down Wildflower Way to see Aletheia, my confidante and friend. After I related the horrible events of my day, Aletheia asked whether I was ready for our juvenile court hearing, whether I had a good lawyer. I told her that it seemed to me you need a lawyer when you're trying to get out of something, not when you're asking for what you and the court should both want: correction of your child. Why did I need someone to speak for me?

Wiser and more sophisticated than I, Aletheia pointed out that judges, usually lawyers themselves, listen to other lawyers and, in their boys' club style, want petitioners to crawl to them asking what to do, not intelligent parents who have worked through the options and need help implementing the best course of action.

She gave me the name of the lawyer who had tried to help when her daughter had been caught with LSD. His help had made no difference in either the short term or her daughter's years-long downhill course. Aletheia's parting advice—she should have been our lawyer—was, "If you go into court without a lawyer, try not to sound too organized or too intelligent."

That afternoon Daniel and I received the summonses, the first set resulting from my conference with Hadigan, instructing us to appear on the by-now-superseded unruly child charges. They had been left at the house by Mrs. Martin, the mother of a friend of Daniel's, who happened to work as a secretary at the juvenile court.

Again I raged impotently. Surely other people receive summonses from designated summons-carriers, not a friend of a party to the case. This was a worse invasion of privacy than our being herded like cattle on the hard benches

in city hall while friends and neighbors passed. My pain was bad enough—did they now have to expose my shame as well? The system was punishing me, and it made no difference that I wasn't guilty of anything.

After all that had transpired that summer and that first terrible week of September, I would have expected that Daniel would have acted chastened and subdued, willing to stay home and away from associates whose incendiary potential had been so incontrovertibly demonstrated. I would have thought that he would have wanted at least to look as if he were trying to make a fresh start. Quite the contrary, he showed no evidence of remorse after that first day. Instead, without missing a beat, he even demanded to go "out" on Friday night and vehemently argued when I tried to impose limits of time and place. As arrogant and self-willed as ever, he gave no evidence of willingness to learn from experience or to change. I don't think he tried to see or was able to see any connection between his attitude and the criminal acts he had committed, or else he just didn't care. Even when I had read in his own writing about buying and selling drugs, it had taken me time to assimilate the fact that I was the mother of a drug-pusher; realization that he was a burglar came faster. These traits I have been reciting are classics in the cluster of antisocial personality. Off and on, bit by bit, little by little, I was coming to realize that I was the mother of a sociopath.

Nine

Visit to Nova

WHAT DOES THAT MEAN, TO BE A SOCIOPATH? Or a "psychopath"? Or someone with antisocial personality disorder, in the latest revision of terminology? For the individual with the disorder, I believe "sociopath" makes a better noun than the adjective "antisocial". Therefore I usually write "sociopath".

Sociopaths are persons whose disorder shows itself in their adverse behavior. As some experts, as well as family members, have noted, they do not get ulcers—they give them. Long before a diagnosis is made, these people attract negative attention from family members or co-workers or the legal/justice system. Still, by no means all persons with family or work problems or problems with the law are sociopaths. Sociopaths are often referred for psychiatric care, but they neither seek nor truly use such help when offered. Psychiatrists ordinarily do not work with sociopaths unless they are in jail or on probation or parole, and someone with clout forces treatment. Hence a psychiatrist does not have the ideal advantage of a willing physician/patient alliance, and this makes deep-seated change difficult, with the sociopath often conning the psychiatrist into his dishonest framework.

My old professor of psychiatry, Esther Richards, maintained that "psychopaths", as they were then designated, were incurable and should be placed on farms to prey on one another instead of on everyone else. But her beliefs were from a generation earlier, so I made my way to the library for an update.

What I re-learned there put me into free fall. One definition sounded all

too familiar. A British group, still using the older term, characterized "psychopaths" by "excessive impulsiveness which causes patients to have multiple jobs, multiple mates, multiple lodgings, and trouble at school, with the law, with money, with friends, with routine; a psychopath lies, charms, and is unreliable." Another researcher advised that the diagnosis is most firm if made before age sixteen, so as to permit a cleaner differentiation from antisocial behavior from other causes without the obscuring effects of other life events. It was a deadline we had already missed, but only by a few months. One other trait was mentioned by various researchers, one that I had observed also in a few patients. It was a categorical denial of responsibility and projection of blame in all directions. Worse, "antisocial personality disorder", as it is now designated in this country, is by no means a rare disorder, affecting 2% of the population and costing society millions.

Daniel qualified for the impulsiveness, trouble with the law, trouble with routine, lies, and unreliability. He was still too young for the multiple jobs, mates, or lodgings. Maybe, I told myself, his case was a mild form, not fully developed, and that would give Nova a better chance to abort it. Maybe Esther Richards had been talking about just the severe cases. Her psychiatric time had offered no treatment facility like Nova. But neither had her era dealt with a whole drug-using middle class, and this late-twentieth-century sociologic pattern seemed made-to-order for sociopaths.

I decided to try something else to help delineate Daniel's disorder. The Minnesota Multiphasic Personality Inventory (MMPI) is the most widely used psychologic test in this country. By responding to more than five hundred statements as true or false, a subject reveals his individual psychologic pattern. The answer sheet can even be scored by computer, which is programmed to count the answers of different types, take into account the age and sex of the respondent, and then print a description of the subject in pre-programmed phrases. The scales with the highest number of atypical responses (true if most people say false and vice versa) define the abnormality. I asked Daniel to take the test, and to my surprise he cooperated. So I sent his score sheet off to be read "blind" by computer, with no emotional interest in the outcome.

In a few days the shocking printout was back. Daniel's profile was the 4-9— or sociopathic-combination, indicating a tendency to play loosely with rights of others and with the law (4) and to have excessive energy powering his engine (9). The main four paragraphs of the readout follow:

"This patient tends to be over-active and impulsive. He seeks excitement and arousal, and is characterized by a high energy level. He may expend great effort to accomplish his own desires, but he finds it difficult to stick to duties imposed by others.

"He may be sociable and outgoing, but his poor judgment and lack of

consideration tend to alienate others. Poor work adjustment and excessive drinking are likely. Among adolescents, college students and various low socioeconomic groups, this pattern occurs fairly frequently and may have less serious implications. However, acting out and impulsiveness may be anticipated. Psychiatric patients with this pattern are described as over-active, irritable and hostile, with poor response to psychotherapy.

"There are some unusual qualities in this patient's thinking which may represent an original or inventive orientation or perhaps some schizoid tendencies. Further information would be required to make this determination.

"He appears to be an idealistic, inner-directed person who may be seen as quite socially perceptive and sensitive to interpersonal interactions. His interest patterns are quite different from those of the average male. In a person with a broad educational and cultural background this is to be expected, and may reflect such characteristics as self-awareness, concern with social issues, and an ability to communicate ideas clearly and effectively. In some men, however, the same interest pattern may reflect a rejection of masculinity accompanied by a relatively passive, effeminate non-competitive personality."

Within a few days the next pair of summonses arrived for Daniel and me, this time placed directly into my hand by Mrs. Martin, mother of Daniel's friend from the old Indian Guides days. These pertained only to the Nature Center break-in, and charged him with breaking and entering and stealing. (The diner incident somehow never made it into the formal record, having apparently been lost in the paperwork.)

When Daniel discovered that he had not gotten himself off the hook by "cooperating" with Peron, he reacted angrily, arguing that Peron had "lied" to him and "cheated" him. Actually, Peron had done nothing of the kind. I heard him promise Daniel only to report in court Daniel's so-called "cooperation", which would be considered only in the sentencing, not the charge. Daniel berated himself for having been a "fool" (I agreed) for having admitted [sic] the theft, since, he implied, they could not have proven it against him.

I was stunned over Daniel's failure to discriminate between what had been said and what he would like to have been said. More than that, I was appalled that his manner and very words conveyed that what he regretted was not wrongdoing but having been caught. I was left open-mouthed at his arrogance, remorselessness, and gamesmanship.

Finally he once again ushered for, of all plays, *A Comedy of Errors.* Handsome in his Black Watch plaid jacket and yellow turtleneck, he looked like an average suburban adolescent. I drove him to the theater forty-five minutes in

advance, as required, circled Glencoe and checked back. He was taking tickets and chatting happily with other student ushers between escorting patrons to their seats.

On the way home, Daniel casually told me about a "friend"—no names, please—who attended high school in the morning, worked for a radiator repairman afternoons and evenings, and lived alone in an apartment because he had been thrown out of his parents' home for "punching his old man in the face". Daniel seemed to see nothing wrong with this, nor did he seem to be telling me to shock me. My flesh crawled.

The time had come to firm up an earlier decision. Before the mountain climbers returned, Aletheia had arranged a sherry and cheese party in my honor, to recognize a newly published book of mine. Our mutual friends, mostly from our Great Books Discussion Group, had been invited. The original date we planned was the Sunday after Labor Day. With the Greenleaf summer problems, she offered to postpone the party, not only because of my turmoil over the approaching court hearing but because I had belatedly arranged to go to Nova to see the facility myself. I hoped this would give me firmer grounds for asking the judge to place Daniel there at our expense. I would have to leave the party early to catch my plane to Maine. Yet on principle and in pride, I would not let Daniel's behavior make me change the party. I planned to tell the guests that I had to leave early to catch a plane to Florida to check out the living arrangements of my elderly widower father, the man Daniel reminded me of, who was now deteriorating mentally and physically.

The last court-related event before the court date itself involved a social worker coming to investigate the house and family. A dapper man in his late twenties, Mr. Santorini elegantly twirled his mustache as he listened to our story. For the forty-eighth time I narrated the long history of incongruous behavior, unsavory companions well known to the local police, high grades in school, rejection by Winslow Academy, heroic behavior in Wyoming, numerous suspicions never validated, one shoplifting incident, and nothing but paperwork separating Daniel from his Eagle award in Scouts. I showed Santorini my pathetic collection of incriminating items: the pot pipe I had found on the beach, the obscene letters replete with expressions from the drug world (which Daniel had purposely left out for us to find, according to Dr. Perez), and pamphlets advertising fake documents, such as driver's license, birth certificate, and marriage license. Peter related the strange occurrences with the lost camera, the coin collections, and the Gibraltar bank notes. We recounted our unsuccessful efforts with Dr. Perez and his recommendations for Nova.

Santorini voiced doubts that Judge Whittier would send a child out of state. Then he interviewed Daniel, asking about former brushes with the law. I was appalled by his tone, which was that of one young rascal in collusion with another. He referred to our heartbreaking experience of Labor Day night as Daniel's "little caper". He then expressed the wish to see Daniel alone, taking him out into the front yard, where they talked for over an hour. They reminded me of Victorian "gentlemen" retiring to the library for cigars and jokes unfit for "ladies'" ears. Oddly, Santorini did not appear in court, and we never saw him again.

In preparation for the court appearance I secured interim reports from all the new teachers. All their comments were negative, but the English teacher's were the worst. Daniel's honors English "A" had crashed to a "D". Later I found detention slips for cuts. More or less resigned to the idea of being sent away, he kept repeating that there was no reason to work in a class that was only temporary and would not "count". This was the very argument he had invoked for not working in Australia, where we eventually learned that he had been truant and where he had run away for several days.

A chill wind met me as I got off the plane in Maine late in the afternoon after Aletheia's party, and I was glad for the coat over my arm. I slept fitfully in the motel where the following morning Nova's van arrived to take me out to the treatment facility. In the motel lounge I identified a well-dressed father and teenaged son also on their way to Nova.

At the appointed time a man of about thirty introduced himself as Vince, and the four of us began the twenty-five mile trip to the tiny town of Sweetspring, near which Nova was located on an old hardscrabble farm. Little passed between us, and I could feel the tension in the van, particularly my own. Vince tried to break the awkward silence by giving us background information about Nova. The subdued teenager expressed appreciation that his judge was letting him serve his time at Nova.

"I hope we get a judge like yours," I thought.

After leaving the freeway, we followed a number of country roads lined with evergreens and deciduous trees, already clad in russets and old golds. "I would think that a setting like this, tranquil, far from urban pressures, would be curative," I said. Even as I said it, however, I suspected I was transposing my values to children of concrete who did not share them. I doubted that

nature would speak to Daniel as it once had.

"It reminds me of the Upper Peninsula of Michigan where I've canoed," said the adolescent.

We turned in to an unmarked dirt road, passed a few run-down farmhouses and arrived at a small cluster of buildings centered around an old farmhouse, including an anchored mobile home. The youth left with his father to be admitted, as I hoped someday to do with Daniel. I was taken to the trailer converted into offices. The secretary, whose voice I knew well by phone, told me that one of the residents would be taking several other visitors and me on tour. Dr. Franklin would be in from Hartford to meet me that afternoon.

Presently Diane arrived, an attractive girl of seventeen, clean, well groomed, and wearing jeans, her hair clipped short over the crown of her head, reminding me of a Juliet cap. She introduced herself as my guide, and we picked up another visiting family consisting of parents and son. Diane took us through an unlocked front door into the farmhouse and showed us a huge organizational chart on the wall. Lines indicating responsibility up and down connected names to each other. As she talked, boys and girls came and went. Occasionally one would knock on a particular door behind us and be told by a teenaged gatekeeper within to wait in the hall. Our young guide told us that these residents were getting "haircuts", which were not tonsorial but were the teenagers' slang for a low-level form of discipline limited to correction by peers, not involving staff. Next Diane took us into the then empty dining room where we could sit while she explained the complicated workings of Nova.

Except for the most recent newcomers, each resident was responsible for at least one resident under him and accountable to his superior, and everyone in sight was taking this responsibility very seriously. Section chiefs could be identified as they came through the dining room with clipboards. Snatches of language we overheard included "haircut".

From the dining room we could see into the food preparation area where a number of residents of both sexes were at work on the chili for lunch, which we were later invited to share and found delicious and plentiful.

Our young guide told us that the goal at Nova was to learn to live and work together, showing mutual respect, exactly the way normal people do in the open community. Each resident was assigned to work in one of four areas of living: food preparation, housekeeping of public areas, and two others I no longer remember. Mornings were spent in this work, much of it repetitious and unnecessary for already immaculate floors, its only purpose discipline.

One unavoidable shortcoming of Nova was that there was not enough genuine work to consume the enormous energies of these hyperactive late adolescents. Hence Nova had to rely on make-work, particularly in winter, the non-growing time of year.

Diane reminded us that new residents had hair-trigger tempers and tough facades. They were notoriously deficient in ability to see how they repeatedly set themselves up for negative reactions from both their peers and adults. They were unable to interpret controls as a sign of caring, and they were even farther from internalizing controls. At Nova they were learning to govern themselves, both psychologically and socially.

Residents who refused to follow directions, and those who showed aggression, hostility, or arrogance, were immediately referred for adjudication to a disciplinary council composed of more advanced residents. Most importantly, everything else screeched to a halt so that this council could be held immediately. There was no lag period; nothing was allowed to get cold, distorted, or forgotten. In the council the staff member or resident who made the complaint told the council his or her grievance, and witnesses might be called. The "defendant" had to face his behavior and its consequences immediately, and could not squirm out of it.

In contrast to the characteristic pattern before residents came to Nova, this immediacy made it impossible for the resident to react by running away or using drugs, as they had usually done at home. For a first offense, a reprimand might be considered sufficient. When punishment was meted out, it might consist of re-washing and waxing a floor that already shone. This represented the lowest level of discipline, the "haircut" that Diane had been telling us about.

In Nova's confined space and time, it was possible to make rights hinge on taking responsibility, a quid pro quo I had vainly sought to implement at home with Daniel. At Nova, everyone in sight was taking the responsibility part of the equation very seriously. The bottom line was behaving in a civilized and couth fashion.

Feigning expectation that the controversial "boxing ring" was still in use, the technique that had attracted negative attention to Nova by the authorities and had been said to be discontinued, I asked Diane about it. She could not recall its use during her residency. Usually peer pressure or a "haircut" worked. Occasionally confinement was needed to give a youth time to think about how he had behaved and how he wished to live.

Over the months at Nova, discipline gradually took on a different connotation from punishment. Coming from the youth's peers, discipline came to represent caring. Improvement was measured by ability to function just as people do on the outside, taking and giving orders, working for the common good without hostility, negativism, or outbursts. As Nova contained its residents and slowed them down, true growth and development of personal assets and talents became possible. Residents began to feel good about themselves, which, Diane explained, was the opposite of the negative self-image she said they all brought to Nova. These positive feelings were earned by genuine

achievement, not a phony 'everybody's O.K.' cliché. Gradually residents developed a sense of community and self.

I could see nothing at Nova that would be bad for normal teenagers or adults, and Dr. Franklin later told me that one of his nephews was voluntarily spending a few months there while thinking about what to do with his life. Just to be held still in one place long enough to learn values was my cherished dream for Daniel.

With improvement, residents were given visits out, first on passes home with older, more stable residents, later to their own home, where they would be exposed to the same persons and adverse influences they had succumbed to before. Later yet, they were weaned from Nova by placement in private homes in the area, with responsibility for their own conduct, reinforced at first by daily returns to Nova.

When Diane talked about "graduation" she was not referring to mortarboards. A Nova graduation was not academic but a formal ceremony staged for a single individual at Nova, signifying that he had rejoined the human race. The residents, Diane said, respected those Nova diplomas. But even then, a former resident might "fall" and have to return to Nova.

"It's a hard program, the hardest thing any of us have ever done in our lives," said Diane.

I glanced down at the literature clutched in my sweaty hand and read a quotation by a Nova resident: "Treatment at Nova is hard, tough, and emotionally intense at times. But if it wasn't, how would a spoiled kid who left home to live in the sewers and not know who he really was ever change? And how would a kid who went in and out of mental hospitals, stealing cars and running to all parts of the country, and doing any drug offered, ever lead a productive life? And how would a kid that beat and cheated people out of money, abused girls so he could feel like a man, and flew high on acid, ever be responsible?"

I asked myself, "Are kids at Nova really nothing but the latter-day version of the 'black sheep' that families used to be ashamed of? Are our twentieth-century 'spoiled brats' sent to Nova in the same way that the spoiled son in Kipling's nineteenth-century novel was sent to sea to 'make a man of him'? Surely many children are given much more materially than Daniel, but use it properly, while other children, from the slums, are here by court order at public expense. They could not have been indulged, at least not materially. They can't all be the 'spoiled kid' that resident is talking about."

Diane excused herself to sit in on a haircut. When she returned, she told us about how afternoons at Nova are spent in "groups". For hours on end, under the guidance of staff, some of them ex-residents themselves, these young men and women focus on their past lives and current encounters and the meaning these have for their self-esteem and sense of personhood.

The Nova credo is that you cannot be given self-esteem—you earn it by growing to become a normal citizen, by learning to act with responsibility in the daily give-and-take of community. Nova is thus the prototype of society, but under more immediate scrutiny of its members. Diane quoted a figure of three months, on average, before residents were willing to take off their mask of toughness, turn around, and start the yearlong consolidation of change.

Diane's talk of self-esteem brought back an old memory of mine, that specter from Daniel's past, returning at intervals over the years to haunt us about a mistake we might have made when his teacher in pre-school suggested that at five he go directly into first grade without kindergarten. Her reasons were that the program he had completed had been at least as advanced and a duplication of what he would get in kindergarten. "He's more than ready," she had said. "I think he would benefit by having that enormous energy channeled constructively."

I had not considered this idea; in fact I had been under the impression that moving a child forward in school sometimes makes problems. Yet the more I thought of it, the more advantages I could see, including the slightly longer school day. By then there was someone else to consider besides just Daniel, newborn Jonathan. I wanted—and believed both he and I needed—toddler time together for the mother-infant things that Daniel had had at that age, without Daniel's older, more energetic presence that was always able to get attention and priority with something urgent. I would have preferred six years between children—to each his own babyhood—but with my problems, having a family at all was its own miracle. Still, I wanted to do the quiet, gentle, important baby things with Jonathan, despite the psychologist's reservations about Daniel's drawing of fingerless hands.

I somehow never got an explanation, nor have I ever, in all the years since, seen anything in Daniel that looked to me like low self-esteem. The psychologist suggested that only time would tell. I did not know how much time it would take for trouble to surface, if it lay ahead for us. Daniel settled into first grade, made friends with lovely Lisa down the road to play with on Saturdays, and joined Indian Guides with Peter. First, second, and third grade teachers all repeated the litany: "I've never before had such a bright child in my class."

As I sat at Nova I asked myself whether Daniel could have been suffering from low self-esteem all along, finally expressing it in his delinquency and bad "acting out". If "low self-esteem" had been the problem, or part of it, it antedated his early entrance, according to the psychologist's test. But if early entrance aggravated pre-existing low self-esteem, could it have related to Jonathan's birth? Was I responsible for wanting to give equal time to Jonathan? Why should the birth and "displacement" by a younger brother have been so much worse for Daniel than for millions of other children? Why should Daniel have been so

much more sensitive to a blow to his self-esteem so trivial compared to the overt neglect and abuse suffered by many children? Regardless of the reason, as with everything else in life, we could only start where we found ourselves. I desperately wanted Daniel's start to be Nova.

Returning from my reverie, I heard Diane explain how Nova held school in the evening, not during the day. As Dr. Franklin had told me over the phone, the staff had experimented with each segment of the day for school and had found that evening worked best because it took all day for these jacked-up young people to settle down to learning. A novel concept: your energy needs to run down before you become able to be productive. I remembered Daniel's high nine scale on the MMPI, indicating excessive energy, and of course that had always been obvious to all of us. Daniel was never tired.

As we sat in the dining room chatting with Diane, a group of young residents entered. She explained that they were from Nova Three, a unit down the road similar to Nova One, the administrative head unit where we found ourselves. Seven units in all served a total of two hundred residents. Nova Three's residents had come for a football game that afternoon and were having lunch with the host team. The visitors were husky, good players, and favored to beat the locals.

As the day unfolded, Diane told us her own story, which she said was typical of those of the girl residents—truancy, sex, drugs, and uncontrollability. Her parents were divorced, but her father had determined to do something to bring her back into the mainstream. He had brought her to Nova in the dead of the Maine winter, and she knew she would not be running away because they had locked up her parka. By spring she had come to accept her need for Nova. She expressed remorse over the pain she had caused her parents. Close to "graduating", she indicated that she loved animals and hoped to become a veterinarian. One other thing Diane told us: "All of us here at Nova have one terrible secret—the worst thing we ever did. We're on our way when we can tell it to the group, and they help us live with it."

A daughterless mother myself, I would have been proud to be Diane's mother. But I was suspicious—was Diane the prime exhibit in two hundred? Was she Dr. Franklin's window-dressing?

The other couple with me helplessly begged their son to remain, but he assured them that he had no need for Nova so they left, an unhappy trio. It would have been the same if we had tried to admit Daniel on a voluntary basis.

Diane said good-bye at Nova's school, after introducing me to the principal. He asserted proudly that the school offered all basic academic courses, including Spanish. Dr. Franklin was rightly proud of his school, which attracted teachers in special education and paid the state's highest salaries. They tailored a school program to each student's needs and offered whatever class

even just one student might require, such as pre-calculus for Daniel. Most residents were below grade level on arrival at Nova but were expected to catch up before they left, and most did.

I told the principal about Daniel, the anomaly of a good student with delinquent ways. I added that if Daniel learned nothing at Nova except to be moral, it would be the most important year of his life.

The principal showed me a huge wall chart listing all residents since the founding of Nova several years earlier, along with their current status. "We call them at six-month intervals, to see how they're doing. Ninety percent continue to do well over time," he said proudly.

Surely Daniel would be in that ninety percent, I thought. Our luck couldn't be so rotten as to place him in the ten percent of failures.

Back at Nova headquarters, the secretary explained to me that Dr. Franklin had been home with the flu for several days. Still not completely over it, he had called in to ask whether I would mind taking a short flight to Hartford to see him at his home before catching another evening plane back to Chicago. I was happy to oblige.

Nova's handyman, Vince, drove me back to the airport. He asked what sort of youth I was considering Nova for. His voice conveyed compassion, and I sensed that he had gone through the program himself, but I was too emotionally battered and drained to avail myself of his tacit offer of understanding. I knew I was not even through for the day but had more to face in Hartford.

And so I hid. "I'm a physician. A sixteen-year-old boy I've been working with is a fine student but out of control in all other ways."

I sensed also that Vince knew, but he respected my privacy, letting me make the rules for our silly game. We would talk about Nova but not about my pain. "Well, now that you've seen Nova, what do you think of it?"

"They kept talking about how hard the Nova program is, but I can't think of anything easier, if you don't need it. All you have to do is your job. I am just reeling at the notion that there are people who require a year of rewashing clean floors to learn to be human. I find this a terrible commentary on our times. Once you accept that reality, it's a blessing that Nova gives them the floors to scrub. But I'm concerned about your security, or lack of it. I don't see how you keep residents from running away."

"When they do, other residents chase and catch them in the woods. They are responsible for each other."

"I'd be more comfortable if your facility had walls," I said. "Thank you for the ride." I hated myself for having kept Vince at arm's length.

The taxi took me to a home in one of the older sections of Hartford. At the door was Dr. Franklin himself, a short, stocky man with round face and grizzled curly hair, wearing a dressing gown and carrying a box of Kleenex under his arm. He took me into a library strewn with small gadgets and devices, many disassembled, and he explained that he collects simple, manually powered nineteenth-century machines.

"I see you have an apple peeler," I said, "though I never could understand why people thought they had to take off the skin. What does that one do?"

"I don't know. I haven't had time to tinker with it yet. Maybe when I retire—." His voice trailed off wistfully.

"Since our last talk about Daniel being picked up for B and E and theft, I have something new." I handed him the MMPI printout. "Can Nova do anything with kids like this?"

"Here they all have 4-9 profiles like this. Some are much worse. Yes, we can help Daniel."

I told him about the court hearing, and my hope to get an official stamp on Nova for Daniel so that all of society would be behind his staying there as long as necessary. Why, I have asked myself many times since then, didn't Dr. Franklin somehow implant in my worried and confused mind the idea of taking the law into my own hands? Why didn't he tell me that he had access to a plane for airlifting recalcitrant youth to Nova? He must have felt that he needed to be defensive and keep as low a profile as possible so as not to attract more negative attention that would jeopardize his whole operation.

I asked the doctor why he thought these particular children, some from poverty, some middle-class, some abused and neglected, others loved but often spoiled, had become shaped into such destructive beings. It was as if Dr. Franklin's machines were all running out of sync. He smiled noncommittally as I cited the clearly non-indulged children from the inner cities now at Nova, and pointed to others of sixteen with motorcycles, cars, horses, boats, even airplanes, not in need of his services.

I told him about my strange lineage, thereby getting a start on Daniel's family history. First, my paternal grandmother, a hard-working, caring woman of high intelligence and common sense but little education, with poor vision, but not poor enough to prevent her from being the first woman to drive a car in her city. Then, her older husband, bookish and taciturn, who struggled all his life with a bad stammer, which had deprived him of his cherished dream of going to seminary and becoming a minister. Then came their two daughters, normal except for severe myopia. Their only son, my father, however, was a wild and uncontrollable teenager who, at seventeen,

spent six months in the reformatory for auto theft. He told me about this time, quoting doggerel he had written in the cell about cockroaches running out at mealtimes for the crumbs. The fact that he had never again been in trouble with the law might support the idea that punishment at an early age had resulted in his curbing his excesses as an adult. Such harshness for youthful first offenders might serve its purpose better than the endless chances given today's youth.

After me in my lineage came my sons. David and Jonathan inherited the severe nearsightedness of my father, his two sisters and their mother, myopia that had mercifully skipped me. Daniel had been blessed with perfect vision, though resembling his maternal grandfather, with the same chaotic, get-away-with-everything-you-can approach to life. Ironically, I had emancipated myself from such a father only to be forced to recognize that I had given birth to such a son.

In between my father and Daniel, I determined at sixteen to have a career in medicine. I was powered by idealistic motives but also determination never again to have to be dependent on anyone else's unpredictable, impulsive, and chaotic behavior, whether father or husband. Those were the days when it was characteristic for young girls to get away from home by getting pregnant and married, in that order; I went to medical school instead, and became a physician at twenty-four.

I told Dr. Franklin that in medical school a strange thing happened that might shed some light on all this. One of the house physicians in psychiatry was doing a study on the effect of suggestion under hypnosis on the brain wave pattern of mild pain no greater than that caused by a pinprick. My best friend and I volunteered for the study and had our pretest baseline brain wave tests run. Hers was fine, but I was told I had to be scrubbed because my tracing was diffusely and irregularly abnormal. There was no explanation—no history of blows to the head, high fever, coma, or convulsions. There was also nothing to worry about. Whatever it was, it was not preventing me from progressing in medical school.

During that same discussion I mentioned a possibly related series of strange experiences from when I was a small child. I would have sudden bouts of a sickening internal feeling coming over me in a wave. They were unpleasant but mercifully short. They never caused me to lose consciousness or do anything else to attract attention. Nor did I ever tell anyone about them because I thought they were attacks of conscience, and who has ever lived who cannot point back at a reason to feel guilty? Later, as I learned something about medicine, I hypothesized that they might have been petit mal seizure equivalents that I outgrew in time, although my abnormal brain wave pattern was not the one characteristic of petit mal.

Yet another neurological abnormality passed from my grandmother, skipping my father, through to me: migraine headaches she and I both endured, known to be rare in men. Hers were much worse, causing her to spend entire days in a darkened bedroom with what was then called a "sick headache". There was little else to do for her. Mine were less severe but would put me to bed for several hours while my medication was taking effect.

My hypothesis, as I explained to Dr. Franklin, is that along this grandmother-father-self-son axis, we might have an ill-defined abnormality of brain physiology that operates on females to cause headaches but on males to produce anti-social personality. I had considered having Daniel's brain wave tested but I had been reluctant. For one thing, nothing could be done medically if his were like mine, and, secondly, I would expect Daniel to use such a finding manipulatively, arguing that we couldn't expect anything from someone with an abnormal brain. Worse, if his proved normal, he would be likely to point to mine as "proof" that I was the crazy one. (He made that precise assertion a year later when his EEG tracing was found to be within normal limits.)

"I hear what you're saying," replied Dr. Franklin, blowing his nose loudly into a handful of tissues. "There's a lot more to brain physiology than we know. You know, I myself have never been able to deal with right-left situations normally, or with direction either. So I had to teach myself to detour around these problems, relying on maps and secondary cues."

"My husband is also poor with directions, will turn off the highway for no reason, but he's O.K. with right-left problems, although several of his family are ambidextrous. The direction thing is considered a soft neurologic sign."

"I know. . . . Can you stay for dinner? We're having spaghetti, and I'm sure there's more than enough. I'll call down."

He reached for the speaking tube, but I told him I should be on my way to the airport because my plane would be leaving in two hours. Actually, I had had all I could stand for one day—the thought of being exposed as the mother of a delinquent in front of his family was more than I could bear. Maybe if I had stayed, the matter of his plane would have come up.

Instead, he called a taxi for me.

Ten

Juvenile Court 101

SEPTEMBER TWENTY-SECOND ARRIVED, the day of the court hearing for the Nature Center break-in. Peter had asked Daniel to get a haircut, but he had just laughed and that morning he had arrived downstairs wearing ragged jeans, his hair curling on the shoulders but clean. Peter sent him back upstairs, insisting he change into a suit. Having failed to learn from the former hearing, and trying not to make the mistake I felt Peter always made with me, of not presenting a united parental front, I backed Peter. Daniel's more formal dress, I believe, turned out to have the counterproductive effect of making him look believable as a high school teenager who took going to court seriously, and would cooperate with the authorities. It made him look implausible as the person I expected the judge to believe he really was, a mass of contradictions.

I carried an attaché case of papers relative to Daniel. Peter and I tacitly assumed—no other idea entered either of our heads—that I would speak for us, since I had had most of the contact with juvenile authorities and dealings with psychiatrists at home and at Nova. That was another mistake. As Aletheia had observed, many elderly judges like Judge Whittier seem to have an "old boys' club" mentality, a kind of fraternity with lawyers, and also fathers. They do not appreciate talking mothers and silent fathers.

We arrived at 8:45 for a 9 A.M. call, followed by the Wilsons, with Kevin also wearing a suit.

For the next two hours we sat on straight, heavy wooden benches, polished by generations of delinquents and their families, waiting to be called before the judge. Meanwhile, clerks, bailiffs, police, lawyers, and youths in all varieties of dress, but mostly looking like the stereotypic delinquent off the street, shuttled back and forth, into and out of the courtroom. The court was evidently cleaning up all the shorter re-hearings and miscellany before getting to Daniel's and Kevin's case.

At eleven, we three Greenleafs and the three Wilsons were called in together. A long table was positioned perpendicularly to the judge's bench, with pairs of chairs jutting away from it at right angles. Only the person closest to the table could use its surface for writing or holding materials. The bailiff directed the two boys to take the two chairs left of the table and closest to the judge's bench. I was placed behind Daniel beside the table, with Peter beside me. Iris and Randall were behind us. The opposite side of the table was reserved for personnel representing the authorities. They included a social worker we had never seen before. Whatever Santorini reported following his visit to our house was never alluded to during the hearing.

The judge advised us all of our rights to counsel, which we all waived, another in my endless comedy of errors. Then the statements from the Metroparks incident were read, and the judge and bailiff talked back and forth about the failure of the Glencoe police to file their charge concerning the diner break-in, despite its having occurred two and a half weeks prior to the hearing. Regarding the Nature Center incident, the boys again admitted their guilt, and the judge pronounced them guilty. He then instructed the Wilsons to leave the courtroom while Daniel's case was decided.

The judge had not addressed any questions to us, and I was becoming alarmed that some sort of decision would be issued momentarily without any input from me, so I requested permission to speak, and the judge granted it.

"Your Honor, a much larger issue is at stake here this morning than a teen-ager who, as the expression goes, 'got in with the wrong crowd' and engaged in petty crime, with the unhappy results of Labor Day. Our son Daniel is a boy of sixteen with serious problems, the full extent of which are not obvious from the tragic incidents before the court this morning. Daniel is not what he looks and sounds like to a newcomer. He is a mass of contradictions."

I tried to explain to Judge Whittier that what he knew was only the tip of Daniel's iceberg. I described his increasing uncontrollability leading to my charge of "unruly child", his lies on the bowling night, the many unexplained or incompletely explained incidents, such as the missing coin collections, the stolen gym key, the balance, the $186, and the unopened Alistair McLean thrillers. I showed him the interim reports from Daniel's teachers, reporting not only failing work by this hitherto honor student but also truancy and

92

obnoxious attitude. I showed him the pot pipe I had found in Daniel's bag, photocopies of the letters Daniel had written relating his drug-dealing activities, a copy of my log, and a copy of Daniel's MMPI printout, some of which I read to the judge. In my efforts to be fair and to underscore the fact that Daniel was, as I said, "too good to waste", I spoke of his high intelligence—identified by all his teachers and other adults—and about his having been invited to enroll in an experimental college on the basis of the PSAT he had taken as a sophomore. I pointed out that he was only paperwork away from the Eagle rank in Scouts. I described his recent part in saving Dennis' life in Wyoming, and his work caring for animals and guiding visitors, including the blind, at the Nature Center, the very place he had robbed.

I cried during part of my pleading, but I went on to relate our efforts with two psychiatrists, the second of whom, an adolescent psychiatrist respected locally, had, himself, become frustrated after five months of work with Daniel and had recommended Nova, a highly structured treatment center in Maine. I referred to the letter Dr. Perez had written to Mr. Hadigan, a copy of which was before the judge. "We are asking for you to send Daniel to Nova at our expense because there appears to be some kind of alien in Daniel's body, and we want his dark side eradicated to free up the good side and all his strengths. He has too many plusses to let the minuses destroy him. We want to do it now while we have over a year of control before he reaches eighteen. He seems to be some kind of budding sociopath, and we want him corrected and redirected before it's too late."

That word enraged the judge. "Dr. Greenleaf, your son is *not* a sociopath. You should be ashamed to call him that! You should thank God he's not a sociopath!"

"The MMPI calls him, in the new terminology, an 'antisocial personality'. Do you think I'm telling you all this out of pride? Do you think I'm slandering him out of malice? I'm relating what has happened, and I'm asking to follow the best advice we have, from a doctor who began with no reason to be negative about Daniel, but ended up with frustration about his lack of response and evidence of criminal behavior in his own handwriting."

That word "sociopath" would have hurt my case, if it could have been hurt, but the judge's mind was already made up, and he was not prepared to deviate from the standard procedure for delinquent middle-class boys.

Judge Whittier began to tap his pen and shift in his seat. He turned to Peter and said, "How do you feel about all this, Mr. Dr. Greenleaf?"

"My wife and I are in agreement that Daniel should go to Nova."

The judge turned to the social worker and asked, "What is the name of that school you came up with?"

"Pleasant Valley Academy, Your Honor."

93

Then the judge turned to Daniel and began describing a school for middle-class boys with social and/or educational problems and/or delinquencies. Like a tsunami rolling over me, I suddenly realized that I was sitting in a kangaroo court, everything I had said being ignored, the outcome having been decided in advance. I had been under the impression that our legal system functions by two litigants going to court to present and hear evidence, not to set in motion plans already made. For the judge to listen to me, patiently hearing me out with a mind already closed, was cheap.

I had not said, "Listen to me because I am a psychiatrist, my own expert, and this is my expert advice." Instead I had said, "I ask you to pursue this course because these are the facts of the case, and the evidence I bring comes from observers other than myself, even from Daniel himself in the form of those letters he wrote and those appalling responses he marked on the MMPI. Advice to send him to Nova comes not *from* me but *through* me, from Dr. Perez, a respected expert in the field, who has worked with Daniel and acknowledged failure." I had expected the judge to be a man of character, judgment, intelligence, and concern for the development of young people. I expected him to be able to see the larger context and aim for a redirected lifetime for Daniel, rather than just following the formula for the next standard approach that is always tried with middle-class, one-shot delinquents.

My crash course in Juvenile Court 101 was off to a fast start, and I had already failed the first test. Lesson number one was that evidence is irrelevant. It was just like the old joke, "There's no reason for it. We've just always done it that way." Lesson number two: I should have read Kafka literally. Lesson number three: just as Aletheia had said, we should have taken her elderly male lawyer along to talk for us, as one old boys' club member to another.

My attention returned to Daniel, who was grinning at the turn of events and agreeing with the judge that Pleasant Valley Academy was the place for him. To me it was obvious that he was as phony as a four-dollar bill.

"But Judge Whittier," I pleaded, "what about Daniel's more basic character disorder, which a regular school can hardly be expected to address? Dr. Franklin and his team work twenty-four hours a day with adolescents like our son."

"Dr. Greenleaf," said the judge, peering over his bifocals at me, "I have nothing against Nova. I once served on a juvenile justice panel with two girls who had been treated at Nova. Believe me, those girls were much worse coming out of Nova than Daniel would be going in. Nova is not for your son. They have murderers and rapists and arsonists there. Let's wait and see what Pleasant Valley does for Daniel."

"But Your Honor, he hasn't responded to other conservative measures, and this time if he doesn't respond, our hold on him as an almost-seventeen-year-old juvenile is fast slipping away. You have seen him for an hour or so.

He talks articulately in complete sentences, he sounds and is intelligent, and he looks like a prep school kid. You didn't see him when he came downstairs this morning in ragged jeans, because we made him change and dress like a regular high school boy out of respect for you. He always looks good at first to everyone new, as people with a 4-9 scale on the MMPI often do. But after a few months' experience with Daniel, that initial impression turns sour. The curve of Daniel's stock is always down, and they are happy to unload. Wherever he is, there is always unexplained trouble in his vicinity. Doubts and suspicions arise. Stories never square, never-quite-explained incidents occur around him, articles are missing or strange articles are found in his possession. He's always between two places, never just either here or there.

"Bea Hawthorne of the Nature Center, a woman of good repute and sense and judgment, began with Daniel as one of her promising young assistant curators, and she continued working with him over a period of several years. Then, much as she hated to be the bearer of bad news, she admitted having become very frustrated in her efforts with him and negative about him and his mercurial personality swings. Her retirement solved her problem about what to do with Daniel. She has promised a letter detailing Daniel's behavior there, but it hasn't arrived yet."

"Mrs. Hawthorne and I once served on a committee together, and I respect her."

"Well, she and others, after giving him a fair trial, were happy to cut their losses with Daniel and get out. But my husband and I cannot and will not do this. Daniel remains our child whom we will fight for. We remain the constants to whom the problem reverts. Peter and I are the ones who have loved him since before his birth and, our efforts having so far failed, want something definitive done for Daniel *now*, not for now but for five, ten, and more years down the road. We want to salvage him. Please send him to Nova."

"Why are you so pessimistic and negative?" he asked.

"Because of my years of hope and disappointment, disappointment in many things, little things and big ones. It kept seeming so simple to me, as it had seemed at first to Dr. Perez, that a little twist or turn, a push here and a pull there, a little more effort on all our parts, and Daniel would be on his way in the right direction, but it hasn't happened. I'm not a pessimist but a realist."

"Dr. Greenleaf, you sound very hostile to me," said the judge.

At first I foolishly agreed, "Yes, you're right." Then I immediately amended my remark. "No, I take that back. That's not true. I'm not hostile. What I am is *angry,* and with good cause. I'm angry because we did everything right, and it hasn't worked. Since before Daniel's birth my husband and I have been working on his behalf—physically, emotionally, intellectually. From his birth on, we have both worked with him trying to teach him not only right

95

from wrong but values and ethics of a high order. We have tried to help him grow into a person with nobility of character, and with what result? He defies all values his father and I hold dear.

"Yes, I am angry. Not only angry, but also frustrated and desperate, as all our efforts have been unsuccessful. I have spent the better part of the past year getting my husband to see what he doesn't want to see, that there is something drastically wrong with Daniel. Now, as you have heard, he sees it, despite wishing there were nothing to see. Peter and I want it corrected. Yes, I'm angry, but my anger doesn't come out of nowhere; it is a reaction to what I have experienced with Daniel and dread for his future. After the horrors we have been through, I shouldn't be called 'hostile'. Nevertheless, I am able to compartmentalize. Being angry is not contaminating my judgment, nor does it prevent me from doing what needs to be done, to work and fight for my child. Desperate situations require desperate solutions. For this reason, not because I'm angry, I'm asking you to send Daniel to Nova now, where they handle youths like this on a twenty-four-hour-a-day basis. I want my child to be saved."

But the judge was not listening. "I think this is a boy who will take advantage of an opportunity offered to him. You don't get out the whole cavalry for three Indians."

"Your Honor, he has been given opportunity after opportunity."

"This is an opportunity given by the court."

I bit my tongue and did not say, "Yes, Judge Chamberlain."

"Drs. Greenleaf, take Daniel out to Pleasant Valley to be interviewed. The court will let them know he's coming. Then report back next week." He tapped the gavel lightly on the desk and haughtily waved us out.

Shepherded out by the bailiff, we passed the Wilsons on their way in and told them of our defeat. Then we were met by a new, unnamed social worker who told us of a plan apparently prearranged as a result of Daniel's talk with Santorini. The judge had left instructions for Daniel to live temporarily with Mrs. Martin, the juvenile court secretary who had delivered the summons, and her son Phil, Daniel's friend from elementary school. The plans for both Pleasant Valley and temporary living with Mrs. Martin had anteceded the official hearing, prior to any input from us.

As we drove home, Daniel was gloating while I was filled with despair and impotent rage over Judge Whittier, who would not be losing a son; he would not be losing five minutes' sleep over what became of our son. In my Kafkaesque nightmare, he had vindicated Daniel's belief in his own omnipotence.

I told Peter I thought we should drive directly to Maine. The insurmountable problem, however, was that there was no possible way to detain our son. When gas ran out, so would Daniel. We were trapped.

Eleven

School for Middle-class Delinquents

I HAD BELIEVED IN A LIFE BASED ON REASON, a principal going back twenty-five centuries to ancient Greece. I had believed that if this principle applied anywhere, it would be in our courts, where wisdom was supposed to prevail. For Daniel, I expected the judge's application of wisdom and law to mandate what would be for the lifelong good of a juvenile offender, not just the standard, lowest-level punishment. That least restrictive punishment was exactly what I wanted to avoid because we had been through so many similar corrective measures. Unfortunately, the court could not think of anything more restrictive than a private boarding school for middle-class boys with mild academic problems and/or records of delinquency. I had prayed for a remedy with teeth in it: I wanted long-term, twenty-four-hour-a-day observation and treatment for Daniel, who had failed to respond to milder measures. Nova fitted that prescription perfectly.

Angry though I was, I have to admit that Judge Whittier probably also wanted Daniel's long-term good. I know that he was not an evil man. He was well regarded in the community. We were together on ends but continents apart on means. The problem was that the judge failed to individualize Daniel's case. He was not influenced by Daniel's chronic, unremitting past history which I laid out before him. Just as Little Red Riding Hood could not identify a wolf in a nightcap, so the judge could not recognize a boy with

antisocial personality disorder in a middle-class family.

Admittedly, my pain may be making me too harsh with the judge. Consider how long it had taken me to see through Daniel, and I was expecting instant recognition by Judge Whittier. The difference between us, however, was that I had begun as a middle-class mother who assumed that love, appropriate training and a proper upbringing would produce the desired results, whereas the judge first encountered Daniel in court. That should have been an amber light. It should have helped him realize that an atypical request like mine might have an atypical basis. I suspect he interpreted our plea, rather, as proof that we were rejecting parents.

Another factor that should have placed the judge in a better position to arrive at a correct assessment of Daniel was a truism I had noticed years before in medicine. When any physician, including myself, reaches a tricky diagnosis, such a person is in no position to look down on those who had missed it earlier. The latest observer has had the longest history to go on. Similarly, Judge Whittier, having arrived last on the legal scene in Daniel's case, should have integrated all the information and reached a better conclusion.

Instead of weighing the evidence and then judging the case on its own merits, the judge cut a swath down the middle. He did not worry about out-lying cases like Daniel's but applied his formula for middle-class, sixteen-year-old, male first offenders whose families, inexplicably, as far as he was concerned, do not ask for probation, which makes them suspect as parents. Therefore he ordered Daniel down the track for first-time offenders with a rejecting family able to afford a private school.

As we drove home, stunned, the truth gradually settled in on me that the problem was not only not solved, but compounded. In the car, Daniel acted delighted with himself, with his new buddy, the judge, and with the turn of events whereby he would not be going to Nova after all. It would have been too much to expect him to see that his ability to outwit a judge of forty years' experience was not a desirable talent to have. In my sorrow, Dr. Franklin's words came back to me: "Daniel will never be any different unless someone or something stops him and turns him around."

Another truth was being ground in on me: If your problems don't fit the standard categories, almost nobody in the Establishment can help. At least for the outlying cases, we have generated a system too complicated to work.

I asked myself whether the mistake could be rectified. Having barely sur-vived Dunkirk, I planned to try Normandy. That afternoon I called the court to ask what moves I would have to make to institute an appeal. The answer

was that an appeal would have to be based on a change of plea to "not guilty" because only a verdict, not a sentence, could be appealed.

"They changed John Dean's sentence," I said. "If they could do this to a Watergate conspirator, why not to a juvenile delinquent?"

There was no answer. Nor could another judge be invoked. I remembered Aletheia's words: "You think things can't get any worse, but they always do."

I made an appointment for the next morning with Aletheia's lawyer, Mr. Shapiro, the only lawyer we had heard of with any kind of recommendation for juvenile work. He and Judge Whittier were friends. I took him despite worrying lest the judge bend over backward not to favor his friend's side.

Then I placed a number of calls to begin gathering evidence of the nature, extent, and duration of Daniel's disorder. I asked Dr. Perez for another letter. This one, to be sent directly to the judge, would document how Daniel had looked so good to him at first but then gradually proved that he had never been truly engaged in therapy, though superficially charming while deceiving the doctor. Dr. Perez was left frustrated by the therapeutic impasse.

Dr. Perez was not surprised to learn of our experiences with Judge Whittier. He said that he had found judges resentful when presented with a proposed solution that they interpreted as a request for a rubber stamp. The doctor told me he had tried to phrase his letter so as to implant the idea into the judge's head that a therapeutic community was his own idea. It didn't work. The doctor later told me that he had also talked with the judge by telephone for half an hour, attempting to underscore the contrast between Daniel's short-term articulate speech and presentable appearance and his long-term unworkableness in a therapeutic relationship. He found the judge adamant, unwilling to reconsider his thinking about Daniel.

I asked Mr. Lipka of Winslow Academy for the school's rejection in writing, and he complied with a generic form letter that would not leave him open to accusations of libel.

Then I called Daniel's high school counselor, Dennis Vargo, to request a letter to support my case, detailing by specific incidents Daniel's poor adjustment in school since junior high days. I thought I explained adequately how Daniel had been caught breaking and entering. I cried—and apologized for crying—because Vargo was kind, and kindness was one thing I desperately needed. I was touched that he went so far as to offer to testify in court on Daniel's and our behalf. I was embarrassed over crying, but surely Vargo had encountered crying mothers before. I hung up on a grateful note.

But I had failed abysmally to make my point to Vargo. The letter he wrote on Evanston High School stationery was unusable for my purposes because his comments betrayed a complete misunderstanding of the problem. He called Daniel "mature", a term I found impossible to understand in light of Vargo's

prior reference to Daniel's behavior at school dances as being like that of a "mascot". Nor did he understand what I had tried to explain about Nova. Whereas I had called it a place for "young people like Daniel", meaning psychosocially, he called it a "private school for boys with a background like Daniel's".

Even before our day in court, I had already written for the testimony of two witnesses I considered objective and accurate. Both had been impressed with Daniel's abilities and frustrated by his unreachableness. The first was Bea Hawthorne, retired director of the Nature Center, where Daniel had been trained and then, like Judas, betrayed them. Bea wrote from California on personal notepaper, gaily decorated with butterflies. She said that Daniel had long been unpredictable. Sometimes he would act perfectly reasonable; other times he would adopt a surly or arrogant tone as if they had no right to tell him what to do. This intelligent and articulate woman had once, in talking, groped for a word to describe Daniel, and finally called him "belligerent", although there had never been any fighting. She had no explanation for Daniel's wild swings. Her letter concluded with a standard parent's comment, that she was grateful her children were grown and gone before the drug era. Bea wished us luck.

So did Annette Walthers, Daniel's fifth grade teacher, who wrote the other letter. She was only the second teacher in Daniel's life who had seen through him and made negative observations about him, despite detailing the plusses, too. She had gone beyond the call of duty to reach Daniel. She had sent him to her friend, the high school librarian, for help with independent research. She had sent him to a young author's conference with the story he had written about *Moby Dick* from the whale's viewpoint.

She had even gone so far as to make Daniel a kind of colleague. In return for accepting her assignments, instructions, and corrections, she acknowledged his superiority over her in spelling and suggested that he correct her spelling, as he was marvelously capable of doing.

Annette reported that for weeks at a time his behavior would be exemplary, and then he would do a flip-flop. Defiance would set in, and he would refuse to work. That year our combined efforts had failed to make any overall change in the Daniel we saw in June over the one from the previous September.

In her letter she related things about Daniel I had not previously heard. At year's end she had the children grade her as a teacher and enclosed copies of Daniel's "report card". He had zeroed in on her shortcomings in a way that bespoke good psychological insights and shrewdness. Some of Daniel's comments also suggested that he was a perfectionist, a trait I had not noticed but that the MMPI had also revealed.

Both of these letters arrived too late to show the judge at the next hearing. Finally I called to explain the whole mess to Dr. Franklin. He gave me the

name of a woman in our Illinois Juvenile Services Division who had heard Dr. Franklin speak at a national professional conference. She had been so impressed by Nova's innovative method that she had visited Nova to study it in action. When I finally reached her, she was pessimistic about my chances with Judge Whittier. Her experience had been that of all the counties in our state, ours was the most idiosyncratic and unbending in its juvenile justice system. Her phrase was, "a law unto itself". She passed along our problem to another young man also in the juvenile system but in our county. He tried to talk to Judge Whittier about Nova, but the judge refused to listen when he learned that Daniel was the subject of the call. In hindsight I doubt whether Mrs. Walthers' and Mrs. Hawthorne's observations, along with those of Dr. Perez, Mr. Lipka, and Dr. Franklin, would have changed the judge's mind. I suspected that the judge sympathized with Daniel for having a mother who tried to get him corrected instead of the stereotypic mother who leaned on her husband, wrung her hands, and cried.

After my afternoon's phoning, Daniel arrived home from school or wherever he had spent his time and went whistling up to his room to gather clothes to take over to the Martins' for the next few days. His door was open as I passed, and I saw a familiar-looking yellow slip in his hand. "What is that?" I asked.

"Nothing," in a surly tone.

I snatched it, and it was, as I had suspected, a detention slip. I had seen them for occasional tardiness, but it was the first for cut classes. When I told him I would keep the paper, he tore it from my hand, grabbed my wrists, then let go. But his hand unintentionally continued upward, knocking off my new glasses, breaking the temple, and causing the frame to cut my eyebrow slightly. I was not hurt but stunned.

Daniel reacted by blowing sky-high. Face suffused purple, he ran up and down the stairs, glared wildly at me each time he passed, acted as if about to explode, swore and yelled disjointed, senseless phrases. At no time did he threaten me, and I was not afraid of him, nor have I ever been, but I have also never seen him so out of control before or since. In a couple minutes he calmed down enough to be able to express more or less coherent thoughts, which I wrote down immediately. His outpouring ran: "Jesus Christ, God Almighty! I didn't want to hurt you. You're lucky I regained my composure. I was going crazy at the top of the stairs. You're trying to fuck up my life. Bullshit!" The thought ran through my mind that this represented the kind of situation that would have benefited from Nova's "electric sauce". Daniel certainly needed Nova.

"Daniel," I pleaded, "we're trying to help you. Can't you see that there's something terribly wrong? Can't the normal part of you trust your father and me to know that you need help? Ask the judge to send you to Nova!"

"There's nothing wrong with me!" he screamed. "It was your fault. You shouldn't have grabbed the detention slip!"

I called the police, showed them my small cut and the statement I had just written, and asked that an incident report be filed and a copy sent down to Juvenile Court, since Daniel was in their charge. The officers impatiently tapped their pencils, and no report was ever sent. In their world of serious domestic violence, it was too small an incident to bother with.

Daniel finished his interim packing and went on over to the Martins' as I started to prepare our first dinner for four. Getting something from the little-used overflow refrigerator in the basement, I found two bottles of pink champagne chilling. I hid them in a locked kitchen cupboard with a single bottle of wine a patient had given Peter the previous Christmas.

The following morning, to my astonishment, Peter chose not to accompany me to the lawyer's office. One reason I had hoped to avoid involving any lawyer was that it meant I would have to begin by educating yet another person about the mass of contradictions that was my son. Beyond that, my recital for the eighth or tenth time was difficult in a new way.

Mr. Shapiro, a small, elderly man, was quite hard of hearing. My voice is naturally low, and that day my depression and despair drained it of its usual force. In order for him to hear, I had to speak slowly, push out each sentence, and make sure not to drop my voice at the end. I tried, as always, to tell my complicated story with all its ramifications, qualifications, exceptions, examples, conditions, extenuations, and complications, in such a way as not to appear to malign Daniel or be entirely negative about him because that was not true and would justifiably be suspect. Within half an hour I was exhausted from this effort. Worse, I felt I wasn't getting through to him.

Finally Mr. Shapiro interrupted, "You mean you think he's like Leopold and Loeb?"

"No, not entirely. He'd never kill anyone. But in a way he is. His conscience has holes you could throw a cat through," I yelled. "Yet there are similarities. Daniel looks and sounds respectable much of the time, but the evil has gone inside, as in Dorian Gray."

The lawyer confirmed the bad news the court had given me about appeals relating only to the verdict, not the disposition, and of course Daniel would never change his plea since it had gotten him what he wanted. Mr. Shapiro

asked for time to think and suggested I return the following afternoon, preferably with Peter.

This time Peter did not equivocate. At least his male voice carried better than mine, and his story tallied with mine. Mr. Shapiro seemed satisfied that our requests were justified so that he could, in good conscience, take our prescribed position. He agreed to set up another appointment with the judge to ask him to reconsider.

Early on Monday the next call came. "Dr. Greenleaf? This is Mr. Dunn, the Juvenile Court social worker that Daniel has been assigned to. I have just called Mr. White out at Pleasant Valley—he's the admissions officer, you know—and he says that he hasn't heard from you people yet. You know the court requires you to take Daniel out there to be interviewed for admission."

I reminded myself silently that dunning was Mr. Dunn's job, and that he was in no way to blame for the judge's actions. He hadn't even been in court the previous Thursday. Yet it was obvious the court was my adversary. I took a deep breath and replied calmly, "You don't understand. We haven't been out there yet because that isn't the outcome we had requested and are still hoping to accomplish. Our lawyer, Mr. Shapiro, is setting up an appointment to return to Judge Whittier in hopes of getting him to change his ruling."

"Do you have Mr. White's number?"

"I have his number, and I'll call him."

During this short conversation, I managed to conceal my feelings from Mr. Dunn because I knew they would get back to the judge. But I was incensed over this degrading treatment, this jumping through hoops that the court was empowered to demand of us despite the fact that we were fighting to save our ailing child. Yet even while offended by their highhandedness, even while bristling over their petty bureaucratic use of power, while swallowing my rage, I sympathized with Mr. Dunn. Whenever he talked to me, he always sounded nervous and ill at ease, and I felt sorry for him for having to be the court's errand boy. In all my dozens of contacts with Mr. Dunn over the next year, I treated him with gentleness, and I let him know that although I was usually fighting what he was doing, I did not blame him for doing his job.

Besides being enraged with the judge, I was furious with Daniel for holding me hostage to his delinquency. Not only had he jeopardized all we had tried to do for him by insuring the court's automatic and mindless involvement, but he had also put me into this degrading position where the court's lackey could crack a whip at my ankles. With the court's hooks in me, I could no longer expect to come and go as the law-abiding citizen I was. Peter and I could be ordered to apply to an inappropriate school for boys with behavior and academic troubles, a school whose name the judge could not remember, by a judge who had ignored my years of observation of my

son's growing disorder. I was infuriated by this colossal disdain. It would have been different if the judge had been helping my child.

My rage mushroomed like a nuclear cloud enveloping an entire society that permits and encourages its young to run wild, does not back up parental control, and lets its courts shackle a parent trying to take corrective action. Parental responsibility without parental authority encourages a delinquent child like Daniel, and it is a nightmare to the parent.

I set up the appointment with Mr. White at Pleasant Valley for the following morning. As we drove the sixty miles, I noticed that Daniel was asleep in the back seat. When he woke up and yawned, I asked why he was sleeping so early in the morning.

"I'm pretty tired. I was out till one last night."

"Until one? Whatever for?"

"Phil and I went to a football game down at Soldier's Field, and it was pretty late."

"But there's a curfew, and surely Mrs. Martin wouldn't go along with a one o'clock bedtime on a school night."

"Mrs. Martin said we could go, and she's the one makin' the rules now. Like I said, the game went on pretty late, and then the traffic was all snarled, and we couldn't make it home. The police know kids go to the games."

What kind of control was this, I asked myself. After Peter and I had spent hours disagreeing about the amount of freedom to give Daniel, now the court had delegated such decisions to an interested bystander who saw no need to observe curfew hours for boys due in school at eight in the morning. Just as I had known for some time, Mrs. Martin could get along with Daniel by letting him have his own way.

Evidently I was the only one who thought that Daniel should be curbed. The more power plays Daniel won, the harder it would be to teach him that he couldn't win them all.

We arrived at the sleepy country town of Quail's Corners and easily found Pleasant Valley Academy, this farming community's primary industry, one block from the crossroads. In its white frame administration building dating back a century was the office of Director of Admissions, Jason White, an affable man in his mid-thirties. He welcomed us and tried to make us feel comfortable by telling about the reorganization of the old school ten years earlier, with new emphasis on students in academic or legal or social difficulties. His euphemism was "students the public schools have failed" to what he called "meet the needs" of such youths. Not all students were there by court order. Some had

learning disabilities. Ten percent were day students, including girls, who had no particular problem, but their parents liked the educational program.

White outlined the school's rules, which were completely predictable and unobjectionable, including mandatory study time in the dorms in the evening and lights out. The school was also experimenting with Saturday morning classes to meet the state-mandated number of class days and hours with enough hours to spare to permit four-day weekends every third or fourth week. Such week-ends punctuated their short grading periods, making parents, staff, and students quickly aware in the event that the student's work was slipping. The school's praiseworthy goal was to permit adolescent boarding boys to see as much of their families as possible while still having the academic and social advantages of Pleasant Valley. There would be individual attention in small classes, and greater structure of study and sports time than public schools could provide. My heart sank at the idea that if he went there, Daniel would be required to come home every third or fourth weekend. Since I could not contain him, I was vainly hoping that someone else who could would.

Jason White showed us dorm rooms, classrooms, dining facilities, gym, library. Dress code was stricter than public schools could enforce, with no jeans allowed in class. He emphasized that he neither knew nor cared about the nature of Daniel's court involvement.

"If he comes here, you'd better know about it," I muttered. He asked Daniel if he thought he could live with these rules, turn over a new leaf, and take advantage of what the court wanted Pleasant Valley to make available to him.

Daniel responded with a disinterested-sounding "Yeh".

White reiterated that it made no difference what Daniel had done. There at Pleasant Valley, his record was clean.

"That's just the trouble," I said, able to contain myself no longer as I real-ized that the same pattern was developing as in court, with White evincing no interest to the specifics of Daniel's problem. "No one ever wants to know what went on before with Daniel. So then he's off and running while the new person who didn't know or want to know what to expect is watching the dust settle. I have taken this 'fresh-start' approach more than once, most no-tably when he entered a new freshman class. Daniel is a boy who has been given opportunity after opportunity, and each time reasonable, well-inten-tioned people look at him and see a reasonable-looking teenager. Rational, socially responsible people like yourself, the judge, and Dr. Perez project themselves into Daniel and extrapolate what they would do in his place. What they invariably fail to realize is that other levelheaded people have gone through the same process before. You all expect that firm, clear expla-nations from people who treat others fairly will bring the hoped-for response from Daniel. You believe he will be inspired to appreciate this confidence

and rise to meet expectations. He won't. As I finally learned, he intends to get away with whatever he can, and I assure you that will be a great deal because he is both intelligent and cunning. He never uses any of the obvious ploys, phony-sounding cajolery, or apple-polishing. He has never yet responded to second chances or umpteenth chances."

I told White how the admissions officer at Winslow saw Daniel as potential trouble. I tried to go into more of Daniel's recent history, but White refused to listen.

"What alternative do you suggest?" he asked me.

"I am asking you to tell the court you reject Daniel on grounds that he needs the tighter controls of Nova."

"I think we can help Daniel at Pleasant Valley, and that he will take advantage of what we have to offer," said Jason White once more. I had already heard that tape.

"So you plan to tell Mr. Dunn you accept him?"

"That's the way I see it."

"I'm sorry," I said, "and not because I see anything bad about Pleasant Valley. You, too, will find that Daniel needs something more and different from what Pleasant Valley can give, and each day of delay is making the problem harder to solve."

White suggested that Daniel take another week off from school, return after their first long weekend, and then begin at the start of Pleasant Valley's second grading period.

We dropped him back at Evanston High, and Peter, my old optimist, suggested that maybe Pleasant Valley would be the answer for Daniel after all.

"Don't believe it," I cautioned. "We're farther behind than ever."

Peter and I also discussed how much we should offer Mrs. Martin for out-of-pocket costs for feeding Daniel since the court ignored practical matters like that. Daniel, like most adolescent boys, ate like a bird—a vulture.

The week following Daniel's court hearing was consumed by conferring with Mr. Shapiro twice, taking Daniel for the interview at Pleasant Valley, and meeting a second time with Judge Whittier, as arranged by our attorney. I did what I had to do that week, changing appointments for private patients, shifting half days at my clinic. But that was not the end of it. As weeks and months passed, Judge Whittier kept demanding that Daniel be brought whenever he chose, often at twenty-four hours' notice, throwing my professional schedule of private patients and clinics into disarray. The judge seemed to enjoy jerking me around. Sometimes Peter went out to Pleasant Valley to bring Daniel

for the appointment, but more often it fell to me. Adjusting my life around the complications with Daniel was not too difficult in and of itself—I worked only twenty-five hours or so a week—but I felt it was my right to make all these changes without disclosing the reason and without letting anyone suspect that there was a reason I did not wish to disclose. I had to do all this in order to provide Daniel another chance to lie to the social worker or the judge, as it became increasingly evident he was doing. I could have tolerated all this if I could have believed that what the court and Pleasant Valley were doing was nothing but a waste of time. Actually we weren't marking time; we were losing precious months while looking for another opportunity to redirect our treatment of Daniel.

I could have handled all this more easily now, in our answering-machine, caller-ID era. But in the bad old days, to find out who was calling, you had to admit you were at the phone (by answering) to anyone on the planet with a dime. As a physician responsible for patients, I had to know if I had a patient on the line. If all this were happening now, I could identify the court's number on my caller-ID and "fail" to get the court's message in time to appear when the judge snapped his fingers.

Postponing some individual patients' times and canceling others' as they were nearing the end of treatment was not problematic because patients know and expect that they must occasionally accommodate physicians' loss of control over their schedules. I did this rarely, less often than many of my colleagues, like obstetricians. Furthermore, though I never kept my patients from knowing the bare bones of my life—"Yes, I have children, but no daughters"—as we had been taught to do (it would have been easier on me had I maintained that anonymity as a psychotherapist), private patients neither expected nor needed to be given more than a generic "emergency" for a change in appointment. In the clinic where I worked two half-days a week, on the other hand, I was an employee and more or less obligated to give a rational explanation for throwing their and all their patients' schedules into a turmoil. "Family business" won't cover it often, especially at twenty-four hours' notice. I felt snarled in Scotch tape.

And so, week after week, having already learned to lie to Daniel as occasion warranted, I descended another step and learned to lie about my life, over which I was having less and less control. I developed a talent for telling lies or half-truths as needed to let everyone think I was somewhere else. I rationalized this partly as a way to spare Daniel's future reputation, in case he should ever need it. More than that, I did not delude myself, I did it to hide my shame over my wayward son.

It is a truism that we often take things for granted, such as health, until they are taken away. I found myself no longer able to afford the luxury of being

open and aboveboard in my movements, of never giving a second thought to who knew where I was on a particular afternoon or morning. For whenever I had to respond to the court's whip-cracking ("Get him down here tomorrow morning!"), I devised a strategy, consisting of lies and artifice, like a stupid Grade-D cloak-and-dagger movie. Fortunately for the privacy I was trying to shield, patients and others knew I was sometimes called in child custody cases by a different court, often with very little notice. This made a perfect alibi for the judge's imperious orders, so I invented subpoenas as needed. Only in retrospect did I appreciate how easy and comfortable life had been when I didn't have to play these silly games, when it didn't matter who knew whether I was at the office, the clinic, the hospital, the bank, or my dentist's office. I resented Daniel's having made me his whipping boy, with its attendant clutter in my life. I also learned the truth of the old maxim: to be a good liar, you need a good memory.

While I did not relish living with ruses and subterfuge, I rationalized my lies by noting that if I were to refuse to give a very plausible reason for a last-minute change of schedule, that very refusal would convey something no one had a right to know, that I had something to hide. Therefore I justified my new way of meeting the world on the grounds that it defended my God-given right to privacy.

Having told my clinic I had been called to Domestic Relations, I sat silent with Peter like a docile litigant before Judge Whittier in Juvenile Court, while Mr. Shapiro spoke for us. Like the admissions officer at Winslow, our attorney had apparently been able to grasp from those two visits the larger picture about Daniel. Having seen me twice and Peter once, he had the advantage of not having his vision clouded by having seen and talked to Daniel, whose appearance and speech always seemed to belie what was being said about him. As an older man, though childless, Mr. Shapiro identified with us as parents. In addition, our letters had arrived from Bea Hawthorne and Annette Walthers, and he showed them to the judge. He emphasized that we were parents to whom our child's long-term welfare was precious.

I wished at the time that I could have taped Mr. Shapiro's statement, a beautiful, compassionate plea, which concluded, "Your honor, I have talked with these parents and they are fine people. Their hearts are bleeding, and they are asking only a chance to save their child. What could be wrong with giving them this chance?"

Judge Whittier was not to be moved from his first position. He repeated his earlier opinion that Nova was for "real delinquents", not boys like Daniel. He

added that he would always be ready to listen to how things were going at Pleasant Valley.

"But," I urged, "what if he fails there? We have only a little over a year before he becomes eighteen. If you send him to Pleasant Valley and he fails, will you then send him to Nova?"

"Why do you take such a negative attitude?" the judge asked.

"Because I have been asking Daniel to prove me wrong, and he never has. With all respect, I am sure your assessment is wrong, and I beg for a chance for Nova to work with Daniel before it's too late. Mr. White says Pleasant Valley is for boys who need love. Like many of Nova's residents, Daniel has had more love than most children have, but love is not enough. Children like Daniel can't use love. Pleasant Valley not only doesn't offer the correction Daniel needs—it prevents his getting it because time won't stand still. I ask for Nova because I love Daniel despite my anger, frustration, and exhaustion."

"Why do you insist on thinking in terms of failure?"

"Because I have had years of experience with Daniel."

"And I have seen thousands of delinquent boys. Trust me," he concluded waving us out. I had asked for bread and he had given me a stone.

As we left the court building, Daniel sneered, "Well, your little lawyer didn't make any difference, did he?"

As we returned home, defeated again, I felt like a character in that beautiful children's science fiction fantasy, *A Wrinkle in Time*. In Madeleine L'Engle's twentieth-century morality tale, the teenaged Margaret enters a new dimension of the universe. She learns that her ability to rescue her father from malignant extra-terrestrial forces hinges on her efforts to make correct moves in a situation for which she has no experience, no precedents, no rules like those encountered on Earth—and only one chance. Similarly with Daniel, traditional logic, need, right, global morality—all these were irrelevant—and we, like Margaret, had to move in uncharted realms, watching for our one chance to save our son.

Twelve

Jockeying for Position at Pleasant Valley

ON THE FIRST OF OCTOBER, a glorious blue and gold day, Peter transported Daniel and his belongings to Pleasant Valley. The three of us were unanimous in deciding that I not go. I had no wish to be part of removing my on-the-skids sixteen-year-old to a school for teenagers whose difficulties were partly academic. Peter approved Daniel's course, which included biology, physics, and advanced algebra, and soccer for his fall sport.

As all our troubles were escalating that spring, I had not authorized Daniel to sign up for Driver's Education in Evanston in the fall of his junior year. I insisted that learning to drive is a privilege to be earned by mature and responsible behavior, not, as most adolescents contend, an age-given right, if not a fiat. Though agreeing to Driver's Ed in addition to Daniel's five academic courses, Peter, to his credit, did hold the line on another option. Pleasant Valley allowed students to smoke—tobacco, that is—at designated times and places, but such permission depended on parental approval, which Peter withheld, as I would have done.

That night, for the first time in months, I slept without stirring, knowing that no child of mine was roaming the streets. I relaxed in the comforting knowledge of my three weeks' respite from Daniel, a time to regroup my battered defenses.

Daniel went to Pleasant Valley on Monday, and by Wednesday night he was on the phone asking permission to visit his roommate over the weekend.

"What? You just got to Pleasant Valley. You don't have to leave already."

"But there's nothing to do here," Daniel complained.

"What do you mean, 'there's nothing to do'? Just do whatever the rest of the kids do on weekends. Mr. White told us that they schedule various activities for the weekends. The court sent you to Pleasant Valley to calm down and conform. Be appreciative and stop agitating!"

"Mom," he said, in that aggrieved tone people use when trying to be patient with someone hopeless, "you don't understand. Practically everybody leaves on weekends."

"I don't care if 'practically everybody' goes to the moon."

"I want to talk to my dad."

"Your father is at an endocrinology meeting." That was a bit of luck.

"Is it true you're going away this weekend?"

"Yes, we'll be gone."

"Where?"

"To see my cousin in Michigan to look for Petoskey stones. I wish you could go. It's the sort of thing we've always included you in, when you tolerated normal living at home."

"Well, fuck you then! Why did I have to be the one to get a loony mother?" And Daniel's utterances degenerated into senseless, disjointed expletives: "Son of a bitch! Up yours! God damn!"

"Good-bye, Daniel. Call when you can talk normally."

The first weekend Daniel was at Pleasant Valley, I felt the same way I had during his whitewater adventure: whether or not anyone else was actually watching him, the responsibility was legitimately delegated, and I was freed to turn my attention to other concerns.

As we slipped into less populated areas of Michigan's Lower Peninsula, through scarlets and russets and golds of hardwood foliage, and as the proportion of evergreens and silver birches increased, I became more tranquil. I could feel my spirit expand into nature. At last I could do something important for me, rather than always something urgent for Daniel. We even found our own bagful of Petoskey stones, fossilized coral from an ancient sea, now Michigan's state stone.

Within the week following our return, we received our first communication from Pleasant Valley. It was an invitation to a parents' day and soccer match. In small print at the bottom, we were notified that a reception in the library would provide parents an opportunity to meet teachers. Peter was able to leave work early enough to arrive for part of the field event, but my clinic went on until 4:30. By the time I arrived, Peter had already been issued a schedule of Daniel's classes.

In the crush of the library it was difficult to meet his teachers because parents with haunted eyes were conferring in a worried way about their children's

problems, mutely begging for reassurance. Daniel's teachers, when we finally got to them, had nothing but good to say about him, based on the two weeks he had attended their classes. My message to all of them was the same: "Sock it to him—he's not here for academic difficulties. Always maintain a level of suspicion—he can't be trusted when you're not looking." The biology teacher, in an effort to show his fairness and willingness to meet students halfway, related having excused Daniel from an ecology project because he had joined the class a marking period late.

"Oh, you should make him do the report anyway," I said. "He could have written it from what he's already learned at our nature center where he's been an assistant curator for several years. The summer before last we visited Jennings Preserve in Pennsylvania, to see the blazing star prairie wildflower and also the protected massasauga rattlesnake. As the naturalist took the five of us and the rest of the visitors around, Dan happened to remark that he had seen a silver fritillary butterfly on one of the blazing stars. The ranger overheard him, pivoted on his heel, and talked to him the rest of the time as to a colleague, ignoring the rest of the visitors and us. Daniel has a much better-than-average background in biology, and he sometimes talks of going into conservation as a career."

"It's too late now to go back on what I said about the project," said the teacher, looking as if he had had just one more trouble-making mother than he could take. "But you're right about Daniel. He identified a great horned owl by its hoot."

"With Daniel it's always too late for something. By the time the message gets there, either Daniel has been inappropriately trusted, or standards have been lowered, or both," I sighed.

After the open house I sent Judge Whittier a copy of Daniel's MMPI that he had requested. I was afraid of the judge, afraid not to 'cooperate', and I also included a letter detailing what I had seen and learned at Pleasant Valley's open house. I mentioned the champagne I found in the basement refrigerator on the day we had been in court, the detention slip, and how Daniel had cut my eyebrow in the scuffle that ensued.

The following Thursday our local weekly printed a story about a theft at the Nature Center. A Canadian red fox had been taken, and, apparently, tortured and killed. The animal was missing, blood was smeared, and tufts of fur were found in its cage. Doubting that Daniel would actually hurt an animal, though with Daniel every incident was always new and a first, on my next trip to Kewaunee I called Jason White at Pleasant Valley. He reassured me that he had done a bed check on the night in question. Doubts rankled, however, because the vandalism could have been perpetrated by the boys Daniel had introduced to the Nature Center.

I called Craig Anderson, the Nature Center's new director, and told him "The school says he was in bed that fateful Friday night. I don't think he'd hurt an animal anyway. The only time I ever saw him angry with one of his cruddy friends was when that degenerate senselessly killed a raccoon."

"I don't think he'd hurt one either," Craig agreed. We talked about Jonathan's work there, which Craig praised. I told him I was happy for the opportunities they were giving Jonathan.

Craig went on, "I don't mind telling you that I've been keeping a pretty close eye on him."

"What do you mean?"

"Well, after what Daniel did, I've just been watching Jon."

"But Jonathan wasn't to blame for Daniel's behavior," I protested. "That's not fair of you. Jonathan hasn't given you a cause for suspicion, has he?"

"No, but how was I to know what he might do, after what Daniel did?"

"The same way you would know what any other kid out there is going to do." Unfair, but understandable, what Craig Anderson had done. At least Jonathan hadn't been aware of being under special scrutiny. Still, the Nature Center was one more well that had been poisoned by Daniel's corruption. From then on, we were too uncomfortable to attend the potluck suppers for assistant curators' families, since we had no way to know who had whispered what to whom about Daniel.

During the autumn Daniel had appointments with Mr. Dunn, the social worker, scheduled to coincide with his long weekends home. The judge wished to be present for one of the meetings with Mr. Dunn, so we were required to get Daniel to the court by early Friday afternoon. This entailed Peter's having to drive the 120-mile round trip to pick up Daniel, although routinely I would have gotten him two hours later, on my way home from the clinic where I worked in Kewaunee. We were never consulted about our schedules, and there was no effort to spare our lives. We were afraid of the judge, so we did whatever we were told. Whatever the court wanted, the court got.

The judge cautioned us to "act natural" (that is, not watch Daniel's every move), and not to "fall all over yourselves" (an expression I took to mean to avoid saccharine artificiality). That was not a mistake I was likely to make.

Another trip to the judge's chambers was scheduled for a few days after Halloween and was to include Peter and me. I showed the judge a glass tube Daniel had left in the jeans he had worn. In it was a powdery vegetable material that their lab later identified as marijuana, but the judge made nothing of this. When I raised objections to Daniel's weekends at home on the grounds that I could not control him, the judge ignored this problem. He indicated that he simply expected Daniel to be subject to "reasonable parental control" at such times. The catch lay in whose definition of "reasonable".

It was Daniel's.

Thus Daniel once again slipped through the meshes of the system. Daniel would need to get into further trouble if he were ever to attract corrective attention. I was the only one who seemed troubled by a teenager making the rules, and coming and going more or less as he pleased.

Determined to be "out" or "away" most of the time when he was home, Daniel would often take a bus to a distant suburb to see boys he knew from Pleasant Valley. He mentioned having seen Scott Sawyer and Kurt Duncan in Evanston, too, but about Kevin Wilson he vacillated between using him for an alibi that Iris did not confirm and suggesting that he, Daniel, was out of Kevin's league. "I don't know what I ever saw in such a faggot!"

His scorn for Kevin confirmed my hunch that Kevin was in a relatively minor transient rebellious phase, and was less seriously disordered than Daniel. Although Iris continued to complain about Kevin's unaltered and uncontrollable behavior, despite his probation, she and her husband were unable to get together on a plan to do anything definitive about him.

After each home visit I called the nervous-sounding Mr. Dunn. Fool that I was, I still tried to give balanced coverage and include anything good about Daniel, while complaining about his ungovernability. It seemed to me that a reasonable hearer would interpret this as good reason to credit my objectivity. I must have been a slow learner. Mr. Dunn would latch onto the positives, and dismiss the negatives, about which he could do nothing.

But when it became apparent that Daniel was bombarding us with demands to leave Pleasant Valley with other students, once again Peter and I disagreed. I favored categorical denials, with the evidence we had for drug use. Therefore Daniel made a point to time his calls in an effort to catch Peter at the phone instead of me. I objected to Peter's letting Daniel wander off with someone about whom we only knew two things: that he was a boarding student at Pleasant Valley and that Daniel had struck up a friendship with him.

Peter would quote an old line of his: "You can't watch them twenty-four hours a day."

"That's why I wanted him at Nova, where they can. Still, Pleasant Valley can and should watch him over weekends."

"But he says nobody ever stays there over weekends and there's nothing to do."

"Do you believe Daniel or Jason White?" I countered. "They have plenty going on. They have intramural sports. They're going to an antique automobile exhibit. When Jason told me, I even gave him some tickets somebody gave me for it. They also had a chess tournament. At long last we do have a way to have him watched twenty-four hours a day. Why not take advantage of it and contain him? That's what he was sent there for. I've noticed that with

Daniel, activity isn't followed by rest. It just revs up his motor."

Daniel's demands continued unabated, but Peter was also a slow learner, and yielded whenever he had a chance. Finally, I asked the court to interpose itself between us and the battering ram at Pleasant Valley. Instead of backing me and placing the burden of proof of trustworthiness on Daniel, they undercut my authority once more and said that Daniel must be treated like Pleasant Valley's "average student". He must not be kept there as if in jail, but be free to come and go the same as the other residents. Once again, Daniel had outflanked the controls.

Trying another approach, I asked Jason White for names of boys from "reasonable" families, who would set standards and use good judgment in the supervision of teenaged boys. He named several boys whom he knew Daniel to be friendly with and called their families "fairly reliable". White did warn me that he could not vouch for their rules or expectations for their own sons or Daniel.

It later became apparent that no screening for "reasonableness" had taken place in White's mind. Daniel had, it turned out, found youths like those he had known in Evanston. Meanwhile, Peter and I agreed on a policy to let Daniel leave one weekend of the three between home visits. My hope was to keep the court off my back.

During Daniel's time at Pleasant Valley, I formed an alliance of sorts with Jason White, whom I tried to use as my eyes to oversee Daniel. I settled into a pattern of calling him when I worked in a nearby clinic, just five miles and a local call from Quail's Corners. But White taught remedial classes, and so their contacts were minimal. Once I asked him how it happened that Daniel and his host left on a Friday night for the weekend when the school's stated policy called for Saturday morning classes to make possible the four-day weekends. His explanation was that they were experimenting with a plan to reward students with perfect attendance records for a week by letting them miss Saturday morning classes.

"Reward not cutting for five days?" I gasped, appalled. "What kind of behavior are you tolerating when they don't even make it to class in a boarding school?" I let him know that I felt robbed to be paying tuition for permitted cuts. The students they enrolled were apparently manipulating the entire school.

My next line of defense, as easily flanked as the Maginot Line, was to chat on the phone with parents before Daniel visited, in an effort to learn more of what was going on. Some of them sounded desperate about their own children, others already defeated, a few unconcerned or oblivious. Verbally they all supported the principle of fixed hours and supervision, but follow-through was another matter. One mother complained that Pleasant Valley had not come through with a promised remedial reading program. One

father explained that he and the court attributed his son's delinquency to the boy's reaction to his mother's untimely death.

Other parents were also fighting over what to do with their intransigent offspring, but usually the mother was manipulable, the father trying to take a stand. I was astounded that as a rule they apparently never investigated or required any prior knowledge about a boy invited for the weekend. Most often they hadn't heard of Daniel or his proposed visit. Nor did they express any feelings of imposition when they learned from the mother of a strange boy that he might be coming for the weekend. Furthermore, they never inquired about his background or questioned a visit by a boy whose mother confessed to having an ungovernable son.

Ripples came back via Daniel himself that on these weekends the host boy and Daniel came and went as they pleased, exactly what Daniel's placement in a residential school was supposed to have precluded. Gradually it became apparent how home after home not only was no more successful than I at imposing limits, but also in most cases had given up trying. Naturally Daniel preferred those weekends elsewhere without even my laughable attempts at supervision.

Thus I was left with no help from the court, no help from Peter, no help from Jason White or Pleasant Valley, and no help from parents of other problem teenagers.

When Daniel was able to reach Peter on the phone, he was always able to persuade his father to let him go anywhere. But Pleasant Valley had another regulation: if a parent could not be reached, the dorm master could make such a decision. This, of course, was a route Daniel manipulated by calling Peter at work when he knew his father would not be there—or telling the dorm master he had tried unsuccessfully to reach Peter. After one round robin discussion concerning a weekend visit about which I said no, Peter said yes, and Jason White and the dorm master, Thornberry, were in disagreement, I told White that I wished Daniel to have no permission to leave the campus unless I personally communicated it to him, White, and he conveyed it to Thornberry. I apologized for Peter's ingenuousness and inability to say no to anything short of Daniel flinging himself in front of a train. I told him that with people like Daniel, you don't need a reason to say no, but you do need an overpowering reason to say yes. I told him I would have to be the one to give it.

White mulled over that request for a few seconds and then agreed. "All right, since you were the first parent to come up with such a stipulation. Usually it's the father." This trivial tightening up had taken a couple months of Daniel leading us all around by the nose.

Daniel went into a tirade over the phone, but I remained in control. "Just a minute. You called here collect, and we've always wanted to hear from

you, never refused a call. But we are paying the phone bill, and I don't intend to listen to obscene talk. . . . No, I won't call your father to the phone to be manipulated. And don't get arrogant with me. I won't tolerate it!"

At that point Daniel screamed into the phone, hoping Peter would hear it in the next room. "Dad, c'mere!"

"I'm not letting you work over your father," I repeated.

And again he replied with a line I had heard from him before. "Mom, why don't you just give up on me?"

My answer had become a litany: "Because you're my son, and I love you, and you're too good to waste. I'm fighting for you as long as I have strength, but there's no way to tell how long that will be. If I win, you win, but if you win, we both lose!"

Thirteen

Delinquent Eagle Scout

THAT FALL WITH DANIEL at Pleasant Valley was easier than the summer had been. How could it have been otherwise? Even though I rarely had a day without a call or other contact involving Daniel in some way, the summer earthquakes had damped down to mild aftershocks.

I wished Daniel had an adult male mentor—a teacher at Pleasant Valley, for example—to whom he would go for advice, someone who would correct the message Peter broadcast, that adults, men in particular, could be worked.

What I did not yet realize fully was that Daniel was unable to establish and experience warm human relationships with anyone. The issue was not one of finding someone for male bonding or mentoring. Daniel lacked the ability to respond to men who, in the past, had tried to relate to him, such as his scoutmaster of many years.

Still seeking answers or even clues, I sought the professional opinion of Dr. Kalland, an older male psychologist at my clinic. Dr. Kalland had an engaging sense of humor. Like me, he spent a day a week in Kewaunee to escape, as he put it, the lonely cave of private practice. I did not think of him primarily as a therapist, but as someone who daily interpreted psychological testing, even for the juvenile court. I began by asking him to assess Daniel's horrendous MMPI. "Is there any hope for a sixteen-year-old boy with this MMPI?" I asked.

He looked at the printout and said, "This isn't my test—I rely on the Rorschach—but I'd be happy to see your son. Bring him out Thanksgiving morning—I like to get out of the house while the turkey is baking. I'll spend a couple

hours with him. I'll do projectives and test his intelligence."

Nobody had ever raised a question about Daniel's intelligence, and at Pleasant Valley he was getting high nineties in all subjects. Half-wishing I had not approached Dr. Kalland, I nevertheless felt committed and got the court's backing to make Daniel cooperate.

After two hours with Daniel, Dr. Kalland saw Daniel and me together and said he saw Daniel as primarily depressed, and frightened by his underlying despair. He recommended therapy aimed at alleviating this depression in an effort to forestall what he felt would be an increasing tendency to run to drugs and alcohol to feel comfortable enough to function in a social group. (A special scale on the MMPI had also predicted drug use, but it had not identified depression.) I would have been happy with these results if only Dr. Kalland had stopped there. But then, in front of this delinquent youth, he said, "Young people try a variety of things that adults are unaware of, fortunately for the adults. Daniel's mistake was not so much what he did as doing it so ineptly as to get caught."

Of everyone I had consulted regarding Daniel, Dr. Kalland had seemed the best able instantly to lock onto the substance abuse problems Daniel was presenting. But depression? And why did he have to make such an outrageous statement in front of this delinquent boy?

When I saw Dr. Kalland alone in the clinic at Kewaunee, I let him know I was appalled over what he'd said to a boy caught breaking and entering. Somehow he couldn't see anything wrong with expressing that opinion to a delinquent. Yet I have no reason to believe such a comment influenced Daniel to try to be a better criminal. Nothing any adult said or did seemed to have any effect, positive or negative, on Daniel.

Another surprise came from Daniel's test score. It revealed a lower intelligence than Daniel had previously been tested to have. He had, in fact, scored so high on his sophomore PSAT that Simon's Rock, an experimental college, had invited him to enroll at the end of his sophomore year.

A chill passed through me at the thought that perhaps drugs had already done their evil work of blunting his intelligence. More likely, Daniel had seen little to gain by putting much effort into Dr. Kalland's tests.

Dr. Kalland noted high scores in math and recommended accountancy as a suitable occupation. I was at a loss to think of a more inappropriate vocation for someone with a life characterized by chaotic impulsiveness.

I was heartened by the possibility of neurotic depression, however. That at least offered more hope for treatment than character disorder, such as the antisocial personality previously diagnosed, although depression does not preclude and can occur in this disorder. Even though Daniel had refused treatment, depression would make him more amenable for help if and when he actively sought it. But such treatment would not be with Dr.

Kalland, because I had no confidence in a man who advised, "Next time don't get caught."

Knowing that Judge Whittier would be getting a copy of Dr. Kalland's report, I informed him that Daniel's new PSAT results at Pleasant Valley were very high and that he was second on the school's dean's list. I asked him not to reveal to Daniel the low intelligence results Dr. Kalland had found, lest Daniel cite that as a result to slack off in his efforts. I also asked him to require counseling with someone other than Mr. Dunn. The judge responded on juvenile court stationery:

> Dear Dr. Greenleaf:
>
> I have reviewed Dr. Kalland's assessment of Daniel. I found nothing there to alter my intuitive judgment of Daniel and our hopes for his normal development.
>
> You may be assured that I will not reveal to Daniel the results of Dr. Kalland's test. Dr. Kalland is a competent psychologist, but for the reasons you state I have noticed that frequently children obtain lower scores when they know that the Court is utilizing the tests. Some years ago we found that on the Otis Group Test, children in the Detention Home scored 10 points lower than they would had the test been administered in school.
>
> I am firmly persuaded that Daniel has more than enough intelligence to do well in school and he knows that I expect him to perform accordingly.
>
> I am not sure as to Daniel's need for counseling. Mr. Dunn is quite a capable counselor and it may well be that he can provide the necessary service in this regard. We can talk more about this at Daniel's next hearing.
>
> Sincerely,
> Samuel J. Whittier, Judge

The phone rang constantly. Almost daily there were hang-ups, which I suspected came from people trying to reach Daniel, probably to buy or sell drugs. We would have preferred an unlisted number, but Peter and I had to be reachable by patients, and answering machines were not yet popular.

Another call came, but on this one we would have welcomed an answering click. Peter happened to be the one to pick it up, and so the shock waves were his. I could tell from his responses and the increasing annoyance in his voice that the owner of the diner Daniel and the boys had broken into was asking him for payment for damages. Peter wearily explained that our son would be required by us to pay his share, if not by the court, once

the court ruled on damages, and the number of boys involved.

Daniel, the court, and even the victims (whose insurance rates would rise) seemed to accept the idea that events like the break-in were why businesses carried insurance, and therefore "everybody" just let insurance pay, which was the "sensible" thing to do. I found that idea an appalling sign of our society's erosion of the principle of personal responsibility. This mindset gives tacit approval to the all-too-prevalent assumption that the perpetrator is not responsible for anything because someone else will always take care of it.

As a result of the diner owner's call, Peter and I contacted Mr. Dunn again, separately, and explained our wish to have Daniel be required to pay his share of the damages to both the Nature Center and the diner. Dunn repeated his tired line, "The judge will make him pay." First the jewelry had to be used as evidence in the trial of Scott Sawyer. The Glencoe diner incident could not be acted on until the matter was turned over to the Juvenile Court, and this never happened.

I observed a curious difference in what the judge could "make" Daniel do (i. e., very little) and what he could "make" us do on his whim (i. e., enroll our son at a private school with no facilities to address his underlying character disorder). Why couldn't Judge Whittier just wave his hand at Daniel to make him pay, the way he waved it at us, to make us jump?

Finally Peter sat Daniel down and demanded he pay the diner. Daniel must have done so, because he paid for Peter's check, the check cleared, and we never heard from the owner again. In the preponderance of cases, with no badgering parents, the court would probably have followed Daniel's policy of "letting the insurance take care of it".

Another call came, this one from Hank Toth, Daniel's second Scoutmaster.

Daniel had been a Boy Scout since he was ten (they didn't realize he was under the entry age of eleven when his friend and classmate took him to the group). As the years passed, our family took part in picnics and other events. Although I had begun by viewing Scouts as a fun-oriented counterbalance to schoolwork, I discovered that Daniel was advancing rather well, without any particular effort, toward the rank of Eagle. When most boys start getting diverted by other school activities, many Scouts require encouragement and input from their families in order to finish Eagle requirements, one of which was a special service project. Like other parents, I became more involved and helped Daniel, through a blind friend, make contact with our Braille library, where they prepared books on tape. Daniel's project became tape-recording children's books for use in schools for the blind. Daniel's talking books, which identify

himself as the reader, are in use to this day all over the state.

After all the formal requirements for advancing to Eagle Scout were met, a recommendation from the Scoutmaster was required. Daniel's first Scout-master, the seasoned Mr. Saroyan, was slow in granting this. He identified leadership as Daniel's deficiency and asked him to spend more time with the younger Scouts. One year later, when Daniel approached him for the second time, Mr. Saroyan again demurred. Though I did not usually take my child's side against other adults, in this instance I agreed with Daniel that Mr. Saroyan was not treating him fairly. I agreed also to Daniel's plan to transfer to an-other troop, whose scoutmaster, Hank Toth, had said he would not "stand in anyone's way" to reach the Eagle.

Daniel had made this transfer eight months before being arrested and had satisfied Hank's specifications for recommendation. By fall, however, after all the delinquent behavior, court involvement, dashed hopes for Nova, and placement at Pleasant Valley, the Scouts were farthest from my mind. Therefore, when Hank Toth called in November to ask when Daniel would be home from "boarding school" for the final board of review for his Eagle, I wavered, but only for a second. I could have said, "You don't want to award the Eagle to a juvenile delinquent." Or I could have let Hank move ahead with the award. After all, Daniel had completed all formal requirements almost two years before break-ing and entering, and he had met Hank's desired intangible criteria.

Maybe, just maybe, the worst was behind us, I rationalized. After all, many adolescents do go through a stage of upheaval and then settle back down, to brag in later years of their youthful escapades. The Eagle might even be a positive step for Daniel.

Missing only a quarter-beat, I replied, "He has a six-day Thanksgiving break. Shall we set it up for then?"

And so, with help from Peter, Daniel completed the last of the paperwork for submission to Hank Toth. The day Daniel arrived home for Thanksgiving, Peter took him to the review at which he had to answer questions about himself and his project. "Sort of like defending your Ph.D. thesis," Peter said, in describing the meeting, attended by only the candidates, their fathers, and the adult leaders. To my relief, Peter related that they had not asked about ever having been in trouble with the law. They also said Daniel's project was one of the best in recent times. The application was being forwarded to na-tional headquarters in New Jersey. The time to award the achievement, the Court of Honor, was planned for Christmas vacation.

Over the Thanksgiving holiday, a girl named Danielle invited Daniel to din-ner. (They called each other Dan and Danny.) I was glad for anything close to normal living for Daniel, but this was another girl I had never met, who appar-ently never attended Evanston High. How had he met her? He would not give

her last name or address, and it sounded as if she lived alone. My source of community information, Iris Wilson, knew nothing of her either.

Over the six-day break Daniel performed the fall job I asked of him every year, which he had taken over from Peter—hand-lettering our Christmas cards in his beautiful printing. I used a picture from several years earlier of the three Greenleaf boys, backs to the camera to represent *"jederkinder"*, contributing to a Salvation Army worker with a sign, "Just a drop in the bucket". As Daniel worked on the cards, I asked him what he would like for Christmas.

"What about skis?"

"I'll take it under advisement," I replied. We discussed where they were available and at what price.

Despite our quiet, tranquil, close-to-normal moments, this break was like every other time when Daniel was home. I literally counted the hours until he would return because of that terrible feeling of never knowing what would happen next. I was exhausted from walking on eggshells.

In an effort to get through Thanksgiving without incident, Peter took the three boys to Crown Point for two days to see his relatives. I was happy to have a clinic that precluded my going.

On their return, Daniel gave me a surly look and snarled, "Gimme my tape recorder," referring to an instrument I had taken for punishment months before and then forgotten about.

"I'm sorry I don't remember where it is," I said. "But I wouldn't give it to you if I did, when you demand it in that tone of voice."

Then I heard him call a Pleasant Valley boy in another suburb to make plans to get together. When I insisted on talking to a responsible parent, Daniel protested but reluctantly put me on the line to the mother, who, un-like other mothers, had heard of the plan and was agreeable. I apologized for having to check on a seventeen-year-old's story, but my display of lack of confidence did not put her off. The visit was arranged.

I told Daniel to run the dogs before leaving. Then I heard a fracas outside. I found Daniel running up and down the driveway yelling over and over, "My mother is a loony! My mother is a loony!"

Peter rushed outside to try to quiet him, but his efforts were fruitless. En-raged, Peter picked up the nearest thing, a shovel, and started threatening Daniel with it.

Daniel, a sprinter, had no difficulty getting away from his father, with his old polio leg. An hour later Daniel returned and apologized to his father, and Peter apologized to him. I told him I was sorry for misplacing the tape re-corder. But what I could not forget was Peter's rage.

The refrigerator incident was comparable. I could understand Peter's help-less frustration and fury. It is difficult not to snatch in desperation at any

preposterous and ludicrous device to attack someone who is goading you. For each of us, Peter with the shovel and me with the tape recorder, frustration and powerlessness can be blamed for our respective impulses to lash back and inflict pain in return.

And so, besides having a son to be disappointed in, I had myself to be ashamed of. I had to live with an increasing tempo of anguish and guilt for eruptions of my own sometimes-vindictive side.

After Daniel returned to Pleasant Valley, I made my customary call to Mr. Dunn. This time I included both the incident in the driveway and our less-than-admirable part in it, and the fact that Daniel's grades had been all A's again. He had again been second on the Dean's List. I praised his beautiful job on the Christmas cards. But there were serious ongoing concerns as well, especially about his visiting others while in Evanston. He had not been reachable at Phil's when he said he was going there, and he went for dinner with Danielle, whose identity and address he would not divulge.

Mr. Dunn urged, "Try to be patient with Daniel. Let him know you're in his corner."

"If I'm not in his corner, who is? The judge he cons?" I asked bitterly, although Mr. Dunn hadn't exactly accused me. "Anybody can get along with Daniel by never opposing him. Acceding to everything he wants isn't the way to be in his corner."

After Thanksgiving, Daniel was no sooner back to school than this letter arrived on Pleasant Valley stationery:

> Dear Mrs. Greenleaf:
>
> Last night's very successful evening of basketball for Pleasant Valley was marred by four students who disregarded regulations by smoking outside the gym during halftime. Dan was among them as reported to me by two different teachers.
>
> My records indicate that this is Dan's second violation, although I confess that the records also reflect the fact that you were not notified of the first incident, which took place on October 27.
>
> According to school policy, Dan will be campused this coming weekend. He'll have a work detail and will be fined $5.00, which should be his personal obligation, not his parents'.
>
> I'm sorry to have to report this but Dan should know better.
>
> Sincerely,
> Luke J. Applegate, Headmaster

The next day I called Mr. Applegate. "Can you explain breaking your own rule by not notifying us of Daniel's first offense?"

"It was soon after he came."

"What difference does that make?"

"I guess I have no excuse."

"I tried to tell Jason White when I asked him not to take Daniel in the first place, that he never intended to accommodate himself to rules, but to push, crowd, and shove to any limits the system will bear. Why does everyone have to give him second chances, which of course can only be on *caught* infractions? Second chances may help frightened rule-breakers but certainly not Daniel. Another thing, what in the hell difference does it make where he was caught smoking. It could have been in the chapel for all I care. His father didn't sign for any smoking. We have no money to burn for his ill-health."

"I can only apologize and promise it won't happen again."

I called Mr. Dunn back and sent him and the judge copies of the Pleasant Valley letter. Dunn again pleaded for me to be patient with Daniel and to "let him know you love him".

"If I don't love him, who does? Why can't any of you see that the only appropriate, genuine expression of love is control of this impulse-ridden boy determined to have his own way?"

This incident reinforced my belief that Nova, not Pleasant Valley, was the only place that offered a prayer of reaching Daniel. The upshot of several letters and calls between Dr. Franklin and me was that with the judge's mindset, there would be nothing to gain by going to him with something as minor as a smoking infraction. We agreed that it was only a matter of time before there would be something bigger. We would have to wait for events to give us a new card to play.

Mr. Shapiro, the lawyer, called several times to remind me that I had promised him copies of Nova's literature. After I sent him photocopies of their packet, he vacillated, saying that he was no longer convinced that Daniel should be at Nova. Since he could not justify supporting what we were trying to accomplish, he was judicially obligated to ask Judge Whittier for permission to withdraw from the case. Then, to protect himself from charges of abandonment, he sent a certified letter, making it clear that the court had given him permission for this action. Why couldn't he see Daniel's need to be contained? Shapiro had kicked the last support out from under me. I felt betrayed.

As mid-December approached, I went to the bakery to place an order for the traditional cake decorated with a soaring eagle, Daniel's name, and the date of the ceremony. "Do you want a deposit?"

The girl's eyes twinkled. "No, we trust the mothers of Eagles." One more errand was checked off before Christmas.

I then visited my friend Aletheia, whose daughter, Judith, a heroin addict, had been away from home for eight years, living on a bare mattress in a slum in Los Angeles. I updated her on the way Daniel was running our show.

Aletheia and I recalled happier times, when our children seemed to be morally healthy, and discussed how we could have gone wrong, or might have done better, or what we might have done that resulted in their taking that wrong fork in the road.

Aletheia was the first person I ever heard question what had seemed the prevailing idea of thoughtful mothers of our cohort: that the child is entitled to reasons and explanations for the behavior we expect. But an immature child may need direction, not explanations. With hindsight we concluded that it might have been better to train them in the behavior first, and later at the far end of the socialization process, with maturity, the reasons would have become obvious. In this kind of learning, perhaps effect should come before cause, concrete before abstract, immediate consequences before vague future possibilities.

Aletheia repeated her cynical conclusion that, if she had it to do over, she would use explanation and reason more sparingly as a child-training device. She would not say, "Do this because..." Instead, she would use a more immediate and adequate deterrent, a deterrent we had believed civilized society had left behind, fear of consequences. "Do it because I told you to."

I told Aletheia about having heard a public radio program that lent some support to her idea. A warm and sensitive woman with a ranch in New Mexico told how a social agency placed neglected, abused, and delinquent children with her. She knew nothing about these children's past. The authorities did not tell her, nor did she ask the children, although later, as they grew to know her, they often volunteered what had gone on before. Instead, she began by giving them responsibilities, building up to each being responsible for the care of a horse. She clarified expectations and let the children earn self-esteem from accomplishment. The more abstract principles came later. Her concluding and insightful comment was: "You don't teach children; you train them." I understand this technique was popularized in *The Horse Whisperer*.

In the climate in which we had grown up, children were expected to recognize the authority (almost always well intentioned) of any adults, not only parents and teachers. As a child, I knew, as did most of my cohort, that if a stranger said, "Get off that fence before you fall," I was expected to obey—and I did.

Into such a society, introducing the principle of explanations had been an improvement over the frequent use by parents of screamed orders and irrational, often contradictory demands and random swats, but as a socialization tool it had reached a point of diminishing returns. I now believe explanations should be used sparsely, judiciously, and as a second line of defense. Twenty-five hundred years ago Aristotle wrote: "Most people bow to consequences . . . to the threat of punishment rather than to the sense of what is noble." Aletheia and I had tried to appeal to our children to be noble, and it hadn't worked.

I told Aletheia about how I finally realized that my own belief in Daniel's right to explanations had boxed me into a corner because he learned to manipulate and stall by demanding these explanations he knew I defined as his right. I saw belatedly that asking over and over for a material thing or privilege, or even for the reason "why not?" was not a request for understanding but a stalling device, an effort to wear me down, and its own form of misbehavior. I told Aletheia that if my children were young now, I would go sooner to consequences, and punish for asking too often. Daniel was half grown before I recognized that, like the fisherman's wife in the child's morality tale "The Magic Fish", he should have had something to lose, not everything to gain, by making too many demands or asking too many times for the same thing. Finally, I identified what I came to designate as "the contentious 'why?'." I had myself to blame for having given Daniel this ploy.

Neither Aletheia nor I had found saving solutions for our children. Daniel was determined to have his own way and truly unable to see that he needed external controls as a device to learning internal controls, even though it was obvious his behavior had to be controlled. Judith, by contrast, had been inordinately sensitive to what others did to her but incredibly insensitive to her effect on them. Both of them had grown into adolescents appallingly susceptible to every Pied Piper prancing past.

As we sat that long afternoon autopsying ourselves as mothers, Aletheia said, "The blame society heaps on mothers, mothers end up heaping on themselves."

Pogo said it, too: "We have met the enemy and they is us."

Since the last day before Pleasant Valley's Christmas break was also my last day at Kewaunee, we arranged for me to pick up Daniel on my way home. As I drove into Quail's Corners, I anticipated the next demand, and I was right.

Daniel's first words were, "How about letting me drive, Mom?"

I thought how happy I would be if only going partway on some things would result in Daniel's coming partway to me. If only my making a reasonable

overture could increase the likelihood that he would do, more or less in gratitude, whatever I had presumed to be his part of the exchange. But I had learned better than to expect it.

Nevertheless I offered a compromise. "I'd hate for you to cross metropolitan Chicago at rush hour, but there's no reason why you can't take it to the rest stop. Remember, I expect rigid adherence to the 55-mile speed limit, and that isn't 56, as well as all the other rules. My nerves have been through a lot lately."

He took the wheel, handling the car cautiously and well, so I relented and let him take it all the way, through heavy traffic.

As we drove he explained that he would be getting an incomplete in driving because of starting late and not getting enough hours of driving with the instructor.

"I'm pleased with what I've seen of your driving today," I told him. "Your father also told me that you drove well. But you have to remember that it's the sudden tight spot that separates the men from the boys. You don't have the reflexes yet, so please try to avoid the tight spots in the first place."

We had received a court summons for the three of us to appear in the judge's chambers on December 27. As with my contacts with the social worker, I still made a point to present the positives as well as the negatives about Daniel. I told him that Daniel had been somewhat less arrogant. He had done his usual beautiful job lettering the Christmas cards. He had returned to his former high school to see old friends. His most recent grades had all been exceptionally high nineties, and his SAT scores would qualify him for any but Ivy League colleges, according to Jason White. Without being told, Daniel had even written his Aunt Natalia a thank-you note for goodies that she had sent him at school. But still his attitude was that it was none of our business where he went, when, or with whom. With his summer track record, I found this outrageous.

Judge Whittier was not interested in balanced coverage. He underscored all the good I had presented, then glossed over the bad.

I called the judge's attention to the smoking incidents.

"Why do you want to smoke?" he asked Daniel. "That's stupid! Look at me. *I* don't smoke."

I bit my tongue and did not say, "Frankly, my dear, he doesn't give a damn."

Again I asked the judge to insist that now that Daniel had paid the Glencoe Diner, he should pay his share of the losses and damages at the Nature Center. He agreed, but only in principle. In practice, since Scott Sawyer had not yet gone to court on the charge, and the jewelry that Daniel had thrown

away in the woods had to be held as evidence, that reparation had to wait. Judge Whittier promised not to forget. The judge could make us do almost anything, but not Daniel.

There were happy memories from that vacation as well. One day Daniel was rolling around on the floor with Whitepaw, his special dog since first grade, when she followed him home from school. We let him keep her, abandoned and pregnant. He trotted back and forth with her water bowl and watched as I helped with her puppybirth. Then we found good homes for the puppies. Ten years later, Whitepaw was arthritic, and her breath was bad. Nevertheless Daniel played with her and was a boy again, happy, loving and a delight to watch. He talked nonsense to her. "Whitepaw, your kitheth thmell like dead fitheth!"

"Nonthenth," I thaid—I mean 'said'. "Her kitheth thmell thweeter than thauerkraut!"

Peter again took the boys to Indiana to see relatives and give me a breathing spell. On their return, Daniel volunteered the information that Aunt Vera had urged him to get a haircut before the Eagle Court of Honor. Length of hair had not been an issue on which I intended to tangle, as long as it was clean and out of the eyes. I liked his wavy chestnut hair, and I had not said a word about a haircut. Daniel made his own appointment with a barber, and I dropped him off while doing errands.

The results were beautiful—chestnut hair contoured around his head, just like his Aunt Vera's. But as we were pulling into the driveway from the barber, Daniel glanced into the rearview mirror, suddenly changed his mind about the haircut, and for whatever reason decided it had been a "rape of the locks". Within seconds he was enraged. Blood suffused his face, and his eyes bulged out of their sockets. As I was stopping, he leapt out of the car beside a pile of firewood he had sawed up over vacation, picked up one of the logs, and holding it high in the air from on tiptoe, smashed it down on the blacktop with all his might.

Frightened for him, but not for myself, and for what he might do in his rage, I pleaded, "Can't you see, Daniel, that this isn't normal? You're angry over a haircut you chose yourself. Won't you let us find someone to help you with your emotions?"

"There's nothing wrong with me!" he screamed.

Over the rest of that vacation there was a lull in the storm. Daniel acted normal, except for one other mercurial outburst. Denied permission to spend a few days with a boy from Pleasant Valley—the same old demand to be

away as much as possible—he smashed his fist into the panel of a folding door. Neither of us knew that it really was a pane of glass painted by the previous owner to look like woodwork. Miraculously, his hand was not cut when the glass shattered and flew in all directions.

"Daniel," I pleaded once more, "How long does this have to go on before you'll see that something is wrong?"

When his fury subsided, I let him know that the repair would have to be done with his own hands, replacing glass and repainting the door. He completed it several home visits later. Unlike the court, I required a modicum of responsibility for his actions.

On Monday evening, we gathered at the church of Daniel's new Scout troop for the Eagle ceremony. Peter's relatives from Indiana could not come because Steve, the only driver in the family, was out of the country, and there was no usable public transportation. My uncle John Bradford, all his adult life an active leader in Scouts in another state, and a firm believer that Scouts would help Daniel shape up, had been looking forward to bringing my Aunt Ruth and attending the ceremony. But to his disappointment, he had slipped on the ice, cracked a vertebra, and could not drive the long way to attend the climactic event.

My father lived fifteen hundred miles away, and my mother, who would have dearly loved to attend, was much farther than that. But guests other than family members included another Scoutmaster, who happened to be our wallpaper hanger, who had followed Daniel's progress with interest, and whose civic contribution had consisted of organizing and running a troop for boys in the inner city. And we had invited our rector, Father Blanning, and his wife.

Daniel was reluctant to wear his beautiful sash with twenty-four badges earned for working and learning in areas ranging from philately to government, from swimming to music. He handed his sash to fledgling Scout David, who was not above wearing unearned regalia.

As Peter and I busily clicked photographs, Daniel mumbled, "I don't know what I'm doing here," perhaps embarrassed over the hypocrisy of the charade.

Before we sat down to the potluck supper, Father Blanning was asked to give the invocation. I recall his praying for guidance for Daniel and the other boys in these difficult times in which to grow up. "Amen!" I said fervently.

Scoutmaster Hank Toth had planned a ceremony both interesting and imaginative. At his request I had prepared biographical material on Daniel, which I assumed would go to the local newspaper. Toth had conveyed it, instead, to the civic officials. The mayor had sent Daniel a citation, as had our

state representative and our congressman, the latter represented by his local secretary, who presented Daniel with a framed letter of commendation. He was also presented with a framed mounting of duplicates of all twenty-four merit badges, grouped around the certificate.

Through all this Daniel conducted himself, I felt, with poise and dignity. Peter and I were justifiably proud. Possibly the Eagle augured well for the future. Maybe, just maybe, this might help Daniel turn a corner.

Though Pleasant Valley would have permitted an early morning return the following day, when I was scheduled at the clinic in Kewaunee anyway, Daniel and I both wanted to get him back that night. I wanted to deliver him before anything went wrong—a dreadful way to feel about one's son. I wanted him to take the rest of the cake for the dorm, but he refused, even though the identifying data had been removed.

In this way the New Year had begun well. Maybe it was an omen. Pleasant Valley had asked for donations, and they were at least trying to help Daniel. I wrote them a check for their endowment fund, with a hope that it would magically help our son.

Fourteen

Exercises in Futility

THE SEVENTEEN DAYS OF CHRISTMAS were over, and that ordeal could have been worse. Even with the flung fireplace log, the smashed French window, and my suspicions about what really transpired when Daniel was with the Pleasant Valley boys, at least we had survived the long break. But my relief would be only temporary. I would have four weeks to relax, regroup and re-chart my course, unless, of course, some crisis should supervene. First a deep breath and a good night's sleep. Then my antennae would go back up, quivering, ready to receive the next message.

Slow learner that I was, I was still trying to work through channels. I called Mr. Dunn and related all the good and bad of the Christmas holidays. I asked whether he could, in his monthly sessions with Daniel, explore this concept of a poor self-image haunting Daniel and explaining his attraction to less-than-desirable boys in Evanston and at Pleasant Valley.

I asked, also, for Mr. Dunn to pursue payment by Daniel for the Nature Center damage and theft, since I had heard that Scott Sawyer had beaten the rap and therefore the stolen jewelry was no longer needed for evidence.

"The judge will make him do it," said Mr. Dunn.

"What do you mean, 'the judge will make him do it?' The judge never makes him do anything." And I reviewed, for the dozenth time, how I had not succeeded in bringing Daniel up to have tough moral fiber and do the right thing out of a sense of integrity. Having failed, I hoped the court would put its muscle there.

Mr. Dunn nervously promised to try. He was evidently uncomfortable around this young con-artist, as well as his mother, and sounded happy to say good-bye to me.

Saturdays we usually did things as a family. Ever since Daniel was in seventh grade, we had watched a local quiz program called *Academic Challenge,* between competing northeast Illinois high schools. Jonathan and David were by then singing out the answers just as Daniel had once done, getting many right that were missed by the contestants—who had to think under cameras and lights.

I had long cherished a fantasy that some day Daniel would represent Evanston High School on its team, just as I had seen children of two of my colleagues on the program (and as Jonathan and David later did). In that relative lull between shock waves, I fantasized this same script, with the competing school changed to Pleasant Valley. I suggested it to Jason White.

"Strange you should mention that now," he replied. "We've never been asked to compete, but it has been on my mind lately to look into it. Daniel and a couple others could represent us very well. Did I tell you he had the highest ACT ever recorded here?"

By the following week's call, White told me he had gotten an invitation for the school for the following season. The Sirens lured me again into optimism about Daniel. The Eagle, the very high grades, and by autumn the Academic Challenge. Maybe Daniel was finally veering in the right direction after all.

But in the Daniel game of parry-and-thrust, I was less sanguine than formerly and covered my bets. I countered that deceptive seductress Hope with the realities of the past. My ties severed from Mr. Shapiro, and with the ever-present possibility that Daniel would be arrested again, I needed a lawyer alerted and ready to move the next time events broke. This could not be a rookie lawyer who would have to be educated about Daniel, since it was discouragingly obvious that no one could grasp Daniel at first telling. I described the problem to a lawyer, the wife of a medical colleague, who had recently carried to term a problem pregnancy much like mine with Daniel. Even with her child's outcome in the remote future, I envied her chances and hid my shame by referring to the boy in question as a patient. I asked her to name a lawyer who knew his way around juvenile court and was not threatened by intelligent women. To the lawyer she suggested, Stanley Hopewell, I told my story and explained why I thought there might be another Juvenile Court appearance. I admitted fervently hoping that by then the elderly Judge Whittier would be retired or dead. Hopewell seemed to grasp the complexities

of the bind I was in. I noted, again, the strange phenomenon that it is easier to understand Daniel if you do not see him. If you have only heard what the prior several years were like, you got a better idea than if you heard him talk articulately and reasonably. His appearance belying his history, it was almost impossible to disconnect the two when he stood before you. You "took his check" even if the last one he gave you had bounced. So Hopewell learned his role and was standing in the wings, waiting for his cue.

When Iris Wilson and I talked, I would tell her about Daniel's relative containment at Pleasant Valley, in contrast to Kevin's out-of-control behavior and failing work in school. The Wilsons kept reverting to the idea of military school for Kevin although military schools are known to back away from youths with juvenile records. When I suggested they consider Pleasant Valley for Kevin, my point was that whether or not the school was doing Daniel any good, his being there made it possible for us to survive and even live a semblance of a normal life for three or four weeks at a stretch.

"I can see why you'd want to keep Daniel away from Jonathan and David," Iris said. "Thank God, Kevin is our younger one. We thought it was bad with Gloria, but nothing like this. No, I don't think we'll go the Pleasant Valley route. We came close to calling when you gave us Jason White's name, but Kevin told me that over Christmas Daniel told him there's nothing you can't get there, meaning drugs. If Kevin can get them here or there, what point is there in Pleasant Valley?"

"No point at all," I had to agree. And in my shame over this failure, I stopped calling Iris and didn't hear from her until the next Kevin crisis.

I shared this anecdotal evidence with Mr. Dunn, for what it was worth. He had no comment.

Time never holds still while you work with one problem; new problems, opportunities and decisions intervene. A Swiss drug firm, for which Peter had done clinical investigation and testing, wanted to send him to present his results at the Pan-American Endocrinologic Congress in Bogota that June. But participants wishing to give papers had to get abstracts of their work to the committee for consideration by February.

Over the years we had used similar opportunities to travel, sometimes with the children, and we had toyed with the idea of someday taking a bus down the Pan-American Highway through Central America. For little more than

what the drug company would spend to fly Peter down to Bogota, all four of us could see life in the Third World. So, in line with my determination not to let the Daniel problem deprive the rest of us of opportunities, and because you are lucky if opportunity knocks even once, I encouraged Peter to submit the abstract.

But what about the omnipresent problem of Daniel? I had vowed never to travel with him again after the management problems and embarrassment he had put us through in Australia. Colombia would be even worse. He could find and bring back drugs. Trying to generate an idea of where to leave Daniel, I reverted to my idea of asking Peter's brother, James, a pathologist in Texas, to put Daniel to work in his lab, as he had done for years with his own children during summer vacations. I felt a little guilty about dropping a problem like Daniel on the unsuspecting James, who, like everyone else, would not comprehend what he was agreeing to.

Peter agreed to talk to James, who agreed to keep Daniel. Peter's abstract was accepted, as always.

During those months, just as during the previous and subsequent months and years, I thought of myself as applying a pincer strategy in dealing with Daniel. While planning everything I could think of for a time when he might again require legal attention by being arrested, I was at the same time looking for anyone or anything that offered a prayer of understanding, treating, correcting, or changing whatever it was that made Daniel such a bundle of grotesqueries. My attention was always hovering, ready to grasp anything new about delinquency or drugs. Articles in the popular press would catch my eye. New information would jump out at me from psychiatric journals. Like my friend Aletheia, who sadly related how for years she had spent all her waking time, whenever her mind was not actively engaged in another pursuit, looking for "clues" that would lead her to a corrective and redirectional process with Judith, I too was always receptive to anything that might start the uncoiling of Daniel's disorder. Specifically, that winter I looked for evidence that would confirm my supposition that my son had a biologic quirk. Often one can treat biochemical abnormalities by altering the body's chemistry. I would have embraced a "quick fix" for Daniel.

Daniel had not had a general medical examination since pediatric days. By the time of his adolescence, attention was being given to trace minerals as implicated in health in general and behavior disorders in particular. Since I was acquainted with an internist who adjusted abnormal mineral levels, I made an appointment with him for Daniel's next long weekend home. Desperate

not to overlook anything, I would need a neurologic examination and an electroencephalogram, to rule out a variant of epilepsy. Yet even if we should find abnormalities in those areas, I realized that they would not prove my hunch that Daniel's behavior was tied to biology, nor would their absence exclude it. Only a favorable result from correcting them would support their role in his condition.

And so I got Mr. Dunn and the judge to support me on this barrel-scraping project (they could hardly object to medical care), put a Band-Aid on my dialing finger, and started making appointments.

On Daniel's next long weekend home, Peter undertook an explanation of reflexes, pinpricks, brain wave, and hair analysis for minerals. He got the expected response.

"Why me? I'm all right."

Peter tried to keep his composure, but his voice took on an exasperated here-we-go-again tone. "We don't find you 'all right'. We're unhappy with your behavior. If you were 'all right', the court wouldn't have sent you to a school for underachievers and behavior problems. We are getting pretty fed up and are willing to do just about anything with a chance of normalizing your behavior."

But Peter was whistling in the dark.

"I haven't *done* anything! Nobody caught me doing anything wrong."

Peter didn't respond, so I did. "That's just the trouble. Nobody catches you. Can't you see that your character is shaped and composed by what you do and *don't* get caught at?"

"I'll never be the kind of kid you and Dad want me to be, and I won't go for those tests."

"As a matter of fact, you heard the judge say you had to cooperate with anything medical we find necessary."

"The judge says I'm O.K."

"The judge is an ass for believing your lies. After all his years on the bench, he should be able to recognize a con artist when he sees one. But 'all right' or not, you're a minor, and you have to submit to these tests."

Then Daniel moved to another argument he had used before. "Dad, you think there's something wrong with me because Mom says so and you believe her because she's a psychiatrist."

Peter controlled his mounting anger as best he could. "And a damned good one, but I don't need a psychiatrist to tell me that you're a loud-mouthed, arrogant bastard. I have eyes, ears, and a good brain, which is more than yours probably is any more, and I can see for myself that you're a psychopath!"

"Whatever that means, I'm not a loony. Mom's the one with the crazy brain wave."

I appreciated Peter's backing me, but it was true what Daniel said about the brain wave. I regretted having once leveled with him about my strange brain wave tracing that I had told Dr. Franklin about. "Don't worry about my brain. It got me through a prestigious medical school. It never got me to Juvenile Court—or Adult Court either. ... Surely you must, deep down, know that we're the ones on your side, not those punks you run with. We're the ones that have loved and cared for you all your life. We're not doing this for our pleasure but because you need control so desperately. You have eyes. Surely you must be able to see that other middle-class boys don't live the way you do, running here and there, always on the go! Can't you see that we're at our wits' end trying to slow you down until you can behave normally? But, like it or not, and whether you can see the purpose or not, the judge says you have to cooperate."

Daniel threw back his head and marched out of the house.

On Friday night Daniel wanted to visit a boy in another suburb. When I called, the father, to my surprise, had already been approached, had agreed to the visit, and was willing to keep an eye on the boys. As we chatted, he expressed appreciation for Pleasant Valley's efforts on behalf of his son, who had started shoplifting after the death of his mother. The father jokingly admitted to reservations about the academic standards of any school where his son received even one A.

"Maybe they're trying to encourage him with a carrot," I offered. I happily agreed to the visit.

Daniel got himself home the next morning in time for his first medical appointment with Dr. Beck, the neurologist. On the way, he volunteered the events of the previous night. A third student from Pleasant Valley had also come over, for the evening. About one in the morning the three boys were waiting outside for a taxi to pick up the other youth when sirens screamed and the police arrived. The officers questioned Daniel and the others about a call from a neighbor that three teenaged boys were lurking near an empty garage. The host boy's father had exploded when he was awakened by the police to confirm the boys' story, which he did, and apparently the police accepted it. Daniel, in truth, had not had to tell me the story at all, but by the time I heard it, I blew up, too.

"Why in hell," I shrilled, "do you have to elicit unfavorable attention so casually and so consistently? Why is there always something to explain? Police don't naturally ask me why I'm standing around, and they don't do it to your father either. Never in my life has any law enforcement official ever

approached me for questioning, and that includes when I was your age, too!"

"What are you blaming me for?" he asked. "I didn't do anything. Catch me telling you something again!"

"That isn't the point! It shouldn't have *happened*." After I calmed down, I added, "Incidentally, we're invited to my cousin Esther's for a ski weekend."

"Great! When do we go?" he asked.

"No, Daniel, I mean the four of us, not you. You'll be at school that weekend. Anyway, you're not deprived. You get to ski when they take kids from Pleasant Valley. Not doing things like this as a family is only one of the losses you're putting us through. Sure, you'd like the skiing—you love the gutsy stuff, hurling your body through space—'stimulation seekers' they call people like you, and there's nothing so terrible about that, but in your case it's out of balance. You can't appreciate the other things we do. We're going to visit a small toy museum up there, and maybe attend a concert in the evening, a real concert, not a rock concert. You wouldn't be part of our congenial group. I've learned the hard way that I can't trust you around refined people. Remember how you embarrassed and humiliated me the time we visited Cyril? I don't know how you'd act, and I won't spend a weekend on tenterhooks over what you'll do next. The truth is, I can't be comfortable around you. Even before I had children, I imagined family events like this to include all of you until you grew up, but this is only one of many disappointments I've had to suffer from you. Maybe someday we'll all get to do these kinds of things together again, but we're not there now. Do you understand why you can't go along?"

"Well fuck you then!"

"See what I mean about you? Come on. Here's the office."

At Dr. Beck's office, the neurologist's exam showed that Daniel was normal. He told me later that the only thing that gave Daniel trouble was rapidly turning his hands over, back and forth, but this is hard for everyone. Dr. Beck promised to call after he had looked at the brain wave test scheduled for that afternoon. However, the test came back absolutely normal, whether Daniel was awake, asleep, in the dark, or with lights flashing in his eyes. Dr. Beck had nothing helpful to offer.

Later that afternoon, Peter came in with a happy smile and a shopping bag marked Jeans Emporium. Pleased with himself, he told about a sale near the hospital. For David, he proudly pulled out a lovely moss-green sweater, and a blue-gray one for Jonathan. For me, Peter produced a beautiful coarse-knit off-white Irish fisherman's pullover. And for Daniel he brandished a pair of rust-colored cords, since his sweater size had been picked over. Everyone was delighted, especially Daniel, who asked whether they had any jeans.

"I bet there were," said Peter, "at a Jeans Emporium."

"I could use some."

"I'll tell you what we'll do," I told him. "Monday at three we have your appointment with Dr. Sylvester for the physical and trace minerals hair analysis. I had intended to have the car packed to head straight back to school because we may be getting more snow, and even if we don't, I can drive at least one way in daylight. Since they won't be serving supper at the dorm, I planned to take you to that little diner in Quail's Corners for a steak, drop you off, and head home. If we leave early for the doctor, we can catch the sale at the Jeans Emporium. If they have any in your size, I'll get you a couple."

Daniel was delighted. By two he had his gear in the car, ready for the trip to Pleasant Valley, and we were on our way to the sale. He found several pairs of jeans, took them to the fitting room, narrowed the selection to the two that fit, and brought them back to the cashier to ring up while he got dressed. As I waited with the bargain hunters, I thought with a sigh of gratitude that at least Daniel had stopped insisting that all pants be two inches longer than his leg, so as to create, with his heel, instant rags, the style popular with the fringe crowd. Then we went to the doctor's office.

After a short wait we were shown into Dr. Sylvester's consulting room, where Daniel's history was taken. With a normal teenager, I would not have even gone along to the doctor. With a teenager cooperating in his own care, agreeing with the need for it, I would have preferred to let him give his own history, without me in the office. But of course I would have to tell Dr. Sylvester why we were there, since Daniel would not.

As we waited while Dr. Sylvester played musical examining rooms, I rambled on to Daniel, "After we talk to the doctor about your history, I'll leave so you can undress down to your underwear for the examination. Speaking of underwear, are you still wearing those old faded bikinis? I bet your white jockey shorts must be gray from going through the coin machines out there all fall. I wish we'd thought to buy a package at the Jeans Emporium."

There was a pause, while a strange look crept over Daniel's face. "Well, which ones are you wearing?" I asked. And then I knew. "You mean you *don't* have undershorts on?" I screamed in a whisper. "You came to a *doctor's* office to be examined without *underwear*? And you tried on *jeans* in a store without *underwear*? You went there intending to get pants and didn't wear *underwear*?" I accused, outraged. "You know, even if that weren't inappropriate and gross and disgusting, it's against the public health laws!"

Just then Dr. Sylvester walked in. I bitterly explained how Daniel had just demonstrated the problem for which we were consulting him. "I never dreamed a child of mine could turn out so uncouth."

The doctor tried to pacify me by reassuring me that he was not offended.

That enraged me all the more, and I directed my impotent wrath against the doctor. "You ought to be! Besides I don't give a damn whether you're

140

offended or not," I swore. "*I'm* offended! I'm *enraged* to have a child brought up in an atmosphere of middle-class living and refinement, who has no *savoir faire*, who's innately lower class, who flaunts his coarseness, who could not live in a more disgusting fashion if he had *not* been taught!" I gave the doctor an abbreviated history of the problems we had been having with Daniel, that made us want to try the trace mineral approach, albeit somewhat skeptically.

The doctor ignored the matter of Daniel's dress and explained to both of us his growing conviction of the value of trace minerals, ten or twelve of which he had incorporated into his routine examination, having them assayed in hair clippings. He attempted to enlist Daniel's cooperation by pointing out that while Daniel insisted that he felt "fine" and needed nothing, a month or two later, after taking supplements of any that might be found low, he might feel more energetic. Only in retrospect might he realize that 'fine' at the time of the office visit had meant only a relative "fair" or "poor".

"In our own family," I said, "I remember when little Jonathan was three and got his first pair of glasses. He saw the fuzzy trees jump into focus and asked me, 'Mommy, why are those stars on the flag?' Only then could all of us know how much he had needed glasses."

Daniel agreed to give it a trial. While awaiting the mineral profile on Daniel's hair analysis, Dr. Sylvester began him on selenium and chromium, the two minerals low in virtually all his patients because of being low in the soil in our area, and hence in its foods. Otherwise, however, the doctor found him to be a healthy adolescent.

As I stopped for gas before the sixty-mile trip out to Pleasant Valley, the enormity of Daniel's behavior welled up in me again. Despairing over the hopelessness of rational appeals, I screamed like a fishwife as the attendant filled the tank. Part of Daniel's defense was that, for all I knew, "everyone else" might be doing the same thing, wearing no underwear.

I yelled that I could probably tolerate one or two peccadilloes in an otherwise normal son, but it had been months or years since I had seen any normality. Then I cried over this child whom I'd loved and cared for for seventeen years, my only reward being piece after piece of this tragic, ugly puzzle. Daniel smirked that maybe I had found him too titillating. To my shame, I told him I wished he would just die.

During this exchange, with the attendant just outside the car pumping gas, Daniel had his hand on the door handle, as if to bolt. Somehow he stayed, and we drove out to Quail's Corners in silence, his arrogant and smug, mine despairing. As we neared the country diner where I had planned to take him for dinner, I reneged on my promise, explaining that I did not care to dine with him in public. I told him, further, that the jeans we had just bought were not for him, at least not then, because they could not produce the mutual

pleasure a gift should bestow on giver as well as receiver, and because they had been obtained under false pretenses. Although there was a mild scuffle over the jeans bag, Daniel did not take it by force, as he could have. We separated in silence.

The leaden weight settled back on my heart. "How long, dear God, how long?" I cried in my pain.

When Peter heard what happened, he also reacted with anger, but it was the anger once removed of hearing the story, cushioned by not witnessing the event himself. He comforted me, but, as in ninety percent of the incidents with Daniel, I had been battered by the leading edge of the shock wave.

The next day I sent Daniel the following letter:

> *Dear Daniel,*
>
> *As I have been thinking about the events of yesterday, I have clarified in my own mind, and I want to clarify in yours, the things for which I am sorry and the things for which I am not.*
>
> *I am sorry for my screaming and talk about wishing you dead that reached a peak when I was filling up on gas. I am not sorry for keeping the pants and for refusing to take you to a public place to eat. I am not sorry I became angry.*
>
> *I am sorry that you are so unrefined as to adopt lower class ways. I could tolerate one habit such as lack of underwear in you and consider it an idiosyncrasy. It is the pattern this fits that caused me to react with rage. It would have been bad enough on an ordinary day. It is much worse to do so when going to a doctor's office and to a store to try on clothing. You should not have to be told this. It should be obvious.*
>
> *Copies of this letter are being sent to both Mr. White and Mr. Dunn, so that they can know where I stand, as well as how your father feels about it.*
>
> *Daniel, we go on trying to help you become a civilized human being, in the best sense of the word. We go on trying to love you, too. You make it horribly hard.*
>
> <div align="right">*Love,*
Mother</div>
>
> *PS Your grades came; they were very good, just as you predicted. About that we are pleased.*

I have no way to know whether Daniel ever read this letter because on another occasion he told me that when he suspected a letter was from me, he would just throw it away.

<div align="center">142</div>

Fifteen

Failing Honors Student

I TOOK MY RAGE TO ALETHEIA, my shoulder to cry on. This time we shared—and compared—our respective murderous impulses. Hers were directed against those who had enabled Judith's drug course. She and George had discussed the possibility of shooting a particular pusher who hung around Evanston High School, regardless of the consequences to themselves. "You should have," I said, adding, "No jury with parents on it would ever convict."

My homicidal impulses were directed against Judge Whittier for not believing Daniel had anything seriously wrong with him and for blocking my efforts to get him genuine help. I could envision the newspaper headlines: Psychiatrist Mother Kills Judge.

Yet Aletheia and I recognized that, hurtful though the Daniels and Judiths of this world are to their suffering parents, even worse is what we parents do to ourselves. After a lifetime of having been programmed about how determinative is maternal care of the young, it is hard to escape the tormenting belief in our own culpability. What atrocity, we ask, could we have committed unwittingly that could have converted those beautiful, innocent babies we were entrusted with into such monsters, despite the fact that whatever we did we perceived at the time and later as being for their ultimate good?

I admitted to Aletheia my wrench of guilt when I would catch myself wishing that our preemie, whom I delivered without pain relief to give a fighting chance, but who nevertheless died at twelve hours, could have survived.

"What is so terrible about wishing your boys had an older brother?" she asked.

"You don't understand. When I visit his baby grave, I find myself wishing that little James could have survived instead of his next younger brother."

I had never told her before how Daniel had come at such a high price, a pregnancy carried at bed rest after three lost pregnancies. It felt to me as if nature owed me three normal children, after my three dead hopes. But life offers no guarantees, and nature is monumentally indifferent.

To struggle and suffer for years with your child, only to end up hating yourself, is cruel. But Aletheia and I acknowledged an even worse emotion, envy. Envy, in Aletheia's and my case, for parents not so afflicted, parents no better and possibly less good than we. Such parents, schooled in the good-parents-produce-good-children theory, can hardly be blamed for committing the logical fallacy of *post hoc ergo propter hoc*—"Our children turned out well, so we must have done a pretty good job", as, in most cases, they did. Its corollary, in their minds, is "Problem children result from improper up-bringing", not "Children can be a disappointment from innate characteristics, despite loving and careful upbringing". We would be afraid that such mothers, whose experience had been that bringing up good children had been so easy, would regard us as having in some arcane way sent wrong messages, resulting in having our children turn out so far off the mark. Long considered a "sin", envy, this most repugnant and disgusting of the emotions, had the side effect of making us avoid mothers of "good" children, thereby needlessly constricting our lives.

How had we handled this shame and grief in normal social interactions? I told her that when acquaintances would ask about Daniel, I changed the subject quickly. If they persisted I would reply, "No comment." When I broached this problem once to Peter, I received no support from him, for he is blessedly able to rejoice in the good fortune of others even though he does not share it. Peter had no comprehension of envy, so I never again tried to share this loathsome emotion with him.

Envy has never been made respectable. Of the "seven deadly sins" it is the only one that brings no pleasure even at the time. I call it not a "sin" but an "emotion" that is ungovernable. Patients rarely mention it and need to be helped to articulate it. A lonely single woman once blurted out in my office, "How can anybody be so low as to be jealous of the attention everybody gives my three-year-old nephew?" Even when I took off my mask to Aletheia, I felt dirty and disgusting. Four hundred years ago, Francis Bacon called envy, "the vilest affection and the most depraved".

I continued doing what was becoming more and more an exercise in futility: trying to work with the responsible adults. Jason White declared himself astonished when I told him about our shopping excursion. From his coaching perspective and locker-room observations, he had not witnessed underwearlessness as a current fad at Pleasant Valley.

My news elicited Mr. Dunn's nervous and repetitive style: "Well, yes, now I don't know. What would he do a thing like that for? Yes, I understand why you wouldn't like it. He's rebellious. Maybe he's reacting against something. I'm sorry but I have a court hearing this morning and I have to go now. Thank you very much for calling."

As always, I felt sorry for Mr. Dunn, a kind man competent in dealing with delinquents who drop what they shoplift as they run out of the discount store, but hopelessly out of his depth in trying to work with an articulate confidence boy. Daniel no doubt dominated the hour a month they were required to be together.

As I reflected on that conversation, Mr. Dunn's trite banality that Daniel was "reacting against something" irritated me. Since I knew I would be unable to reach him for several days, and since my adrenaline was flowing, I wrote him a note asking him to enlighten me about what Daniel could be "reacting against".

I was learning another lesson I would rather not have known: the tainted pleasure you feel in the accomplishments of your healthy children while you grieve over the behavior of their hitherto equally dear sibling.

That spring I was again chair of the annual potluck for the Court of Honor in the Scout troop Daniel had left, but in which David and Jonathan were progressing, enjoying, and benefiting from what the system had to offer. And so I faced another night of having to hide Daniel when people asked about him. One adult leader, who had continued to work with the boys after his own son had gone on to become a high school band instructor, expressed pleasant surprise at having heard that Daniel had finished his Eagle in the other troop.

As we were cleaning up, the Scoutmaster who had been prescient about refusing Daniel's application made a point of telling me what exceptionally fine boys he found Jonathan and David, complete with examples. He saw my eyes fill with tears, even as I thanked him.

I recalled having first learned of this perverse paradoxical reaction many years before, when a friend described coming home from parent-teacher conferences in which her younger son was praised for academic excellence. Though pleased about him, she cried over her older son's lackluster performance and refusal to work (his intelligence was masking his dyslexia, as they finally learned). Later he studied from tapes, graduated from a college for dyslectics, and

became a successful businessman, in contrast to his younger brother, a ski bum. Did the father of the Prodigal, I wondered, also weep when neighbors praised the stay-at-home son?

I was reminded of a biography of Michelangelo that one of my sons had brought home. The artist's two sons had been disappointing, one especially— a wastrel always putting the bite on his father to cover his gambling debts. On the other hand, Michelangelo enjoyed and was proud of his only daughter, a professional woman of her time, who gathered and prescribed medicinal herbs. Tragically, the plague took her young. Over all those hundreds of years, my heart went out to the artist who gave the world so much.

I shared my feelings with David's teacher, Mrs. Morningstar, after I learned her two sons had turned to drugs, asking how she could teach sixth-graders when so disappointed in her own children. I received this letter from her, in beautiful elementary-school-teacher penmanship:

> *Dearest Victoria:*
>
> *I've taken the liberty of writing this very personal letter to you as a friend, not as David's teacher.*
>
> *Your letter touched me deeply. I have felt all of the feelings you so honestly described in your letter to me concerning parents and children. I once dreamed beautiful dreams for my sons, followed the rules, opened many doors to their curious minds, gave them countless experiences in travel, stood by them through scouting, music lessons, the whole thing—only to discover the one important ingredient I could not give them—(no one can, really)— a sort of gut-level determination, drive, call it what you will—that each of us needs, to really succeed in anything—perhaps it's genetic—perhaps not—but I do know one cannot will another person to do what he thinks he should do, no one can force another person to fulfill his own dreams—it seems we must all be free to dream our own dreams, to follow our own star in our own way. Though I am deeply disappointed at the choices my sons have made in their lives, they are pleased and in their own way happy. We are still quite close and have learned a sort of mutual respect for each other. I did learn, however, to continue dreaming dreams for my own life, over which I have a measure of control, and 'released' my sons to find their own way.*
>
> *I have dedicated my life to teaching—with the hope that every now and then I can 'touch' a child who is receptive to me, and provide an opportunity for him to formulate a dream or a vision or just plant a small seed which might one day take hold. . . .*

146

I also hope that now and then my life might touch a parent and perhaps lend the support or direction he is looking for.

And so I've made my <u>own</u> choice in life and am determined to make the most of whatever talent I have—and give as much of that away (to anyone who is receptive enough to reach out)—as I can.

Because two boys seemed to reject most of what I offered, does not discourage me from my offering to others.

I'm afraid I've rambled on quite a lot.

I do believe, however, the 'verdict is not in' yet on your boys, and one day you may find that <u>your</u> dreams for them, may in fact be <u>their</u> dreams too! I will not be surprised if Dave might be the one out of the three of them to bring the greatest joy to you and to bring something quite special to the world in the future.

In the meantime, I <u>do</u> hope you will continue in <u>your</u> work, and never, never stop being the unique and totally fascinating person I know you to be!

Sincerely and quite personally,

<div align="right">

Millicent Morningstar

</div>

PS Victoria, I do not know what your faith is, but at one point in my life, where my sons were concerned—during their more troubled years—when I 'released' them, it was not that I no longer cared—but I 'let go and let God'. I might add that I've been praying for them ever since. I do not feel <u>bitter</u>, for I did the best I could—no one can do more. That is my personal motto in life—'Do the best <u>you</u> can!'

As the school year raced by with no negative feedback about Daniel, I let him drive home again the next long weekend, and again he was cautious and skillful. In the car he related that, to his surprise, since taking the trace minerals he noted he had more stamina for running. Whereas before he had done only dashes, he was now able to do the mile run and had come in third in the school. It was a modest validation of Dr. Sylvester's prediction. Later, when angry, Daniel screamed that he had thrown away the rest of the mineral supplements. Another time, he denied discarding the pills and said he had made that remark only to get back at me. That was a modest confirmation of Mr. Dunn's working hypothesis that Daniel was "rebelling". Who can tell where truth resided in all this tissue of statements, contradictions, and lies? Yet stamina was the least significant problem in Daniel's life.

In line with my general life policy of doing the hardest, most anxiety-producing tasks first, rather than putting them off and having to dread them—*Worst First* is my slogan—I developed a pattern of calling Pleasant Valley early each Monday. No news was always good news, since my transactions concerning Daniel had not been noted for happy surprises. Often Jason White's only bulletin was that he had waved at Daniel in passing, since Daniel never sought out the avuncular admissions officer.

But one such weekly call foreshadowed trouble. After a weekend pass I had approved, Jason White would not come to the phone when I called on Monday but asked that I call back the next day. On Tuesday I was told that Daniel was at that very moment being questioned, and White was unwilling to disclose the nature of the interrogation until the school had "reached its decision".

I told Peter that something bad was coming, and we agonized until Wednesday. White's story was that a nearby girls' school had had a weekend dance to which Pleasant Valley students went by bus. However, Daniel and three other Pleasant Valley students on weekend pass had crashed the party. The parking lot guard had found an unopened six-pack of beer in the driver's car, and all four had been sent home. Since there were no other complaints, and since the boys were, technically, not the school's responsibility for the weekend, no action was being taken.

"I think you should have told me about the dance and I wouldn't have approved the pass," I told Jason White. "For years I've been complaining that no matter how I've tried to teach intelligent choice-making, if Daniel has a good or neutral option and a less desirable one, he always goes for the latter. He'll always pick immediate gratification with no substance or the more unstructured and less supervised possibility, just as in this case." I said.

"I'm sorry, Dr. Greenleaf." His tone implied, "You can't win 'em all."

As winter ice thawed into spring mud, the tempo of problems from Pleasant Valley increased. As I was pounded by incident after incident, it became crystal clear that Pleasant Valley was no solution for Daniel.

Final proof, if such had been needed, arrived in the form of this communication from the headmaster:

> Dear Drs. Greenleaf:
>
> We have reached that time in the year when staff members are asked to share in an evaluation of each student as regards re-enrollment. Such a survey of the faculty indicates that a significant number are seriously concerned about Dan's social conduct during this year. Given these concerns, we have to conclude that unless much positive observable change takes place

between now and the end of May, Dan's option to re-enroll will be highly unlikely.

When a final decision has been reached at the end of the school session, we will notify you at once.

If you have any questions or views to share, please call or write Mr. White or me.

<div align="right">

Sincerely,
Luke Applegate, Headmaster

</div>

"Mr. White," I began, "I don't understand. Were you being aboveboard with me? Last week when we talked, you gave no indication that Daniel might be thrown out of school. Why this change within a week?"

"Not 'thrown out' but be asked not to return, if that should be the final decision."

"What is the operational difference?"

"None, I guess. I'm sorry, but this action—and I hasten to emphasize that the final decision hasn't been made yet—but this letter is the result of a faculty meeting held each year at this time. The dorm master and one of the teachers feel strongly that Daniel isn't benefiting from Pleasant Valley's program and doesn't belong here."

"Exactly what I told you seven months ago. Why have they come to see it that way now?"

White made the helpless spluttering noises I had encountered so often from those I asked to be specific about Daniel. "Well, I asked them that, too. ... Here's one, for instance. One of the boys in the dorm said that Daniel had borrowed a record and hadn't returned it. Mr. Thornberry, the dorm master, said to the kid, 'Let's get him in here and get this straightened out', and the boy immediately said something that didn't make any sense at all, something like, 'Don't call him—maybe I made a mistake.' And he couldn't get any more out of him than that. The boys seem afraid of Dan.

"He goes out on the campus after study hours at night—perfectly legal and allowed—and then comes back and locks himself into his room. Why?

"I guess I'd have to say our reason is his attitude. He always hangs around with the druggie-alcy group, and next year he would be a senior and might be a very bad influence on the underclassmen. As I watch him, all I can say is that he seems little by little to be going down the drain. Yes, I'd have to say it's his attitude."

"Mr. White, I hate to be the kind that says 'I told you so', but you know I did. If you will recall, when we first came out to Pleasant Valley, when I was trying to get the court to send him to Nova where they treat character disorders twenty-four hours a day, and the judge said he was too good for them,

I asked you to reject him for Pleasant Valley. But you believed him when he said he could live with the rules and turn over a new leaf. I told you then that he had no intention of doing anything but working the system, just as he has worked every other system. Much as I wished you could have been right, I knew you were wrong. Winslow's admissions officer caught it and rejected Daniel. I wish you could've seen it—it might have saved us a year. As it is, we're back to square one. It's worse than square one—we haven't accomplished anything. We've lost a year of partial parental control over him until he's eighteen, and he's worse."

Mr. White mumbled, "What can I say? What do you suggest now?"

"For one thing, you could go to the judge and say, 'I was wrong about Daniel. He can't be reached in a boarding school. He needs twenty-four-hour-a-day walls and supervision.' For another, immediately cancel all visits to other kids' houses. I know you can't be responsible for the supervision given by the parents of other kids, and Daniel is always drawn to kids who need constant surveillance and whose parents may have never offered much guidance or maybe just got tired and gave up.

"I knew in my bones that if he had intended to make a fresh start, he would have shown his appreciation for his chance at Pleasant Valley, pulled in his horns, stayed quietly at school over weekends and taken advantage of your activities. He would have earned privileges. If we wanted him running wild, he didn't need to be at Pleasant Valley.

"Do you see why I'm discouraged and despairing? Over and over, each new person, even professionals like yourself, get taken in by him. The new arrival on the scene treats him as if he were normal and trusts him without his having earned it, like the old belief that people live up to the trust we place in them. New people always act as if they're going to save him from a rejecting mother who asks for structure and walls, definitive treatment and control, instead of that proverbial 'second chance' that mothers are supposed to ask for. Then months—wasted months—later, Daniel's new self-appointed savior exercises his option to dump him, just as Pleasant Valley is threatening to do. Do you know if there is anyone with whom Daniel has a trusting relationship? I don't mean someone like the English teacher who likes to shoot the bull with him, but someone with whom Daniel would level about personal matters?"

"Not that I know of. Certainly not with me. He comes to me only when I request it, and there is no evidence of his seeking guidance."

"That's typical. He can be fun to be with. He's articulate and a good conversationalist with an impressive fund of information. Superficially he's likable, but with no emotional connection to the other person. As soon as there's a conflict of wills, Daniel won't tolerate not having his own way. He sees him-

self as the final arbiter of everything. I don't know where it will all end, but I see nothing good ahead, and I am very discouraged."

White, of course, never contacted Judge Whittier.

Facing, as usual, an unknown future without rules or guidelines, I continued to gather material for what I thought of as my "brief" that I hoped would help me someday get appropriate help for Daniel. I talked to the teacher and the dorm master who had voted to oust Daniel the following year. One related the same incident as Jason White but also used phrases like "mixed emotions—his attitude, not behavior" and "negativism much of the time" and "dangerous, like dynamite ready to explode". The other compared Daniel to "an apple rotting in the barrel". They seemed unable to be specific, but made the same kind of helpless, spluttering noises I had so often heard from people asked to comment about Daniel, then trailed off into vague rhetorical questions, like "What would Dan do if something happened that he didn't like?" They also referred to another of my complaints, Daniel's choice of the worst associates in the school. One called Daniel's identified misconducts "just the tip of the iceberg"—a judgment I had long recognized as valid. The other called Daniel "one of the two or three smartest kids in the history of the school", concluding, "I don't see Daniel making it through the senior year." He was unable to say what he forecast as the denouement.

Besides keeping a log on Daniel, I had developed the habit of never talking on the phone without a clipboard. So when I wrote both of them, I was able to quote their own remarks back, asking them to be so kind as to put them in a letter back to me. They were both reluctant to take this risk. The letters they wrote were vague and general and of no use when we returned to Judge Whittier.

When we saw Daniel next, he cockily indicated that he was sure he could persuade Pleasant Valley to reverse that unfavorable impression and accept him back in the fall.

Before our meeting with Judge Whittier I sent him copies of the report card, the dean's list, and Applegate's letter from Pleasant Valley. I asked the judge how he explained the letter. He, in turn, asked Daniel. Daniel asserted that he had been in to talk with Mr. White and had been assured that if he improved, he would be taken back in the fall.

The judge scanned the letter—I had the distinct impression it was the first time he had looked at it—and said, "They don't say what you've done wrong, Dan. Maybe we'd better get Mr. Dunn to contact the school."

"Judge Whittier," I said, repressing my anger as best I could. "I have talked to Mr. White." And I related the upshot of that discussion, quoting my notes that their complaints were about furtiveness, sneaky and evasive ways, other boys' apparent fear of Daniel, and that old "attitude".

151

"That doesn't seem so terrible," was the judge's response.

"But, your Honor," I said, "when you sent Daniel to Pleasant Valley, it was with the understanding that he would use the school as a corrective experience. If he had done so, there wouldn't be any question in anyone's mind. Teachers are professionals who perform a poorly paid job because they wish to make a valuable social contribution. If they were in it for the money, they'd have a factory job instead. But they do this work because they care. They care even though they misjudged in Daniel's case. But the fact that they misjudged is evidence that they didn't begin with any bias against him. In essence they began their association biased in Daniel's favor. They had no reason to single him out to reject next year. But the bottom line is that he has converted them into people who no longer want him or the trouble he creates for them. They don't like his attitude, and this warning letter is evidence that he hasn't met their expectations.

"If highly concerned and motivated professional people have serious doubts about a boy who is consistently on their dean's list, doesn't that say *something* to you? When Daniel was sent to Pleasant Valley instead of Nova, where they were prepared to work with him twenty-four-hours a day, you said that we would wait and see. Now we have waited and we have seen. Will you send him to Nova now?"

"Well," said the judge, "They're not very specific, and it's too early to tell."

"Why is it always too early to tell until it's too late to *do* anything?" I asked, but the judge was already waving us out of his office.

Sixteen

Plotting Strategy

ALMOST FROM THE DAY OF DANIEL'S ENROLLMENT at Pleasant Valley I had lived with the nagging conviction that, unless we outflanked the judge, Daniel would soon be back with us for the summer, worse than when he left. We were obviously unable to control him, and if in Evanston, he would run wild with his erstwhile associates in the Greater Chicago area and with new ones from Pleasant Valley. Our family could not survive another summer like the previous one. Before Applegate's letter, I had raised with Jason White the question of summer. He suggested their summer school, but Daniel had almost enough credits for graduation, and we didn't want him to graduate yet.

Another suggestion was a federally funded program for high school students to work in state parks, putting in or upgrading trails, helping in fish and wildlife conservancy. Jason promised to talk to Daniel about this and supply him with forms. Meanwhile, I called Springfield and learned that the program had been so popular the previous year that applicants would have to be selected by lottery for each of two three-week sessions. Even if they drew Daniel's number, the program would offer nothing for the other nine weeks, nor would we know until early summer which three weeks Daniel would be away. No reply ever came because Daniel, it turned out, did not apply.

I really couldn't blame him. The work, designed for students needing summer jobs, was elementary, routine, and dull compared with what he had done

for years at the Nature Center. It would have meant just three weeks of peace for the rest of the family.

I returned to the not entirely satisfactory option of sending Daniel to stay with Peter's brother, James, in Texas. James wanted to help us. He was planning to put in a road and plant some junipers on his canyon property, with a view to building a vacation retreat. He already had lined up a nineteen-year-old he considered fairly reliable, and Daniel could help with the project, for room and board. He could also wash glassware in the lab.

Listening to Peter's end of the conversation, I was aware that Peter had not leveled with James about what he was getting into with Daniel. Even if he had, neither James nor anyone else ever got the wide-angled picture of Daniel and how normal vigilance was just not sufficient. I was afraid to warn James, but I also had reason to believe the plan would not materialize anyway, for reasons I was keeping to myself.

When I got on the phone, I tried to steer a course between explaining why Daniel could not be trusted out of sight and scaring James off completely. James reminded me that he had his own work and could hardly baby-sit Daniel, and to this I could not take exception. If a school for 'students with academic and social problems' could not control Daniel, how could a private citizen, one who was almost as ingenuous as his brother Peter?

All these trial balloons had gone up before Pleasant Valley's recognition that they could not handle Daniel and the judge's most recent unwillingness to admit his error and send Daniel to Nova. He had already approved the Texas plan for Daniel's summer.

After precious months had been wasted at Pleasant Valley, I once again set to work to save my son. I began by talking to Peter after the others were in bed. "Surely you must see that we're farther than ever from a solution with Daniel. Pleasant Valley has belatedly recognized that they've bitten off more than they can chew—but, unlike us, they're in the enviable position of being able to spit it out. That's the ultimate irony—Daniel being thrown out of a school for delinquents, and the judge still won't admit he was conned."

Nervously, I reached out to the man I had once loved so dearly but who had disappointed me so bitterly with his ineffectual behavior in our shared crisis. "Are you ready to hear my plans? I hope you'll cooperate with me, but at least I expect you not to stand in the way. . . . I plan to get Nova to pick Daniel up straight from Pleasant Valley."

"But the judge said we couldn't send him there!"

"Screw the judge! What has he done for us? Besides, the way I'm going to do it, the judge won't ever know. He's already agreed we can send Daniel to James for the summer, so he'll think Dan's in Texas and by fall, we'll say he ran from there. Nobody can trace a cold trail at that distance, and James'll

confirm our story. By then we can explain to James what's really going on. Over the summer, if Dunn or Whittier should call James, he can use the cover story that Daniel is out in the country working on the driveway and staying in the mobile home without a phone. By then we'll let James know about the runaway alibi. James is reasonable—he won't demand adherence to the law so aptly characterized by Mr. Pickwick."

"Yes, the law is certainly 'a ass'," Peter agreed. "But your idea will never work."

"Why not? What haven't I thought of?"

"I don't know. Let me think."

"What else have we got? This is our last desperate chance to thwart the blossoming of a sociopath. Help me. But even if you don't, I'll do it alone."

"All right. I'll cooperate. What do you want me to do?"

"Sit tight for now, and keep your mouth shut. I don't know where the leaks might come from. Tomorrow I'm going to call Nova and let them know that they'll have to pick him up, at our expense, of course, and I'll work out the time and place where they can snatch him without warning." I started to cry. "Who would have thought when his whole baby hand could wrap around my little finger that someday I'd have to be planning his kidnapping?"

The next morning I got out my file on Nova and called Dr. Franklin. "Remember me? I'm the mother of that kid the Juvenile Court got its hooks into before we could send him to Nova last summer. As you predicted, he's no better."

"Yes, I remember, Victoria. His name was Daniel, right?"

"He's the one. Now the school for middle-class delinquents where the judge insisted on sending him wants to get rid of him, and still the judge can't admit his error. Peter and I want you to arrange to pick up Daniel, without warning. I want to achieve this without either the judge or the school knowing. Nova might even register him under another name, so if somehow our court calls, you can tell them you don't have anybody by that name."

"I don't have to answer to anyone concerning who is being treated here."

"I've learned more than I've ever wanted to know about our judicial system. I've concluded that nobody can trust its power with its irrational base. I don't trust them not to have access to search warrants and so on and to use them to defeat common sense. Another thing, the day Dan's picked up, I could probably get Thorazine into his muscle while your people held him, to tranquilize him and get him to you without incident. I know he'll try to run."

"That won't be necessary. My staff can handle him. Kids get the idea very

fast that they have no other options when our people arrive for them."

"Daniel never gets ideas like that, and unfortunately he's always right. Please don't be overconfident with him. He'll be much more than your usual run-away risk because he's slick, and he'll have no trouble surviving in the Maine woods in summer. He can take care of himself in the wilderness."

"Don't worry. We've had slick kids before and can handle them. Let me give you the name of the pilot, and you can work out a time and a place of pickup with him."

"A *pilot*? I visualized a station wagon coming out here. *That's* a relief! A plane will be much easier. I wish I'd known about the plane last summer! You can do a thousand things right, make one miscalculation, and never recover from it."

I promised a letter updating the old application, and Dr. Franklin gave me the name and number of Nate Moorehouse, the owner and pilot of a small propeller aircraft.

I explained the complicated mess to him, and Nate quoted the cost for this service in what Madison Avenue people call ballpark figures since cost would be figured from air time, which would depend on winds and flying conditions. He used the cliché that in my experience is always prophetic of problems: "No problem! We send out several people so that force can be used if necessary, but usually they catch on quickly that there's no sense resisting. Basically the kids we pick up are afraid, and the toughness is all a show. How big is Daniel?"

"Five feet seven or eight, maybe. He's burly. One of my friends says he reminds him of a Dutch burgher—I'm Dutch by descent. He's wiry and in good condition—has done rock climbing and wilderness survival. He's been the goalie in field hockey, and now he's in track. He's also very smart and cunning and can outwit just about everybody."

"Don't worry. We have a lot like that at Nova. What date do you want us to come?"

"I don't know yet. I'll need to get the time of his last final, so he'll think we've just come to take him home, the school will think he's gone home, and the judge will think he's gone to Texas."

"Why all that? Daniel is underage, and you can legally admit him to a rec-ognized residential treatment facility."

"You don't understand, but nobody ever does." I explained what we had been through over the prior year.

"All right," Nate went on. "Which airport shall we use? We can fly into any airport, large or small. We've even picked kids up at O'Hare."

"I'll find you one. I'd rather deliver a protesting and struggling young man to a small and remote one. I'll look for a community airport in the cornfields."

Nate suggested I bring along Daniel's birth certificate so that if somehow

the police got involved, we could prove he was a minor and that we had the right to send him to Nova against his will. I alerted Nate that in such an eventuality Daniel would loudly demand his rights, which would include their contacting the judge, even from another jurisdiction. "But don't do it," I cautioned, and explained how he and the judge were in cahoots. I asked about flying time, the need for refueling, possible weather problems (ours being tornado country), the use of Thorazine if necessary, the dependability of their "strong-arms", and to each of my anxious questions he replied, "Don't worry."

"Please don't be overconfident with Daniel," I warned him. "We need everything on our side, including surprise. Daniel is very clever and has been outwitting us all for years."

"Try not to worry," he repeated.

"I have observed that the things I worry about, and hence prepare for, almost never happen. It's the ones I never dreamed of that pulverize me. Therefore I try to anticipate everything that can go wrong, so it won't happen. But you can't think of what you're not thinking of. That's multiplied by a thousand with Daniel."

I called the principal of Nova's school, Evergreen High, and told him to expect Daniel, an honors student with no transcript. I promised a grade card when I got it.

At the same time I started looking for an airport Nate could use. Proximity to Pleasant Valley and seclusion were my prime considerations. The Federal Aviation Commission gave me the names and locations of three small community airports within a twenty-mile radius of Quail's Corners. And so the two days a week I was working at the Kewaunee Clinic I began leaving home at five, instead of my usual six-thirty, in order to scout the facilities.

The first airport I checked out was very secluded, off a road with little traffic, yet not far from the highway we would have to take as we "brought him home" from Pleasant Valley. I liked the layout that permitted us to drive close to the airstrip. Though farthest from Pleasant Valley, this airport was a strong maybe.

Another morning, when Aurora streaked the azure sky with coral and melon and mulberry, I sought out the second airport but never reached it because traffic was being detoured around the gap where a bridge had been washed out. My heart thumped when I realized I could have made all the arrangements for that airport only to find that the washout had occurred just prior to the critical day and we would have hit that roadblock with the unwilling Nova resident in the car.

The third airport was as secluded as the first. Half a mile off the country road, only a hand-painted sign that soon would be overhung with elephant-eye-high DeKalb corn proclaimed its existence. The airstrip was accessible through a gate in a cyclone fence. This one was also near the interstate, and

by back roads, a scant nine miles from Quail's Corners. But could I overcome the disadvantage that that tiny airport lay in the wrong direction for taking Daniel home, thereby alerting him immediately that something was amiss? I would need the strong-arms in the car before heading to the airport.

With a few runs I learned the route without false turns, and as I practiced, I passed only an occasional farmer's truck. On one such run I stopped to extend safe conduct across the road to a turtle playing out its springtime biologic urges even though such an instinct could cost its life. On my final run, turtles would have to take their chances.

As I drove the country roads, I thought of the long road I had come with Daniel, and of the road ahead. A screaming siren interrupted my reverie, and a state trooper overtook me. "Lady, you were doing seventy-three," he informed me.

"Sorry. I have other things on my mind."

"That's no excuse. I might have to give you a ticket."

"Of course," I said, disdaining to offer the bribe he was asking. I made a mental note to watch my speed on Nova Day.

On those practice runs, I saw beautiful birds unfamiliar to me. I also passed a field where daffodils had gone wild, and I stopped to gather some for my desk and for the conference table at Kewaunee. Years before, I had realized that always, but particularly during periods of pressure and grief, while doing everything possible to resolve the problem at hand, I must guard against the trap of letting myself stop living. Therefore each day I did whatever the Daniel problem demanded but I went on with my life, with the end-of-school activities of the younger boys, the final meetings of my Great Books group for the spring, and even unexpected offerings, like the daffodils.

Knowing better than to trust Jason White not to tattle to the judge if he knew my summer plans, I let him know only that my continuing inquiries about the end of school should not be construed as pushing for Daniel's readmission in the fall or even for a premature answer. Therefore, without volunteering any gratuitous lies, I alluded vaguely to "family plans". I was perfecting my new deceitful and devious ways.

Late in May, Jason White was finally able to give me a partial answer about when Daniel would be ready to be picked up for the summer. "We begin finals on Monday, Memorial Day, and work right through the week until Thursday. I've checked with Dan's teachers, and he'll be excused from four of them, maybe five, on the basis of grades. The math teacher is a stickler for the rules and won't say until Dan's last paper is in. If he has to take that test, it'll be Tuesday morning, and he'll be out by eleven. If not, he'll be officially through his last class the previous Thursday at three."

White hung up with a sigh. It was obvious that he would be happy to be

finished with me.

If Daniel left on Tuesday, I could have him at the airport by noon, which would allow more daylight to airlift Daniel to Maine, search him and his possessions for contraband before admission, and check him in. But the previous Thursday would start his treatment five days earlier, free me from the intolerable suspense of being on hold, and let me direct my attention to our rapidly approaching trip to South America for Peter to give his paper at the Pan-American Congress of Endocrinology in Bogota. Tragically, Daniel could not use such a trip educationally, as we had always expected, and could have no part in such an event. Worrying about what I had come to think of as our upcoming Operation Roc had made intelligent thought on any other subject unbelievably difficult, and planning next to impossible. So Thursday was my preference, but my preferences were carrying less and less weight. The flight day hinged on Daniel's math grade.

Many nights I would wake up with my heart thumping from a recurrent nightmare of Daniel running through cornfields. If he escaped before boarding the plane, I had no backup plan. If weather prevented flying that day, how could I get him to Nate at another airport on another day?

As I had promised, I updated Nate. "We don't know Daniel's final day of school because if he maintains his A average, he'll be excused from all finals."

"That doesn't sound like Nova kids," he said, and promised to hold both dates for us.

I told him the strategy I had rehearsed a hundred times in my mind. "Daniel will be bringing clothes, books, bedding, and so forth, thinking he's on his way home, so we'll arrive with my station wagon. By this time your plane will be at the airport, just nine miles from the school. But if I started driving in that direction, there'd be no explanation because it's the wrong way to go home. Therefore I will have to pick up you and your boys first at the airport before we go for Daniel.

"But I won't want you there when we get him at the school because he'll know something is wrong and refuse to get in. Instead, I'll have you stationed in Quail's Corners, at a place where I can drive in. It might be a no-longer-used gas station or a country general store with a spinning wheel and cornhusk dolls in the window, where you can lounge around drinking Cokes like the Pleasant Valley kids, until we get there.

"When Peter and I drive the wagon into wherever I select for you to wait, you people can jump in on three sides—one on each side of Daniel in the back seat and one through the tailgate. You surround him, and within ten seconds I'll be on my way to the airport. He'll catch on instantaneously—he's not stupid—and there may be a struggle, but I'll just keep driving. Peter has a bad leg but strong arms and can help. I'll have intramuscular Thorazine under

my maps in the box, and Peter could give it while I drive if you hold Dan."

"It sounds as if you've thought of everything."

"I hope so. I've rehearsed it in my mind a hundred times and practiced the nine-mile run a dozen."

As the day approached, I continued my morning trips to Kewaunee via Quail's Corners and the county airport. One morning I encountered a pack of boys running through the town. I did not spot Daniel and hoped, if he had been there, that he had not recognized my station wagon.

I was still undecided about the inconspicuous place to pick up the Nova people. Should it be the small town park, or would the trees there make escape easier? Would three or four strangers loitering around an unused gas station attract negative attention? I decided that the dirt turnaround in front of the general store would be the site of rendezvous. If I could survive starring in this Grade-D movie, I could survive anything.

One final weekend Daniel came home from Pleasant Valley. When the subject of the Bogota trip came up, to my surprise Daniel asked whether he was going.

"I thought we all agreed that by then you'd be with James in Texas. I always wanted to include you in adventures like the trip to South America, but I have no reason to think that you wouldn't act tough, obnoxious, and uncivilized and humiliate us. Besides, of all places in the world where I wouldn't take you, Colombia heads the list. You might try to smuggle back this year's crop of 'Colombian Gold'."

Daniel was driving during this interchange and he did not reply. However for an instant, out of the corner of my eye, I thought I caught a glint of a tear in his. I probably imagined it, yet I did not trust myself to pursue his feelings on this subject because I had my own deception to contain. I worried about Peter and his ingenuous ways, and whether he would somehow sound the alarm to Daniel. But the weekend went the same as always, with no evidence that Daniel's antennae had picked up the fact that he was the center of cloak-and-dagger plans.

On Tuesday, Jason White had the answer he had promised. The Advanced Algebra final would be waived. Therefore our airlift would be Thursday.

My plans clicked into place, with just fifty more hours of this fearful suspense until lift-off.

"I might add," White went on, "that we hope Dan will be back the following Wednesday, when we traditionally clean up the campus for graduation and then have a picnic out at Lakepoint Park."

"I hope he can," I lied.

I thanked him, hung up, and dialed my Thursday clinic. "I've just been handed a subpoena for Thursday. Please reschedule my afternoon patients."

160

Without putting down the phone I called Nate to give him the firm date. We reviewed my plans for meeting at the airport and transporting his people to the country store. There would still be time on Thursday to coach the young men from Nova on the method of capture. The weather forecast called for fair and cool, with no turbulence.

Seventeen

Operation Roc

Life does not prepare you to kidnap your child.
God willing, there will never be for me an encore.

I DID MY USUAL HALF-DAY AT THE CLINIC THAT MORNING. I hoped to occupy my mind before the ordeal ahead, when my plan would congeal into reality. I worked mechanically and, at 12:30 sharp, left for the hospital where Peter headed his research unit. As he crossed the parking lot, he suddenly looked old and tired. His limp, residual from the polio he suffered as a child, was aggravated, and his white hair seemed thinner and more receded.

Wordlessly, we headed west toward Quail's Corners, circled the campus of Pleasant Valley (bypassing the West Dorm driveway, lest Daniel be out early and spot us), and then made sure there was no change around the country crossroads general store that I had selected for the ambush. We continued on out the country road, zigzagging around cornfields, and finally parked the station wagon in the empty lot of the county airport.

"At least they've got good flying weather," said Peter, looking eastward into the azure sky.

We waited silently, growing more nervous as time passed.

"We're expecting a plane from Maine. Any word yet?" I asked the young man sitting at the radio, staring idly out the window.

"That's probably them now," he replied as the radio crackled, and a Down East voice requested permission to land.

A speck in the sky took the form of a Cessna, which circled, touched down at the end of the airstrip, and taxied up the field.

As three young men in jeans approached, my heart did a flip-flop. They were short one; could three handle Daniel? I focused my camera and took their picture. "We are the Greenleafs," I said. "You must be Nate, and I remember you, Vince. Don't you recall? You drove me out to Nova last fall, a century ago."

Vince gave a nod of recognition but wasted no words. The oldest, a man of thirty, acknowledged my identification. "Yes, I'm Nate. And this is Gary," he added, indicating the third young man with curly black hair. The men shook hands all around, and Peter inquired about flying conditions farther east.

We returned to the station wagon and headed back to Quail's Corners. My palms were sweaty and, swerving to avoid a pothole, I almost side-swiped a car that had silently overtaken us to pass on the lonely stretch of country road.

"I guess we should go over the plans again," I said. I was bone-tired and fed up to the point of nausea, but I could not afford to let up. Any small slip and Daniel would be gone again, perhaps forever. "I told you about this little general store. It has a large drive-in area, where students and the locals lounge and drink Cokes. Just sit on the steps like generations of other men and boys, and we'll pull in with Daniel and all his gear. He'll know right away something is amiss, so you have to move fast and surround him. Get in on both sides of him and through the tailgate. I'll be moving in ten seconds."

"Perfect. Just let us take care of him from then on. We've done this sort of thing many times," Nate reassured me.

"Please don't be overconfident with Daniel. He's not like other boys," I cautioned. "As I've told Dr. Franklin and everyone else I've talked to everywhere, Daniel is a high runaway risk. He has wilderness survival skills, and he's extremely intelligent. He's exempt from finals because of high grades— the only kid in his school leaving today instead of next week, yet not wanted back next year. When he was out in the Wind River Range of Wyoming last summer at mountain-climbing school, he saved a man's life."

"Then why are you sending him to Nova?" Gary asked.

"His antisocial behavior," said Peter. "Trouble with the law, breaking and entering, and drugs. My wife thinks there's more we don't know about. The only drug we're really sure about is marijuana, but—"

"Nobody ever knew I was on the hard stuff either," Gary interrupted. "I went through everything I could steal and several thousand dollars' worth of photographic equipment."

"You mean you're one of the, uh, residents?"

"Oh, yeah. I've been at Nova almost two years. After eight years on drugs

I was ready to go back to the straight life. I ran once—well, I just walked away—but decided to walk back."

"What do you expect to do after you, uh, graduate? Go back to photography?"

"No, it's hard to make a living in photography, with all the amateurs. I don't know. My dad's a doctor in Houston. Of course, as a convicted felon, I couldn't get into medical school. I don't know what I'll do."

"How old are you?"

"Twenty-five."

"All those wasted years," I mused. "Doesn't it bother you?"

"In a way it was stupid, but I guess I just wasn't ready to face the world in a normal way. I even hated myself while I did it."

"I get really tired of how people consider it legitimate to screw around until they're 'ready' to start behaving in a civilized fashion. I'm not surprised to hear you say that about hating yourself. One of the residents told me that the common denominator at Nova is self-contempt, but I don't see that in Daniel."

"I'd say that's true, but we keep it pretty well hidden. Dan probably feels that way, too."

We drove in silence, each pursuing his own thoughts. "Daniel seems drawn to people worse than he is, people with no values, no capabilities, no plans, all of which he once had. I don't know what we'll do if he runs at the airport. We have no legal support. We're sending him to Nova against the court's order."

"The judge won't like that," said Gary.

"We don't like what the judge does either," snapped Peter. "Believes Dan's lies, makes excuses for him, and gives him free rein to go on destroying himself."

"How'd he get the judge on his side?"

"He's a con artist, that's how," I said.

"How about when he finds out Dan isn't where he's supposed to be?" Nate asked.

"The judge has directed that Daniel live and work with his uncle in Texas for the summer. By fall, we'll tell him Daniel ran from there," Peter explained.

"Why doesn't the judge want him at Nova?" Nate asked thoughtfully.

"He's convinced Daniel's too nice a kid to associate with all those 'low-life hippies, drug pushers, thieves, rapists, and murderers'."

"Oh, we're not that bad," said Gary, taking mock-umbrage at the epithets.

"We didn't say you were—the judge did. He also said he had served on a panel with two girls who had finished Nova's program, and that Daniel isn't as bad now as they were at the end of their treatment. The trouble is, Daniel looks and sounds misleadingly good, so the judge refuses to believe he's always up to something. That's why I'm telling you, never trust him, and expect the unexpected."

"I gather Dan hasn't any idea about Nova."

"Not quite true. Peter tried to get him to go voluntarily last year. Of course, he'd have none of it, but the mother of one of his friends told me the two boys looked up Nova at the library. He's also been hanging around with another delinquent who spent time out there, one of Nova's failures."

As we approached Quail's Corners, Nate instructed me: "When we get back to the airfield with Daniel, I want you to drive right onto the tarmac, up beside the plane, so that when we open the passenger-side door, Daniel will be just a few feet from the hatch."

"They let you drive the car onto the field?"

"Oh, yes. Now about Daniel, is he heavier than we are?" asked Vince, the odd-job man.

"No," said Peter. "He's about three inches taller than I am, stocky and solid. He's in good condition—earned a letter in soccer and did some track this spring."

"We can manage. I doubt he'll try to run. They always catch on fast that we have them surrounded and are taking them by force."

By then we had reached Quail's Corners, sleepy in the late May sun, and dominated by Pleasant Valley Academy.

In this way, in defiance of the legal establishment, Peter at fifty-six and I at fifty were making a last-ditch effort to stop our child from destroying himself. If all went as scheduled, I would never again need to see Quail's Corners, with its grievous associations. I stopped in front of the store with the cornhusk dolls and a spinning wheel in the window. "Here's a five-dollar bill. Have some Cokes and look natural, but don't throw any cans around. With my luck, the police would pick you up for littering. We should be back here with Daniel in half an hour."

I could feel my heart beat against my chest wall as we circled the school and pulled onto the cinder driveway behind West Dorm. Daniel had been watching for us and, with the help of a classmate, started carrying out armfuls of books, two canvas bags stuffed with clothes, a tennis racquet, a radio/phonograph, tapes, and other paraphernalia. What a parody, I thought, of a loved son finishing a year at prep school in a blaze of glory. Hardly my goal when I kept temperature charts, made love on command, took hormone shots to preserve the shaky pregnancy, and stayed off my feet for eight months to carry him to term. As the boys brought the last load, Daniel's friend reminded him of the beach party the following week.

"I know about the party," I told Daniel, glad to make nervous small talk. To myself I thought, "Just the kind of fun at the end of high school finals that I always wanted for all my dear children!"

"See ya' Wednesday," said Daniel, waving good-bye to his friend from the car window.

"My tongue stuck to the dry roof of my mouth as I asked, "Are you sure this is everything? Any more blankets, clothes in the laundry room? Books somebody may have borrowed?"

"No, this is it," replied my handsome seventeen-year-old son, his beautiful, long, wavy chestnut hair tied back, my son who had already attended three different high schools and was heading to his fourth at Nova.

"This surely is it," I agreed silently, killing the motor once before moving.

"Why are we stopping here?" Daniel asked in front of the cornhusk dolls. Suddenly, three muscular men entered the car and I revved the engine. As predicted, Daniel caught on right away and did not struggle. In my rear-view mirror I could see his hands shake as he put on his "shades"—his one-way silver-mirrored sunglasses—and lit a cigarette they gave him. "What's going on?" he asked, then added, a master at thinking on his feet, "We'll have to go back. I left a book in the lounge."

Having been schooled by years with Daniel to meet his duplicity with disbelief, I replied, "I'll get it next week."

We drove in silence. Nine miles later my heart missed a beat when I saw a closed gate across the concrete access to the runway. Assuming it was locked—nothing ever goes right where Daniel is concerned—I stopped as close to the gate as I could. Vince jumped out, swung the gate wide, and beckoned me to drive through. I did, and he relatched the gate and ran ahead to the plane. The click of the gate behind the car created a measure of security around us, since the fence was high and would take time to climb in the event Daniel should break loose and run.

Nate said to Daniel, "All right, now. You can go quietly, or we can take you. We have handcuffs and we'll use them if we need to. Which will it be?"

"You don't have any right to grab me like this, you bastards!" Daniel vituperated. "I demand my rights! I want to talk to Judge Whittier." I was stunned by the irony of Daniel, who broke the law with contempt when it suited him, but now demanded its protection.

"We're the closest to the law that you'll have where you're going. And keep your voice down. I don't book no shit," said Gary.

"I demand to talk to my dad," Daniel snarled.

"You heard the man. He 'don't book no shit'," I mimicked.

"As soon as you're on the plane you can talk to your dad," said Nate, who was quietly running the operation. "He'll get on after you. We are on the same side as your folks. They asked us to come here to do what needs to be done for you."

Flanked by Gary and Vince, Daniel disappeared into the belly of the Cessna. Nate asked Peter for help with Daniel's belongings. To expedite departure, there was no sorting. Everything went except the books, tennis racquet, and

radio. Peter knew about a camping knife, which was quickly found and removed. Within two minutes, bags of clean and dirty clothes were on the plane.

His strong arms compensating for his bad leg, Peter drew himself up the steep access stairway. I waited alone in the station wagon. Ten minutes later Peter returned, saying that Daniel had asked us to reconsider sending him to Nova. Nothing was really wrong with him, he had claimed. We were unreasonable, and he would be "all right". Daniel tried to drive his usual wedge between Peter and me, but this time Peter had held firm.

As the motor roared and the Cessna taxied to the takeoff strip, Peter opened the gate for me, and I drove off the field. Outside, we rested in the car a few minutes before heading home. We held each other in silence and cried as the plane lifted off, circled, and dwindled to a speck in the sky, north by east. I was both tired and proud. I had choreographed the kidnapping of my son by these tough-loving strangers. Judas-like, I had led my son into a trap intended to save him. He was finally out of our hands and in the hands of the only people with any real understanding of antisocial children and the only skill for changing them that had a prayer of succeeding. Now the burden was Nova's.

Eighteen

"Good Night, Moon."

THE DAY WE KIDNAPPED DANIEL was the longest day of my life. Fear lest one false step jeopardize the entire operation kept me dry in the mouth and wet under the arms. But finally the Cessna took off with Daniel and, wrung out from the experience, we drove home in silence. Yet, the exhaustion was like the exhaustion following labor and childbirth, when the work is done and the prize sleeps in your arms. Our horror was over, and I no longer had to be tormented by fears and nightmares of Daniel running through the cornfields. I could turn my mind to other things and catch up on life at home, trusting the people in Maine to start working their miracle on our enraged, duped son.

We had no reason to tell the younger boys what had happened. Like the court and Pleasant Valley, Daniel's brothers could just be allowed to assume that Daniel had gone straight to Texas. The fewer privy to such a secret, the better it is kept.

I dropped Peter off at his car in the hospital parking lot, saw one of my patients on the ward, wrote orders for her weekend pass, and picked up pizza on the way home. It was a perfect night for pizza. The little boys were acting like brothers—Cain and Abel, that is—with "he kicked me" and "he punched me first" routines.

"Boys, I don't care who gets the last piece! Divide it or nobody gets any. Just stop this bickering! When can we expect a little maturity? Check the schedule for whose night it is to load the dishwasher! You're giving me a headache!"

I went upstairs to call Aletheia and tell her that Operation Roc had gone as planned. "Until you've kidnapped your child, you haven't drunk your cup," I told her.

She gently corrected me. "No, you really haven't walked the walk until you watch your child coming cold turkey off heroin beside the Christmas tree."

I promised to call again the next day to give her the details. I hung up and lay back on the bed watching the moon as it rose full and orange just as it had done two hours earlier over the forests of Maine.

It paled to a lemon, then cream, then white just like the moonrises Daniel and I had watched the summer he was two and a half. From his bedroom window, we were able to see the moon untangle its way up through the branches of the huge old sycamore tree, bathing the hillside in silver light.

"Moon lives in sycamore tree," Daniel would tell me.

"Yes, I can see that she does."

"Say 'good night' to Moon," he would say, meaning, "I want to go outside."

Who could sleep in such radiance?

"All right. For a few minutes, before I sing your lullaby and tuck you in."

And so we would walk on the hillside, and he would wave and say, "Good night, Moon."

"Are you ready to go in now?"

"No, wait. … All 'wite. Now Moon say, 'Good night, boy!'"

"Did she really? I couldn't hear. My ears must be too old."

"Now go in. Sing 'Fourteen Angels'."

And where had those fourteen angels gone? Were they asleep themselves, or had they died, or just repudiated their watch over Daniel?

❦

170

Nineteen

Greenleaf Waterloo

WITH THE LITTLE BOYS IN BED, I changed into my lilac duster with pink cherry blossoms, realizing as I did, that in recent weeks I had been wearing mostly drab, colorless clothes.

I went down to talk to Peter. Drained, he had fallen asleep in front of the news. But we needed to plan the trip to Colombia. The first leg would be by bus to Nuevo Laredo.

I slept fitfully, and through my dreams wandered a runaway seventeen-year-old, who no longer ran through cornfields but led me, finally, over a cliff. Mocking laughter mingled with the ringing of the alarm.

That morning I got a note off to Dr. Franklin with praise for his operation, a last warning about Daniel's running potential, and a substantial check for the first three months of treatment.

It was not that I had no pressing work. There was catching up to do, a mountain of things I had let slide over the past month, professional paperwork, promises to keep to the children, preparations for the trip. But first I gave myself a gift of time. I rewarded myself that entire Friday—with the little boys in school—with the kind of satisfying job I save for myself, a job whose results one sees on the spot, a simple finite job with no ambiguity about when it's done and no question that it could have been done differently or better, an easy, routine, mechanical job without incessant decision-making and judgment calls, with an immediate sense of accomplishment, a job too good to waste on an unappreciative child who would prefer to be playing.

Such a job was play for me. I spent the day cleaning mud from leftover slate roofing shingles I had found in the high grass and weeds from before we bought the house. After drying the slates in the wind and sun, I stored them in the garage for later roof repairs. And every few minutes, whenever I felt tired, I would lie down on a blanket in the shade and doze off. Later that afternoon Aletheia came over and fixed Viennese coffee and nurtured me. She offered to drive the four of us and our luggage to the bus station when trip time came in another ten days.

I thanked her for being my mother.

By Saturday I felt the manic impetus of success and prepared to start re-deeming held-over promises. Unlike Daniel whose taste favored gutsy power-craft, Jonathan and I loved the whoosh of water on the keel of a sailboat. Walking a tightrope between caution and confidence, and trying not to let my expe-riences with Daniel color my judgment about Jonathan, I made a decision. "Come on, Jon," I said. "Let's go to Penney's and order that Sunfish. It should be here by the time we get back, and you can use it the rest of the summer."

Next I tackled one other leftover job relative to Daniel, trying to seal in advance any leaks that might alert the judge to Daniel's whereabouts. To avoid having Peter, with his ineptitude for duplicity, taken off guard at work by a call from either the judge or Mr. Dunn, I needed to alert Peter's secre-tary, who might pick up such a call. And so, to cover that base, I sent her a note asking her, in the event of a call from Juvenile Court, to say that Peter was out of the office, even if he should be sitting right there doing nothing. She was also to say that he would not be back for the rest of the day. Then she should notify me.

I resented the dilemma that confronted me of either giving her some kind of explanation for a strange request like that or letting her think I was trying to shield my child from the long arm of the law. I ended the note: "It may not sound like it, but this is part of our overall effort to help our son by more stringent methods than the juvenile court will permit." With a delinquent child, your life becomes an open book.

Our work-and-vacation trip to South America finally began. I liked the sense of vast distance evoked by travel by surface for several days. It felt like being rocked in a cradle just to be carried passively in the womb of the bus as we slipped farther and farther south through Missouri and Arkansas and Texas. During the years since I last traveled cross-country by bus, a new formula had been introduced into the canned welcome from each new driver. We were reminded that drug use was prohibited on the bus, including marijuana.

As we rode down the Pan-American Highway beyond Mexico, we saw smoking volcanoes and mahogany that had thus far miraculously escaped the lumberman's saw. We met English-speaking locals on the bus, and were

even searched by the military. We drank tropical fruit *batidos* (ice cream drinks), and watched women washing clothes and children playing in the Rio Guayule. I even saw an iguana swimming across the river, its sinuous reptilian motion unchanged since the Jurassic period. Fascinated, open-mouthed, almost hypnotized, I forgot the camera hanging in front of me—and missed my chance to photograph that enormous lizard.

When I thought of Daniel, I employed a device I had found helpful in difficult situations. When a cherished goal creeps slowly toward me although I wish it would race, or, conversely, when something dreaded is crawling toward me but at least has an end point, then I calculate its progress in percentages. With Nova having projected nine to fifteen months of work with their residents, and knowing Daniel would never surprise us by being easier than feared, I estimated five hundred days for his treatment. Thus, for every five days I let myself think of Daniel as one percentage point on the way to being cured. We already stood at two percent and were moving toward three, small, admittedly, but not infinitesimal. It was obsessional, magical thinking, but at least something to clutch and from which to derive comfort and hope without doing me or anyone else any harm.

I sent Daniel a post card and a letter. I reminded him that a year earlier I had wanted him to go to Nova and be cured in time to return and finish high school with his class. It was too late for that, but his treatment had to take precedence over his education.

From Guatemala City to Panama City we rode on a revamped Greyhound with air conditioning working part of the time. Nights we disembarked and had adventures in tiny hotels. In Guatemala City we visited the zoo to see animals and birds unique to Central America.

In Panama City we spent three delightful days with César, our medical school classmate, and his family. We joked that the bunting they had put up for President Jimmy Carter's visit was for us.

I felt like a cork that had been forcibly submerged for longer than I could remember but had finally been released. My sons' merry laughter at our host's stream of jokes made me realize what a dry spell for merriment we had all weathered. We took the world's only seventy-five minute transcontinental train ride along the canal where the sun rises in the Pacific and sets in the Atlantic and watched iridescent butterflies as large as my hand float in the jungle.

There was no time to take coastal shipping to South America as we had planned, since the medical congress was already assembling. And so we agreed for Peter to speak at César's medical school on our return, and reluctantly

boarded a plane, ascended, and leveled off at Bogota, world's highest capital, where we were met with Colombian coffee, courtesy of the growers.

Bogota, too, was a lesson for the boys that the world is more than Evanston. Mothers with babies suspended from their backs in hand-loomed shawls had no more permanent address than the thick, deeply recessed carved mahogany doorways of beautiful centuries-old churches. Old beggars showed the ravages of disease, including the healed finger and foot stumps of leprosy. With the dubious distinction of leading the world in street crime, Bogota's shame was and is its ten thousand *gaminos*—homeless boys as young as eight who sleep in doorways and live by their wits, and little girls who live by their bodies.

As the Congress was winding down, the boys and I visited the pre-Colombian gold artifacts kept in a museum behind bank vault doors. We joined a wives' tour to an orchid farm while Peter attended sessions. In the evening, as we were eating guacamole in the hospitality suite of one of the drug firms, Peter dropped the bombshell: "Nova called me," he said in a worried tone. "I tried to get back to them, but the operator said there would be a two-hour wait. I got the message just before my paper."

"You know what that means, don't you? He's run. They wouldn't call down here for anything less."

"Maybe it's something else," said Pollyanna Peter. "There you go again with your pessimism. They said they called families once a month."

"Not pessimism—realism. They call families, yes, but not in South America."

"I'll try the call in the morning," Peter said.

"I'll try it now," I replied. Using a plea about a sick child, I was able to talk my way through a bilingual operator, who got me an emergency line to Nova, but a Mr. Westover, the name Peter had been given, had left for the night, and no one else could or would talk.

Even that evening I let cruel hope tempt me when I knew I should not let myself be tempted. Maybe this really is that monthly call they make to the family after all, I lied to myself. Nietzsche had called hope "the worst of all evils, for it prolongs the torment of men".

In the morning, one of the Congress' bilingual hostesses demanded a telephone line for an emergency for *"la señora"* and got me through to Westover, the director of the unit to which Daniel had been assigned. He explained that a door normally locked had been open for five minutes, and during that time Daniel had run. They had gone in pursuit but were too late. The Maine troopers had been notified. Westover was sorry. "In all likelihood he'll be found and brought back," he concluded. "Ninety percent of our runaways are returned. Dan's description has been circulated nationwide. We'll send a plane anywhere in the country as soon as he's detained," he promised.

"But nobody will detain him once they get word from Illinois," I whimpered. "Don't you realize that Daniel went to Nova without court sanction, in fact expressly against court order? I've explained this over and over. Nobody in Illinois will help us, and if anybody picks up Daniel, he'll demand that they contact Illinois."

Westover acted as if he had never heard of any of this before. It had always been my experience that if three people needed to be briefed about Daniel, communications always broke down before the third.

Westover urged me to call him again soon for an update, since he had no way to reach us once we left Bogota. I did not tell him that I had no intention of calling. How many punctured balloons could I endure? "Worse than despair, worse than the bitterness of death, is hope," Shelley had written, and I did not intend to live any longer with hope for something I could not influence.

After the call, I stumbled over to an unused passageway partitioned off behind the congress display area, dropped into a chair, and succumbed to bitter crying. I would get up and pace, then sit back and sob, then walk dazedly around the cluttered area. One of the congress' bilingual facilitators found me clutching my wadded-up Kleenex and asked if she could help. And, considerably more easily than if I had known her, I mumbled that we had had bad news about a son who had given us nothing but trouble and heartache for years. She patted my shoulder and said, "These are hard times we're living in. I have a brother who's been doing that to our parents. It's the same story. You hear it over and over. Let me get you some coffee."

"I'd appreciate that." And when she brought the coffee, she looked at an open window as if questioning whether she could trust me alone three stories up. That lovely stranger offered to get help for me when she had to leave, but I promised I'd be all right and not do anything foolish.

As I sat there, I prayed. "If You have any control over these things, please just let Daniel die and get it over with. Let our next word be that we have to identify the body, so I can wake up from this nightmare. Let him die so I can survive."

As soon as I could think beyond my grief, I was consumed with bitterness about Nova. How many people and how many times had I warned? After all that, someone's time was too valuable to follow Nova's own rules. They just left a door open. If they had had to leave the door open, why couldn't it have been for a resident less cunning or with a judge less obdurate? It had taken Daniel fewer days to run, seventeen, than it had taken me to get him there. Was it really worth sinking any more time and thought, energy and money, but mostly emotion, down the Daniel rat-hole? When I saw the ragged, dirty *gaminos* of Bogota, I had asked myself how many of them might have been saved if the resources Daniel had engulfed had been diverted to them?

Our destinies hinge on very small things. In this cosmic shell game of life, I found it almost inconceivable that such a chance of fate as an open door would keep my child from ever becoming human. "A tale told by an idiot."

There was no point in getting Peter out of his session, and so it was not until the end of the morning that I told him how Nova had snatched defeat from the jaws of victory. We considered flying home, but there was nothing to be gained. No one knew where Daniel might be. I guessed that he either slipped over the border into Canada or else got himself to Wyoming for the ranch job offered that previous summer, a thousand years earlier, when he had brought the doctor for the diabetic climbing instructor. Was there any point in calling contacts and contacts of contacts? We were in agreement, for once, that we should not hasten our return for these remote possibilities, since, even if they should lead us to Daniel, they would not implement his return to Nova.

"Maybe if we had gotten him there last summer," I said to Peter, "it would have made all the difference—that sloppy attendant might not have been working, and Daniel might have stayed long enough to engage. Maybe if he had only been average. Maybe, maybe, maybe . . .

"For my own sanity, I intend to try as hard as I can to write him off, to think of him not only as dead but as never having existed. I will not live with the exquisite torture of hope, not to mention the exhaustion of endless defeats. I will not call Westover back."

But Peter said, "I will go on trying to help Daniel. I will call Westover from Panama."

And then, as we do, in our pain, I turned on Peter and attacked. "Great to talk about what you're *going* to do! *I'm* the one who's been *doing* it. And *doing* it and *doing* it and *doing* it! *You* received a call yesterday, but *I* called them twice."

"I'll call from César's," Peter replied, "but I don't see any reason to hurry home. We'll leave Bogota tomorrow as planned, and I'll give a talk to César's students on Monday."

At the final banquet that night I endured another quarter turn of the knife in my wound. A lovely older doctor's wife made a point to come up to me to say, "I've been noticing your boys—you have such a nice family! I'm sure they'll do very well. You remind me of how we used to travel with our two daughters. We had them in Paris, and the older one said, 'Someday I'm going to study at the Sorbonne' and we never thought any more of it, but by golly, she did! The other one adopted an orphan when she was in the Peace Corps in Brazil. You never know what they see that'll influence them. The love you give your children comes back in later years."

"I'm glad it did for you. There seem to be so many children who don't

love their parents these days." And I excused myself before tears brimmed over my eyelids.

We spent two days with César and his wife Ida and actually did some sightseeing. But the laughter had gone out, at least for us. Peter gave his lecture, which the students loved, including his illustrative anecdotes, which had to cross not only language but also cultural barriers. Peter and I were dreadful guests but Jonathan and David, who did not comprehend the immensity of the Nova failure, kept laughing at César's jokes.

Leaving Panama City and wending our sad way northward, I found myself trying to bargain with God in the same way that patients do who face death from cancer. "I beg You to save Daniel. It wouldn't be hard for You," I wheedled. "Oh, all right, I can see that it's not fair to make distinctions between kids with loving families who intercede for them and those without, but what has fairness got to do with anything? Besides, it isn't as if I'm just sitting on my—well, just asking for a miracle. You might notice how hard I've tried on my own. Couldn't You just give me some credit and take that into consideration?

"You probably ask, 'Why should I do anything for you? What have you done for Me?' And I grant you my faith hasn't been the greatest, and I admit I'm praying because it's all I have left. But if You'll rewrite his script, I promise I'll work harder at it. I'll come back to You."

But just like the answer to the cancer patients, the answer I learned when Westover told Peter that Nova hadn't found Daniel was a resounding 'NO!' God had no compassion to waste on my child or me. "The gods heed not our wishes in the fortune of our lives."

As we retraced our steps northward, for a few brief days I managed to persuade myself that my involvement with Daniel was truly at an end—that there was no point in searching for him and that he would never reappear. During that phase I thought of us as a family of four and enjoyed a blessed numbness. Then the rage returned—rage against Daniel, against Judge Whittier, against fate, against my father for the utterly unintentional evil he had done me in the form of the seed I carried and passed on to my first surviving child. But most of all, the rage that tore me apart was directed against Nova for delivering this Pyrrhic defeat. How could it have been anything but mindless arrogance that they had ignored my repeated warnings about Daniel as nothing but the ranting of a guilty mother? Whether or not they accepted my

assertion that Daniel was completely unprincipled, how could anyone justify one worker not bothering to honor the rules about locked doors long enough for one resident, any resident, to escape? And because Murphy is correct that all tolerances are additive in the wrong direction, my son, soon to be legally an adult, had once more slipped through the lattices of the system and the odds had risen sharply against his ever becoming a truly fulfilled human being. Chance holds all the cards.

As we pushed north, we made just one change from what the trip would normally have entailed. We skipped something that would otherwise have been included under my when-you're-close-see-it-because-who-knows-when-you'll-be-in-this-part-of-the-world-again rule: a side trip to one of the Mayan ruins in Guatemala or Honduras. I would have liked for Jonathan and David to see one, just as Daniel and Peter and I had visited Chichen Itza and Uxmal following a meeting in Mexico City nine years earlier. But with the failure of our salvage efforts we felt the fatigue like no other that follows a massive effort ending in defeat. We skipped the Mayan spur.

Using the hiatus in real time, which would start clocking again when our everyday lives resumed in Evanston, I turned my attention to clarifying my feelings about Daniel, in contrast to planning to save him. Persuaded, at least for a few days, that I would do nothing further about Daniel, I nevertheless had to grapple with my conscience for no longer loving him, or caring what happened to him, or at least trying not to. I told myself I could not let him go on battering me; the pain was too great.

A question on which I gnawed was, "What love do you owe someone for no reason other than having borne him?" I had experienced two blighted pregnancies (empty maternal sacs with no growing embryo). While thinking I carried a real child in rudimentary form, I loved each one, only to learn that I had loved a mirage. Was it like this with Daniel? I had loved him much longer, those years in which he looked like—and I had assumed him to be—a human being with potential for human emotions, despite the fact that I had come to believe that from the moment of conception, he apparently lacked some basic human quality. Having borne him and thought of him as fully human and having cherished him, then having come to think of him as deficient in some ingredient of humanity, surely I need not hold myself to those impossible love standards of motherhood. During the homeward trip my feelings for Daniel had changed into that kind of hatred that can result only from unrequited, betrayed, devastated love.

But mingled in all this tangle of reflections was a new and growing realization that in all likelihood Daniel had no control over his deficiency in humanity. I realized more clearly than before, that he must have carried that genetic programming from all eternity. But I, likewise through no credit to myself,

was human, able to feel love and hate, joy and heartache. My selfhood must not be allowed to depend on Daniel's fate, I told myself, and to care for myself I had to distance myself from Daniel. If Daniel was not responsible for his lack of humanity, neither was I for my humanity. I was a child of the universe, in need of gentle handling.

I had known for many years that for me anger and rage are easier emotions to live with than impotent love. But once more, as I moved into the radius of home, I changed again, resolved that if the possibility arose, I would try again to implement a return of Daniel to Nova or anywhere else that might restore him to the human race.

I amended my silent prayer: "Please help my son and my sons, my husband, and myself. Please."

Twenty

Unholy Alliance of the Establishment and the Young

WE LIMPED HOME ON JULY 5, with sprung luggage hinges and broken camera straps, crushed under the weight of our defeat. We were met with four laundry baskets full of accumulated mail, including Pleasant Valley's form rejection of Daniel. There was also a bulletin from the kennel that had been housing Whitepaw (whose kitheth thmelled like dead fitheth), to the effect that the tumor on her leg, formerly thought benign, was abraded, infected and malignant, and should come off immediately. But the veterinarian had not removed it. Instead, she had dallied when time was of the essence, and for what? To ask us whether we wanted the cancer left on Whitepaw? Fortunately, Whitepaw came through her surgery swimmingly, and, at the appropriate time, I taught David how to remove the sutures.

Most alarming, we discovered an attempted break-in through the basement door in our absence. The broken off doorknob had rolled across the concrete floor. A storm window was broken but the inside window was intact. With almost no additional effort, the intruder could have entered. Why hadn't he?

The next day I turned my attention to trying to locate Daniel, with the rather forlorn plan that if I knew where to send Nate with the plane, he might be recaptured.

First I reversed my decision never again to contact Westover. As I dialed, I tried not to let myself be seduced by the hope that meanwhile the Maine police or someone had found and returned Daniel. "Hope, fortune's cheating lottery where for one prize a hundred blanks there be," Cowley wrote in the seventeenth century. What had been Cowley's hundred disappointments?

No luck at Nova.

I then tried to call Dennis, the mountain-climbing school instructor, to ask for help in tracking down the Wyoming Ranch, though I should have known that Daniel would never follow a year-old lead. Unable to reach Dennis, I decided to ask Jason White to provide details on Pleasant Valley's rejection to serve as documentation for future moves. He wasn't at the school, so my call was switched to the headmaster. Recognizing my name, Luke Applegate did not give me time to ask but immediately responded to his own guess as to why I was calling: "Dr. Greenleaf, I don't know where Daniel is now, but the last I heard he was in some kind of court-sponsored home for runaways."

I gasped, "You mean he's in Illinois?"

"Well, of course, where would he be? You people put him in that center for drug addicts and took off for South America. He stayed with one kid after another he knew from here, until he wore out his welcome with each family. Then he came back to the school, looking for a friendly face. He told his horror story about being abducted to a place for rapists and murderers where he was in fear of his life. I can see how he must have felt, being kidnapped! How could you do such a thing?"

"What do you *mean*, 'how could we *do* such a thing?' How could we do *what*? Send him where his psychiatrist said he should have gone in the first place, since he knew of no schools for smart psychopaths? Someplace with a prayer that they could confine him long enough to get a handle on him? Not give him *carte blanche* to prowl the Greater Chicago area, the way Pleasant Valley did? How could we do what, exactly, now that you people have failed with him, and Jason White sees him 'going, little by little, down the drain' and you are exercising your option to unload him?

"I resent your acting as if we're the guilty ones for trying to treat his antisocial personality. And speaking of failing with Daniel, you can conjugate the verb 'to fail' around him—in the perfect tense. Pleasant Valley has failed—and wasted eight months in the process. Dr. Perez has failed, not only with Daniel but with Judge Whittier as well. Judge Whittier and Juvenile Court have failed. His father and I have failed, again, but at least we tried for the nth time. Daniel has failed. We have all failed, and now Nova has failed because their time was too valuable to waste locking him in. . . . So what do you know about his whereabouts?"

"I think he finally went to the Juvenile Court to complain, and they put him

182

in a place called 'Safehouse' for runaways because the last anybody heard, you were gadding around South America."

"I resent your 'poor, abused, helpless, neglected kid' tone. It's none of your business, but it so happens that my husband was working in Bogota, giving a paper on his research to the leaders in endocrinology in this hemisphere. We seized the chance, while Daniel was presumably being held in one place and treatment begun, after years of his consuming 98 percent of our time, energy, thought—stealing it from his brothers—to give them a kind of education you can't get in schools. We've done this for years for Daniel, too. We included him in the past, and God knows we wanted to continue to, but his disorder showed he couldn't use it and needed treatment instead.

"Now you, having washed your hands of him, eight months after I told White that Pleasant Valley should reject him because he couldn't use it, have the gall to sympathize with him. That's a new height in irony. Here's another kind of first—a sociopath running to the court to demand protection from the treatment his behavior is crying for. Anyway, that's great news about Safehouse. Let *them* take care of him, then. What I really called for was to ask the reasons for your decision to dump Daniel."

"We call it 'not accepting him back'."

"I don't give a shit for your euphemism. Don't worry—I won't beg you to reconsider."

Applegate was no more specific than the others. "Other boys were afraid of him, for reasons I was never clear about. You know, others look up to seniors, and it was the consensus here that he wouldn't make it through the senior year. It would have been a waste of your money."

That final remark was a match into a munitions dump. "A waste of money?" I screamed. "When have we ever quibbled about money? What do you suppose it cost to charter a plane from Maine? What about *time*? What about *Daniel*? We hoped to get him straightened out, regardless of expense, and Nova is a hell of a lot more expensive than Pleasant Valley, and now Nova goes on the list of those that have failed with Dan. I don't see how we can ever make up this last terrible loss."

And so Daniel had run to the law to cry foul on us. For the first time since our return to Evanston, I cried.

The court having taken Daniel to its bosom, I sat back to await developments. With Daniel, you never have long to wait. That very Sunday night, as we were all watching *Sixty Minutes,* a young barbarian stormed the house. Throwing his body with each step, Daniel was suddenly in our midst. His arm in a sling, he was instantly getting out clothes, talking to Peter, and swearing at me.

Peter asked why he had scuttled our efforts to get him helped at Nova, and he replied, "They were *rough* there! They didn't like me. They might have killed me!"

183

As he talked to Peter, I did the only thing I could think of. I called the local police to ask them to hold him for Nova to pick up. Like all the rest, this was an exercise in futility. When the police learned from Daniel that he was free to come and go from Safehouse where the court had placed him, they could not and would not interfere.

As he left, I screamed, "Get out of my house! Get out of my life!" and ran crying upstairs. I pulled out my collection of medication samples and selected a packet of six Mellaril tablets at the highest strength, 200 milligrams, enough to be fatal to someone naïve to the chemical. I sat on our bed, staring at this major tranquilizer, sobbing at intervals. I knew even then a suicide attempt would be pointless and stupid and would lower my professional stature. Peter would have found me, taken me to the emergency suite, and had my stomach pumped.

But during the scene with Daniel, Jonathan had been watching me out of the corner of his eye and soon followed me to the bedroom. He came in when I ignored his knock, put one arm around my shoulder, gently took the Mellarils with the other hand, and said, "There, now, Mom, it'll be all right."

As he comforted me and I cried, I felt ashamed that even for a moment I had let the anguish from Daniel cause me to forget the riches I had in Jonathan and David, and, during moments of no impending crisis about Daniel, in Peter.

When I returned downstairs in the wake of the tornado, Peter and I moved farther apart in the alienation we were developing over Daniel. I tried to reintroduce my perspective of sanity, but Peter saw my stand as vindictive, prejudiced against giving Daniel a fair hearing and the benefit of the doubt. Instead of comforting one another, Peter and I rapidly escalated to the recrimination-hurling stage.

"And another thing. That was a damned-fool thing you did to let him take that mountain-climbing rope. What'd you do that for?" I demanded, referring to the collection of clothes and stuff he took back to Safehouse.

"What difference does it make if he takes it?"

"Why should he do anything—just anything he chooses—after all he's put us through? Why can't you ever take a stand and stop him from *anything*? Why can't you ever say 'no' if for no other reason than to let him experience you as somebody he can't run over like a juggernaut? The longer he goes on in life without experiencing a stone wall he can't smash through, the harder it'll be for him if he ever has to tolerate the frustration the world dishes out with such a generous ladle. I don't think you ought to go along with everything!"

"But the rope is his."

"What does 'his' mean? One way or another, we bought the rope, and that is as good a reason as any to keep it from him. If he didn't buy it out of allowance, maybe he bought it out of something else."

"What do you mean by that?"

"Pushing drugs, for example."

"That's just your opinion."

"It sure as hell isn't Queen Elizabeth's!"

"You're always so suspicious!"

"And you're so gullible! Another thing. What about that sling?"

Peter, it turned out, had already heard from Blue Cross that Daniel's shoulder had been broken, from, according to Daniel, a little scuffle with friends. The arm had been pinned under anesthesia, and the pin would need to be removed later.

Our verbal broadsides finally trailed off because both of us were crying without tears for our son, who did not know enough to cry for himself.

While I waited to let the court make its next move concerning "abused" Daniel, a call came from Safehouse requesting that we come down to visit. I declined, but Peter went. He reported that he had found it a clean house in a very bad neighborhood. It was supported by United Appeal and federal funds, run by social workers, and oriented toward placement of the transients in its care. The young people, unfortunately including Daniel, were completely free to come and go within the hours of closing for the night, and were expected to take rotation of the household tasks. Of course Daniel's case was different—what else?—in that the judge had sent him.

The young woman in charge told Peter that Daniel's behavior had been acceptable and that he had been performing assigned chores. She added that she tried to rotate jobs fairly, and not gauge them to the background of the young person and what he or she knew how to do. This required that she teach some of her charges which end of the mop to use on the floor. And this was the kind of education Daniel's conduct had brought him to.

When I spoke for the last time to Dr. Franklin at Nova, he said simply, "I'm sorry."

"I know you are," I told him. A good man he was, but unable to control his employees. He denied Daniel's claim of having been in physical danger at Nova, and I (but not Peter) believed the doctor. I asked Dr. Franklin for a report of Daniel's time at Nova for future reference. In due time I received a copy of the note sent to Dr. Franklin by Paul Westover to close out Daniel's case. It was not in time to show Judge Whittier, nor would it have helped. His mind had closed almost a year earlier.

Dear Dr. Franklin:

This is a summary of what occurred during Daniel Greenleaf's stay at Nova Three. This material is a composite of written and oral reports from the various staff members and residents.

Dan projected a lazy, apathetic and hateful attitude as soon as he arrived. He made it clear right from the start that he did not like being here and had no intention of staying. Every person who had contact with him said that he tried to project himself as having a tough guy image and was very reluctant to take an honest and objective look at what other people were pointing out.

He rebelled against almost everyone and everything in the program. This was his way of saying that he did not really have to be here and this mode of therapy was not designed for him, that he was different from the other residents here and did not have the problems that the other residents had. This came out in a very condescending attitude and saying that he was better than everyone else. People saw him as very arrogant and cocky. There was definitely a great deal of hostility in his manner of relating to others.

In the few short weeks that Dan was here, he never really gave the program a fair chance and would not really become involved in the functions of the program. Dan would not get involved on a regular basis in morning meetings, seminars, group therapy sessions, etc. He would not relate on his own to other individuals. Any participation came only when the staff would put him on the spot, and he had no choice but to participate. Dan was confronted during his stay here in a number of group therapy sessions. Some of the different things that we tried to get Dan to relate to were his need to uphold his image of being a 'cool' and tough guy, and why he could not let down his defenses so that people could see him as he really was.

Some of his inadequate feelings related to how badly he really felt about his size. Indications of this were feelings that he had to compete with other men, and also feelings that he could not be accepted by women. Dan also had a group and a general meeting run for him where he was confronted heavily on his racial prejudices. It was pointed out that by degrading and looking down on other people, he could not give himself a real sense of feeling better about himself as a person.

Almost all of what Dan was confronted about in groups stemmed from the arrogant attitude that all others saw in him daily during his functioning in the house. We dealt with Dan

regularly in verbal reprimands, pointing out this attitude, his prob-
lems and mistakes.

Although his attitude was one that we see in many new resi-
dents, in Dan's case, he seemed to carry it much further than most.
Overall, Dan did really nothing for himself in his short stay here,
except that he found out that other people saw through his games
and image, and they did not accept him for it.

<div style="text-align: right">

Paul Westover
Staff, Nova Three

</div>

Several days later the expected call came for our command appearance in the judge's chambers. We took Stanley Hopewell, the lawyer I had briefed months earlier, but he was correct when he warned that it was unlikely he could do anything to help. Daniel arrived with his lawyer, a young man with long, wiry reddish-blonde hair in a pony tail, a man who evidently wished to help emancipate the young and did his part by contributing his services to Safehouse and its residents. He was the type Aletheia called "camp followers of the young". I called him their Pied Piper.

The judge treated Peter and me like bad children. "Dr. Greenleaf," he began, peering over his glasses at me, "I cannot believe that you, an educated person, would do such a stupid thing. What you did was in defiance of this court."

"Your Honor, my concern for my son outweighs my respect for the court," I replied.

Nothing new came out of the discussion. Judge Whittier called me a "very stubborn and highly opinionated woman", and I sat silent.

To no one's surprise, the judge would not hear of a return to Nova but ruled that Daniel should go to his Uncle James in Texas, as we had discussed earlier. It was left that the juvenile authorities there would be informed of Daniel's probationary status, but they never were. I asked once more that the judge require Daniel to pay the Nature Center his share of damages and theft. The judge told Daniel to do so, Peter and I nagged, and finally Daniel took them a check.

While we were making arrangements and plans, Judge Whittier sent Daniel back to the Martins' home with Phil, his mother, and his sister. Peter bought the bus ticket to Texas.

Before Daniel was to leave, Peter suggested that out of appreciation for Mrs. Martin's efforts, we take their family and Daniel out to dinner at a small German restaurant. Phil, Daniel, and Peter ate in silence, while I nervously made small talk with Mrs. Martin and her daughter, a bright junior in college, majoring in biology. In the parking lot I said good-bye to Daniel, who stuck out his lower lip and kissed Phil's sister good-bye. I have no idea what was going on there. Daniel lost a couple days getting to Texas.

The old demon hope nudged me and whispered, "Maybe someday a sensitive and intelligent girl will love him. She might be able to save him, if he can return her love." But I answered the demon, "More likely, he would destroy her love and her, too."

As we drove home, I compared this small, uncomfortable dinner with what I had dreamed for my son: graduating with high honors from a public high school; then being feted in the company of friends he would enjoy for a lifetime, and relatives who would share our pride; and finally leaving home for an academically challenging college, a socially contributing future, and a warm family of his own.

By a strange quirk, that summer when I was unable to save my son, a father asked for my help with his son, Tony, who sounded much like Daniel, a young man whom, as it turned out, I never saw. I never saw his father either, but as the father told his story on the telephone, I recognized it, having heard it from Aletheia, who knew the family. This adopted only child had been discovered at sixteen to be addicted. His mother finally gave up the struggle to get him back on track, but his father pursued one treatment after another, including one in Florida on the same model that Ad Astra later developed in Evanston. The father was, in fact, the very person who brought the concept back and worked with Dr. Hyatt in its realization in our area. Ad Astra, however, had not proven to be the answer for Tony, and more recently I have seen in the newspapers that it has had to fold because of new patients' rights legislation that prevented it from exercising even a modicum of control over its young charges. Having explored the options with Tony's father, I finally wangled a psychiatric bed, which were tight, and called the father back with word of my success, but by then Dr. Hyatt had also pried loose a bed in his hospital. (It was a summer of full psychiatric wards in Cook County.) "You've been very kind, said Tony's father. "Doctors rarely invest time and trouble for a patient they haven't even seen yet."

"When Tony gets out," I said, "You might consider a place in Maine—"

The day after Daniel left for Texas, a call came from a young woman who identified herself as Mary Kovach, a sociology major working for the summer for a federally-funded study on the effectiveness of crash pads for runaways, juvenile shelters like Safehouse. She asked for an appointment to interview me concerning our experiences with Daniel's time there. I agreed, but only with the understanding that I would have an opportunity to make my own statement about Safehouse and other similar beacons for out-of-control children to run to, and her promise that my statement would be included in her report.

On the appointed afternoon I set up chairs under the trees. She asked the expected questions, to which I gave the unexpected answers. Daniel had not

run from home but from a facility medically advised for his correction. Daniel had run to the judge to protect him from his parents' efforts on his behalf.

Mary maintained her deadpan expression as I went on to the unwelcome answers that Daniel was not only no better for his Safehouse experience, but worse for having been encouraged and supported in his defiance.

I explained how Daniel had exploited the judicial system to facilitate his own antisocial system in the interest of his personal ecology. I accused the legal structure of being stacked in favor of adolescents with their impulse-ridden nervous systems and their immature judgments, an arrangement implying that children have to be protected from parents who discipline them. I admitted that there are children who run from unbearable situations. But I maintained there are also Daniels who split when asked to carry out the garbage, clean their rooms, go to school, stay away from chemicals, make a future for their lives. I deplored perpetuating our out-of-control society by listening to adolescents as if they were peers of adults, taking seriously their demands for unlimited freedom, and supporting their coping by running. The first assumption, I insisted, should be that the parent is justified, and the burden of proof on the child's side. I complained bitterly that once again I had asked the juvenile system for bread for my son but it had given me a stone.

Sounding like someone without children and closer in age to adolescents than parents, Mary asked if she might call for a follow-up questionnaire in six weeks. She seemed glad to get away, and I never heard from her again, nor did I see a copy of the report she had promised to send me.

Twenty-one

Expanding Ripples in Daniel's Pond

WITH MY ANTISOCIAL SON now his Uncle James's responsibility (who could tell how fleeting the moment?) I snatched the chance to address my mirror-image problem: the legitimate medical and social needs of my aging antisocial father. I flew to Florida.

Since my mother's death, I had monitored by semiannual visits the intertwining signs of Alzheimer's Disease and his lifelong characterologic disorder. He was losing his cunning and shrewdness, and neglecting himself and his house. As a child, I had been frightened by his unpredictable and irrational rages, and his sister, my Aunt Gretchen, had told me he once held a gun to my infant head to bend my mother to his will. As irascible an old curmudgeon as ever, his rage reactions made visiting him like touring a volcano.

Return to my father's turf was returning to the emotional world of my childhood. It rekindled all the old anxiety over what his next outburst would be, from which I had consciously emancipated myself by first securing an education that would make me self-sufficient and then finding a man who was unimpeachable as a husband. I did not fall into the trap the girls I knew in high school fell into: escaping a father by getting pregnant and married, in that order, and thereby falling from the proverbial frying pan into the fire. My adult world no longer included my father's, but whenever I visited him, I re-experienced all the upwelling of anxiety I had felt as a young person—that if

191

I did something "wrong" he could have a temper tantrum—and no one could predict what constituted "wrong" in his view. The blessed difference was that he was no longer in control. I could do whatever I needed to do—and leave.

My father had recognized his need and had tried several housekeepers, each of whom quit after a couple weeks. My Aunt Gretchen, then widowed, agreed to live with him and housekeep—over my strong advice—and she lasted three weeks. The coup de grâce came when he accused her of stealing his shirts.

On my visit, a new housekeeper seemed able to ignore his childishness and roll with his foibles. Her enthusiasm and glowing reports made me realize that she had her own agenda. As it turned out, she was cashing his dividend checks, eyeing his estate, and trying to get him to the altar. He was still too shrewd for that, but the problem remained of how much she was stealing.

Even before the visit I had been getting more frequent and urgent calls from my Florida liaison, Howard, my father's stockbroker and the closest he had to a friend. The neighbors complained about his loud rages and behavior such as urinating off the front porch through the wisteria. My dilemma was that my father was still able to appear normal for short bursts. Unless I waited until he was farther along to file for incompetence (since he would never enter a nursing home voluntarily), he could look all right for an hour, con the judge into believing he had no need for a guardian, and the judge would deny my suit on the assumption that I was a grasping daughter. Howard and I agreed on systematic pooling of information as we moved toward the necessary court actions.

My visit went well until the last day. Then my father had one of his outbursts, unexplained and unforeseen. At issue was how we were to get my suitcase to the airport.

As I flew home, I thought how alike my father and my son were, and how my feelings of responsibility left me at the mercy of whatever shock, unexpected, irrational, and cataclysmic was produced by whichever of them was nearby, emotionally or geographically. Daniel could hardly have learned this by imitating his grandfather because they lived in different states and had spent very little time together, a total of no more than a hundred days in scattered holidays and visits. For each of them I had an obligation to do what they needed but didn't want.

As my plane descended for landing at O'Hare, I pondered the problem of getting my father to a nursing home.

Peter's first words were: "Daniel was arrested in Texas."

"Already!" I gasped. "What now?"

"This is what James told me. Dan asked James for permission to go to a movie with some kid James knew. It turned out that he didn't go to the movie,

nor was he with that kid. Instead, he and a couple other older boys that James didn't know were sitting in a parking lot and drinking beer. Daniel got out of the car, urinated, and—"

"In the parking lot? How gross!"

"As luck would have it, a police cruiser happened past, and they saw him. They searched him, as they have to do in cases like that, and found a joint. For this, they took him into custody, and he spent a night in jail. James got his divorce lawyer to get Dan out on bond. We'll have to pay the lawyer, of course."

"Why get him out? Why a lawyer? Besides, with the crummy divorce settlement James got, you have to wonder about that lawyer."

"What else could James do?"

"What do you mean, 'What else could he do?' He could let Daniel sit in jail, that's what he could do, just as I thought you should have done here. Why do people always mitigate the offense by rescuing lawbreakers from jail? What would have been wrong with leaving him with the roaches and vermin, thinking about the advantage of a joint-free life? Why not let Daniel see that it doesn't pay to have a joint on you when you're loafing around? Why not let him learn that urinating in public brings unwanted attention?

"I happen to be treating a woman now with a son much like Daniel. When he got himself thrown into jail, her husband left him there a week on the theory that it would be a learning experience. It was. It was better than a year in college. That kid is now staying away from the drug crowd, back in school, and looking toward the future. What a smart father that kid has!"

"James' lawyer said that Daniel had a really bad beef."

"Yeah, sure! Everybody's wrong but that kid. What would you say if you were the lawyer?"

"Look! Do you want to hear this or don't you?"

"All right. Educate me. Why was it a bad beef? He had the joint on him, you said."

"Because the police were just young kids themselves, like those seventeen-year-olds in khaki we saw in Salvador, swaggering around with sidearms."

"So? What's that got to do with it? Did they put the joint into his pocket and make him urinate in public?"

"It wasn't that public. It was a dark alley. It was just that they happened to be patrolling past just then."

"You're the one that said it was a parking lot. Anyway, parking lot, alley, what difference does it make? It wasn't where civilized, not to mention cultured, people urinate. I don't know why you and James and the lawyer defend such behavior. And the pot. Over and over and over—this kid won't conform, is determined to set his own rules, does anything he damn well pleases—"

Peter interrupted, "James says the lawyer thinks he can get him off with a

193

warning, since it's his first offense, at least in Texas. Also, by Texas law, since he doesn't have a juvenile record, he's considered an adult at seventeen. It would have been different if he already had a juvenile record in Texas. Then he'd go back to juvenile authorities there."

"Hey, that's a great law! That alerts you that if you intend to commit a felony at seventeen, the thing to do is cover yourself by getting a juvenile record at sixteen. James is just like you, can't say 'no', can't do anything but coddle Daniel."

"I know you think I'm weak. I call it being a B type."

"Yeah, 'B' all right—'B' as in 'babying' Daniel."

"Anyway, we sent Dan to James, and now we have to let him handle whatever comes up as he sees fit."

"Wait a minute! You talk as though Texas was my real choice. I wanted him at Nova, with his 'peers'.

"And, yes, I *do* think you're a pushover with Dan. That wouldn't have been so bad if you hadn't always been a dead weight when I tried to take a stand, but it was always the same thing, your weight and your sympathy, spoken or unspoken, with Daniel against me. But I'm going to tell you something. I've been thinking a lot, and I've finally come to the conclusion that, weak or not, supportive of me or on Daniel's side, what you or James or anybody else did, or what I did or didn't do—none of it made a particle of difference with Daniel. The flaw, I have finally had to conclude, lies in Daniel, just as the flaw lies in my father. He's a prime example of an 'antisocial personality', with a lot of oral narcissism thrown in. What he has become is not because of anything anyone did but in spite of everything everyone did."

The discussion continued after I greeted Jonathan and David, but it was the same old accusations and recriminations resulting from our disappointment and bitterness about our son for whom we had once had such high hopes.

People like Daniel are usually someplace else, rarely on the scene to observe the impact of their behavior on those who love them. It was the same as when we found the evidence of drug use and theft while Daniel was off mountain climbing. But whatever the event and wherever Peter and I learned of it, we were there to have the wind knocked out of us. And there was no one but each other to blame and abuse.

As I reviewed the Texas developments, I thought that this might be a time to use Stanley Hopewell, the lawyer I had found to replace Shapiro. I asked him to find out for me what was going on in Texas and what implications it might have as a toe-in-the-door device for getting Daniel back to Nova. He agreed

to look into this but despite his having been paid promptly for former services, I never heard from him again.

When I realized that a return call was not forthcoming, I asked myself what function lawyers really serve. I pondered my earlier court fiasco, remembering how everyone but me seemed to get the judge's ear. Surely this was not Justice blindfolded.

Following James' divorce, I was still friendly with my ex-sister-in-law Agnes, whose long hours working on a newspaper had been one of the reasons for the breakup of their marriage. She was a good first contact to call for on-the-scene information since she knew everyone in town from her work.

We normally just exchanged notes at Christmas, so I gave her a few seconds to recover from the surprise of my call by inquiring about her elderly mother, then sketched in what I had learned about Daniel and asked her to inquire about his hearing.

Agnes knew that Daniel was in Texas from her children, his cousins. She had no trouble seeing the unsuitability of James' lawyer, nor did she question whose side I was really on. In fact she asked, "Have you ever considered just letting the justice system roll over him in its own way and work its will with him, so to speak, so he can feel the results of his actions?"

"That was my first choice. It would be great, if there ever were any negative consequences. The idea makes tremendous sense, but only in theory. It falls down in practice. Anything that would hurt enough to slow him down is too far down the pike to have any educational value. New people like James and his lawyer are already mitigating the consequences. Nobody but me does anything but make excuses for Daniel. He never even has to ask for another chance. People always think that his misbehavior was a fluke, and a smart kid like Daniel will know better than to do 'it' again, whatever 'it' is. We never catch up.

"It's like running up the stairs, always three steps behind. And Daniel is dropping smokescreens all the time. All I can foresee from letting each new decision-maker come to his own conclusion regarding Daniel is that by the time they catch on, they can't do anything about it.

"Daniel once had a fine mind. Now I suspect his brain is pickled. I ache when I foresee his ending up some pale reflection of what he might have been. 'The saddest words of tongue or pen—'"

She finished the quotation,"'—It might have been.' The kids brought him over, so I saw him in his pigtail, but I had no idea about any of this."

"Nobody ever does. It's partly my fault because I always kept the incidents quiet. I don't enjoy telling things I'm not proud of. Except for the arrests, what he's done isn't so terrible if taken one at a time. It's the sum total, the absolutely relentless and unremitting sequence. One of the terrible by-products for Peter and me is that each incident is rounded off by a fight between us.

195

I never would have believed that a child could destroy a marriage, but I'm starting to worry that this is what Daniel is doing to ours."

"That's too bad. Surely, as intelligent people, you should be able to work together."

"You'd think so, but so far it hasn't worked. I began this whole parenthood thing with the tacit assumption that in day-to-day observations and assessments about the children, Peter would be as likely to be right as I. It didn't take long until I began to learn that despite his scientific mind, he's not psychologically astute, nor does he see things going wrong. I began by trying to involve him, but we don't work well together in these matters. He feels like a dead weight to me. Each time I have to begin by educating him, then dragging him along on whatever I think we need to do."

"How are Jonathan and David?"

"They seem all right, but I used to think Daniel was all right, too. One thing I'll never forgive Daniel for, if I live to the age of Methuselah, is that he's made me lose my innocence as a mother. Now I look at the other boys with suspicion, too. I try to act natural, but I end up being what you might call selfconsciously unselfconscious. Jonathan is just the age when things started falling apart with Daniel."

Agnes agreed to get the court information without letting James know.

Within half an hour she was back on the phone with the names and phone numbers of James' lawyer, her lawyer in case I should want it, and the county prosecutor, the date of the court hearing, and Daniel's case number.

I began with her lawyer, who was noticeably less perceptive than Agnes. He could see me only as an adversary of Daniel's and suggested that I contact James' lawyer first to see if we could all agree to something. I still find it hard to believe that I listened to that advice, but, with trepidation, I placed a call. I left the name Greenleaf, which James' lawyer should surely have recognized from James and Daniel. His secretary told me he was on another long-distance call and would call me back shortly.

I stayed home the rest of the afternoon, but the phone never rang—a minor miracle. I had tried to "cooperate" but was relieved to have legitimately avoided talking to him.

The next day I called Alfred Philpott, the county prosecutor, to fill him in on Daniel's history and to ask his help in getting the judge to send Daniel to Nova.

"From what you say, it sounds as if that's exactly what Daniel needs," said Philpott thoughtfully, "but I doubt that under Texas law the judge could send your son to such a place outside the state, even at your expense. But I'll talk to him."

"If he won't or can't, what about treatment there?"

"He can certainly do that and would be very likely to send Daniel for

196

counseling by someone here who is not conned by young sociopaths. We even have a federally funded mental health center here. I'll talk to the judge and get back to you."

"Please tell him I'd be happy to fly down and talk to him in person or send copies of all the letters, reports, testing, et cetera. One other thing, could you get me the exact charge against Daniel? My ex-sister-in-law got me the hearing date."

"I'll have a notice sent. Dr. Greenleaf, I appreciate your concern. I wish more parents of delinquent boys were this willing to help. Let me go to the judge first and ask him how he'd like us to proceed."

Philpott reported that the judge had studied Texas law but could find no device for sending Daniel to Nova. He promised to stand firm for probation with mandatory counseling of a year's duration, rather than the knuckle-rap that James' lawyer would request. He also relayed the judge's message that it would be "unnecessary" for me to appear in court, and I decided not to go because of my poor track record of impressions made on judges. Philpott told me I would have to find a counselor for Daniel.

As promised, he sent me a letter outlining the charges. I stared at the cold black ink under the letterhead in Gothic script of "Organized Crime Unit":

> Dear Dr. Greenleaf:
> Your son was filed on for a Class B misdemeanor for possession of marijuana.
> His bond is returnable August 30th, 1978, which is docket call at the Wilder County Attorney's Office in Golden, Texas.
>
> Sincerely yours,
> Eddie Ingalls, Agent

An arraigned criminal for a son, but I had no time to cry.

I made more calls. I found the mental health center Philpott had mentioned, talked to the director, and finally to Mrs. Artemus, a psychologist, to whom I sent an enormous packet of material about Daniel so she would have background on him when he arrived. I was less than delighted with how she sounded—she was too understanding and ready to come partway, an approach that had had notoriously poor results with Daniel, but she was the best I could find. There was nothing to do but wait for August 30.

One evening in mid-August, Peter answered the phone. Hearing his bewildered tone, I picked up the other phone and joined the conversation with James.

"What in the hell is going on?" James bellowed. "I called in a lawyer, and now you're making me look like a fool in front of him. What's the idea anyway? What are you trying to accomplish?"

"Exactly what I've been trying to accomplish for the past year and a half—trying to get someone with clout to contain Daniel in one place long enough to get him off his collision course."

"But you went to the public prosecutor and told him about Dan's earlier arrest. You made him a two-time loser!" James roared. He didn't even need a telephone for that line.

"What do you mean, 'I made him'? He made himself into a two-time loser, and I'm trying to prevent his becoming an n-time loser!"

"Look, I'm handling this—you sent him to me. Why don't you let me do it my way?"

"Let's get the record straight. We didn't voluntarily send him to you—that asshole of a judge did. I wanted him with the rest of the sociopaths at Nova." I paused, took a deep breath, and went on. "I like you, James, always have, and my respect for you has grown over the years. But you're no match for Daniel, and that's no insult to you, or anybody normal. Good, decent people never are. I admit it really wasn't fair to load him on you. But in the phrase of our past president, I want to make one thing perfect clear. And that is that whatever I think is right, regarding Daniel or anything else, that thing I will do, regardless of what anyone else thinks. I wish I could believe that what you are trying is for the best, but it is my bedrock belief that what Daniel needs is to be contained. I may not be able to do it, and maybe nobody else can either, and even if somebody can, it may not be enough. Nothing may ever save him, but I intend to do all I can. I am absolutely certain that only a small percentage of the crap he does ever gets anybody's attention, but whatever I know about I will not hide, gloss over, 'wait and see', or stand idly by while everybody else minimizes his offenses. I don't know how much longer my strength is going to hold out, but as long as I can, I will keep trying to save him in my own way, because nobody else has demonstrated a better way. In the end, however, if only one of us makes it, it will be me, not Daniel. I don't intend to let him destroy me. Meanwhile I won't go along with your or Peter's easy way out, always letting him—"

"That's not true," Peter interrupted. "I tried for Nova too, and those bastards couldn't hold him, let him slip through their fingers!"

"Yes, you did. And the fact that that didn't work was no more your fault than mine, but the hard truth remains—"

"Peter, can't you stop her?" James yelled.

"Just what do you mean by that? She's an adult, makes her own decisions, and I'm not responsible for her behavior any more than she is for mine."

"That's not worthy of you, James," I snapped, "to suggest that your brother gag his wife." I sighed and continued, "Do you think I'm doing any of this for fun? I'm trying to stop this kid because nobody else is. I'm trying to act with intelligence and judgment, attributes that have been in pretty short supply. I have plenty of faults and flaws, but stupidity isn't one of them. Your lawyer's approach of rushing to get a delinquent kid out of jail is asinine. I'd let him sit there as long as they'd keep him."

I paused to catch my breath, then went on. "But why are we fighting? Emotions run high over teenagers, even when they're not delinquent. Don't you see the irony? Daniel ought to be in pain, remorseful, and determined to change, not going his merry way while we all fight over him."

James calmed down. "Look," he said, "I get the idea that you're going to do what you think is right, no matter what. O.K., but why didn't you at least talk to my lawyer first? I called in my lawyer, and you went to the public prosecutor and made me look like a fool."

"I'll tell you why I didn't talk to your lawyer," I yelled. "Because he refused to talk to me."

"What do you mean 'refused'?"

"I waited an entire afternoon for the call his secretary promised he would return, that never came. I'm a professional person too, and I treat everyone with respect until they show that they don't deserve it. I return calls even if the foregone answer is 'no'. If I had a call from an unknown lawyer in another state, I'd return it. I'd call even though it might be to say that I couldn't ethically talk about a patient or even admit he was my patient, at least until I got a release. But I didn't get that courtesy from your lawyer. And I won't call twice. I don't have to beg people to talk to me."

That call with James went on for another half-hour. Afterwards, Peter and I argued, exchanging angry, hurtful, sometimes irrational words that bespoke our pain over our son and our impotence either to change him or to accept what he was.

Finally Peter spilled out, "I don't see how much longer this marriage can last."

"Well, nobody's holding you. You can take off any time you want."

"Why don't you go? I have a job here." Peter glared at me, and his eyes bugged out in a way that infuriated me.

"It's typical of your passivity to ask *me* to accomplish what *you* demand! Why should I leave? You're the one who screamed that you wanted to end the marriage. I'll tell you one thing: even if I wanted to terminate our relationship—I don't yet, but it might come to that—I won't be the one to do the dirty

work of it, think through the ramifications, do the backbreaking work of relocating. Nor would I leave via our so-called justice system, after what they've done to us. Besides, the boys and I are settled here, too, and I intend to stay."

"Half of everything is in your name. I've always been fair to you. You could go back—"

"I never said I wanted to go 'back' or that you hadn't been fair financially. I don't want to leave you. This is your dumb idea, so if anybody goes it has to be you. And what has fairness got to do with it? Your proposed solution is to the wrong problem, and a self-limited one at that. The problem is that Daniel drives this wedge between us, and everything we try is thwarted, and we end up so miserable that things always escalate, and you always come around to the subject of divorce. Can't you see that about 98 percent of what goes wrong between us is over him? Can't you see that we have to band together to fight it? Can't you see that we have to protect ourselves from Daniel?"

I wrote my "minutes" of the call from James, as I had begun months earlier for events I anticipated would be critical in this work—to minimize the vagaries of memory.

Twenty-two

Friends from My Adolescence

IN LATE AUGUST PETER AND I RETURNED to my hometown for my high school reunion. People I hadn't seen for years came to talk to me, and I felt better liked than I had during my painful adolescent growing-up years. I also saw old friends in new contexts. Victor, a staid class member whom I had dated in high school, told me that his only child was autistic. Shifting effortlessly and almost unconsciously into a therapeutic mode, I gave Victor the identical kind of grief therapy I would have if he had been in my office, encouraging him to ventilate his pain, his anger, and his self-doubts.

Victor's story interested me from a different viewpoint. He related his and his wife's experience pursuing expert after expert in search of answers and help for their son. Finally they arrived in the office of Leo Kanner, our old professor who had first described, named, and worked in the area of "infant autism" as he termed it. With small groups of us medical students in his office, he had brought in and demonstrated children who did not speak but treated persons and furniture exactly alike. Victor related that after a long examination of their son, followed by detailed history-taking and compassionate discussion with Victor and his wife, Dr. Kanner's conclusion was not, "I do not diagnose your son as autistic" but "Your son cannot be autistic. You are not the kind of parents who produce autistic children."

201

I was shocked by this example of a scientist performing whatever mental acrobatics it took to preserve his initial hypothesis, in the face of evidence to the contrary. Seeing parents who, he admitted, did not warrant blame, yet clinging to his belief that if a child is autistic the parents must be responsible, Dr. Kanner preferred to deny the diagnosis. Refusing to re-examine a hypothesis in the face of contradictory evidence represents the ultimate in the paranoid position: abandon anything but your *ideé fixe*.

I thought how, had the cosmic dice rolled differently, an autistic boy could have been Victor's and my son. And I was well aware as we talked, that if given the choice, I would in my own grief have traded Daniel for an autistic child and considered myself a happy woman. Now that Daniel's oscillations are damping, I no longer feel that way.

Some of the personalities from the past had not grown with the years. During the reunion speeches, Tommy (who hadn't matured to "Tom" yet) hoisted himself to his feet during someone else's remarks, proclaimed, "Pen'cillum izza greates' 'venshun inna hist'ry uvva worl'!", belched, fell back into his seat, and snored.

Isabelle from American History leaned over and whispered, "Tommy's third wife just left. Nobody can live with his alcoholism!"

My mind drifted back to our high school days when Tommy's mother had told my mother she was growing more and more worried about what she was seeing in her son, since Tommy was already pretty wild.

"Don't wild high school kids settle down sometimes?" I asked myself, remembering that Daniel's MMPI had predicted excessive use of drugs and alcohol.

The next day Peter and I visited Joyce, who had been several years ahead of me in high school, but with whom I renewed my friendship when she did graduate work in classics in the same university where Peter and I were studying medicine. This was our first visit since Joyce had lost her husband Francis to cancer and her college son to a drunk driver. Having adopted three children and then having another three by the more customary route, Joyce updated us about the children. She rounded out for us the episodes that led up to her oldest daughter Denise's disappearance, the most gifted of the lot, a daughter whose exploits we had heard in fragments over the years.

"As I look back," she said, "I should have known it was all inevitable. There was no point where doing anything different would have produced a different outcome. When Denise was in seventh grade, Francis would go out looking for her night after night. One night when she was fourteen she had sex with three men.

"We struggled for years to keep it quiet in this small town, while we were trying to straighten her out. We called it 'protecting' her, but it was also to hide our own shame."

"I certainly know what you mean," I said. "I've come to believe that the game is fixed." I told her Daniel's story, especially the past two years.

"Do you mean that that darling little seven-year-old you brought here did all that?"

"That's the tip of the iceberg."

In my mixture of sadness and relief and embarrassment, I was glad to sink back into the cushions of Joyce's couch while she went to the kitchen to get us some plum wine of her own making.

She returned to the subject of Denise. "Do you remember that night you were here with Daniel when Francis excused himself and left while we went on talking?"

"Yes, why?"

"Well, she slipped out the back door when she was supposed to be studying, and Francis went out looking for her."

"She was already making trouble way back then? She must have been only thirteen or so. Why didn't you tell us?"

"We were ashamed."

"That night I thought it strange that you said to little Daniel, 'What you do will probably make more difference to your little brothers than anything your parents do or say.' I wondered why you would say that to a seven-year-old. Did it really work that way? Has her influence been bad on the others? Because I'm coming to doubt that any influence from the family makes any difference."

"Probably not, but you expect it to." We sipped the plum wine. "I kept thinking that night that I should tell you."

"You didn't owe me or anyone else any explanations, but I know just how you felt. I feel false and dishonest for not just screaming from the housetop about Daniel. Even at the reunion last night, I felt two-faced even while I kept reminding myself that I really didn't have to tell anyone anything.

"Daniel puts me into more than one bind. When I feel the urge to tell someone, there's usually not time for such an involved story. At home we're always doing everything on the run. You have to leave home for a few days to make time take on a different dimension, like this evening. Yet I'm embarrassed to admit that I can expose myself to you tonight partly because I know I won't meet you on the street tomorrow. I can 'hit and run'. When it's someone in the community that I see face-to-face fairly often, I find that when I tell them the horror story and see them later, they are likely to ask if he's better. Even if they don't say anything about it, the fact that they know my dirtiest secret makes me feel naked and ashamed. I almost always end up regretting my confidence.

"The same thing happens if I write it to someone in a letter. They naturally feel obligated to respond, but by the time I get their response, Daniel has

moved on to the next incident, and what they say rarely helps. Who can grasp the essence of Daniel in one telling? Not the psychiatrist. Not the teacher. Not the doctor. Not the judge. Surely it's too much to expect an average person to understand. Whatever they respond, it's wrong and just makes me feel more miserable. There just isn't anything *right* to say. Their efforts feel like ground glass in my gaping wound.

"Lately, though, I've noticed something else. I've noticed that some people have stopped talking about their children. They change the subject, look away, and become evasive in a number of ways, as I have learned to do. Yet before they do, I recognize a look of pain in their eyes. I think of them as 'the parents with the haunted eyes', and I can identify that look across a crowded room. Someone did a crayon sketch of me, and it was very good, much better than most photographs, but there in the sketch looking back at me are those same haunted eyes."

"What did we do to deserve this?" she asked, sadly.

"We played Russian roulette and lost."

"I don't understand."

"Of course not. That wasn't your case. Denise was adopted, while Daniel was our biological child. But I don't see that it makes much difference whether it's your own reshuffled genes or somebody else's. We all carry a lot of bad ones, and some of mine came from my father. Yet if someone had given me odds of, say one in ten, of having a child like Daniel, I know I'd have risked it, even though I'm not normally a risk-taker."

"So would I. I really wanted children."

"'Wanting a child' is a complex matter. It's not just the idea of little arms around your neck. Back in those days, it was at least partly the stigma of childlessness. On the other hand, if you needed to adopt, you had to be highly motivated—close to masochistic—to go through what friends have told me the agencies put you through, and often with ludicrous results. I also 'wanted a child'—but not a child like Daniel. Too late to do me any good, I've come to realize that it's not wise to play a game you can't afford to lose.

"Another thing that's hard to get over is our generation's training that we women are identified by our husband's career and that we prove ourselves by the success or failure of our children. It's worse than being defined by our own occupation, which is bad enough. We women have been like chameleons, taking on the coloration of those closest to us. This is too great a dependence on something we have so little control over.

"I find myself going around my daily business, carrying this horrible secret about Daniel and always wondering who knows it. The optician who makes my glasses asked, in what I took to be a snide tone, 'Has Daniel straightened out yet?' and I angrily retorted, 'I don't think that's any of your business.'

204

Maybe he was genuinely concerned, but I felt humiliated.

"I realized years ago that life would be a lot easier if I just didn't care who knew about Daniel, but I feel the shame that should be his shame. I fight my own secretiveness and what my friend Aletheia calls 'protecting' such children, which is nothing but a rationalization for protecting myself. It means protecting myself from the opinions of my contemporaries, because people of Daniel's age group are not shocked by anything like this. They don't feel contempt for their contemporaries for going through this kind of phase and later rejoining the mainstream, or maybe never returning to old-fashioned middle-class values. I would be happy if there were a social stigma for living like Daniel—that kind of pressure used to help keep people in line—but there's no such pressure in a culture whose social fabric is unraveling anyway. It would help if I could only truly write off Dan once and for all. . . . Have you been telling other people? It must be worse in a small town."

"Well, when Francis died, I decided I didn't need Denise at the funeral, so I didn't even try to find her. I guess she's still living out in California with that college professor who got fired for growing pot in his apartment. But when people ask, I still don't know what to say, and Denise is twenty-five."

"Your other children—are they all right?"

"Pretty much. Ralph's eyes are no better. Yet even with that terrible amblyopia, he's working in his grandfather's bank. Linda says she's going to move out the day she's eighteen."

"I'm glad for Ralph. That's an example of overcoming your handicap. Sometimes I wish we could all have a handicap that's not overwhelming but of just the right severity because I've seen a lot of people with handicaps make the effort to accomplish something regardless. I think Peter's bad leg made him excel in other directions. I wonder whether I'd have done much with my life if I'd been popular in high school and if I hadn't had to live with everybody in town knowing about my father.

"One of my friends told me that he has evolved a metaphor for life that we are all wheels. But the wheels don't go forward unless there's friction. My spin on that is that we need a handicap to overcome, and sometimes the worst handicap is no handicap at all. I used to think that was Daniel's handicap, but now I know it's his antisocial inheritance.

"Poverty is another good handicap, as long as it isn't too grueling. It makes work a realistic option. Sometimes I think it might have helped our children to be born poor. But even if it's an advantage, it's an impossible one to give your children. It's artificial to try to fake limited means. I was always trying to make the point that even though we could afford something, they couldn't have it unless I thought it was good for them, and that was a harder point to make. . . . What happened to the rest of your kids?"

205

"Matthew was our jewel. Everyone loved him." Joyce blew her nose and then told the details of the fatal accident.

"Do you ever find yourself wishing it could have been Denise instead? Because I have fantasies about our little James, who died in infancy, surviving instead of Daniel. Then I feel horribly guilty."

"Yes, I find myself wishing that if the car had to hit someone, it could have been Denise. Then of course I feel guilty for thinking it. No matter what you do, it's wrong."

Joyce asked about Jonathan and David.

"Whenever people ask that, I feel sort of an internal wrench when I tell them the little boys are fine, which they are, but of course only so far as I know. I always wonder if something evil will raise its head. I pretend to trust them, and I do trust them, but only to a point, through no fault of theirs.

"At this point I can't think of any reason, never mind a good one, to have children. And Jonathan and David don't deserve for me to feel that way."

We talked late into the night, and finally I came around to the one emotion I had been fighting ineffectively. "The thing I find hardest to cope with is envy—envy of parents apparently no better than I, with kids who are all right. As Peter says, 'You have two who are all right too.' But of course I mean not having any who are not all right. With what we did for Daniel, we should have had three 'all right'. I look around and see that even though a lot of kids are messing up there are still kids making it. And most of them have a lot less going for them than Daniel.

"I keep coming back to where he got his tragic flaw and I ask the question as old as pain: 'Why?' It would be bad enough if I just had to suffer about Daniel, but that pain is aggravated by my envy.

"Envy is an emotion you almost never hear about or see discussed, but there was an article about it in *Harper's Magazine,* in which the author used a marvelous phrase. He called envy 'the last dirty little secret'. In Shakespeare, King Henry IV, whose son Hal is messing around with the low life of London, envies the father of Hotspur, who has all the traits of nobility Henry would like for his heir apparent. He wishes it could be shown that the boys were switched at birth.

"I know a woman who likes me and seeks me out to talk to at meetings at the library, but I find myself trying to avoid her because her kids are 'making it'. Just last week our paper carried a little article and picture on her oldest son, who just graduated from high school and is going on to study physics. This summer he's taking a backpack trip in the Arctic, hiking alone in the Canadian tundra, ablaze with wildflowers in its meteoric blossoming season. It's just the kind of wilderness adventure I'd love for Daniel between high school and college, as a reward and enrichment.

206

"I've gradually come to accept the fact that I can't control the envy I feel—it's apparently incurable—but I determined that, by God, I can control how I behave. So I don't let myself avoid her. I even clipped the article and put it in my purse to give her, so she'll have an extra.

"But I envy her and all the other parents who don't 'deserve'—whatever that means—to have normal children any more than I do. I envy all the parents without the cross of a Daniel to bear.

"But I'm taking action. I'm starting to collect material for my next study, which is going to be on envy, the emotion we don't even talk about in psychiatry."

Back in Evanston, Mary Kovach returned for the follow-up interview I promised her about Daniel's adjustment after Safehouse.

"No," I replied to her question about whether my feelings had changed, "I don't feel any different about Safehouse or Daniel's experience there. Now he's been picked up in Texas, spent a night in the slammer, and has a court hearing pending for possession of marijuana. Remember that you promised to put my statement into your report."

Having been sensitized to Safehouse, one day as I drove down a street I had taken a hundred times on my way to work in a community mental health clinic, I was jolted when the name Safehouse jumped out from a freshly painted but ramshackle building in a bad neighborhood. "Why would anyone choose a path leading here?" I asked.

I also happened to hear a radio interview with the social worker in charge of Safehouse. She claimed that in the three years she had worked there, she had never seen a "bad kid".

"You must have been taped before Daniel's time there," I told the radio.

She described a process she called "sorting out" the problems the adolescents brought. "And then we ask the parents to come in to tell their side of the story," she added.

"Whatever for?" I asked the radio, slamming on my brakes. "You already have whatever you need from the kid."

"How do children get there?" the interviewer asked.

"Many ways. It's impossible to generalize."

"You bet it is!" I told her. "Not many get sent by a judge intent on giving them the rope to hang themselves."

"Sometimes parents just drop them off at the court and say, 'I've tried, but I can't do anything with him any more.'"

"I have no trouble with that," I told the radio.

"You mean people just abandon their children?" the interviewer asked in a shocked tone.

With some compassion the director replied, "Sometimes they feel so frustrated and unable to cope they just can't see any other way."

The program switched to Ravel's *Mother Goose Suite.*

Twenty-three

Adolescence in the Late Twentieth Century

As AUGUST DRAGGED TO A CLOSE and families with schoolchildren were buying Flair pens and book bags, I stayed as close as I could to the phone for Philpott's promised call about Daniel's disposition and treatment. Finally I couldn't wait any longer and called him on the first day of school when, with our sons on their way together to junior high for the first time, I had quiet and privacy. "How did the hearing go?" I asked.

"Good to hear from you," said Philpott. "It hasn't been held yet."

"Why not? The letter said August 30."

"Daniel and his lawyer didn't show."

"So what did they do, throw Daniel back in jail?"

"No, it wasn't exactly his fault. His lawyer didn't tell him about the hearing."

"Didn't tell him? Why not?"

"That lawyer often misses court call."

"Well, doesn't something happen at that point? Doesn't the judge have a tantrum and declare them in contempt and slap an injunction on them or a fine or something?"

"No, they just set another date."

"I don't understand. Time is set aside, people are paid to run a court, and then nothing happens. Does everybody get a free holiday at taxpayers' expense? Nobody wants to go to court. So if somebody who didn't want to go

209

in the first place doesn't go and nothing happens but that another date gets set, what's to prevent the same thing from happening until the year 2000?"

"The bondsman will demand his money. That'll get Daniel to court."

"What if they just forfeit the money? It's our money, and I'm sure that saving our money is low on Daniel's agenda."

"The bondsman is 'good' for both your son and his uncle. They'll get there."

I was dubious. "Has a new date been set?"

"October 24."

Like many other matters of principle, this one too boiled down to a matter of money.

As the Texas brew simmered, calls kept coming. With increasing insistence, James demanded that we provide some proof of Daniel's age. On each call Peter promised to cooperate, but I made no such promise, nor did I intend to put myself out for something that sounded unnecessary and frankly suspect. I kept safe the copy of the birth certificate that I had made for Operation Roc.

"I don't understand this, James," I responded to his third request. "This is something new that ordinary American citizens of seventeen have to carry identification. What do you have down there, some sort of police state where you have to produce a passport on demand?"

James mumbled something evasive and diverted me by saying, "And another thing. Couldn't you send better clothes? He looks awful in my lab in the same shirt and jeans he wears to school."

"Hold it a minute," I said, taking a deep breath and forcing myself to be patient as if with a slow child. "I don't like the implication that somehow we—or I, since I seem to be the one to blame for everything else—that I am somehow responsible for how Daniel dresses. During his growing-up years I would buy him a variety of pants in a variety of different colors and materials—not just jeans—and shirts in interesting solid colors or patterns, stripes and plaids. I taught him to pick a shirt containing one color to coordinate with the pants. When he did it my way, he looked so good that a boy friend in junior high once asked him to go shopping with him to help buy clothes because that kid wanted to look as well turned out as Daniel. But soon Daniel wouldn't wear anything I bought for him, so we started letting him pick his own clothing. He'd get pants too long and walk on the bottoms to create instant dirty rags. He took everything to Texas that he'll wear. What's left hanging in the closet he won't touch, and it will all go to Jonathan when he grows into it. If Daniel needs anything, we'll pay for it, but I suggest you have nothing to do with the selection, or he won't wear it anyway."

"All right. We'll get something. …Another thing. I don't see how we're going to manage without a car for him. I've got him in Alamo High, our Catholic high school, our only private school and the best, since public schools here don't maintain discipline, and all my friends' kids go to Alamo. It's across town, and somebody has to take him—we don't have buses."

"Oh, great! I can see your problem, but I hate like hell to reward him with a car after everything he's done. No matter what happens, there's always some reason why that kid comes out on top. All right, I'll sell some of his stock that we bought for his education."

"What do you mean? We can get him a car," Peter yelled on the other phone.

"But why should we have to? Why reward him?"

We hung up, but not in time to avert a fight between us, this one over where to get money for a car for a seventeen-year-old delinquent.

Hard though it may be to believe, our lives and work continued normally. Significantly, my psychiatric work was reflecting the staggering changes our country had witnessed in my lifetime. A pretty sixteen-year-old named Madeleine, who was starting ninth grade for the third time, not having earned a single credit, was referred to me. Hard as nails, she calmly and deliberately did exactly what she wished. At fourteen, she had climbed across the roof when the family was asleep, taken her mother's car, crumpled it against a tree, and crawled home streaming with blood, waking her parents several hours after they had gone to sleep under the assumption that she was in her own room. They described the moral bankrupts she ran with. The mother complained bitterly that she had tried to bring up Madeleine not to judge people by externals like income or social status, but by traits of character, personality, and motivation. But Madeleine had found contemporaries with none of those virtues, and she spent her days running through the parks doing drugs. "This is not what I sewed Halloween costumes for," her mother cried. "This is my punishment for encouraging her to be democratic." Madeleine's father, a corporation lawyer, sat with tears streaming down his face as he described morning after morning trying to drag Madeleine out of bed and move her in a schoolward direction. Have earlier generations also been able to reduce their elders to sobbing parents? I asked myself. I don't think it was anything like this.

As the weeks passed, it did not surprise me that I was unable to effect any change in Madeleine. I was also unable to persuade her parents that they had little to lose by sending her to the girls' school equivalent of Pleasant Valley, the one that had invited Daniel's class to the dance. When they terminated

therapy with me, the mother was considering exorcism.

Madeleine had been referred to me by a school psychologist whose daughter, Nancy, I had worked with. Nancy had disappeared for three months when she was fifteen. She had dyed her hair, worked as a waitress, and finally been turned in to the police by her roommate when they had a falling out. That family was lucky—Nancy's boyfriend had been sent to the reformatory.

Evidently word had circulated that I was working with teenagers, for I was then called in to see a girl-child of fifteen in intensive care where she had been brought in coma. Her parents, an engineer and a journalist, believing that their daughter was spending the night down the street with a girlfriend, had answered the doorbell at nine one summer evening, and, as a car squealed around the corner into the night, discovered her unconscious body propped against the door. Those parents were lucky too—the girl could have been found in a dump, dead. Three days later, on the intensive care ward, the child regained consciousness. A scant month later, as I tried in vain to reach her, she was able only to demand, officiously and peremptorily, that her parents "trust" her. She didn't understand me when I told her, "For them to trust you again, you will need to earn it, and it will take a long time. It's up to you." Her mother also cried in my office. Is our new age marked by parents crying over children who do not know when or how or why to cry for themselves?

One evening Peter let the boys and me out at the church door for a fundraising spaghetti dinner, while he pulled into the parking lot. As I paid for four dinners, a woman at the ticket table looked at me quizzically and asked how many sons we had. Without missing a quarter beat I answered, "Two, Jonathan and David." David looked at me aghast.

An elderly woman, just chancing past, in an effort to be friendly, said, "I think it's so nice how your family always comes together to the church dinners. I've noticed that most teenagers won't go with their parents any more."

"Mine know that here is where dinner is being served tonight. It's the easy way to get us all fed and at the same time help raise money for the men's shelter."

Daniel sometimes called to talk to Peter, and by October was beginning to ask if he could come home for "the holidays" (this meant Thanksgiving) because he did not "like" Texas and considered the residents "rednecks". Peter refused Daniel's request and tried to help him see that he should settle somewhere and stop running frenetically every time something didn't measure up to his unrealistic expectations. Neither he nor his father took into consider-

ation the fact that Daniel had a court hearing scheduled for October 24.

When Peter made a short junket to Switzerland to consult with a drug firm, a call from Daniel reached me. I made a point to tell him that Whitepaw's tumor had recurred and that she wouldn't live more than a few weeks. He made no comment about his dog. His voice was cold and harsh throughout the call. He let me know that whenever anything bore a return address of mine or was forwarded in my printing, he destroyed it unopened, because I had had him kidnapped to Nova and had gone to the public prosecutor in Texas. Therefore I stopped forwarding his mail and began reading it all in search of something I could use to trap him into his salvation.

Twenty-four

Daniel's Portfolio

AS DANIEL'S EIGHTEENTH BIRTHDAY LOOMED on December 7, and with it his legal majority, any trivial control we, his parents, had over him vanished. Yet one factor was in our (and his) favor. His leaving school was not an issue, since he never intended anything other than to go on to college. He would no doubt be calling the shots on that decision too, and our input into where he would go would not matter, unless we should refuse to finance it, and that was not our intention.

But I faced a painful Daniel-coming-of-age financial chore. Shortly after his birth, realizing that the early years of children's upbringing are the least expensive, Peter and I had set aside money, investing it in stocks intended for his education, under the assumption that he would need support for college and graduate school. Our legal advice at the time was that since I was younger than Peter and, as a female, had a longer life expectancy, these stock purchases should be made in Daniel's name with me as custodian. By that arrangement they would be legally his at eighteen, and he could claim them.

The only way to prevent this would be to sell them before then, as a custodian might in managing a portfolio. Even so, the proceeds were supposed to go to him or for his use, and by law that could not include normal middle-class living expenses or ordinary schooling. Of course the year of eleventh grade at Pleasant Valley and twelfth at Alamo High in Texas, not to mention the aborted treatment at Nova, were considerably more expensive than the costs of a normal high school student living at home. Therefore a case could

be made, if I should ever be held to account (and I would not have put it past Daniel to take me to court), for selling some of the stock for his pre-college schooling and delinquency-related expenses. The crux of the matter, however, was what could revert to Daniel at eighteen.

I explained my plan to Peter. "Before Daniel turns eighteen, while I can still do it semi-legally, I intend to get those stocks transferred to the younger boys. We could look at it as selling and rebuying without commissions."

"But it's not legal for the proceeds not to go to Daniel," objected my stickler for the law.

"You're putting me on!" I bristled. "What the hell has legality got to do with all this? Whatever has the legal system ever done for us or for him? We've already spent much more money than a normal child uses up by his age, and securities held by a custodian could have gone for that. But even if they couldn't, we planned for his future on an entirely different set of assumptions, with no way to anticipate what he would become. What do you want to do, give him control over thousands of dollars to buy drugs? Times and circumstances have changed and demand a different strategy, legal or not. It would be insane to let stocks of that value pass to someone not only irresponsible—that would be bad enough—but an acid-head or whatever you want to call him. It would be worse than just squandering it on booze and drugs. He'd use it to pickle his brain some more. When you're dealing with an antisocial personality or whatever he is, you can't afford niceties about what is or isn't legal. Besides, if he should ever shape up, then we could replace the diverted money with our own and use it as we originally intended, for Daniel's benefit. Meanwhile, tuition at Pleasant Valley and in Texas, lawyers' fees, phone bills that look like heating bills, what we paid Nova, our lost income as we've dutifully trotted back and forth to court, maintaining Daniel in Texas when a normal son would have lived here—all these expenses were intended for his benefit, whether they ever work that way or not. I see us as justified in having spent his money on him. We can even keep some sort of private books if you like, to show how we're keeping his money in escrow, and repay him if he ever rejoins the human race. What is this dumb hang-up of yours on law in the face of common sense?"

The bitter argument continued, Peter, of course, taking the position that I had no right to "steal" what could reasonably be regarded as his portion of the contribution to purchase the stocks, because it had been our joint decision and the stocks were in my name as custodian only on a technicality. I maintained that I would exploit that technicality to follow my own judgment since it was better than Peter's. As for getting the stocks out of Daniel's name, I would not be bound by legalities based on decisions made when we watched newborn Daniel in his baby seat tracking us with his

enormous blue marbles, and we had never envisioned anything but Daniel's being, at eighteen, strong and free, idealistic and ready to save the world, as we had been at eighteen.

"Can't you see that we shouldn't be fighting over either money or Daniel?" I asked.

"All right, all right," he said hotly. "But I want to say that I think some of the stock is genuinely his. I refer to the stock we got him with the money your Aunt Lith gave him as a reward for finding and turning in the uncashed checks. I think that ought to be left as his."

Peter was designating reward money that my Aunt Lith (so called by the entire family ever since as a toddler I couldn't say "Elizabeth") had given Daniel at eleven from his great uncle's estate. Daniel found a secret catch disclosing a cache of my deceased uncle's uncashed paychecks in a "piggy" bank—in the shape of a copper bust of George Washington—that he had been given from the estate. Recognizing their value, he brought them to me, and my aunt was able to make the place of employment honor them. For this she gave Daniel half as a way to reward and encourage honesty. I could see this money as coming closest to being Daniel's "own", though surely my aunt would not have intended her reward money to be under the control of our current Daniel, any more than I intended the money we had invested for educational purposes to be in his hands.

"If we're talking about 'ought', it all 'ought' to go for its original purpose. Wouldn't it be nice to have that choice? I get your point about the money from the I-cannot-tell-a-lie piggybank. I'll transfer that parcel but flag it so as to reimburse it if he's ever able to be trusted to use it with integrity."

And so I transferred the stock to the names of the younger boys, again with myself as custodian. Stock powers, signatures guaranteed by the bank, dealings with transfer agents—I had a crash course in aspects of business that I, like most of my sisters in our chauvinistic age, had left to male minds.

To cope with anxiety I always braced myself whenever I answered the phone (long before caller ID), since it felt as if this magically made those calls I dreaded less likely to materialize. One day while I was in the throes of the stock transfers, bracing didn't protect me from an unknown caller who asked for Peter. Having answered the phone and having no way to deny that I was there, I asked if I could help, in Peter's absence.

"Yes, doctor," he began, "I'm Frank Blevins from Illinois Mutual Insurance Company, and we have a bill from Dr. Pryor for a repair performed on Daniel Greenleaf two or three years ago. Are you related to Daniel?"

217

I had grown wary about answering questions over the phone about Daniel. When our sons had been in seventh grade, my friend Emily and I had both received identical calls to the effect that Daniel and her son had been throwing mud clods at a postal truck, but the caller had not been, as he had told us, from the Postal Service. Later, Emily's husband had pointed out that we should not have given information to an unidentified stranger, as we had done in the days of our innocence.

This call might be another booby trap, I thought, on guard not be sucked into anything without something in writing before me. In my life that mixed nightmare with reality, things were often not what they seemed. I could never tell how far-flung the repercussions might be. Yet the hospitalization that Blevins referred to had been legitimate, though longer ago than he had said, so I plunged. "I guess you could say that." Then I added, with trepidation, "I'm his mother," the exact line that I had always dreamed of uttering in a quiet voice of restrained pride.

"Well, Mrs. Greenleaf—Dr. Greenleaf, I mean—the problem is this: we can't find any record of this claim. Can you tell me about the accident?"

I was beginning to wish I had just referred the call to Peter, but I was committed. "Why are you only getting billed now? That was years ago."

"I don't know, but the doctor's auditor just caught the oversight."

This sounded like no more than the usual doctor's office's foul-up, so I went on: "It was longer ago than that, way back when we had winter Daylight Savings Time as a conservation measure, and my husband and I foresaw that it would make problems with children going to school in the dark. Then the child had to be ours." I answered Mr. Blevins's questions about the accident as best I could remember, couldn't recall the driver's name, and had to refer him to Peter anyway.

When I hung up, I sat trembling on the bed, reliving that terrible day when Daniel had returned just five minutes after leaving for school. His face was not streaming blood but oozing bloody serum, looking like thawing frozen hamburger. He could have been the monster in a grade-D horror movie. "I was hit by a car and thrown into a snowbank down in front," he told me.

While Peter suggested a certain plastic surgeon, then broke down into hysterical yelling, I checked Daniel's eyes, which were spared, then called Dr. Pryor, the plastic surgeon, to meet Daniel at the emergency room. Then and only then I became livid. "Eighty-nine times I've told you to stop and look first, to walk, not run, to cross streets at corners, the way I taught you when you were five, six, and seven, with practice sessions and repetitions and explanations. We have been over this and over it.

"I talked to you when Mitzi was kinder than most parents who figure it's none of their business—she made it a point to tell me you were cutting through

yards and across the train tracks behind her house.

"I talked to you when Lisa from the Nature Center called to tell me she'd seen you tearing across Broad, dodging traffic. Now not only you but all of us have to pay the price. You may go through life disfigured. Your father and I may have a kid called 'Scarface' instead of a nice-looking kid, just because you *refuse* to act sane. Because you refuse! It would be different if nobody had ever taught you." Then I cried. "Go on down—your father is backing the car out to take you to the ER."

Daniel has, over the years, cited that incident, criticizing me for lack of sympathy, even accusing me of criticizing him for bleeding on the carpet. My response has been: "I gave you better than sympathy. First I taught you how you could have prevented accidents like that, which you rejected. Then when you came in looking like the monster from the meat-grinder, I kept myself together and did what had to be done. I could have let myself go to pieces, cried, yelled, sworn, called the pediatrician first, wasted half a day. I could have called the paramedics, who would have taken you to the emergency room at the wrong hospital, where they would have done a repair that would have required later revision by the plastic surgeon. Instead, I caught Dr. Pryor while he was shaving, arranged for definitive care, repair and revision all in one, saving you a second surgery, and doubtless with better results. And I did all this in forty-five minutes.

"That may not be sympathy, but it did a hell of a lot more for your face. And you didn't even learn from that but went on ridiculing my efforts for your safety as 'womanish', meant as a chauvinistic insult. You *still* jaywalk, dash between speeding cars, cross the railroad tracks on the curve. Your impulsiveness will be your downfall, if not your death. . . ."

"Do you remember the time David was hyperventilating for fun because it was the 'in' thing for kids? I told him to stop, but instead of stopping, thirty seconds later he was on the floor convulsing and had bitten through his lip? That time I was the parent who met Dr. Pryor at the emergency room, and on the way I told David that he would be punished later, not for being hurt but for willfully disobeying, leading to being hurt. The difference between you two boys is that David could see the justice of being punished. In his case, when Dr. Pryor shot Novocaine into his lower face, even though he went white from the pain, he didn't make a sound because he knew he had done it to himself. That was a time when he literally 'took his medicine'. David has a sense of justice even when it goes against him. So I relented later and told him the pain had been enough punishment. And he never did it again. David can learn from experience, but apparently you can't."

The day of the accident my blind friend who taught the retarded and later arranged for Daniel to tape-record, and who considered herself a "sensitive",

219

called to say she had sensed that something was wrong.

"You don't have to live this way," she said after I told about the accident. Projecting a future that would become increasingly dark for all of us, she advised, "Put him in a private school, any school that'll take him."

"But how, with all those kids, can they watch him as carefully as we, two of us, can watch three kids, when we have the special motivation that they're ours and we love them?"

My friend knew and sensed more than I did.

From that accident Daniel has only a hairline scar that turns pink in cold weather. Otherwise, the remnants of that day are entirely in our respective memories.

As I sat on the bed after Mr. Blevins' call, I asked myself whether on the day of the accident I might not have lost my last chance to reach Daniel, prevented by my anger, even though it was the anger that had probably kept me mobilized for effective action. And I was resentful that I should even entertain an I-could-have-done-it-better regret.

I have long found myself resenting when "love" consists only in saying so, not in living the hard expressions of love. When someone says "I couldn't make my little girl have a shot—I love her too much," I resent the fact that weakness and selfishness should be permitted to masquerade as love.

So, as Daniel grew older, I continued my efforts at loving by doing what was needed, but this was wearing thin from too many years of ineffectual efforts. I had acted my love ninety-eight percent, but Daniel evidently could not read that as love, and perceived my legitimate anger as rejection.

I questioned again whether I might have been able to tolerate his impulsivity, and deal with his failures to measure up with less threat to my personal integrity, if I had not already been drained by too many years of futile efforts without adequate recompense. Still, that day of the bloody hamburger I may have muffed another precious chance.

Twenty-five

Legal/Social Work Tango

As CORN SHOCKS GIRDLED LAMP POSTS, Indian corn graced doors, and pumpkins grinned from porches, I waited in vain for the promised call from Philpott in Texas about whether Daniel and James' lawyer had showed up for their second try at a hearing, on October 24th. Finally I called Philpott.

"Good morning, Dr. Greenleaf, nice to hear your voice." (He could have heard it a week earlier if he had called me as promised.) "They finally got the lawyer and the boy in, and he's been put on probation with referral for mandatory counseling, as we discussed."

"That's a relief. Can you give me the name of the probation officer?"

"I'm not sure, but I think it's Tony Shelby. I wasn't in court that day. Let me check and get back to you."

"Please do. I had copies of all the material about Daniel's testing, evaluations, etc., sent down to that counselor you recommended, Mrs. Artemus."

"Well, wait a minute. There's been a little switch. I think the court wants him to go to the drug rehabilitation center for counseling instead."

"Why there instead of to Mrs. Artemus?"

"I guess they felt they couldn't pay for it."

"But I told you to assure them that we'd be good for it, so money shouldn't be a factor. Don't you remember?"

"As I said, I wasn't in court that day, so I don't know the exact reasoning. But let me check on that too and let you know."

Prosecutors, social workers, probation officers, everyone, apparently, but

judges like Whittier that you would like to get rid of, drift in and out of court on each other's cases everywhere.

"Not, I hasten to add, that I have anything against the drug center. They may be better for this type of young person than someone like Mrs. Artemus with her mixed middle-class counseling practice."

"As I say, I'm not sure. I'll be out of town the rest of the week, so you can expect to hear from me the early part of next week." I put a note on my calendar to call Philpott in ten days.

When his call didn't come, as usual, I called him, and he repeated that he thought the probation officer was Shelby. I berated myself for having bothered to go through channels.

"Adult Probation," the receptionist said. I gulped, just as I had when the letter arrived from the "Organized Crime Division". The reality that I had a son who was continuing his delinquent/criminal ways was being ground in on me, and, as James had said, I had myself to thank for accomplishing it. By contacting Philpott, I had crossed my Rubicon.

Again I was beset with doubts that exposing Daniel might not have the desired effect, that it might freeze Daniel's hatred of me and his antisocial mold. In this dangerous game, is the conservative, cautious, run-of-the-mill, hoping-the-bad-behavior-will-go-away strategy more likely to be corrective than the long shot I was playing? Of course hiding or not exposing Daniel's bad behavior had never accomplished anything either. In any case, once they knew about his juvenile record, I was past the fail-safe point and had no choice but to go on.

Shelby confirmed that while he had indeed been the probation officer in court at Daniel's hearing, the case had been transferred to another officer, Jenny Hand, and so was my call. She admitted being Daniel's probation officer.

"What do you think of him so far?" I asked.

"Well, Ma'am, I've only seen him twice, and all I can say is that so far his urine has been clean."

"Yes, but whose urine is it?" Does somebody watch him?"

"Oh, yes, we send one of the men in with him. And we draw blood too."

"That's the kind of healthy skepticism I like."

She gave me Doug Sage's name, Daniel's counselor at the drug rehabilitation center.

"That drug center is probably a good idea for counseling. They're probably used to young con artists and have heard all the lies," I muttered.

"Oh, yes, Ma'am, they certainly have," she assured me. "Doug'll be good for Daniel. He's a sharp guy who relates well to teenagers, talks their language."

"I hope so." And she gave me his number.

Without putting down the phone I dialed Doug Sage. He listened patiently

as I warned, "Keep a high level of suspicion. Always question what Daniel's doing when your back is turned. He can look so reasonable, but you never know what he's up to in the twenty-three hours he's away from you." I told Sage the whole Nova story.

"Daniel manipulates his father more than he does me, and he's already dunning Peter to request that he come home 'for the holidays'. For just a minute my emotions took over and I thought what I wished, that he wanted and needed the family that loves him. But right away I realized that there's no sign of remorse. It was just more endless bouncing back and forth and never settling anywhere. He spent four days getting to Texas, a trip that should have taken two. Who knows where he was or why. Please, Mr. Sage, ask the P. O. not to listen to any of this nonsense about a visit home. We couldn't handle him before, and we can't now."

"Don't worry. For one thing I don't know him well enough to start making changes in his program, although if the parents requested it, we'd consider it."

"What do you think of him so far?"

"I think a lot of his trouble is that he's highly intelligent, talks well and gets bored very fast. That's one of the ways he gets in trouble."

"I'll drink to that! Interesting that you should use the word 'bored'. That word I wouldn't accept from them when the children were growing up and it was the 'in' thing to say how 'bored' they were. 'Oh, la-di-da,' I would mock. I always held that being bored has no place for anybody halfway intelligent, at least when given a choice of activities. Yes, if you would be required to perform a monotonous job—knit, purl, knit, purl—over and over, you'd be entitled to feel bored. But with all the fascinating opportunities to enjoy wholesome things, learn interesting things, and work at constructive things, I can't see any excuse for boredom.

"That is to say, I couldn't until recently, when I came across scientific work by a psychologist named Marvin Zuckerman, who has devoted several decades to studies on human variations in the need for sensory stimulation, hence 'high stimulation seekers' versus 'low SS'. His studies show that the high SS trait is often found with susceptibility to boredom. These two together are often found in antisocial personalities like Daniel, who then gravitate to alcohol and drugs for stimulation and escalate in usage.

"Although I tried to have the children set their own stimulating goals, that takes self-discipline, which I was never able to help Daniel develop. I've thought for a long time that if I knew how to translate discipline imposed by standing over someone into self-discipline coming from within, I wouldn't be here, I'd be in Stockholm—collecting my Prize.

"But you're right, the deadly emptiness of boredom, which is his own fault, is one of his triggers. And he gravitates to friends who don't have anywhere

223

to go, on Saturday night or in life. I'm afraid he's found the same kind in Texas as up north."

I told Doug I'd send him a copy of Daniel's already bulging dossier. "Because," I added, "if you wait for him to tell you anything, you'll be waiting till hell freezes over."

"I'll watch for your packet."

"Please keep my phone number. As I've told the last dozen or so people who tried to work with Daniel, I'm still trying to help. I'll keep my fingers crossed for you—you'll need all the luck you can get."

"I'll do my best, but I don't know how much I can accomplish in six months."

"*Six months*? I understood them to promise me a *year*. Did they give him only six months?"

"I'd have to look to be sure, but probation is usually only six months."

A whole year may have been my projection, but the six months felt like another betrayal. I called Jenny Hand back, who confirmed the six-month limit. They didn't have personnel enough to work with first-time offenders any longer.

Score another defeat for me—and for Daniel. I came close to crying on the phone. And, as usual in life, I was not talking to the responsible person.

I vented my spleen on the innocent Jenny Hand: "Why, after they promised me a year? I'll give you enormous odds that you weren't told that I offered to come down to ask for stringent measures in person, and they told me it would serve no purpose. I was afraid to come because in the Cook County Juvenile Court I had never accomplished anything but antagonizing the judge, and I didn't want a repetition down in Texas. Nobody knows how to deal with a mother asking for the lid to be put on an out-of-control child. Maybe I should have come. But if I had, I would have arrived that day in August when Dan's lawyer was probably off at some barbecue. Then I'd have had to decide whether to try again in October. Why? Why? Why?"

Jenny Hand had no answer, nor did I expect her to have. My question was purely rhetorical.

For a few hours I just sat immobilized, with that sick emptiness under the breastbone that I had come to associate with dashed hopes for Daniel.

Once again I made myself the same promise I had made in Bogota (and subsequently broken), a promise I would make and break many times over the years. I would write off Daniel. I would divorce him from my thoughts and from my hopes. I would no longer throw endless time, energy, thought, money, and effort, and mostly hope into this humanoid. "Hope where there

is no hope," the little-touted gift that Prometheus brought to mankind, is like that other Greek gift, the Trojan horse. Beware of Greeks bearing gifts.

I tried to cry but couldn't. I tried to convince myself that though I was unable to change the fact that I was the mother of a lost child, I could free myself from those accidental, random, intangible bonds of generation so as not to retain responsibility forever. To save myself, I had to give up on him emotionally, as he had often asked me to do, even while clinging to my determination never to slack off in my efforts on his behalf. I would no longer wear him as an albatross. I would work mechanically on his behalf when opportunity presented itself, yet without the enervating hope of success.

Photocopying the entire packet was easy. I asked Drs. Perez and Kalland for their unexpurgated reports to go directly to Doug Sage. (Halfway through his time with Daniel, however, Sage told me that, on the technicality relating to patients' rights, he had been prevented from opening my packet.)

That distasteful job done, I paced, I cried, I went to the attic and screamed, like Medea reviling the Fates from the housetop. But as the hours passed, already I could feel the insidious tentacles of hope reaching out to entangle me with the possibility that Sage might be the one who could reach Daniel, even in six months. I reminded myself of the long string of failures and knew, really knew, that this would be no exception.

Hope is a terrible thing, Hope, a promissory note not worth the parchment on which it's written. I knew even then how trivial this new disappointment was. Compared to Daniel escaping from the twenty-four-hour-a-day treatment at Nova, it was nothing. But a lesser trauma could wreak its damage because I was worn down to a point of exquisite vulnerability.

Twenty-six

Whispers from Daniel's Past

Peter was a rare and wonderful husband. Over the years he has encouraged and supported my professional life, both practice and writing. One way he did this was by giving me the special gift of time, time to work undistracted on papers I wrote for psychiatric journals, and later, poetry. Since I could not concentrate in the chaos of three small children, Peter helped by taking them all to visit his family 120 miles away for a day or two at a time.

I loved to visit my in-laws, but I also loved my times alone, when the footsteps I heard on the old wood floors were my own. Time to be alone was the gift that fueled my interest in writing.

When my three men still living at home went to Crown Point that November, however, I was writing not to convey thoughts but to hide feelings, not to reveal but to conceal. It was time to initiate the Christmas season by addressing Christmas cards. Having outgrown the Victoria-designed, Greenleaf-jederkinder-posed, and Daniel-printed cards of Christmas past, I would use the commercial ones that look naked to out-of-towners without a note on the back. But whenever I had tried to level with people across the years and across the miles, to give some insight into Daniel's *danse macabre,* what returned was an unbearable lack of comprehension—how could it be otherwise with such an atypical story? The worst were the mindless reassurances,

227

including stories about someone the writer knew, once "much worse than Daniel", now doing remarkably well.

Yet how could I blame them? There was no right way for them to respond—no kid gloves soft enough for my prickly skin. And so, in order not to get that kind of response back, I skipped most of my notes and sent the standard cards just as a reminder that we had thought of them. It is truly remarkable, I thought, how problems with an adolescent could touch all phases of life, even Christmas cards.

Reminders of Daniel continued. On television that fall the Balanchine ballet, *The Prodigal,* was presented live from Lincoln Center. Through streaming tears I watched the old man cradle the returned youth in his arms like a child. I knew that as often as I promised myself to look on Daniel as a bad dream from which I had finally awakened, a returned Daniel with signs of remorse would reduce me—or expand me—to a forgiving parent, who would also enfold him in my arms. But through the ballet my heart went out also to the unsung, stay-at-home, nose-to-the-grindstone brother, serving and loving a distracted parent who focused on his errant son and had little time or attention to devote to the non-squeaky wheel.

I conscientiously—and with pleasure—avoided that particular error with Jonathan and David. The four of us went that fall to see the already legendary Marcel Marceau, and the boys' French teacher came up to inquire how they liked the mime. We already had tickets for one of our area's productions of *A Christmas Carol.*

When our sons performed in their junior-high holiday concert in the gym with the uncomfortable bleachers, I saw a woman nudge her neighbor, indicate Jonathan and ask, "Who's that handsome kid—the blond boy in the flute section?" I flushed with pride. I also overheard the mother of Bruce, the genius pothead who hadn't recognized me at the bowling alley, talking to her husband. They were also the parents of Lisa, a childhood playmate of Jonathan's, now an honor student in his class. She said, "The concert is so beautiful—you forget what a horror they are the rest of the year." When the choir sang "Bless the Beasts and Children," I heard other whispers around me, some cynical, none directed to me: "Beasts *sí;* children *no!*" "Beasts, children, what's the difference?"

I hoped nobody in the audience recognized me, and I got out after the concert as fast as I could move Peter.

Watching Mr. Goodman conduct, I was reminded of the disquieting things he said at the special parent-teacher conference he had requested years

earlier. "Dan just keeps creating disturbances. It's as if he's determined to keep us from working together as a band. He acts like such a fool that I'm embarrassed for him. I don't want to throw him out, but sometimes I'm tempted."

"Throw him out if you have to," Peter asserted. "We know you have to think first of the good of the other students and of the band."

"Well, I'll try again. I wish he'd just shape up. Dan has ability and would have more if he'd make the effort."

That was the only parent-teacher conference at which I ever cried. Daniel's response when I told him what his band teacher had said was to accuse Mr. Goodman of drinking at work. To my shame, I was left with a lingering doubt about the teacher. But Daniel's behavior improved temporarily after that conference.

Over the holiday season I was surprised by a call from Iris Wilson, whom I had not heard from since she invited Jonathan and me to an open house at Winslow, where Kevin was attending. We declined because Jonathan loved his public school, and I had wanted all our sons to live at home through high school. I wished I could have suppressed that twinge of envy as I asked about Winslow, meaning, of course, Kevin.

"They threw him out."

"What for?" I asked, wishing I could undo the envy I had felt for her presumably adjusted son.

"For—you'll never believe this—getting into a fight, drunk at a basketball game."

"I'm sorry. Things started off so well." I told Iris, who teaches physiology in a community college, about a study in which levels of certain metabolic chemicals, cyclic adenosine monophosphate and cyclic guanine monophosphate, were found to be higher in the cerebrospinal fluid of men discharged from the army for aggressiveness than in normals. "It's just got to come down to chemistry. Somebody ought to be studying these nucleotides and androgens and everything else they can think of in teenagers like Kevin and Daniel."

I told her about another study that related more specifically to Daniel and me. Adolescents who had as fetuses been at risk of being miscarried because of a shaky pregnancy and therefore the mothers treated with progesterone to preserve the pregnancy, had shown more aggressive behavior up to twenty years later than had their normal controls. "That was exactly what happened in all my pregnancies. Now I have to worry about the younger ones also becoming aggressive teenagers because I was on high doses of progesterone. I'd had to give myself a daily shot when I was bleeding with Jonathan. Now, of course, the experts don't think progesterone does any good anyway."

"I wish they'd hurry up and find out something, but I'm afraid it'll be too late to help ours. I have a friend who says she hopes to live long enough to get revenge by witnessing what her children's children do to them," Iris muttered.

"I don't even want to see any of mine *have* children. I worry that Jonathan and David could be carrying the same bad seed as Daniel and pass it on."

The purpose of Iris' call, it turned out, was to ask whether I knew how to handle for income tax purposes the tuition of a private school recommended for therapeutic purposes, with the added twist of the kid being expelled. I imagine she lost both ways—surely no refund and probably no tax break.

It seemed as if I had taken only a couple deep breaths when we heard from Daniel again. Peter picked up the phone, and it was obvious that another squeeze was on. "What?" yelled Peter. "But you just got there! Why leave so soon? . . . But you have a job. James likes your work and needs you. . . . But you can't be on the move constantly. You need a few more credits to gradu- ate—get them there and work and finish high school. . . . James says he'll find you another place to live—I know he says he can't keep you any more, but stay in Texas. . . . What's this about Peoria now? That's no place for you. . . . But you don't need diesel school! You're no good in mechanics. . . . What's that? That's nonsense. The people there are no different from any others. The court sent you there to make a new start. Make something of your opportu- nities. . . . What do you mean 'put you in jail'? What are you up to that anybody should be putting you in jail? Stay out of jail the same way I do! What in the hell is the matter with you? You can't run every time you don't like something!" And so on for half an hour.

"What's this talk about jail?" I asked, after he hung up and leaned back in his leather lounger, drained.

"Oh, you know, it's just talk. He says he thinks they might pick him up for something," he replied evasively.

"Yeah," I replied, making a mental note to find out. "And what's this about leaving? Hasn't it percolated to that kid's brain yet that he's on probation and can't leave for the duration?"

"He says they'd let him come back here if we agreed."

"I can believe that. They'd just love to solve one of Texas' problems by making it Illinois'. But what does he mean by 'back here' and for what?"

"To live with somebody he knows in Peoria."

"With whom in Peoria?"

"I don't know. I didn't ask."

"You *never* ask the next right question. I don't trust anybody he knows in

Peoria. There'd be no supervision at all for a kid who's not making it under the flimsy controls they're able to impose in Texas. It's lunacy. As you said, what's to be gained by all this running? He's already attended five high schools."

"Five? He hasn't been to five. How do you get five?"

"I wish you'd stop contradicting me without thinking. Can't you count? Evanston High, Telopia Park in Australia, Pleasant Valley, Nova's school for a few days, and now Alamo down with James. What's he running from this time?"

"He says they're all rednecks down there," said Peter.

"Whatever that means. And what's this about James finding him another place to live?"

"James called the other night when you were out, and told me he'll have to find Dan another place because James has too many evening meetings and is away too much. He says there's an apartment building called the Haystack, where semi-emancipated kids stay and the parents pay the rent. It's kind of a transition to leaving home. James is looking into getting him a place there."

"I know we can't make James keep Daniel, and I wouldn't try—again. I can't blame James for having his fill of him. But how does bad behavior make a teenager 'semi-emancipated'? What's this fiction of adult status? Why should a record in Juvenile Court in one state and Criminal Court in another entitle a teenager to an apartment? Why should any kid who isn't earning the rent have an apartment? Where is it written that your own apartment is a middle-class perk? Daniel has been given and given, but none of it has ever done anything to solve the root problem. When will this ever stop? I stand in awe of a system in which, if a child won't live by our rules, we subsidize his living by his own. But apartment or no apartment, I got him a six-months' probation with mandatory counseling, and I don't intend to scuttle it for some hare-brained move to Peoria."

"That's what I told him." And for once Peter and I were acting together on Daniel's behalf, against his wishes.

The next morning I was on the phone. Jenny Hand couldn't shed any light on the line about jail, and she pointed out that she would be the first to hear about any new complaints. It was apparently a real-life red herring. She added that she had no intention of terminating probation, certainly not if we didn't request it. But she had heard from the counselor about Daniel's request to go to diesel school in Peoria and live with someone named Brett Lamb.

"Brett Lamb," I gasped. "But that's a boy from here. How did all this come about?"

"Evidently they've been in contact, but I don't know any more about it than that, except that apparently Brett's in diesel school in Peoria."

"Daniel has never shown a particle of interest or aptitude in any kind of mechanics. Not that I have anything against Brett Lamb," I went on. "The

231

worst I've heard about him is this news that he seems to like Daniel. To the best of my knowledge he's never been in any trouble, not in Evanston anyway." I told her of my conversation with Mrs. Lamb a year and a half earlier. "Please, Miss Hand, don't change anything now. We'd like to see Dan stop running and finish something."

"Of course not letting him have his way may just make him more rebellious."

"But that's blackmail, kowtowing to his incessant demands. Besides, letting him have his way never made him any less rebellious."

She agreed to hold firm. "Of course what he does after the termination of probation is beyond my control."

"How well I know!"

The receiver had no chance to cool off before I had Doug Sage on the line. "What do you know about this absurd request of Daniel's to go to Peoria?" I asked.

"Only that Daniel would like to go live with friends named Brett Lamb and Kurt Duncan, and go to diesel school."

"Kurt Duncan!" I cried. "He's the one that the Evanston juvenile officer said was one of the two worst influences in town, second only to Scott Sawyer, the one Daniel got in trouble with before. Please, if Jenny Hand asks for an opinion, don't go along with this asinine scheme. That would be from the frying pan into the fire."

"Don't worry, Dr. Greenleaf. I don't think he should leave either. He's just beginning to make an adjustment here and get to know me."

"Is there any special reason for this push to leave?"

"Not that I know of."

"Can you explain his talk to his father about being put back in jail?"

"Jail? This is the first I heard of that."

"That's what Jenny Hand said, too. But with Daniel you never know. The only certainty is uncertainty. "

I was immediately back on the phone to Jenny Hand to alert her that Daniel's attraction to Peoria was not just the innocent Lamb boy but also Kurt, the boy with a juvenile record here in Evanston.

That evening I dialed Mrs. Lamb's number. "Oh, God, what are you calling for?" she almost wailed when I identified myself.

I could hardly blame Mrs. Lamb for the fact of Daniel's making me an unwelcome caller, but I registered anger with Daniel that I should be tarred with the same brush. In a tone intended to imply that we were on the same side, and enlist her cooperation, I updated her on what I had learned.

She sounded wary and suspicious. "I don't want Daniel around Brett" was all she would say at first.

In an effort to learn more, I let her know that I was trying to keep them apart. "We don't want Daniel in Illinois either. Believe me, we're doing everything we can to prevent it."

"Why did this have to happen now?" she asked, not of me but of Fate.

"Why do you say 'now'?"

"It's less than a month since we dragged Brett back from the brink of death."

"I can't tell you how sorry I am. Is he all right?" I was truly concerned, but I could also tell I would have to be politic or she would hang up.

"Yes, thank God we were in time to get him to the hospital." She didn't say more, but seemed more willing to talk about Kurt Duncan's mother. "Fran Duncan and my husband and I went to visit the boys. I feel so sorry for her. She's spent the past few years trying to get Kurt straightened out. She's had terrible problems with him, and like any mother, she loves him and is trying to get him back on the path. It's been a hard row for her to hoe."

I slipped naturally into my best interviewing technique. "Doesn't Kurt's father help?"

"No, he disappeared after they were divorced when Kurt was ten. It's been hard. She's had to bring Kurt up alone."

"And we know the thanks she got from Kurt. He's the one I tried to get Daniel away from, the same way you've been trying to keep Brett away from Daniel. And I always figured Kurt must have come from an uncaring family to be so rotten. Now that I know, my heart goes out to her too. Is he her only one?"

"Yes, and in a way that makes it harder. I have Brett's older brother, who is doing well in his own little business and advises me about Brett—you know, to keep him away from Daniel. He's a comfort to me. You have one or two younger ones, don't you?"

"Yes, and they're sort of a consolation for Daniel. Has Kurt been in any more trouble lately?"

"Not so far as I know. ...Isn't Daniel that kid that they all say is so brilliant?"

"Oh, yes, but only in theory. In practice he doesn't learn from experience. He also doesn't learn the values we've been trying to teach. He's defiant and stubborn, and determined to have his own headstrong way."

"Please don't call Brett and let him know we talked."

"Oh, I had no intention to, even if you hadn't asked. And I'll do everything in my power to keep Daniel in Texas."

"Good luck with Daniel."

"Thank you. I hope Brett is O.K., and Kurt too."

The next morning I told Jenny Hand about my call to Mrs. Lamb. "Now I've found out that Dan's proposed roommate has had a close brush with death, according to his mother. It sounds suicidal or drug-related. Otherwise, why, when she told about getting him to the hospital, wouldn't she have added something like, 'Brett's a diabetic and had an insulin reaction'? Since she told me only that much, I can't think of an alternative."

I also told Daniel's counselor, Doug Sage. "It could have been what is commonly called an 'overdose', though I don't use that term for something for which there's no legitimate dose."

As the days grew shorter, Whitepaw waned. First she could just go out in back for the necessary functions but not run, just lie in the warm sun of autumn. Despite treatment with steroids, her energy level declined so much that she could no longer manage the rawhide treats she'd always loved. "It won't be long, old friend," I whispered.

I recalled the happy days when Daniel and Whitepaw were juveniles together. He was in first grade when this frisky, mostly black, mostly collie (a 'purebred mongrel', as Peter called her) followed him home from the school bus. We agreed that he should have her, and he picked an appropriate name for the dog that of an Indian guide. Pregnant when she arrived, she had seven puppies that Daniel and I helped deliver. We ran a dog adoption agency and found good homes for them.

Whitepaw's tumor grew, and she needed more medication. Then she stopped eating solids and I had to help her drink protein supplements from a syringe. She was tired, but not in pain. I was surprised that she survived through Thanksgiving, but in early December she died in her sleep. We buried her with Sappho and Sybil (her older step-siblings), and Jumper (the guinea pig) and Pompeii and Vesuvius (the seahorses Daniel had named) and Godspell (the cayman that the grandmother of Peter's little patient from Florida had given the boys, that had nipped nearsighted Jonathan's nose—how many can claim to have survived an alligator bite?). Our burial plot for pets was filling up.

Twenty-seven

Two Brothers
Studying Reptiles

A FEW WEEKS LATER, on Christmas morning, I once again let myself dream and hope. The phone bill had carried the legend, "A long distance call is a smiling, happy way to visit someone far away." James had sent a Polaroid picture of Daniel holding his cousin's baby and smiling into his face. "Maybe he finally sees what we're all trying to do for him," I thought.

I Walter Mittyed a fantasy of myself as the parent of a son who would now call to say he had finally reached that critical juncture at which to return to the life he had grown up with, and that he was sorry for what he had done to himself and us.

That afternoon the real call came. Again Daniel demanded to move to Illinois, and Peter loudly pointed out the folly of incessant moves.

James also came to the phone, and the three of us rehashed the subject of the apartment for Daniel. Through no fault of Peter's or James's, I felt rage well up in me again. "Why," I screamed, "why should this bastard be subsidized instead of controlled? Why should we give him the perk of a reasonable adult wage earner and taxpayer, an apartment on which *we* pay the rent? Why do we as a society let atrocious behavior command rewards instead of punishments? Why do we tolerate it and act out the fiction that it's somehow normal? Why do we let him exploit and use us so shamefully? Why do we do *more* for sociopaths? Why not just let them do without?

235

Why not do more for normal people, or for underprivileged gifted?" I added, "Why not do something for me and my pain?" Tears of self-pity and fury streamed down my face.

When Peter, the boys, and I finally sat down to the cold turkey, I told Peter, "At least you could have told him how tenderly I nursed his dog," though I hadn't thought, either, when we had him on the line, to tell Daniel of Whitepaw's death.

Those days I felt as though I was gradually giving way to a current pushing me in the wrong direction. There seemed no place for Daniel but that apartment, and of course the car had already been purchased. Phone calls multiplied, and one letter arrived from Daniel:

Dear Dad,

My report card came a few days ago and the grades were better. About half an hour ago I took my senior pictures at Fred Potter Studios. They were $97.50 and you get at least nine pictures, six in a suit, three in a cap and gown.

Alamo is a good school, best in West Texas. (But that is saying nothing.) Its academic and athletic programs aren't what make it good, but the people that go there. Public schools in Golden seem to be revolving around fighting. They get gangs together to go out and beat heads. Craig Warren (a friend from Alamo) got his ass kicked even though he was going to Alamo.

There was a going-out-of-business sale at a clothing warehouse; most merchandise was more than fifty percent off. I bought a jeans jacket, shirt, and pants for fourteen dollars. The jacket alone sells for twenty-eight. Could you give me seven dollars for the pants? (A twenty-two dollar value.)

Jim and Charmaine [James's daughter and son-in-law] will probably be coming over for Christmas. James throws a party every Christmas Eve. Everyone in town must know about it by now. Charmaine's baby is able to stand up and walk. (If he is holding on to something.) That has to be the finest baby I've ever seen.

Could you tell my mother to quit hassling me? Yesterday my drug counselor told me she sent down a lot of psychiatric bullshit to some doctor. Included were some of my court orders (I don't know if they're new or old ones), which are no one's business down here. In fourteen days she will not be able to do anything. Next time I see my drug counselor I'll be able to see what she sent.

I've received many college brochures but few sound interesting. I want to go either to a big school in a small town or a small

school in a big town. What I'm trying to say is, I'd like to be in a large community (either the school, the town, or both). I don't really know why, but I need to get the big city life out of my system.

A letter just came from Austin where they still have the boots I wanted. They're $125 (old price, the new one is $147, two years ago they were around $100), but the money I've saved is going to the car. It needs a tune-up and undercoating. If you'll pay half, I'll either get the money from Superior (my passbook is in Maine. Could you talk to these people for me?) or owe it to James.

Merry Christmas to the family.

Dan

P.S. If J & D both want the shirt, have them flip for it. Tell them to give you (& send) my ski hat & gloves because I'm tired of them keeping them.

"Why should a delinquent have $125 boots?" I asked, but it was a rhetorical question. At every turn Daniel was becoming more expensive, and Peter tried to hide some of these expenses from me, partly to reduce our incessant fighting. Money had become Daniel's reward for behavior that was eroding so many once-happy lives.

"Be sure there's money in the bank," Peter called over his shoulder one morning as he left for the hospital. "I wrote a check to James for $915."

"Hold it. Wait a minute! Stop! $915? Where did you get that figure? What chicanery is going on now?"

"Well, there's $230 a month for rent, and a security deposit of $150. Then they spent a couple hundred on clothes and a haircut."

"A haircut's an improvement. But my quick addition brings that only to $580. What about the rest?"

"Don't forget about replacing that windshield that the kids in the neighborhood threw a brick through, and of course we didn't get anything but liability insurance on that old Chevy."

"Yeah, I never believed that windshield story either, but I know a windshield can come to over $150, but that still leaves close to $200. What about that?"

"There were other troubles with that eight-year-old car. James helped him get it into safe running condition."

"Of course James can't be left holding the bag, and I'll move money from the savings account to cover that check, but I want you to know that I don't believe Daniel, or, at this point, you. I think you're hiding something, and just remember that I didn't hide what I was doing with the stocks."

During the months of Daniel's school year I continued to be in contact with the Texas people. To buy freedom for myself, I used my Worst First

principle on the Daniel jobs so as to convert the rest of any day into a normal, hectic, but nontraumatizing mother-wife-doctor-person day.

I told Jenny Hand, the sympathetic probation officer, of my skepticism about the money leakage following so soon after Daniel's strange talk about returning to jail.

When I paused for breath, she interrupted. "Dr. Greenleaf, I have to tell you that we've had sort of a shakeup here, and in the process Dan's case got transferred back to Tony Shelby. He'll be the one you contact about Daniel from now on." So we were back to Shelby, and I had no objections to him, but to the instability of incessant change. I ended my call to Shelby with, "You won't let Daniel leave, will you?"

"Let me put it this way. If the parents were to ask, I would certainly let him return home, but not to live with peers."

As we discussed Daniel's recent history, I detected an edge in Shelby's voice. He sounded less sympathetic than when we had first talked. He was getting tired of Daniel, me, the whole affair.

He went on, "But of course what Dan does or doesn't do after probation ends, I have no control over. I understand he just turned eighteen too, and that makes him of age."

"Unfortunately. That's why I've spent the last year and a half trying to get somebody to back me on something definitive for him."

Shelby admitted, "I told him he could get an apartment of his own that he's been asking for, and apparently his uncle agreed."

"Agreed! He can hardly wait to get rid of him, and I can't say I blame him. It isn't the money. I'm outraged over the principle of setting up a delinquent like a bride in an apartment of his own because nobody can stand him."

"His uncle says he's making a good adjustment in all ways."

"His uncle's and his father's idea of 'good adjustment' consists of not having heard anything bad lately. Also, their way of helping is to look at only the surface, believe whatever he says, minimize, ignore, cover for him, gloss over, and come up with money. What about that $915?"

Shelby couldn't explain the total either.

I immediately dialed Doug Sage and was told he was out of town until after New Year's.

Having done what I could for Daniel, I was temporarily out from under that burden. While Jonathan and David were taking advantage of the Christmas break to sleep late, I turned my attention to my long-neglected home office, since I would need a new work area. In one pile I found a piece of paper with Daniel's writing in pencil, that I could not remember ever having seen before. It was written as a list: stage fright, upstage, downstage, ginseng root, dried roots. Most likely drug terms, I surmised. At the bottom of another pile I

238

found a runaway note dated from when Daniel was fourteen, which I had forgotten about, from an occasion when he went to the Martins' for about an hour. It said:

> Dear Mom and Dad,
> I know I've almost ruined your marriage. I'm sorry! Mom always talks of getting me out of the house so I'll get out myself. You both think I'm a shlunk, and I am! You don't like my grades in school, but I'll try harder. I'm going to try to make something out of my mind. I'll try not to be an atheist. I'll try to see Grandma.
> Your still loving son,
> Daniel
> P.S. I'll always treasure what you have done for me. Now I'm going to do something for you.

That note's remorseful tone tore at me. When had we reached the point of no return, or had we? I photocopied it and sent it to Daniel in a plain envelope in hopes it would stir something in him before he had a chance to destroy it as a message from me. To the bottom I added my note: "I'm glad you've followed through on the part about your mind. Now, when will you learn to live morally? Love, Mom."

That Saturday afternoon I happened to be alone when the phone rang. "Is Dad there?" I reached for a clipboard because I had begun taking notes on phone calls and everything else pertaining to Daniel.

"No, how are you?"

"Give me the number on the MasterCard. I need some things for the apartment."

"What things? We'll send you what you need."

"Dad said I could buy them. Just read me the number."

"I'm not Dad, and I don't see furnishing an apartment for you for a few months as the way to help you. Besides, how do I know he said that?" Of course that would have been Peter's way, and I should not have led with the chin.

"Well, fuck you! I don't like all this shit you heap on me!"

"And I don't appreciate your language. I understand your behavior down there has been pretty bad lately." (I was fishing for anything I could learn, but Daniel was too slick to fall for it.)

"Well, aren't you the Calvinist minister now?"

"My standards are the same as always."

"I don't like you at all. Get off my case! I happen to know you called my P.O. just two days ago. Why don't you leave me alone? I haven't bothered

you since you threw me out of the house and the family."

"I told you to get out, yes, but you're the one who really defected. You rejected everything we stood for, standards and values, and turned your back on us and our love for you."

"You used to hit me with the wooden spoon!"

"Yes, that too, after I had escalated through the verbal appeals. What did I teach you that ever got through?"

"Why don't you let me live my own life and quit butting in?"

"What do you mean 'let you live your own life'? Your father just sent almost a thousand dollars! What more do you want?"

"And sending me to Nova! You *had me kidnapped!*"

"You bet I did! Exactly what you needed!"

"You smiled when they said they'd break my arms."

"Are you confusing us with your playmate who broke your shoulder?"

"And when that guerilla said he'd break my leg—"

"Well, which was it, arms or leg?"

"What difference does it make? Why did you send me to Nova?"

"Because we wanted them to cure you!"

"Bullshit! I don't even want to talk to you. I—"

"Daniel, you talked to me reasonably when your father was in Switzerland. Try again."

"I try to be nice to you, and where does it get me? I don't know why I try. Just *gimme the credit card number!*" he shouted.

"It's astounding to me that you think that by increasing the loudness of your demands you can intimidate me into changing my mind. You know I've never backed down in the face of decibels. It's a long time since you've wanted anything of real value that I could give you. Morality, a sense of integrity, the excitement of using a first-class mind—these are what I had to offer and you rejected. I don't have money or credit cards for you."

"I don't like you at all. In fact I hate you. Fuck you anyway. And sending all those lies about me to my P. O.!"

"Daniel, I've gone to everybody that I thought had a snowball's chance in hell of getting through to you by holding you still and making you listen. I don't tell people your misdeeds out of pride. I wanted to be proud of you and your life and I wanted you to be happy in a socially responsible way, happy as a byproduct of doing worthwhile things. I hoped someone down there might be able to teach you what it means to be human. But it looks more and more hopeless. I saw you as somebody too good to waste, and that meant stopping your self-destruction. There was a time when if somebody had given me the choice between my life and yours, I'd have gladly given mine, but no more. You're not worth it." By then the connection had been broken.

240

I wandered aimlessly through the empty downstairs and cried. I remembered that in *The Gulag*, Solzhenitsyn observed that when an individual does enough evil, he becomes evil. Had Daniel reached that point?

When Jonathan came downstairs, he could tell that I was hurting over Daniel again and patted my shoulder while I murmured, "Don't ever do anything like this to yourself or me or us." At fourteen, he could hardly know what to say, but his tenderness comforted me. I was also grateful that he seemed to be at peace with himself, wasn't driven by whatever demon was driving his brother. So far as I could tell, he had no flowers of evil blooming in his soul. He could love and return love.

I had always been aware that my younger sons' lives were also valuable and that each day, each week, each month would not return for them, any more than for anyone else. Consequently I never failed to take advantage of whatever opportunities for them presented themselves. With the approach of the New Year, the change in myself was my resolve not to let the poison from Daniel seep endlessly through our home, but to do these things with joy, even in the shadow of Daniel's spiritual death. *Carpe diem.*

A few nights later the phone rang just as Jonathan and I were heading out the door to see Mr. Crosby, a retired high school science teacher who served as a Scouting merit badge counselor. Jonathan had made an appointment to be examined on his reptile studies, his last badge for his Eagle award in Scouts, just as Daniel had done with Mr. Crosby an eon earlier. I hesitated in case the call was from one of my patients. Instead, I reached for my clipboard to log it in, as I heard Peter yell: "What did you do such a damn-fool thing as that for? Why don't you stay out of jail the same way I do? . . . No, I don't want your money. Your uncle shouldn't have to pay either. Put James on—I want to talk to him. . . . I know you can't baby-sit him, but we don't want him in Peoria! We've talked to the parents of those kids, and they don't want him there either. He's a bad influence on them and vice versa. . . . Look, he's lied to me more years than he's lied to you. No, I don't take any responsibility for the way he is. I've spent years with him. I've been in Indian Guides and Scouts. . . . The same with her. She's also tried to teach him and work with him and offered enriching experiences. . . . Ever since fifth grade we've been getting called in about his bad behavior and conduct marks. Nova couldn't hold him, and the school for kids with social problems threw him out. . . . What good is a *haircut* in all this? What do you want me to do—send a medal?. . . No, we'll send the money. Money isn't the issue. It's how long this kind of life can go on."

Apparently the authorities never caught up with whatever it was because there was no other jail incident in Texas.

That call delayed Jonathan and me, making us half an hour late to Mr. Crosby's. It also destroyed my mood of tranquillity. I had been anticipating our trip with pleasure and had hoped not to hurry home after Jonathan's session, but to linger and talk about books with this retired teacher, a member of another Great Books group. As I drove, I knew I also wanted to tell Mr. Crosby about Daniel. Like one of T. S. Eliot's characters in *The Cocktail Party,* I yearned for the luxury of confiding in a stranger.

I rehearsed what I hoped to say, especially if he should link the name Greenleaf with the Daniel who had so impressed him several years earlier. Something like "You don't know real pain until you wish your child would die so you could find peace."

But Mr. Crosby had suffered his own losses—his wife was no longer there—and seemed preoccupied as he took our coats. I settled into the comfortable chair he gave me in the living room, my mind half on the *National Geographic* I had brought, half on the words I heard from the kitchen, about the olfactory apparatus of the pit viper.

Mr. Crosby didn't suggest we stay. As he helped me with my coat, he said, "I rarely have a boy as well prepared as Jonathan."

"That's exactly what you said several years ago about his older brother Daniel," I replied, but Mr. Crosby had also suffered losses in his hearing. Suddenly realizing that, after all that had gone before, I was still trying to take parental pride in Daniel, I felt myself blush. I turned away, but Mr. Crosby gave no sign of noticing.

I promised myself then that I would never again try to salvage any pride in Daniel. David had been reading *Gone With the Wind,* and as we talked about the book, he had quoted Scarlett O'Hara's famous line, "As God is my witness, I'll never go hungry again."

As we drove home, I vowed: "As God is my witness, I won't bootleg pride in Daniel again. But I will take care of myself. This is my year to be healed."

Twenty-eight

From Defensive to Offensive

THE LAST DAY OF THE YEAR I had a long morning of outpatients, followed by a visit to the ward to see my only inpatient, Forrest, a schizophrenic of twenty-three. His disease had blossomed under the encouragement of street drugs, causing him to speak back to the phantoms in his mind. His mother had been my friend since the days when Forrest's younger brother was a classmate and Indian Guide brother of Jonathan's. The circle was completed by the fact that Forrest had been plied with drugs by his roommate, the son of Judge McDervott, the very judge who had questioned Daniel regarding Scott Sawyer's part in the Nature Center break-in. Evidently, the judge was no more immune from problems in his children than were we, despite working in his professional way toward a healthy society.

As I put on my coat, I heard the paging operator, who referred me to Dr. Blauschild in Intensive Care. I was puzzled because he was a neurosurgeon who had never before referred a patient to me.

"Dr. Blauschild, this is Victoria Greenleaf. You must want my husband Peter. I'm a psychiatrist."

"No, you're the one. I want you to see a girl of sixteen who attempted suicide. They tell me you're great with teenagers."

"I wish! I'll be glad to see her, but I'm skeptical about the teenage part. I don't know anyone who's really good with that age. What pills did she take?"

"She shot herself through the face."

"Good Lord! I'll be right up."

Blauschild related the facts of Megan's case. With her father's gun she had put a bullet through the front part of the right side of her face. This gunshot had done miraculously little damage for having been fired at point-blank range, but the bony socket of her right eye had been fragmented, and how much usable vision she would have was as yet undetermined. There would have to be eye repair and facial plastic surgery.

"Why did she do it?" I asked, horrified. "Why?"

"You're not going to believe this. I have trouble believing it myself. She says she did it so she wouldn't have to go to school. She said she couldn't take the pressure they put on her about drugs."

"Young people use terrible ways to solve problems," I gasped. "They see the problems as permanent but not their proposed solutions. I haven't seen your girl, but I can tell you one thing without laying eyes on her—a suicide attempt with firearms has serious implications, psychiatric as well as medical. Many, many teenaged girls make suicide attempts by swallowing a handful of pills but then call for help. Attempts with firearms are in an entirely different category. Almost no females of any age ever use guns, but when persons of either sex or any age hold a gun against the head, they're obviously very serious about killing themselves. Fortunately your girl was a lousy shot."

Blauschild told me about the other specialists he had called in to evaluate the damage to her face and head.

I talked to Megan, transferred her to my service on psychiatry, ordered suicide precautions, and began coordinating plans by the various consultants, including an otolaryngologist, when it became apparent that her ear drum had ruptured from the pressure change at time of impact. I talked to her parents, both for history and evaluation, and to assess their strengths for help in her future care. And I began to work on the underlying psychiatric problems that had made Megan more vulnerable than other teenagers to negative peer pressures.

When I did rounds on New Year's Eve day, I found Megan's parents visiting her, as well as her unkempt, greasy-looking nineteen-year-old brother, Sean, who accosted me. "I want to talk to you."

"That's not how people arrange to see me."

"Sorry. May I have a word with you?"

"I'll be glad to. Wait for me in the lounge, and I'll be there in about twenty minutes."

When we were settled in comfortable chairs, Sean reached for a cigarette.

"Not here," I said. "I don't care to breathe your smoke." He put away the pack.

"I appreciate your wish to help your sister by coming to me. What can you tell me about all this?"

He gulped and looked at the floor. After a few seconds he began in jerky fashion replete with "like"'s and "y'know"'s to relate how, as a self-designated leader of the druggies at their high school, he had been responsible for the greater-than-normal pressure on Megan that, along with her innate fragility, had led to her attempted solution by suicide. He told me that just a week earlier Megan had ingested pills, which Sean wanted me to be sure to be aware of, lest Megan conceal it from me. In teenage fashion he had not "betrayed" Megan at the time of the pill ingestion by going to anyone with maturity and judgment, like their parents. He realized that this could have been a fatal blunder.

"What else can you add?" I drummed a paradiddle on the arm of the chair.

"I guess that's about it." Sean heaved a deep sigh.

I sat motionless for a couple minutes, to give Sean time to squirm. "Now I talk, you contemptible punk! You guys and your 'now' generation and your 'rights'. You play God with the health and lives of others, including your own sister. You're like an armored tank running over everything in its path. You don't give a tinker's dam for the harm and future harm you do yourself, your family, and other kids like yourselves. Some of your 'me-first' generation will live out their lives with whatever physical and emotional harm this has done, maybe even damaging genes that may injure children who have the misfortune to be born to you. Then, who knows? Maybe ten or twenty years from now you'll deign to grow up. Someday you might accept responsibility for your acts. You might even be 'sorry' for the hurt you can't correct, as if that could put your sister's head back together. . . . You're a big man, all right! Well, you can shove it. Megan won't have depth perception, so she'll be a dangerous driver if she ever drives at all. She'll see only light and dark out of that eye as long as she lives. . . . I hope you carry guilt for this to your grave." I paused to let this sink in. "Tell me if I've said anything that wasn't true."

Sean had long since stopped squirming in his seat and was by then staring straight ahead, the blood drained out of his face. "No," he said, "I guess I deserved that."

"You deserved one hell of a lot more, you and the rest of your 'if-it-feels-good-do-it' generation. You guys who favor 'telling it like it is' really ought to love me." We sat silent as I let him reflect on that. Finally I admitted grudgingly, "It does you credit that you faced your part in all this and came to me. That's more than some acid heads would do." Including my son, I thought, as we both left the lounge.

I remember wishing that something short of a gunshot wound would make Daniel change course, as I suspected Sean might now do. On sober reflection, I decided I'd settle for a change even with gunshot wound, though not to an innocent bystander.

Peter and I spent New Year's Eve at home and once again chewed over the options about Daniel, including another try for Nova. Having been defeated in the first Nova attempt, when he had not yet been of age, the prospect seemed hopeless in the unfamiliar terrain of Texas. My hope had finally died that anyone like Dr. Franklin could ever contain and change Daniel. In its place I felt a leaden mantle settle on my shoulders, which made everything I did or thought an added cost in effort and will, like driving a car with the brakes on.

As we talked, I let Peter know once more that I didn't approve of setting Daniel up in the Haystack, supervised, if you can call it that, by a landlord whose interest in him was rent, in an apartment building for young people whose parents couldn't tolerate them at home. The whole solution was antithetical to my belief that you should grow up expecting to have to work for whatever you needed and wanted, eventually enjoying the fruits of labor. For Daniel to be given an apartment did not jibe with what I had tried to teach the children about ways and means. Waiting while working for things might even teach the need to work toward more than minimal-wage jobs, like James'. But, as usual, there wasn't time for that lesson—Daniel had to be billeted somewhere.

Peter's wishful thinking had led him to buy into their idea of the Haystack as a launching platform toward adult living and responsibility. He quoted James as saying that the landlord held his young tenants to reasonable standards of conduct. He thought (hoped?) this would help Daniel's self-image.

I was more than dubious. "He was held to middle-class standards for sixteen years, with the results that now confront us. Surely you can't think that a businessman babysitting Daniel can achieve what hasn't been accomplished by a Juvenile Court, an Adult Court, a drug rehabilitation counselor, probation officer, Pleasant Valley, Dr. Perez, James, Nova, etc., ad nauseam. You *are* gullible." But I had nothing else to suggest.

"It's eleven-thirty, half an hour to the New Year," Peter remarked.

He made tea, and I had an orange. "To a better New Year for all of us," I toasted.

"*Na zdrovye!* To health with you!" I laughed as a dutiful wife at one of his old jokes. "Is there anything else you want to bring up?" he asked.

"Two things, and tomorrow all four of us can sleep late. I don't know what Daniel's done this time, and I guess I don't want to know, but I do know you're hiding something—all the talk about jail and the unaccounted money—but I have my suspicions. And I want to put you on notice, in advance, just in case.

"I want you to know that if Daniel is ever responsible for a pregnancy and the child is killed, I will never have anything more to do with him. I think it's both grim and ghastly that our young take their pleasure over the bodies of their own children. Furthermore if you aid, abet, or pay for such a death, I will leave you. I couldn't stay with anyone who sacrificed *anyone's* grandchild, least of all his own."

"The Supreme Court doesn't uphold you."

"Screw the Supreme Court. Each of the justices, just like you and me, was once a fetus indistinguishable from those they now permit to be destroyed. They ought to make them just look at the dead little bodies before they do their ruling. Remember Winston in Orwell's *1984,* how the one thing he couldn't stand was the very thing they used against him, the rats on his face? Well, the one thing I can't stand is the thought of the mangled little corpses in their absolute and complete innocence and defenselessness. . . . I would adopt a child of Daniel's, if it came to that. One of the psychiatrists out at Kewaunee did just that, and she's raising her little granddaughter, while her son continues messing up his life."

Peter's face was impassive, while his voice said, "I understand. What was the second thing you want to tell me?"

"In the coming year, my life will be taking a new turn, and I know it will make life harder for all of us. I've come to the realization that working with patients, privately or in the clinics, usually helps them, or most of them, and often has an indirect beneficial effect on their families. The papers I publish also are intended to have a ripple effect on other patients via the psychiatrists who read them. But how many people can one psychiatrist actually benefit in a professional lifetime? Ten thousand maybe. All my efforts can't really be expected to make more than a ripple in the ocean of human misery. With what street drugs are doing, and the permissiveness and irresponsibility our society fosters, and all the other things that are loosening the social fabric, I think we're entering a kind of mini Dark Age. I want to do something to try to reverse this trend—something I hope will do more good than anything I can accomplish with one individual at a time."

While I stopped to organize my thoughts, Peter asked, "And what might that be?"

"I plan to write a book about my life as the mother of Daniel."

Twenty-nine

Musical Couches

PETER WAS DUBIOUS, RELUCTANT, unenthusiastic, and actively negative about my book project, but neither then nor in the subsequent years did he ever try to alter my course, since he has always subscribed to the principle that we must all live our own lives, I no less than he.

On January 2, I called to explain to Doug Sage my idea of writing a first person, participant-observer account of my life as Daniel's mother and how it could affect his treatment. But Doug also had news: he had to relocate in order to serve as protective guardian for a paranoid schizophrenic brother.

"That speaks well for you," I told him. "Most young people wouldn't want their lives messed up by caring for a sick relative, even a brother, and who can blame them? I'm glad you care. He probably doesn't realize how lucky he is to have a brother who will watch out for him. If Daniel ever needs a guardian, I don't know whether Jonathan or David could or would do it for him. . . . But this is a blow for Daniel to lose you. Can you tell me who'll be getting him? I have a new idea to talk over with his counselor. I am starting to write a book about my life with a sociopathic son. It might serve as a mirror—to show him, to confront him, to ensure that he doesn't not look, that he can't not see."

And so, with just three and a half months of probation left, Doug referred me back to his supervisor, Donna Marquardt, who would be reassigning Daniel's case. Her imagination was piqued by my idea of sending his therapist my first draft for use in therapy. She considered keeping Daniel herself

for this experimental fillip of treatment, wavered, finally decided on another young man, Cory Jaycox.

I sounded like a broken record as I explained to Jaycox that he would be getting a young man who had sat through many counselors and counseling sessions but remained laid back and unengaged. I explained my idea for a kind of shock therapy in the form of confrontation with the scenario of his life. "I'm not too optimistic, but I keep trying."

Cory Jaycox, in his soothing cowboy drawl, agreed to try my method.

The weeks of January evaporated as I sorted my notes, cudgeled my brain, planned my more lacerating chapters to write first, and wrote almost as fast as I could type. Each week two copies flew to Texas, one each for Daniel and Cory. I also wrote another letter to Daniel, offering him the chance to write the last chapter, once he returned to normal living.

Problems were surfacing in my own life too. That month I lost my job at a mental health clinic. Actually I quit, angry because the director cut my time from two half-days to one. I knew that budgetary requirements were behind that, but also I was aware of having been snappish with the staff, which I could relate to my own family pressures. I detected a reserve in the director and suspected that she would be happy to see less of me.

Still, allowing for all that, I felt ill used by the director for yet another reason. A week prior she had called the staff together to tell us that her husband's "mole" had really been a malignant melanoma, and that the G.P. was planning to "watch" the area of removal. As a conscientious physician, I went to her office directly and confronted her privately with the fact that watching for a recurrence of a melanoma is malpractice and that a G.P. has no place in cancer treatment. I referred her husband to the correct specialist, who saved his life.

It felt to me as if by doing what she had to do as clinic director, reducing my hours, she was rewarding me in the classical manner for the bearer of bad news.

Losing the clinic job was not like being suddenly thrown out of a full-time job, since I also had my own private practice. Losing those paid hours reminded me of the time I lost a re-election but won a year of freedom. What I regretted in losing that job was the loss of a professional opportunity I had hoped to pursue at the clinic.

During those months and years I spent besieged by new problems Daniel was throwing at me and having to choose among unattractive alternatives, I was aware of no longer enjoying even my normal sons as I would have wished, and as their lives warranted. While I never compromised our life together, the sweetness had gone out of it. I found myself thinking thoughts I wished would not have arisen. Considering what a time and energy and emotion sink Daniel had become, with no sign of change in the future (though I never spared myself in working for that change), I found myself wishing I had never had him, though I fought that realization. Not only did I rue the day I'd had Daniel, but I asked myself the question whether, had I known in advance that the "package" would include all three sons, I would have had any children, whether the joy I felt in Jonathan and David warranted my grief with Daniel. I didn't wish for such thoughts; they seized me. Scrutinizing myself, I was willing to acknowledge that perhaps I should consider myself as not mother material. Maybe I wouldn't have been qualified to be a mother even without Daniel and even if I'd had only children who were essentially within the large, ill-defined category of "normal".

Of course there is no such option. We take potluck with our children one by one, just as they take potluck with us.

I was shocked, about that same time, to read a column of Anne Landers' in which she cited one of her surveys in which she found seventy percent of women saying that if doing it over, they would not have children. Of course her uncontrolled surveys elicited a disproportionate number of responses from the disenchanted like myself.

Meanwhile, I tried to turn these questionings to a useful purpose. This is where the mental health clinic fit in. I was beginning to plan a study to be done there, intended to determine whether there are personality types that may be of predictive value in determining which people, women in particular, are likely to find parenthood a rewarding experience, and to which women we might be able to say, "We find that women with certain traits like yours usually find the negatives of motherhood outweighing the positives, even when they're blessed with only normal children, but just one abnormal child can twist your life into a pretzel. You are likely to find parenthood a disappointment."

Other than the clinic, I had no access to enough women forty and over to pursue that study. In some ways I'm glad I didn't. I would not like to see persons who think and plan their lives discouraged from remaining in the parent pool, because they may pass better traits, on average, to succeeding generations than do random breeders.

One snowy afternoon late in January I went to Aletheia's for coffee. I updated her on my lost job and lost research opportunity, and also on my rumination about myself as a mother.

"One thing I always regretted when Daniel was small," I told her, "was that I had to spend inordinate amounts of time just making sure something bad didn't happen. I lived with the awareness that I could never trust him not to hurt himself, resulting partly from the time I saved his life by retrieving with my little finger the safety pin he jammed down his windpipe. With the others too, I tried to find that fine line between giving all my active children freedom to explore but not enough to be risky, and this always kept me on the knife-edge. I loved watching my boys grow mentally and physically, and it exhilarated me to stimulate them in all the ways I could. I have notebooks on each child containing all the charming moppetish things they said, the quality of their childish errors being evidence of growing powers of observation and reasoning and intelligence, like the time David, having completed his Oedipal phase, announced his intention to marry the dog so as to have puppies. I had no difficulty predicting before I had children that all the routine and repetitive tasks would be boring, and they were, but I took them on willingly.

What I hadn't anticipated was the much worse strain of that constant vigilance because of the hazards of the environment, worst in the case of Daniel. It was like being a security guard, who may have to pace around slowly for seven hours and fifty-five minutes, then spring into action in the last five minutes when shots ring out, and make critical life-and-death decisions. I was never able to be comfortably watchful while doing other things around Daniel. This related to his energy level and unpredictability (though the other extreme from attention deficit), but also to his being a pearl of great price following my calamitous obstetrical history. With Daniel, this was the burden that made me want someone else reliable and conscientious to watch him, to relieve me, and I loved it when he went to camp, but at the same time I knew no one else was ever as cautious. Safety, like freedom, is bought with eternal vigilance.

"I suspect also that compulsive, perfectionist types, people like myself for whom things are never good enough, may be less than happy as parents, especially if they have other talents, other ways they could be spending their lives. If it's true that I shouldn't have had children, this may be for reasons completely separate from the fact that I have one who's giving me lifelong grief."

"That's not true that you shouldn't have had children," Aletheia gasped, shocked. "You gave them so much, but I can see that it must have been hard being the mother of active boys. Their energy level is so high. Judith was always easy, until she fell apart. I wish one of yours had been a girl."

"That's what Peter says. Boys make ozone in the air. People I know with

both say girls are worse in the teen years. Girls tend to make a different ambiance in the family, but of course we weren't given the choice, our only girl being stillborn. Now I wish one had been a girl, but then my preference was always boys, and not for my sake but for theirs, so they wouldn't ever have the awful conflicts between family and career that women faced then, and now often carry as a double burden. There's no question that it's harder to be a woman, and I wanted their lives to be easier.

"But what I'm trying to tell you is that whether or not I gave them a lot, whether I was loving, involved, and so forth isn't the point. The point is how women like myself might be happier and more fulfilled. With only a career, I would not have been pulled in two directions by children and career. What I'm questioning is whether perfectionists who are also cerebral types, left-brained people whose style is cognitive, may not end up frustrated and unhappy as parents. Even when there's nothing drastic the matter with a child, if you expect too much, you're sure to be disappointed.

"What it means to be a mother also relates to when in history it happens. My generation of mothers was programmed to accept the blame for everything that went wrong—an unfortunate spin-off from the correct admonition by the early Freudian psychiatrists, that parents should be sensitive to their small children's mental processes, needs, and sensitivities. On the other hand, we're belatedly coming to the conclusion that a child may have something wrong innately, something he brings to the equation. Some flaws in children, there may not be much you can do about but live with them. You can write off your family of origin, transfer to a different college, get out of a bad marriage, change jobs, move to another part of the country, or change citizenship, even begin a new career in midlife, but if you find yourself with a child who zigs when you zag, you're left with many years of zigging and zagging. It's what I call the "eighteen-year contract signed in bed". I question whether, with all my love for the little boys and all the good things from all three in the past, if I were offered all three, knowing what I know now, I'd reject the package because the pain from Daniel alone has more than offset all the good. When I think of how my love and thought and efforts have not paid off, it feels like a kind of cosmic rip-off. I get angry at Fate because I'm ending up with a handful of ashes.

"It gets easier with time," Aletheia comforted me. "Not much, but a little."

"Many women in my place might not feel so devastated. Maybe I won't either, in five years. Time may work its healing. I hope so. I'm suggesting that since you have no way of knowing at the outset whether you'll have a tiger by the tail in a few years, and since you may have little or no control over the outcome, I question whether there may be certain signs of likely trouble ahead, a combination of bad things in your parents' generation and a perfectionist

personality in you, the prospective mother-to-be. Maybe women like me should think twice before they sign that eighteen-year contract."

"If young people thought of all the hazards, who would take the risk? I worry about the wrong people not having children."

"So do I. I don't like to think of mothers becoming an 'endangered species'. I don't like to think that women who plan their lives leave childbearing to those who breed by chance. But the question is, 'Who are the wrong people?' There certainly are 'wrong people' from the child's standpoint. They include women who are immature and solipsistic and hedonistic and unwilling to make the effort. We call them 'narcissistic'. But for purposes of my study I would have tried to delineate women who are wrong from the standpoint of the woman herself, women who will end up wishing they had put their lives to some other use, something with a less chancy outcome."

"So what now?" Aletheia asked. "Are you going to look for another job?"

"In a way, I have a new job. Actually, if this had to happen, the timing was perfect." And I related how my soon-to-be-unemployed status would mesh with plans for my book, displaying the classic American tragedy of the late twentieth century. "'Every generation must write its own books,' Emerson noted, and this book could not have been written a generation ago."

Aletheia, my long-time cheering section, was enthusiastic. "Whatever else you tell parents, tell them not to let a child like Judith or Daniel destroy them, as I've let it do me. Nobody should carry forever the load of a child gone wrong."

"You'll be in my book, with your experiences with Judith, as a mother/only-girl-child counterpoise, like a Greek chorus, or another facet of the mother/child problem illustrated by Victoria and Daniel. I'm even giving you the Greek name for truth, Aletheia.

"New year, new work, new Victoria. I intend to start taking better care of myself. I think I'm finally learning the next-to-last major lesson of life, that we are completely and ultimately responsible only for ourselves."

"And what's the last lesson?"

"That we are existentially alone and imminently mortal. We know this intellectually from about the age of ten, but we feel it at a gut level only when we have our fatal illness."

"Can I get you some almond mocha, with a dollop of whipped cream?" Aletheia asked.

"No, thanks. I'm biting the bullet these days and very little else."

Thirty

New Guinea Comes
to the Greenleafs

THAT WINTER WAS A WINTER OF VISITORS. Peter's brother James came to see us when he was in Chicago for a meeting. Not a word about Daniel passed between us, but just before leaving he took my hand and squeezed and patted it, sympathy of a type I had never before had or expected from him. James, it seemed, had learned.

Another strand that reappeared in the complicated braid of our lives was a visit from Lawrence, a linguistics specialist we had met in Australia, who was lecturing his way back to England. We honored Lawrence with a reception, where he told our friends and us about aboriginal languages in New Guinea and "creoles and pidgins", which are not gourmet recipes, but special varieties of languages.

Lawrence's visit was good for all of us. I was delighted to see him again. I was happy also because I had engineered, wherever I could, opportunities for all our sons to fraternize with adults of as widely different backgrounds as possible, people leading interesting lives, and seeing the world from a different vantage from ours.

Jonathan and David enjoyed Lawrence as they had César, though not because Lawrence was funny but because he treated them as peers. For one thing, after Peter and I were in bed, he let them stay up with him to watch Benny Hill, an Aussie favorite but one I wouldn't have let them see. Also,

255

Jonathan found out that Lawrence liked *MAD* magazine and loaned him his *MAD* collection. The boys' eyes widened when Lawrence opened our *Britannica* to the entry on languages with his initials.

Peter and I each took off a different day to show Lawrence around Chicago. As he and I walked through the Art Institute, I told him about our sadness coming from Daniel, and how it was so bad I had often wished for news of his death so that all the smaller soul-eroding acid-drippings could stop. I'd had such fantasies, I explained, until recently, when within a month I learned of the suicide of the son of one acquaintance, the death by mugging of the son of another, and the death of yet a third by accidental hanging while masturbating with a cardiac stimulant. How much are parents required to endure? Then I realized how Daniel's possible death would be even less tolerable to me than their losses were to them, particularly the non-self-inflicted death of the boy beaten up near the university, because it would seal my bitterness forever. Those three women were learning to cherish their memories, but my happy memories from Daniel's growing-up years were still lodging like food stuck in the gullet.

It is remarkable to me how a few days shared by two people from half a world apart enabled me to open up in a way that I couldn't with people I saw daily, people I would see again, who, if I told them, would remember that I was the mother who wished her son would die.

As we sat on wooden benches in the almost-empty art galleries, Lawrence responded to my candor by telling me about his own pain about his wife, who had already been ill when we knew her in Australia with what appeared to be schizophrenia. In the meantime a new doctor had come to suspect an unusual variant of epilepsy and was treating her for this. Lawrence clung to a hope that on his return he would be rewarded with an almost magical improvement. "I couldn't stand it any more," he told me. "I had to get away. I couldn't watch that all the time. I'd come home and say something, and her first few responses would be all right, but soon she'd trail away into nonsense, and then I'd get mad at her, even though I knew it wasn't her fault."

"How could you have sex with someone who wasn't really at home?"

"You couldn't, or at least I couldn't. And she couldn't understand that, and that came between us. I'd take care of her all her life no matter what happened, but then I'd find myself thinking—the same thing you thought about Daniel."

We were able to comfort each other in our parallel griefs because we would soon be running from each other, in the same way I had been able to run from the bilingual facilitator at Peter's congress in Bogota and could have run from Jonathan's herpetology counselor, if he had given me a chance to talk.

Peter and I attended the Evanston Junior High potluck for parents of David's class. I looked for places at a table with parents whose children were all Jonathan's age or younger. But Mr. Slominski, Jonathan's English teacher and Daniel's teacher before him, came to sit with us because, whenever we had a chance over the years, he and I would talk about books and reading. That evening as we chatted he praised Jonathan as one of the most "delightful" kids he had ever taught. "Makes lots of worthwhile contributions too—brought in slides about Hannibal and the Tom Sawyer fence."

We almost made it through dinner when Mr. Slominski asked the dreaded question.

I was more than tired of doing all the dirty work relative to Daniel, serving as family representative, and being a buffer between Peter and the rest of the world. I decided to wait out that question, forcing Peter to handle it this time. Peter's slower-paced pattern had been to wait until my discomfort made me reply. But that time I just sat until Peter finally gave out the bare-bones official (truthful) "release" about Daniel finishing high school in Texas and working for his uncle.

"Is he going to college next fall?"

Peter waited in hopes I would answer, sighed, and finally said, "There's talk of it."

No further questions. Mr. Slominski could see that he had touched a raw nerve and tried to be kind.

Over the years of increasing trouble with Daniel, I had been growing away from Vanessa, a long-time friend and writing mentor. The excuse I made to myself was that I shouldn't impose on Vanessa because her life had become complicated by her teaching assignments and her studies toward a new degree. But I knew it was a lie. The real obstacle was my second major character flaw, which I managed to hide from most people and wished I could hide from myself—envy. Vanessa's daughter and son, slightly older and younger than Daniel, had always been quiet, reserved, stable, predictable, reliable, and lackluster to the point of being uninteresting. Karl, their father, imposed rigid hours and regulations, which I would have loved for Peter to do. When Daniel was young, I was proud of his inventiveness and initiative and pleased with his spontaneity. But as Daniel's life unfolded I would have traded him for the most pedestrian of teenagers and considered myself a happy woman. Thus it wasn't Vanessa's schedule but my old *bête noire* of envy that kept me away from her. I couldn't stand being near someone whose kids were growing up normally.

Yet this envy was one I had been fighting and hoped to quell. It was obvious that spending my life in withdrawal and self-pity constricted my life. I was determined not to let Daniel destroy me doubly.

Even as I withdrew from Vanessa, I realized that I needed her again. I dialed her number and asked when she could come over to help me with some writing. By then I was crying.

"Vicki, what's the matter? I'm free tomorrow, and you know I'll do anything I can to help you. What's the matter? I've never heard you like this before."

"Tomorrow's fine. Come as early as you can."

Putting off plunging into the icy water of my grief about Daniel, I began by telling her about losing my job. After a long pause she said gently, "Well, I know you didn't ask me over to hear about the job. What else is going on? Wasn't it something about writing?"

I dabbed at my eyes with some tissues.

"What can be so terrible? Is it Peter?"

"No, it's not Peter. Oh, I'm so ashamed."

"'Ashamed'? I can't imagine you've done anything wrong. Come on, tell me. Have you robbed a bank?" She looked worried.

"No, but I have a child who's delinquent and in trouble with the law and, worst of all, lacking in human feelings." I filled her in on the main events. "Haven't you heard any of this? I can't imagine that Mitzi didn't know some of it from her daughter at Evanston High."

"If she did, she never said a word. I'm completely bowled over. I don't know what to say. And you, who've done so much for your children—caring and planning and working. How long have you known?"

"At some level I knew all along, almost back to when Jonathan was born. For a long time I thought it was his brother's birth that Daniel couldn't come to terms with, though normal children get over the birth of a sibling—billions of us have to. And I thought age four might be the worst time to acquire a brother or sister because the child is old enough to remember being the only one, too young to have the self-confidence to handle it.

"Over the years I tried to make up whatever deficit it was by spending more time and effort on him. Things would seem better for a while and the vibrations would damp down, and I would be falsely reassured that we had overcome it, whatever it was. I noticed that after a small incident and its resolution I would be giddy with relief. But then the next round would start, and my roller coaster would plunge."

"I don't know what to say, she sighed, after a long pause."

"No one ever does. There's no right thing to say, so you may as well not try. It's like a hot iron burning me." She was rubbing my shoulder. "I'll be all right in a minute."

"But it isn't fair. You've always been such a good mother."

"Fairness has nothing to do with anything. Ideas of fairness and justice are man-made constructs."

I told her my plan about the book. "In one of his novels Herman Hesse's protagonist wanted to write an account of a journey he had made as a young man. He realized, finally, that his motive was to give his own life meaning. This is part of my motivation, too."

When she left, Vanessa carried several chapters for criticism. Over the succeeding months she tried to be my true friend by being honest. Next to criticism of your child, criticism of your writing is hardest to take since what you have written feels like an integral part of yourself. When the subject matter is your own wound, criticism is like having your wound probed. Thus I had given Vanessa a difficult task. She and I both knew she was on a tightrope between compassion and the cruelty of false reassurance. Her observation that made me feel the most attacked was that my defensiveness was making me sound apologetic, and thus I was not presenting myself with dignity. Hard as she and I both tried to do what needed to be done, after a few sessions I found I could no longer bear to stand naked in front of her.

Then I approached Alan, the only male freelance writer I knew. Too idealistic to tolerate high school teaching, Alan had gone to full-time writing when the pressures in the inner city had given him ulcers by day, nightmares by night.

"Let me see if I understand," Alan replied. "Would you say this is a kind of mystery story, the mystery being how Daniel got this way?"

"That's part of it, but not the main thrust. My search for clues to find a solution for Daniel are intertwined with my efforts to take care of myself in the face of his dissolution. It's the opposite of entropy, trying to make chaos go uphill into order." A former physics and math teacher, Alan understood.

I was able to use Alan's help longer and with more effect than Vanessa's, partly because he was the other sex from me, and childless. Working with him over the months, it was my pleasure to get to know him better, as he told me his own stories about today's late adolescents in and out of school. Several times Alan's brother had flown to various parts of the country, to bring home his shoplifting, runaway daughter. "It's the speed of change," said Alan. "It's no longer possible to bridge a generation. I find I can't 'rap' with people more than eight years younger than myself any more. We're talking a different language, living in different worlds." Eight years! That's a scant half-generation.

The April 26 probation deadline was looming. Did reading about himself and the people and places and incidents he had lived have a chance of reaching Daniel?

Thirty-one

Cannon Ricocheting Across a Pitching Deck

THAT WINTER, GRACE COLLEGE, a nearby private Methodist liberal arts school, asked me to become a consulting psychiatrist for them. In that role I gained yet another perspective on changes in late adolescence since my college days a third of a century earlier in a similar college. Unlike when I was in school, the enrollees' (I could hardly call them "students") main problems involved drunkenness and substance abuse. I was told that Thursday night had become on-campus party night, since by Friday everyone would be off gallivanting. The revelry continued through Sunday, with many coming to Monday classes hung over. This led to brawling in the dormitories, sometimes causing injuries such as broken jaws. Drug raids were not unknown, irate parents threatened lawsuits against the school, and the counseling service increased its professional personnel, including me.

As the school year wore on, Daniel continued to call Peter. Once Peter hung up in less than a minute after saying, "I'm not going to listen to it." Another time I picked up the upstairs receiver simultaneously, so that neither father nor son knew I was listening. Daniel enunciated his syllables poorly, and ran his words together.

Daniel was insisting that he quit working for his uncle because James' head technician was "just like Mom", meaning that she expected her instructions to be followed promptly and correctly, which Daniel did not fancy. He

proposed getting a job at a car wash instead. Peter opposed this notion, trying to persuade Daniel that working for his uncle benefited both of them: James needed his unskilled lab help, while Daniel needed to learn responsibility, reliability, self-discipline, and the moral obligation to repay James.

Finally Daniel said: "And what's this about your wife [sic] and her so-called book? Get her off my case. I don't look at my copy, and my counselor and I just laugh at it, but we're getting tired of hearing from her. I showed it to some of my friends, and they said she must be crazy."

In a tone that conveyed "We males have to stick together, but don't worry—nothing will come of it anyway," Peter said, "Let her write it."

Peter referred to a recent television special about young people strung out on marijuana and its long-term damages, including the amotivational syndrome Daniel was certainly evincing. Daniel was happy to say he had not seen the program, but his friends had told him that there was not a particle of truth in it.

Daniel mocked Peter's efforts to reach him and expressed his intention to leave Texas as soon as his credits for graduation and his probation permitted.

"Stay where you are!" roared Peter. "You can't just move constantly. Some day you've got to learn to *adjust*. You can't just leave every time you don't like people or they don't like you. The world isn't that way. You won't like everything anywhere!"

[Though the difference was academic as far as reaching Daniel was concerned, I had pointed out to Peter that his frequently used phrase, "The world isn't that way", was wrong. Our society, unlike Peter's memories of growing up in the depression, *is* "that way". We make endless accommodations to ungovernable, impulse-ridden young people, who wander here, show up there, make no provision for the future, "borrow" money with no intention of repaying, start and stop chaotically. Safehouse had been a tragic example of a beacon to malcontent youth, beaming a message on arrival that an affluent, over-privileged society picks up the pieces—continually.]

"That's not true," Daniel replied. "Most people like me. People like me everywhere I go, except at Nova. They hated me there, and that's why I left. That plus I thought they might kill me."

"They didn't hate you. They were trying to help you." Peter was beating a dead horse. "What do you hear from Case Western Reserve?"

"Nothing."

"Well, aren't you doing anything to get to college?" he yelled.

"Don't worry. Something'll come through."

Daniel's nonchalant attitude infuriated Peter. "That's not the way to plan your future! Another thing—Dr. Casey says you're going to need that pin taken out of your shoulder."

"Maybe I'll be up this summer. But first I'm going to Florida to tell Grandpa he owes me money." (This referred to money my mother had tried to leave each of us in her will, but she unfortunately involved my father's unscrupulous lawyer, who unethically reported to my father what she was doing, and my father, behaving exactly in character, had never probated her will. Daniel had known this sleazy story about his grandfather's circumventing all of our portions, since I preferred doing without the money to taking my father to court, which would have taken years and cost more than it would have gained.)

"I'll tell you one thing," roared Peter. "There's no point in going to Florida. Not only does J. G. still have the first dime he ever earned, but he's a psychopath just like you, and you're no match for him. You won't get a cent out of him!"

Once more Peter agreed to send Daniel money. Without letting Peter know I had listened in on the phone conversation, once more I objected to spending any money for someone on probation in Texas to go skiing in Colorado. Once more, Peter and I quarreled.

Demands from Texas for money were constant, with Daniel complaining that by mid-month he had to "eat Coke bottles". Peter spluttered, while trying to introduce some element of planning, of budgeting. The situation never held still long enough for us to anticipate Daniel's needs and send checks on a regular schedule.

I talked occasionally to Cory Jaycox, Daniel's new counselor, who always listened with interest but scrupulously avoided any response that could be considered a betrayal of confidence. I let Cory know my outrage over a system that rewards an out-of-control delinquent by setting him up in an apartment. But I couldn't come up with an alternative, nor could Cory. He agreed that it would be best for Daniel to remain in Texas after the probation ended, but we both knew that neither Cory nor anyone else would have any control or influence over Daniel. At my request Cory talked to Peter on the phone to try to discourage Peter's willingness to accede uncritically to Daniel's incessant demands for money, but Peter heard only that part of Cory's advice he wanted to hear, which was to beware about sending more than rent and fixed expenses. These figures were never defined, and Peter continued to send skiing money. We lurched from crisis to crisis.

I never saw hard figures on expenses. It was my suspicion that whatever Peter sent to James on Daniel's behalf, Daniel was spending more. I began to wish Daniel would be caught selling drugs so that a judge could justifiably give him a choice between Nova and adult incarceration.

James was doing his best. He attended a conference with Daniel's priest/counselor at Alamo High who reported perfect attendance. The school psychologist assured me that although Daniel had arrived with "a chip on his shoulder" and "a cocky attitude", he had improved, and there had been no occasion for reprimand. She was unable to confirm or deny a story Daniel had sold Peter about having been asked to judge a forensics contest, but she hoped Peter and I would come down for graduation.

"We were billed for graduation pictures that we never saw," I told her, "but I regret that Daniel himself doesn't intend to attend."

And I was right. Even before formal graduation, the harbinger of Daniel's presence in the Cook County area materialized in the form of phone calls with no response at the other end except the hang-up click, telltale evidence that someone in our community was trying to reach Daniel.

By June, word trickled to Peter that Daniel was living again with Phil Martin and his mother, whose friend had given Daniel a job for the summer in his butcher shop. Peter took Daniel to Dr. Casey to evaluate the pin in his shoulder. Casey was equivocal as to whether to remove it then or wait. Daniel chose to put it off until after his job and a "vacation".

Meanwhile, the time had come for my semi-annual trip to Florida to check on my father, who had turned eighty in April. I arranged a dinner party at a nearby restaurant —complete with sugar-substituted cake for my now-diabetic father—and invited eight people who had known him and my mother. It was heartwarming that my father appreciated my effort, repeating over and over that no one had ever given a party for him before. He had forgotten the one I remembered my mother having given for him when I was a child. I got through that visit without any untoward incidents.

Fetching me home from the airport, Peter was silent on the subject of Daniel. But when we arrived, Jonathan and David immediately started chattering about Daniel's having been living at home from the day I left until that very afternoon. Then Peter announced that Daniel had been accepted at Case Western Reserve in Cleveland and would have to go out for testing and placement in July. As I carried my own dirty clothes to the laundry room, I noticed that two six-packs of beer and the better part of a gallon of wine were no longer on the shelf. I asked Peter, a non-drinker, what had

become of these.

"I gave them to Daniel," he said. "I'd rather he drank here than elsewhere."

"You had no right to try to buy Daniel with booze!" I screamed. "You had no right to give that leftover stuff from Lawrence's party to Daniel! That was mine!"

"I'll get you more beer!"

"That's not the point, you idiot! I don't want it, but especially I don't want Dan to have it. You know his MMPI showed 'a tendency to abuse drugs and alcohol'." There followed an acrimonious argument between us in which he accused me of being hostile and intolerant "just like your father", and I called him a "passive-aggressive wimp". Our fury escalated to a level we had been reaching all too often lately.

"Can't you see how every time something comes up about Daniel we end up at each other's throats? Can't you see that we should form an alliance against him? Bad as it is, the end is in sight. The Daniel problem is self-limited."

"We shouldn't have had children," said Peter bitterly.

"Maybe. But if you knew we were going to get dealt a wild card, why didn't you warn me back then? Besides, then we wouldn't have had Jonathan and David, and I wouldn't have given them up for the world. When I was growing up as a singleton girl and wishing I had a sister, I had romantic ideas about big families and all the fun they had. My mother told stories about her family of six kids, and I hoped to recreate something like that, with the addition of a stimulating career that my mother should have had, as I see it. I expected my children to be charming moppets straight out of Robert Louis Stevenson and A. A. Milne. I expected their childhood to be characterized by exploration and play and learning with me as mentor. It was the kind of life my mother and I enjoyed. She told me later she enjoyed me 90 percent of the time, a percentage I would be delighted to settle for. The other 10 percent she called my "ornery phases". Ten percent I could have rolled with in Daniel. But you never know how the genes will shuffle until long after you've signed your eighteen-year contract in bed."

One evening Peter asked if he could take my car the next day.

"Sure. Is your transmission giving you trouble again?"

"No, it's not that. Daniel called me today, and somehow his car is broken down on the West Side. He asked if he could take mine to go over and take care of it."

"What's the matter with it? And how did he get back to Phil's?"

"I didn't quite get the details. Somehow he had been sleeping in the car

over there with a blackjack for protection, and he had to get back here for his job, but somehow Danny—you remember Danielle—has the keys. He needs me to pick them up from her and get them to him. . . . It is a confused story," Peter admitted sheepishly.

"Not only confused, but ludicrous and manipulative as hell. If you didn't have any idea of what was going on, why didn't you refuse until you had one? Why don't you ever stall? Tell him you'll call back. Ask me what to ask. Tell him you're with someone in the office and can't talk."

"I don't know where he is. He's always at a pay phone."

"Then tell him that's *his* problem. Tell him that people who need help need to be reachable. Doesn't it strike you as incongruous that a son of ours is living in a car like a wanted criminal, which maybe he is by now, and at the same time talking about going to Case Western Reserve University this fall? Years ago I finally realized that I don't owe either him or anyone else an immediate yes or no answer. When the kids were little and said they had to know right away, I finally caught on to tell them that then the answer had to be no. Especially somebody like you should always begin with 'no', play for think-time, learn what you can about the traps and pitfalls, and then talk to me. I see angles that would never occur to somebody as ingenuous as you. Someone who's honest is always at a disadvantage with someone who isn't."

"He always takes me by surprise, and this time I did have someone in the office."

"Then what's the matter with saying that? Besides, it doesn't matter whether it's true. Why should you have the luxury of telling the truth? He's got the technique down pat to use anything, including your embarrassment over him, to get what he wants. It's an awful way to live but I've had to learn. When the phone rings, I always begin with the assumption that it's Daniel or about him, something new and outrageous, and I brace myself for it. Then if it's anyone or anything else, that's an improvement. But I can't assume it, so to be prepared, I always take a clipboard and pencil to take down names, places, and numbers. I'm also psychologically prepared to get information without giving any, and not to make decisions without think-time. If he hasn't got a phone, let him figure out a way for you to reach him.

"I'm just asking you not to say 'yes' reflexively, the way it feels a kind parent and reasonable person would do. Ironically, there's this perverse reversal whereby giving is really taking, but denying is giving. You should be long past treating somebody who sleeps in a car with a blackjack as if he were normal."

"It's hard. Why should we have to live like this?"

"Because I picked the wrong father." I let that sink in before I went on, "Now I have to go back on what I said about letting you take my car. I

266

assumed it was a reasonable request. I didn't allow for Daniel being part of the transaction, complicating and distorting whatever it was. If it were for your need, you could have my car or anything else, but not for him. If he chooses to live like the homeless, there's nothing I can do about it. But I won't lend my car as backup for a way of life I don't endorse."

Peter didn't argue, and I never learned what he did about the car.

Assorted thrusts jabbed the soft underbelly of my pain. One night Peter and I both picked up the phone at once. All I heard were the words "Rolling Hills" in an older male's voice asking for Peter. Within two minutes he had hung up and was backing the car down the driveway faster than I had ever seen this ultra-conservative driver move.

That evening I was watching the episode of *I, Claudius* in which Augustus learns of his daughter's nymphomania. As the actor cried on screen, his jaw worked back and forth the same way little David's face always contorted when he cried. Augustus' was a parent's lament across time: "I can run an empire, but I can't manage my own family."

Peter returned an hour and a half later, his slow, heavy tread like that of an old man. "Where were you?" I asked. There was no answer, and I repeated, "Well, where *were* you?"

"I went to see Daniel. He doesn't have his job any more."

"What did he do *this* time?"

"Nothing, he says. He says that Mrs. Martin's friend let him go because he wanted the job for a relative."

"I guess that's possible, though you'd think he would have known that just a few weeks ago when he took on Daniel."

"I also scheduled for Casey to take out that pin in the fall before school starts, while we're in Europe."

"It ought to be now while he's not working anyway, so it heals in time for school."

"I thought so too, but he wanted a 'vacation'."

"About what I'd expect."

Opportunity had knocked again. Peter was scheduled to give a paper in Karlsruhe, and the boys were going with us. This was another time for them to learn not only what foreign cultures had to teach but also how to negotiate in a foreign place and with foreign currency. It was also a chance for an

old-fashioned style of transatlantic crossing. In fact, in mid-Atlantic, the ship acquired a new teenager, and David was the object of all the hoopla surrounding a birthday at sea. We wanted our sons to learn wise ways to travel, unlike the pattern we had seen in teenagers who might come home having seen only the interior of every bar from Cork to Kabul.

But as our date for sailing to Europe approached, there were last-minute errands and arrangements regarding Daniel. Peter took him to Cleveland for Case Western's testing, placement, registration, and dorm assignment. He placed in advanced math.

While Peter and Daniel were away, David and I attended a ballet at Ravinia with friends, leaving Jonathan to spend the early part of the evening on Scout matters with his scoutmaster. As my friend dropped us in our driveway at midnight, my heart did a flip-flop because my car was missing. So was Jonathan. In my state of hyperarousal and suspicion, I immediately imagined myself to be fighting on two fronts, the Daniel and now the Jonathan fronts.

"Oh, God, I don't know what to say," said the scoutmaster. "I told Jonathan yesterday that I had to cancel for tonight. Can I help you look for him?"

"I'll call you back if I can't locate him."

I called the police immediately. "My fourteen-year-old son is gone, and so is my car. Do you have any accident reports?"

"No, it's been a quiet night. You assume the two are together?"

"It looks that way, but he doesn't know how to drive or even have a temporary license. He's only fourteen."

"Lady, kids do this all the time. Describe your car, and I'll put out an alert, but I expect he'll come driving home before long."

No news was good news from the several hospital emergency rooms, and I was pondering my next move when up the driveway came flashing amber lights. I ran to the door to see a tow truck with my car attached and Jonathan getting out his wallet. "Wait for me in the kitchen," I ordered.

"Where did you get my car?" I asked the garage man.

"In a driveway across town. It wouldn't start." My eyes must have been flashing. "Lady, don't be too hard on him. He was awful scared."

"You'd better believe I'm going to be hard on him! He's only fourteen and driving without a license a car he had no right to take. Has he paid you?"

"Yes, Ma'am, fourteen dollars." The man looked relieved to hurry away. I never learned how Jonathan got such a cheap tow.

I returned to the kitchen for interrogation. "I want an account, Jonathan Peter Greenleaf!"

"I drove over to John's house for a little while. Then I went to Mark's. I would have been home at eleven, but the car wouldn't start."

"Your excuse is my car wouldn't start! You intended for me to think you

were still going to Scout headquarters. That was deceit. Then you took my car without permission, which you knew you couldn't get. You hoped to have it here before I got home, so I'd never know. More deceit. You drove without a license. Illegal. Jonathan, are you aware that you *stole my car?*" I paused for this to sink in.

By then Jonathan was snuffling, and he looked both frightened and ashamed. I made sure this was all loud enough for David to hear.

"How did you know how to drive it?"

"From Daniel's *Sportsmanlike Driving* that he used in Driver's Ed at Pleasant Valley."

"They call it 'sportsmanlike' to steal a car when you're underage and drive it without really knowing how and without even a learner's permit?"

"I'm sorry, Mom. I know I shouldn't have."

"You'd better believe you shouldn't have! And if it hadn't been for my faulty starter, I wouldn't have known, and you would have gotten away with it. Who knows what you would have tried next?"

"Can I go to bed, Mom? It's late, and I'm tired."

"You should have thought of that sooner. How tired you are is your problem. I'm tired myself, but I want you to know one thing: if you step out of line once more, I'll send you to Winslow so fast your head'll spin. I'm not going through anything with you or David like what Daniel has put us through. If you can't use the public school, I'll send you where they have shifts to watch you twenty-four hours a day."

"I don't want to leave my friends." Jonathan was crying.

"Then you'd better keep your nose clean because I'm on a short fuse. [In moments of emotion, one may mix metaphors.] I'm going to be watching the quality of your friends, boys and girls, and I'd better find them acceptable. I'd rather have you live home with us, too, but I can't and won't take anything from you and David. One lost child is enough."

"Can I go now?"

"We haven't discussed the punishment yet. What do you suggest?"

"I guess I should be grounded."

"Until we leave for Europe. . . . You can go to bed now."

As he walked silently past me from the kitchen, he stooped to kiss me on the cheek. To the best of my knowledge he honored the rules of the grounding. I was glad that the incident, if it had to happen at all, had happened in Peter's absence, leaving me free to discipline without interference.

When Peter returned from Cleveland, his step was, if possible, heavier and slower. "You don't know what I've been through. I had to buy Daniel shoes in Cleveland. He met me at a reception for new students and their parents—*in bare feet.*"

"Oh, that's insane! Now maybe you see what it's like to be the one who gets the shock waves I've been talking about all these years. What did you do?"

"Bought him some boots for eighty dollars."

"Why boots? Why not shoes for half that? Why reward such low-class behavior with something so expensive."

"Vicki, I didn't have time to think. We were supposed to be at the reception. Getting boots was the fastest. And you have no idea of prices in Cleveland."

"Now, maybe, you see what it's like to be criticized for a decision you made under stress, by somebody who didn't have to act under fire. You've been morning-after, armchair-quarterbacking me all these years for decisions I've made in novel situations, no two alike, and you always felt justified to sit in judgment on the two of us, Daniel and me, and bend over backward to rule with Daniel. . . . So you got him shod and back to the reception. What did you find out?"

"They've assigned him to a dorm with nine hundred students. I wish he'd been given the small one with better supervision, but it's a lottery."

"You should have asked for the smaller one anyway. People in education make every effort to accommodate students' needs."

"I talked to one of the assistant deans and told him a little about Dan. He said a lot of freshmen, boys especially, spend their first year settling down to being away from constant supervision. The school lets the students know that they rapidly tighten down. One chance or two and they're out. The school doesn't function as a babysitter."

"Of course not. I don't expect Dan to make it through the year."

"There you go again. The perennial pessimist!"

"Pessimistic about somebody barefoot at an academic reception? I'm a realist!"

"Anyway, what I'm getting to is this: I think Daniel might as well stay in our house while we're away, especially since he isn't working, rather than pay Mrs. Martin room and board."

"Never! I won't go if you let that kid into this house while we're away. It's bad enough when somebody is on the scene to watch him."

After a few mumbles, Peter reluctantly acceded. We agreed that after the shoulder pin came out Daniel should drive the Chevy to Crown Point, leave it at Vera's, and take the bus on to Cleveland. There was neither a place nor the need for a car at Case Western.

And so we left the keys with Hal, who did odd jobs for us and would watch our property, occasionally turn over the motors of the cars, and change the

pattern of the timer devices on the lights every few days. We notified the police of our plans, locked up the house, and departed for Montreal to board ship to sail down the St. Lawrence and across to Germany.

As we left, David mock-grumbled, "Other families get to take a real vacation—they go and lie on the beach somewhere. We always get a 'learning experience'."

Thirty-two

Five Days that Shook the Greenleafs

Aᴄᴛᴇʀ ᴛʜᴇ ꜰᴀʀᴇᴡᴇʟʟ ᴅɪɴɴᴇʀ ᴀɴᴅ ʟᴀꜱᴛ-ɴɪɢʜᴛ ꜰᴇꜱᴛɪᴠɪᴛɪᴇꜱ on the *M. V. Lermontov*—singing Russian songs, folk dancing with Jonathan as my partner, receiving "diplomas" from our language class and David's chess award, packing ("Keep your passports handy, boys"), farewells to shipboard friends— we slept a few hours and were on deck to watch the Verrazano Narrows Bridge glide overhead in the chill light of mid-September dawn. And then out of the mist appeared Ms. Liberty, looking like a young adult woman to my age-wearied eyes. I felt my customary lump.

Peter and I recounted family anecdotes about our forebears and their American baptism at Ellis Island. I told the boys a story about my mother's father. My Grandfather Harry had come to this country at sixteen with a widowed mother and seven younger siblings in tow. He was their sole support for two years, until his mother remarried. "Do you realize, boys, that that's barely older than you? Can you imagine yourselves supporting me, not to mention seven brothers and sisters?" Peter related how his father happened to cross the Atlantic in steerage on the Carpathia, the ship that went to the rescue of the Titanic. At nineteen he had stood at the rail, watching survivors being hauled out of the icy waters. From near-illiteracy to educating two sons to three doctorates, Grandpa had illustrated the best of the American dream. Emma Lazarus would have been proud.

From opportunity to apocalypse in three generations. From working twelve-hour days, when he could get them, to keep his five children fed, clothed, and sheltered in the Depression, my father-in-law had lived almost long enough to see his grandson reject the hard-cutting edge of the mind for dreamy, drug-sotted nirvana.

And what, I worried as we headed west on the bus, is Daniel up to now? He was supposed to have begun at the university almost three weeks earlier. By the time we learned about Daniel, things had usually come apart. Conversely, no news never meant good news. Wouldn't it be nice, for a change, to find no surprises at home? But I knew my vacation from shock waves was almost over.

Our taxi drove up our driveway early the next morning and stopped behind a Chevy with a Texas plate that I had never seen. Fear seized me.

"That's Daniel's car," said Peter. "I don't know why it's here—he was supposed to drive it to Vera's before going to Cleveland."

"I don't like this, but what's new about that?"

"What's all the garbage doing by the garage, Mom," Jonathan asked.

"How in the heck should I know?"

"The raccoons probably knocked it over," Peter suggested.

"We didn't leave garbage for the raccoons to knock over. I left garbage cans for Hal to put away after the pick-up."

"Hey, the screen on the front door has been cut," David discovered.

"Stay back, boys. We don't know who or what is inside." Peter entered cautiously and called back that the house was empty. The living room looked generally as we had left it, yet the house was not the same. We proceeded with trepidation into the dining room and found a note on the table:

Sept. 1st

Dear Dad,

My house was broken into Aug. 30 while I was sleeping in Davey's room. I woke up to see figures in the back so I grabbed a golf club and chased them out. At least one was trying to get into your bedroom (I locked it when I first came in) and the door was damaged. I'm leaving a note with the keys at Spencer's to have him look at it.

My car wasn't running well and Mr. Brown said gas was $1.20 a gallon on the way to Cleveland. Brett was going to drive me after dropping off my car in Crown Point. Neither of us could afford it so I borrowed $50 from Mrs. Martin for a bus.

My shoulder didn't heal right and I was scheduled for a second operation Sep. 1st, but Casey looked at it before operating and he let me go. I'm going to find an orthopedic surgeon in

Cleveland to look after it for me. Mom's special delivery from Florida is very important and should be signed immediately and sent back to Howard.

My car was broken into while I was in the hospital and my stereo was stolen. (John Pope had his car stolen out of his driveway a week before.) The house is as clean as I could get it but the kitchen sink is still backed up. Thank you,

Daniel

P.S. My car needs 2 radiator hoses, if you call Kurt Duncan he will fix it but needs money for parts. Sorry about the car but I can't move it.

I stared uncomprehendingly at Peter. "What does he mean—he tried to clean it up? What was he doing here? You agreed not to let him stay here while we were away."

"He had to pick up some clothes."

"What do you mean? He took everything he would wear when he went to Texas."

"I told him to pick up the key from Hal."

"You told him to pick up the key from Hal? You *lied* to me! You let that creature live in our house while we were gone! You told Hal to let him in!"

"I didn't lie to you," Peter mumbled sheepishly.

"The hell you didn't! You lied to me and double-crossed me and let that son of yours live here after I said I wouldn't go if he had the run of the house while we were away. And you knew it. I'm going to tell you one thing right now. If you ever let that person into this house again, I'll leave you! I won't have him use my house as a base for his disgusting operation. I can't and I won't live under the same roof with a liar, thief, cheat, and hopped-up drug-user making free with or even touching my possessions that I've worked for and taken care of." I wanted to hurt Peter, and I did. I would have preferred hurting Daniel, but Daniel is never on the scene for hurting. Nor is he hurtable, at least not by me.

I cried and wandered aimlessly around the house. "Boys, take your baths, and get over to school to get your lockers assigned." When I raged again at Peter, he suggested I take tranquilizers. That made me livid. "I take *antidepressants* because of what Daniel is. I don't intend to take *tranquilizers* because of what *you did!*"

On the kitchen table I soon found another note, this one from Hal—"When you get home, call me any hour of the day or night."

I found our phone dead, so I drove to a pay phone to get the worst over with. I asked for an explanation of the mess at home; Rose said that Hal wanted

to tell us about it personally. He was dressing and would be over in half an hour.

"We've had a lot of trouble with Daniel," she said. "First, the day after you left, he came for the keys."

"Peter said he could have them?"

"Yes, I think he said that Daniel would have to get in the house. I don't think he said anything about Daniel living there. But Dan just stayed, and we didn't know what to do. We figured that since he was there anyway, he might as well be the one to start the cars, so we left the two sets of keys with him. But I was uneasy. I'd call to see what was going on, but Daniel was never there. Somebody named Mike would answer, and the story was always the same—Daniel was at the beach. So Terry [her daughter] and I drove over, and it was obvious there had been a lot of drinking. Bottles everywhere. We met Daniel coming up from the beach, and I talked to him and told him straight out that there was to be no pot smoking, and he kind of hung his head. The police got called in on it, too."

"Why?"

"Well, Hal can tell you more because he went over to the station to talk to them. Some of the neighbors called to complain about Daniel and the loud party on the beach. Somehow—Hal will explain it when he gets there, I can't remember, so many things were all going on at once—I think they didn't call us until the next day, and then Hal went to the police station and got them to drop charges."

"Why did he do that? I guess I shouldn't ask—that's exactly what the average person naturally does. I would rather the police had done whatever they do—fined or thrown him in the clink."

"We didn't know that. Then later on, I guess you know that Daniel said that someone broke in."

"We found his note. You sound as if don't think it really happened."

"Well, that story never hung together. He said he heard intruders while he was sleeping and that he chased them out with a golf club, but there was no golf club around when Hal arrived. Also, did you have the door to your bedroom locked?"

"No. We threw the key away when Jonathan locked himself in on New Year's Day when he was three. We had to have the fire department get him out. And we don't have any golf clubs."

"Well, Hal found your bedroom door locked and the latch sheared off from the *inside,* so he put a new lock on the door and left it locked."

"Let me get this straight. You're saying that a burglar or someone somehow got himself locked into our bedroom without a key, then ripped the door off to get out?"

"We couldn't figure that one either. Also the kitchen door was tampered

with, there was glass on the floor, but nobody seemed to have gotten in through that door."

"We saw right away that the front door screen had been cut and the snubber had been ripped off the frame. . . . I should have warned you about Daniel, but I trusted Peter," I said. "Peter agreed not to let Daniel into the house while we were away, and then he double-crossed me. It never entered my head that Daniel would come to you for the key, but evidently Peter told him to. You can think of a thousand holes in the dike, but the one you don't plug is the one Daniel gets through. Even if Peter hadn't told Daniel to get the key, you'd have had no reason to withhold from Daniel a key to what you saw as his own house.

"For years we've been trying to get Daniel back on track. I don't talk about it needlessly. Who wants to advertise having a delinquent son, a kid who's led us a merry chase to Juvenile Court and beyond? I get so tired of trying to second-guess Daniel that I must have let down my guard with Peter. Daniel has always been able to get anything out of him. In his own wrongheaded way Peter keeps trying to reach Daniel, but what it amounts to is letting Dan con him repeatedly. One nightmarish spin-off of all this trouble with Daniel is that it drives a wedge between Peter and me. We can't even discuss Daniel without fighting because we never see how to handle Daniel the same way.

"When will Hal get here? Our phone is dead, and I'm at a phone booth, so you can't call us. I want Hal to drop this bombshell on Peter since it's of his own making. I'm fed up to the gills with being the one who almost always gets the bad news and then has to relay it to Peter. How soon will Hal get here?"

"Hal's on his way, and I'm sorry about Daniel."

"Thank you. None of this is your fault."

When Hal arrived, he repeated the story to Peter.

Then I asked him to tell both of us what Peter had told him about Daniel before we left.

"Well, as best I can remember, he said that Daniel would be going into the hospital for surgery but that he'd need to get into the house first. Once Daniel got in, he just stayed."

"For five weeks," I added.

"It wasn't five weeks," Peter protested.

"How long was it, then?"

Peter was silent.

"Rose said he got the keys the day after we left, which made it July 23rd, and his note dated September 1st referred to this 'break-in' on August 30th. That's five weeks except for hospital time. I hate to put you on the spot, Hal,

but we have to get this straight. You're quite sure Peter told you Daniel could have the key?"

"Well, yes, he did. And once Daniel was there, I didn't feel it was my place to boot him out."

"Of course not. I'm sorry I didn't alert you to the whole Daniel mess, and I'm also sorry to put you into this awkward spot about who said what to whom, but I have to verify that Peter lied to me. I want to say just one thing, for the record, with Peter and you both hearing it. No matter what Peter says in the future, I don't want Daniel in this house ever again. No matter what Peter tells you, if you ever let him in, I'll personally fire you. This is just one more thing I hold against Daniel—now he's humiliated me in front of you, not to mention those snooty people next door whose prissy kids never step out of line."

"I can't think of *any* reason to have children these days," I cried, "let alone a good one, and I would hate to see Jonathan and David or anyone I loved suffering the way I am. You can change majors, schools, jobs, careers, spouses, countries even, but you're just stuck with a child, and the pain never stops." I dabbed at my eyes.

After a few minutes' silence Hal said, "I tried to unstop the kitchen sink, but I guess they threw bottle tops down it. I'm afraid you'll have to call the plumber. I want us to go up to your bedroom together. Except for the new lock I didn't touch anything, didn't know whether you'd had a chance to make the bed before you left, didn't even flush the toilet. I left it just as I found it."

"No, the bed was made. We left in the afternoon, so I thought how nice it would be, for a change, not to come home to the usual mess. . . . My pearls Lith brought from Japan are here, and so is the silver belt Peter gave me as an engagement gift. We won't really know if any particular thing is missing until we look for it."

The toilet was clogged with dusting papers and decaying, putrid feces.

"You know," Hal said, "one thing just made me see red with Daniel. After all this, he didn't even have the decency to return the keys to me when he finally left for college. I didn't know he'd even left town until I got a call from some girl in Wilmette who said he'd left the keys with her. You'd better believe I jumped right in my car and tooled over there to get them before she took off or something. That wasn't right. I was responsible, and he should have gotten those keys back to me!"

"As I told Rose, I should have warned you about Daniel, but it never occurred to me that he'd exploit our relationship with you. I should have thought of it. I should have warned you, but"—I was crying by then—"you just hate to warn people about your own son." (My tears were those of rage: not only had our son not protected us from a break-in, he had been the cause of the break-in, and I had been cozened by my husband.)

"These are hard times to have children," Hal mumbled sympathetically. "That fellow Terry was going out with was the pits. We just thanked our lucky stars when he stopped coming around."

Hal was understandably happy to leave for the comfort of his regular security guard job.

"They're expecting me at the University," mumbled Peter. "I'd better move along too."

"Not so fast. What do you suggest I tell Mrs. Innominata? I'm not going to have her think we slummed the place like this. Do you expect me to tell another employee about that kid of yours? Well, what'll I tell her?"

"Tell her that the house is pretty dirty for reasons beyond our control."

"When we were *away*? That's your dumbest line yet."

"It's late. I've got to be on my way to the University."

"When the chips are down, it's always late, and you've always got to be on your way to the University. Well, I'm on my way to play catch-up. But I won't insult Mrs. Innominata by asking her to clean that filthy toilet and scummed-up shower stall and the garbage behind the cars and the broken bottles on the patio. It's your baby. You got us into this mess—you can get us out. You tell her something. On second thought, you can clean it, and you can call the plumber, too."

Without a word Peter accepted these responsibilities, cleaned the mess, and told something or other to the cleaning woman after I had left. He missed his weekly endocrine conference.

While he worked, I made my day's agenda, rank-ordering jobs by urgency, and trying not to backtrack: milk and bread, the backlog of mail at the post office, finding out about the phone, home to meet the plumber, then back to the police station to check out the incident report.

At the police station the officer in charge finally found the report. It was just as Hal had said.

"Did you notify them at Juvenile Court about this?"

"Why Juvenile Court?"

"Because Dan's still on probation with them."

"He's on probation? We didn't know that."

"Surely you have a file of local juveniles on probation. Didn't you check against that?"

"Ma'am, I wasn't on duty that night. I guess they didn't think to do it, or it would have been down here."

"They certainly didn't expect *Daniel* to volunteer the information, did they? Will you contact his probation officer now to notify him of this incident?"

"It wouldn't matter to them now, since the formal charge was never filed. If you want them to know, it would be just as well if you called."

279

"Why do I always have the dirty work?" It was a rhetorical question.

Just before leaving the station, I saw Heidi Cunningham, the juvenile officer I had started with more than two years before. I hoped she wouldn't see me, but as she walked past, she gave me a smile, half-quizzical, half-sympathetic. I slunk out, promising myself that the time would come when I would stop cowering and cringing and crawling.

As I started unpacking, I began to discover household objects that had been broken or tampered with, sometimes in senseless ways. A calendar made of wooden cubes and chips had been scattered over the family room floor. The gusset from the front screen door device turned up under a pile of old newspapers stacked for the next drive. The metal slat edging the egg rack in the refrigerator was missing, and the handle was broken off an enamel frying pan. I found a list, in Daniel's writing, of nine boys' names or "handles", such as "Skippy" and "Snort" and "Snort's Pal". After school Jonathan reported that the gasoline saw he used to cut driftwood for the fireplace was missing. "Tell your father," I told him bitterly.

Later Jonathan announced that his new Bicentennial quarters, which we had gathered to replace the coin collection stolen two years before, were now missing, and his tent and sleeping bag. Also, the contents of his cabinet for storing collections and miscellaneous childhood treasures had been dumped on the floor.

David reported missing records and cassettes. "Mom, did you know that they took your psychiatric medals?" He was referring to a series of bronze medallions struck of pioneers in psychiatry and given out by a drug firm in the psychiatric market. All the easel-like holders were left standing.

"That's funny," said Peter, when David showed him the easels that night. "They couldn't have gotten more than a dollar or two apiece, and there are a lot of things they could have fenced for more. The television set is here and looks intact."

"I suspect that taking the psychiatric medallions was intended as a slap at me." Though I hadn't had any particular attachment to the medallions, Peter's eyes avoided mine that night. As the week passed, other losses were discovered: a sound movie camera, binoculars, my amethyst earrings, costume jewelry of silver and turquoise. I hoped the buyer would know they were not genuine Navajo. I was also missing a beautiful inlaid malachite brooch that, years earlier, I had bargained for in broken Spanish in the open market in Mexico City with the eight-year-old Daniel in tow. Another brooch had vanished, a gold figure of a tequendama, an Incan god, with a chip emerald, from the factory the little boys and I had visited in Bogota.

I discovered the strangest of all the thefts when I reached into the sewing cabinet for thread and was astounded to encounter—emptiness! Three-quarters

of my spools of colored thread were gone. "Did they take the spool holder too, Mom?" David asked.

"I'm afraid so," I sighed ruefully, "and it was such a lovely gift from you."

Later, as I was putting something away into my dresser, I noticed an opened envelope and letter lying in the empty corner of the room. I recognized the envelope as belonging to a letter returned to Daniel three years earlier.

Fiona, a girl we met when we were on sabbatical in Australia, had written to Daniel several times. I disapproved of their friendship for several reasons, one of which was that I had found her and Daniel breaking a Greenleaf rule of lifetime duration. They had been alone together in our flat, apparently watching television, without an adult on the premises. Therefore, when a letter from Daniel to her was returned marked undeliverable, I deliberated what to do with it. Not yet cast in the role of eavesdropper-detective, I hadn't returned the letter to Daniel, but neither had I opened it because their relationship could hardly be anything but dead with them half a world apart and mail undeliverable. But I kept it, stuffed it into the back of my underwear drawer, and forgot it.

During Daniel's invasion, however, someone had searched the drawer, opened the letter and discarded it on the floor in the corner. No longer able to afford the luxury of not reading Daniel's mail, I picked up the letter and read:

> *Fiona,*
>
> *I am in such a good mood I figured I had to write you. I just [good?] a chick from Glencoe (near Evanston where I live.) I am listening to a Gary Wright concert in FTS (WFTS, my mushroom T-shirt) and I fixed my cross I wear (the leather broke.)*
>
> *My friend Matt asked me if I could go to Blackhawk Park, some tourist place. So we went there because his brother was the leader of some sailing group that was going to have a meeting up there. Matt starts chasing some chick. I didn't [come?] until later because me and her had a really close talk from about 11 until 4. This whole time I was drinking and getting wasted! But I really like this chick, she's never smoked pot and I don't really want her to. I have been getting spent lately though. I got busted early in the summer.*
>
> *Friday night I was at the football game and some young Evanston kids started pushing around Wilmette kids so everyone wanted to fight until we found out these were 7th graders (1st form) or something. But it was too late because the Army came out. About 20 Wilmette dudes (25 & over) with hard hats and clubs I almost got fucked over because they thought I was being a smart ass to 'em.*

I went climbing at Blackhawk. I bought a new rope and a harness a while ago.

Do you have any school dances, not the kind where pigs stand at the door to push out <u>undesirables</u> (me & you). But dances where you get dressed up and go to dinner and all that shit. I'm taking that Glen chick to the Homecoming Dance. See you my Senior Summer.

<div align="right">

<u>The</u> Head—Dan
</div>

P.S. Say g'day to [he named eighteen boys and girls] and anyone else I forgot.

As I stood with the letter in my hand, David came in swinging an old golf club.

"Look what was under my bed," he said. Daniel's stories were always a blend of fact and fiction. David went on with a new problem. "Mom, I can't sleep in my bed tonight."

"Why not? What's the matter with it?"

"I mean the sheets. They're filthy."

"You're not usually that fussy. Let me see." And it was true. They had obviously been slept in for at least a month, and by someone who had not bathed.

"All right. Strip the bed, David, and take the sheets to the basement. I'll give you clean ones."

We had arrived home on a Wednesday. By Friday evening I had worked my way through the laundry basket of mail down to the bank statements I was reconciling. While I searched for mistakes, Peter told me that Daniel had called to say that he had somehow not been credited with a check we'd written to the university bookstore, even though the check had come back— I had just checked it off the list—with a university stamp. Therefore, Peter explained, Daniel had borrowed money for books to get started. Predictably, we rapidly escalated to our most recent area of discord over Daniel: his camping in the house, using it as the base for a month-long house party, destroying, stealing, creating an ongoing commotion in the neighborhood. At school, I added, he had apparently diverted book money in some way.

"What did Daniel say about living here for five weeks? And all the broken and missing things? And the neighbors' call to the police? And the alleged break-in?"

"I didn't ask him."

"You mean you had him on the phone, and you acted as if nothing had happened?"

"He said he was trying to do better. Look, Victoria, I know you're mad—"

"How can you tell?"

"—and you may be justified, but I'm trying to do everything I can to help him. I'm his father, and I want to set him straight."

"And you can't see that ignoring all his flimflams doesn't help him do anything but get worse? How could you act as if nothing had happened? Why didn't you tell him he owes us several hundred dollars for damages and losses?"

"Victoria, it's only money, and only a few hundred at that. It could have been worse. Somebody could have gotten hurt."

"What's *that* got to do with anything? Maybe that's what we'll hear about next, somebody getting hurt. So it's only a few hundred that we know about so far. You and your 'it's only money' routine! Just because something isn't a matter of life and death doesn't mean it has no value! You and your black-and-white dichotomies. Well, money is one of the gray areas. Yes, it's not the most important, but it has value. It has value for how it can make life good and beautiful. It's not even as if the money Daniel stole did *him* any good. Even if it didn't go for drugs—which is most likely where it went—it made him a thief, again. Can't you see that? I was victimized by losing a few pieces of jewelry, but Daniel damaged himself by being an accomplice to theft if not the thief himself. Just as with everything else in this mess, everybody lost, but Daniel lost most of all. If I could save my son, I'd give a lot more than a little costume jewelry." I was crying.

"I'll get you another tequendama."

"Oh, what an air-brain you are! You and your infuriating grandiloquent solutions! You talk as if you can cure anything with a stroke of the tongue! The tequendama isn't the issue, but I'll take you up on your offer. Wave your magic wand and produce another tequendama, and while you're about it, you can get me another squash-blossom necklace—and a malachite brooch, too!"

"They're covered by insurance."

"I'll lay you ten thousand to one you haven't called the agent." I paused. "Well, have you?"

"No."

"And you won't, and neither will I. I don't intend to explain all this to the agent and produce a police report. Besides, I'm not like you and that asshole judge and everybody else who would just let insurance pay for criminal acts, rather than making the criminal pay for them. Daniel is morally responsible even if he didn't take the stuff himself. Let him feel the cost of playing with these losers."

"I'll talk to him about it. He's my son, and I'm trying to help him, too. But I'll stick by him even if you won't because we know that in some way that we haven't even defined yet he's sick. Sometimes he says he doesn't know himself why he does some of the things he does. Remember about his low trace minerals."

"Yeah, sure! If the trace minerals explained it, we'd *all* be knocking over diners and fencing jewelry. My trace minerals were twice as bad."

"Victoria, he's still a child."

"And won't ever be anything else if you do nothing but bail him out.... Another thing, why wasn't he at Case Western when it opened? His note was dated August 30th, and school started about the 26th. What's the idea of arriving a week late?"

"I don't know what happened about that either. But I'll tell you one thing. I intend to stick by him the same way I stuck by you when you were so terribly sick. Now he's sick."

"The difference being that I took my treatment, fought my disease, and beat it. I resent being compared to that kid! I cooperated in my cure."

"So is he. He's going to school, . . . I think."

The next morning being Saturday, I had private patients. Peter had a conference at the University. As I was scurrying around getting ready, Peter just lay in bed. "It's 8:30," I reminded him. "Don't you have a conference?"

"I'm not going this morning."

"Why not?"

"Because Daniel is in town."

"Have they kicked him out of school already?"

"He called yesterday and told me he's staying out in Glencoe. He got a ride with an upperclassman in order to pick up the car and get it to Vera's."

"What's the point of that? The car was supposed to be left at Vera's only after it served to get him part way to Cleveland. He's supposed to be in school studying, not playing with a car he has no use for."

"You're right, but he says the radiator hose is broken and he couldn't get it fixed, for some reason, so the car couldn't be driven. He borrowed money from Mrs. Martin to get to Cleveland by bus for school. So now he's here to get the car fixed by a friend."

"Fixed so it can stand around? Look, the car was bought for transportation when he was with James. Now he has no use for it, Vera has no use for it, and neither do we. Let's get rid of it."

"I'll suggest that to him."

"*Suggest? Tell* him! And tell him to get back to school where he belongs and to work."

"I guess he intends to return tomorrow. But—you're not going to like this—he's coming here."

"Here?" I screamed. "Just two days ago I told you I don't want that human pollution in this house again. Why did you agree to that?"

"Do you want to hear what he wants from me?"

"What does he want?"

"Me to help him with trigonometry."

"Well, for him to ask for help is a switch. But why trigonometry when he placed in advanced math? Why didn't he go to his professor or a graduate assistant?"

"I asked him that, and he said he had, but that somehow it hadn't worked. Then too, he was a week late getting to school."

"I was just coming to that. How did he explain that?"

"Well, when Casey took the pin out of his shoulder, somehow it didn't heal right, and there was abnormal bleeding, so he didn't discharge him from the hospital when he expected to."

"And Daniel, of course, hadn't allowed one extra day for anything to go wrong."

"As you recall, I wanted him to get it done earlier in the summer too, but he thought that would interfere with his 'vacation'."

"He's had nothing *but* vacation, the way I see it."

"You would, you and your Calvinistic work ethic!"

"You and your wimpy 'he wants, he wants' attitude! Now his playing the odds kept him from getting his tuition's worth—or rather our tuition's worth—and made him get behind and in academic difficulties too."

"Another thing, Casey raised the possibility that Daniel might have some kind of bleeding disorder, lack of some clotting factor, maybe a condition in the hemophilia group."

"What's that?" I gasped. Could my wishes for Daniel's death be coming true? I needed no final solution like that. "So why didn't Casey call in a hematologist and get a blood work-up?"

"I don't know why he didn't do the tests while he had Daniel in the hospital anyway, but he told me a clot kept forming, and he'd evacuate it, and the next day it'd be back. It may have just been a bleeder Casey didn't tie."

"So Daniel refused to go to the hospital until the last minute, a complication developed, he didn't start school with the class, and he's behind and having trouble with trigonometry when he's supposed to be in advanced math. Now to solve the problems he takes a weekend off to fiddle with an old car he doesn't need and has no use for. Typical! Dumb and typical!"

"I'll try to persuade him just to leave the car here."

"Persuade? It's your car—just keep it, for God's sake. He has the upper-classman to ride back with."

"Another thing. Remember how you said it would be better for him to use our old twin bedding than to rent sheets at the University? Now he needs sheets and a blanket."

"Perfect! Those filthy things he left on David's bed haven't been washed yet. He can take them the way they are. He made very free with everything in the house but the washing machine."

"I guess there's poetic justice in that."

Peter said he would take Daniel over to his office to work on math, but when I returned from the hospital, Peter said he hadn't shown up. I took David grocery shopping because the new unisex junior high home economics course required the students to go shopping to get the point that food does not appear in the fridge full-formed, like Venus from the ocean foam.

When David and I, arms full of groceries, opened the front door, I heard a swishing noise followed by the slam of the family room door and found Peter alone in the kitchen. Hearing me, Daniel had Houdinied out the back way.

"Why did you have to come *now*? In thirty seconds we'd have left," Peter carped.

"You son-of-a-bitch! Criticizing *me* for coming home to my own house and catching you with that creature after I told you I don't want or trust him here! I'm fed up with you blaming me instead of Daniel or ever taking any blame yourself."

Peter followed Daniel to the office. Daniel, Peter later told me, had been astonished that Peter could help with a kind of math he hadn't used for many years. "You have to give Daniel credit," Peter told me. "He offered to pay for the things that were stolen."

"Take it," I snapped. "Collect that money on principle! That's the first evidence I've heard of Daniel feeling any moral responsibility. What did he suggest he use for money?"

"The stock we talked about. He brought it up himself."

We estimated the loss, but I don't recall the transaction ever being completed.

I cancelled plans for Saturday night so as not to leave the house unattended with Daniel in the community. As usual, the phone was clicking and going dead as it always did when he was nearby. But no more was heard from or about him for several weeks.

Daniel gone, I tried for closure with Juvenile Court. After a silence of more than a year, I telephoned Mr. Dunn and launched into my story about Peter's double-cross of the living arrangements, the neighbor's call to the police about rowdy behavior on the beach, Daniel's surgery put off until the last moment, its complications resulting in a late start at Case Western, and the alleged break-in, after Daniel himself apparently tried to force entry into the basement.

Mr. Dunn listened in stony silence and then replied, "I knew about the surgery. I visited Daniel in the hospital." His icy tone suggested, "Your son was injured, and where were you? What kind of mother would neglect a sick child?"

"You have to remember that his father pushed for surgery before we left, but Daniel refused. And as you know, we didn't recommend those rough playmates of his who broke the shoulder in the first place."

"I didn't hear the development about the police, but anyway this matter is no longer of any interest to the Juvenile Court," said Mr. Dunn with the first note of annoyance I had ever heard creep into his voice. "The judge terminated his probation in August. Daniel will just have to learn that he can't do whatever he wants."

"Tell me, why will he have to learn that? There hasn't been any reason so far. Don't you really mean that we will have to learn that he can do anything he damn pleases because nobody ever throws in a roadblock but me?" That distinction seemed to escape Mr. Dunn.

"Well, if he gets into any more trouble, it'll be as an adult," he added piously, his tone implying, "What more could anyone have done?"

I felt my last surge of rage against the innocent Mr. Dunn and the guilty Judge Whittier. "You mean to tell me that the judge terminated Dan's probation while he was raising Cain in Evanston just four months after he came off adult probation in Texas for a drug offense?"

"What do you mean, 'off adult probation in Texas'?"

"When he was sent to Texas, I understood it to be your business to contact the authorities down there."

"I was never instructed to be in contact with them," Mr. Dunn apologized.

And so I told the story of how Daniel had collected another probation while living with his uncle.

The chaos was no different from ever before—in Daniel's world, the word never gets from one to another, one court to another, one state to another, one adult to another.

During the eon since we had steamed into New York Harbor, the calendar had advanced just five days.

Thirty-three

Two Strangers

"WHAT'S BLUEBELL BARKING ABOUT?" asked Mrs. Innominata as we passed on the stairs.

"Probably a squirrel. Small animals excite her."

"I thought it might be that stranger again."

" What stranger?"

"Last week, when you was at the clinic, I saw a funny-lookin' kid out in the back yard three times. When I let Bluebell out, she ran at him so he took off over the hillside."

"What did he look like?"

"He wasn't very old, but he looked sick. He was tall but not heavy built, and he had a lot of hair around his face—moustache and beard. He was dressed ragged, like a hippie."

"What about his hair and eyes?"

"His hair was dark, but I couldn't see his eyes. When I saw him, he ran."

"Well, let me know right away if you see him again, and I'll call the police. If I'm not here, you call them."

That night I told Peter the incident. "You realize, don't you, that this represents the aftermath of Daniel's living here and letting those punks in. He couldn't have invited them in more clearly."

"You can't prove that."

"Tell me a better explanation."

A long silence followed.

A few days later I was working at my typewriter under a picture the toddler Daniel had drawn in orange crayon, and that I had framed many years before. As I stopped to stretch, I looked through the window into the back yard and saw an unshaven, dirty, slim young man staring upward toward the sun deck outside David's window. As I reached for the phone, my eye fell on my camera. I clicked just as he directed his gaze toward the window and, spying the camera, fled over the hillside. The police put out a watch, but I had more faith in the trespasser's belief that my camera held his likeness. It was the rare time, however, when my camera hadn't been loaded.

But at that moment I felt something die in me. If my son could invade our home with such people, if he could betray his family with whom he had broken bread for sixteen years, I had raised a Judas. Daniel had severed the blood tie and become a stranger.

Thirty-four

Doctors' Lounge

I WAS HAVING COFFEE IN THE DOCTORS' LOUNGE one morning when Dr. Casey, who had removed Daniel's shoulder pin, came in and asked the generic "How are you?"

Instead of the generic "Fine, how are you?" I responded, "Very tired. I'm suffering the physical fatigue, mental anguish, and emotional drain that follow gargantuan efforts that have failed."

"I'm sorry," he replied, and, hoping not to get into anything heavy, tried to sidestep with "How is your son?"

His attempted diversion failed. "I have two sons who are fine. Daniel, however, is not well at all. If the truth be known, he's a sociopath, and I'm trying to come to terms with this by no longer hiding it. I'm trying, finally, to 'come out' as the mother of a sociopath."

"What? What do you mean? Dan seemed like such a nice young man."

"Have you ever met a con man who didn't? Daniel can be 'nice'; he can charm the paper off the wall, until someone or something opposes him. But you never know what he's doing behind your back. He's been in all kinds of trouble."

"What kind of trouble? Drugs?"

"Drugs, breaking and entering, he was even thrown out of a school for delinquents. The admissions officer said, 'He's just going little by little down the drain.'"

Dr. Casey's mouth literally hung open.

291

"You look incredulous—people always are at first—but after dealing with him for a while, all you'll want is to put distance between the two of you. Daniel has unbelievable holes in his personality that you wouldn't notice just talking to him. My father has the same kind of flaws, and after years of struggle I've come to realize that I carried the bad seed and passed it on to Dan, a thing I never would have thought could happen. . . . I wish he could just die."

"I'm shocked to hear you talk this way."

"I'm shocked to be the one talking this way. It's shocking to have a child who warrants being talked about like this. . . . Do you think he has a bleeding disease?"

"Maybe. Suggest to him that he get a CBC and a PT." (This is a complete blood count and a prothrombin time, a test for ability to clot when bleeding.)

"You might as well whistle 'Dixie' in the dark. You always have just two choices: make him do whatever it is or forget it. We'll find out soon enough in the normal course of events whether he really has a bleeding disease."

During this interchange several other doctors had wandered into the doctors' lounge and formed a semicircle behind Dr. Casey. One contributed his cousin's experiences with his son, the cousin and his wife now bringing up their grandchild. Another said, "It's spine-chilling to hear a mother talk this way."

"It's more spine-chilling to *be* the mother talking this way. But it's better than pretending things are all right when they're not. Some day he may quiet down, but he'll never have the one trait I've always wanted for him more than any other: integrity. I hoped for him to be part of the solution, but he's more of the problem."

When I left the lounge, I crossed more than that threshold. I couldn't always level with even distant acquaintances, and closer ones were harder, but for once I had dropped the mask and abandoned the lying and deceit that I had girded myself with, as insulation around my pain.

Thirty-five

False Starts and Close Calls

ALETHEIA AND GEORGE RETURNED from a fall vacation that had included a visit to Judith and her newborn Milo and, unavoidably, Mike, the drifter whom Judith appeared to have gotten around to marrying before the birth. Aletheia and I met at the Jolly Crepe to catch up over lunch. I went first with my story of Daniel's invasion and occupation.

Her news was happier. She had finally made substantial gains in her years-long efforts to reestablish relations with her daughter, and draw her back into mainstream living. She had reached one of the happiest milestones of all: the birth of a grandchild. She told me how amazed she had been to discover that out of her daughter's years of tumult had come such a beautiful child, and how she was astonished to observe herself basking in loving the baby. Nevertheless, Aletheia pitied little Milo and feared for his future, both from the heredity he could be carrying and from the marginal existence he would be living, on income from his father's intermittent cab-driving. "I worry too what will happen when he gets to junior high and is offered drugs, as Judith was. But for now I think having him has changed her. She really loves that child."

Golden and scarlet maple leaves floated to earth as we left the Jolly Crepe into the glorious October brilliance, more precious for its transience.

293

I would have liked to give up on Daniel. I yearned to settle for a four-member-family pattern of life, with just two sons, both happy and well adjusted. But once again I realized that I was constitutionally unable to ignore Daniel. My child needed correction and I had to provide it. So I looked for on-the-scene help in Cleveland, specifically another pair of eyes on Daniel, to report to me while I waited for a way to intervene beneficially.

Unfortunately, within this century the pendulum has swung. Now most of our society is pitted against this kind of help for young people. Current regulations, including "privacy" issues and devotion to students' "rights", place young people outside the control of the university community. Once when Judith was at her worst, one of her professors called Aletheia and said, "I'm putting my job on the line to contact you, but if I were Judith's parent, I'd take the next plane out here to see what's going on." Parents cannot get grades from the school. If their child is unwilling to divulge, the only course is to impose financial sanctions until the son or daughter produces a grade card. That strategy seemed eminently appropriate in our case, but I knew that for Peter such a device was at best far in the future, and in the short term he would be outflanking me by sending money to Daniel. As for education, it was obvious that Daniel was in no condition to benefit, but I knew the odds are against those who drop out for whatever reason, ever to return to school.

Whenever a crisis is upon us, it's always too late for introductions. And so I called Carol Levine, the graduate student manager of the 900-student dormitory. I gave her a thumbnail sketch of Daniel, who hadn't yet attracted her notice.

Like everyone else, not grasping the difference between Daniel and the usual entering freshman, Carol tried to reassure me. "It's not at all uncommon for college freshmen to test their limits with a bit of drinking once they're out from under the watchful eyes of their parents, then settle down. I did this myself when I went away to school. While I don't condone it, I suggest you try to keep it in perspective." She described their system of floor chiefs—stable upperclassmen with responsibility for supervising freshmen.

"Here's an idea," I said. "Could you find a 'floor chief' with a foot in each camp, so to speak? Someone straight, or you wouldn't have appointed him in the first place, but still devil-may-care enough to be acceptable to the fringe element like Daniel. Then take that person into your confidence about Daniel, ask him to make friends with him but be in contact with me—I'll pay him

294

whatever you think would be right—to be a sort of mentor for Daniel. Could you do such a thing?"

Carol sounded dubious but agreed to look into this role model possibility. "I'll have to discuss it with my superior," she told me. She also promised to keep me informed about any trouble that came to her attention, though there was no assurance that a dorm manager would necessarily hear of police or court action concerning her students. Carol said she would have no compunctions about letting me know about warning letters. "I think it's amazing," she went on, "that you still are trying to help Daniel after all you say he's done."

"All I can do is keep trying to save my child, but I'm fighting a retreating, ever-less-effective battle—in a swamp. I feel as if paralyzed in a dream watching an inevitable tragedy about to happen."

Then, as I had done in Mr. Hershey's office years earlier, I cried. It was as if I were leaning on the daughter I never had.

As Daniel began at the university, I took another precautionary step. I found another lawyer, Alfred Beauregard, who agreed to scan the court dockets once a month for Daniel's name. For many months it did not appear. As we planned, almost in an aside, he told me, "I understand what you're trying to do. I have a son I expect to see some day in a penitentiary."

One night when Peter was out, a call came from Texas. In the excited tone of one eager to be the first with good news, James blurted, "I've had a letter from Daniel, and he says he's quit booze and chasing women and is hanging around with hard-working upperclassmen!"

"For what it's worth, his saying that."

"I guess so," James agreed, his happiness quenched.

"James, I want you to know how much I appreciate your calling to tell us, and I'll let Peter know. But as for Daniel changing, I guess you'd have to say I'm from Missouri. I'll believe it when I see it. I've been lured too many times into believing what I wanted to believe, and then slapped down."

I related to James the story of the loud partying, the shambles in our house, the police intervention, the alleged break-in, the bizarre thievery, and Peter's complicity in opening that Pandora's box.

"Maybe the medallions are misplaced and will turn up."

"With all the little easels left standing? Be realistic. You're just like Peter and everyone else, always trying to put the best face on everything. I seem to

be the only one who knows there never is a best face. You know, one day after all this happened, I told Peter that somebody insane must have been here. His eyes widened, and he said, 'That's what Daniel said too.' If Daniel were normal, he wouldn't hang around with somebody who brings a buddy he considers 'weird' to a house where neither the host nor the guests have any business in the first place. It's just like a novel Jonathan was assigned, where kids took over an old man's house while he was in the hospital. We are entering what I think is a new Dark Age. We're over the peak in terms of what civilization has achieved and are on the downward slope."

"But that was Daniel's own home."

"No longer. I've ordered him out. You see? Like everyone else, you immediately start looking for ways to make excuses for that druggie."

"It's hard with kids. They humiliate you with their behavior and make you think they'll never grow up, but you have to keep trying just because they're yours."

"They certainly can twist your life into a pretzel. But I don't see how the rest follows, the part about having to keep trying with them forever. By that reasoning my mother should still be taking care of me. I've been pondering this question lately: If there were a guarantee that devoting my entire effort, twenty-four hours a day, would someday save Daniel, how long should I hold myself to these obligations? Until he's twenty? Twenty-five? Forty? But there is neither such a date nor such a guarantee.

"Meanwhile, I have to take care of myself. I have to have an end point, when I will no longer be subject to dropping everything and getting re-involved because of the latest word about Daniel. There has to be some kind of cutoff, some time to close the door on a child who has everything his own way, leaving us nothing but the possibility that maybe someday he might deign to rejoin the race. Being always at his mercy has come to feel too much like blackmail. I have a limited number of trips around the sun, a limited number of heartbeats. Someday in the not-too-distant future I'm going to stop pouring my efforts into a solipsist. My mother never stopped loving me, but she stopped being responsible for me when I grew up and left home, and I intend, when Daniel is out of school, to do the same."

"I guess. But you can't give up hope."

"That's true, but unfortunately not in the way you mean it. I'd *like* to give up hope. I *try* to give up hope. I try to *kill* hope because it's too hard to live with, promising something it can't deliver and setting me up for the next strike. Hope is a luxury I can't afford, but that doesn't mean I'm quitting. The dorm authorities have promised to keep an eye on Daniel for me." I didn't trust James with the plan about my legal surveillance because I considered him a pipeline back to Peter, and I wanted no interference.

As chilly nights called for evening fires, I got out a pair of warm bedroom slippers I hadn't worn since spring. When I slid my foot into the slipper, my big toe encountered a hard object, disk-shaped, with beveled edges, looking like compressed wood fiber or even dried cow dung, but as if sawed into a disk and shellacked, about two centimeters in diameter, and covered by green nylon netting. My consultant, a young male social worker at my clinic, said it was probably hashish. Conan Doyle set that style with Sherlock Holmes's harem slipper for cocaine.

When a letter Peter wrote failed to produce any explanation of the university bookstore money, I began my round of calls. After several false starts, incorrect offices, and disconnections, I finally got someone on the line with Daniel's account in front of her. The money Peter had intended for books, all but twenty dollars of it, had been returned to Daniel by check. They were about to return another forty-five to him. "Hold it! What's that forty-five for?"

"You overpaid on tuition."

"How can that be? We paid just what our son said was due."

"I can't be sure, but it could be a lab fee from a dropped course. Anyway, our books show you overpaid."

"Will you find out about the rest that got returned to Daniel? Will you please put a note into the file that any overpayment should be returned to us, so he won't drop courses just to get the rebate? And will you return the forty-five to us because it's from a check signed by my husband?" She agreed, but we never saw any of it, though Daniel promptly started collecting dropped courses.

The woman in the business office explained that money could not be deposited at the bookstore to be drawn out in books and supplies, and that therefore there had been no alternative to cashing the check for money for Daniel. The university, understandably, did not intend to baby-sit fiscally irresponsible children. When I told Peter about the call, he responded, "Their office must have made a mistake." I gave up on my quintessential ostrich.

A month later I called Carol Levine back. Her tone was considerably cooler, having by then had personal experience with Daniel Greenleaf. "We've had one incident report about him. Someone saw him shoot a bottle rocket out the window. And there've been other rumors, none confirmed, about his throwing a beer can and pizza carton out the window. We're sure about the rocket because he was seen in an Indian vest he wears all the time."

"So what did you do?"

"I've left a note asking him to come see me, but he hasn't come yet."

Once again I explained that asking had no effect on Daniel, and that the

options were simple: force him or forget it. "What line do you plan to take when you talk to him?"

"I'll ask whether he's happy with this dorm. If he'd rather be in another, we'd try to accommodate him."

"*Accommodate! Happy!* I can't imagine what happiness has to do with this. I personally don't give a damn whether he's happy or not. Happiness ought to come after responsibility. Besides, wouldn't it be pretty much the same in any other dorm?"

"Well, not exactly. Rockefeller has a bad name. Students think of it as a place to spend a year or two and get out as soon as possible. For one thing we have nine hundred students. All the others have a hundred fifty."

"But they must all have pretty much the same expectations. I can't imagine any dorm tolerating students who jettison trash out the windows."

"Of course not, but I can't begin to know all the students."

"You know Daniel soon enough! Tell me, what do you hear about his grades?"

"Nothing. But the warning lists aren't out."

"I really don't expect his grades to be all that bad, because through all this he's kept his grades up. Yet nothing he does would surprise me." I told her the story about the discrepancy in payment, and she promised to look into it for me.

"Have you spoken with anyone who has an image he would admire? Remember when we talked about the floor chiefs?"

"I talked with the counselor, and it seemed best for now if we didn't say anything to anybody, unless he does something first."

"Nobody ever wants to do anything until it's too late."

I wrote off Carol Levine as unlikely to become an instrument of change in Daniel. As soon as he became unmanageable, she would exercise her option to dump him. I felt envious of her for not being tied to him by invisible bonds like mine.

When no rebate check came, I called her back once more, but she was unable to shed any light on the money question. By then, however, there had been more incidents involving Daniel and his guests, boys and young men whom Daniel had brought into the dorm even though they had no connection with the university. They had ripped announcements off the bulletin board outside the monitor's room, yelled through the halls at three in the morning, and even kicked a hole in the wall. The culprit had paid for it, she told me, or charges would have been brought. She asked for my reaction to her option of putting Daniel on "disciplinary probation". Such a move would place him in jeopardy should there be further offenses. "You have nothing to lose," I said, "but very little to gain." I decided to abandon my messenger role with Peter and see what he could learn when he visited for Parents' Weekend.

One Friday evening Peter, David, and I went to see *Apocalypse Now,* the message of which I had hoped would reach David, but, as it turned out, he was too immature to see the horror of sending teenaged children to fight in drug-ridden jungles. Jonathan stayed home to prepare for a debate tournament, and took a phone message from Daniel. "He says he can't go to Detroit this weekend, so he wants Dad to come for Parents' Day tomorrow and see Reserve play his alma mater."

"This is no time to ask me that!" Peter snapped. "If he'd wanted me to come, he and I should have planned it, and I'd have gone as far as Vera's tonight."

"What's this about him not being able to go to Detroit? What's in Detroit? He's supposed to be studying. What do you know about all this?" I asked Peter.

"He said something about it, but nothing ever got settled."

"But last week when you and I talked about Parents' Day, I understood that you planned to go because you're trying to keep communications open. That's why I left the flyer on your dresser."

By noon on Saturday Daniel called Peter again.

"Why didn't you ask me sooner?" Peter whined helplessly, his passivity irritating me. He went on, "It's too late now. How are you doing in school?...That means 'pretty poor', I take it. Well, I can't worry about you any more."

Peter hung up and returned to the kitchen, where I was reconciling another month's checking. I told him, "I wish he had wanted you to come today for a better reason than not having anything better to do because of not going to Detroit for some cockamamie reason."

And the fight was on, Peter insisting on sending Daniel an allowance of $35 a week, with all his expenses paid and even clothes bought when Peter took Daniel to Crown Point. He had also met Daniel's new girlfriend, a sophomore art major. Although I had no objection to his taking her out occasionally, I doubted the legitimacy of how he spent that amount of money. Peter pointed to several plusses about Daniel, such as his picking up our dog and running her on the beach while we were away. And I agreed that he loved animals, recalling his anger when one of his scuzzy friends once senselessly killed a raccoon. Peter was, commendably, trying to promote the good in Daniel. And I was the parent who tried everything I could think of to eradicate the bad to let the good take over.

"I've always said that I don't impugn your motives, but we're light years apart on method. You don't have to be a member of the Mensa Society to see that he's using the money for drugs, and you're subsidizing his self-destruction at the rate of $140 a month."

"If he doesn't live like a middle-class citizen, how will he ever feel like one?"

"He's lived like one all his life, and you can see where it has gotten him."

"I'm trying to save him. He's floundering and has to find himself."

"I hate that expression! Aletheia was saying the other day that when people like Daniel and Judith have to 'find themselves', or the new equivalent, "find out who they are", all they need to do is come to her and she'll tell them where, as they say, it's 'at'. She'll tell them that it's not easy to earn a living, and most of the world's work is done by people who don't feel like it, and there's no free lunch. But that's just the trouble. There *is* a free lunch. If you don't bother to care for yourself, somebody, a parent or maybe a social worker, will materialize and lead you by the hand to plug you into some system that will feed and clothe you. Whether you can't or won't or don't, it makes no difference. Too many safety nets result in making us not have to be responsible for ourselves. Someone will put you into the hospital after every bad trip, if they find you in time, or set you up in an apartment. What good did that do his self-image? Peter, you keep running with the free lunch to Daniel, but what you fondly believe is 'help' isn't help. It's an obstacle to maturation."

"Otherwise he'll steal for it."

"Did you hear what you just said? Isn't that a terrible indictment, to admit that you bribe your child not to steal? By 'helping' you are hurting. The issue could be forced sooner if you didn't make it so easy for him to be delinquent.

"And you blab all our shame about Daniel to perfect strangers, the way you did at the medical alumni meeting, and to your family. Your stupid sister Vera, who thinks you're so smart, supports everything you do."

"Don't attack Vera!"

"I'm not. I'm attacking what you do!"

"I know I'm lucky to have my family." He was not mocking.

Then I reflected on what kind of person I was becoming. Why, I asked myself, had this call set me off more than other, worse calls? Partly it was my festering anger with Peter for his passively going along with Daniel's materialistic demands. Partly it was how I hate for people to make promises without evaluating the cost or intending to follow through, as in the matter of the tequendama, which I reminded him of, to try to make him see that a person looks like a fool to promise something he has no way to accomplish. But it wasn't all Peter. As I looked at myself, I didn't like what I saw. Trying to be a parent to Daniel had made me become like a top slowing down, and it took less and less to worsen the wobble. My personal gyroscope was failing.

Thirty-six

Family Holidays

AT JONATHAN'S OPEN HOUSE, Mr. Janus, the Latin teacher, asked, as the other parents moved toward their next class, "What's happening with Daniel these days? I haven't heard anything about him for a long time."

Like the unseeing bust of Cicero behind him, Mr. Janus stared at me, but I remained mute, determined to force Peter to handle this one. After what seemed an age, Peter sighed and said, "He's at Case Western Reserve majoring in biology and having trouble with trig."

"I'm delighted to hear it," said Mr. Janus with a smile, "glad he's a little more settled. Now Jonathan, *he's* settled, and I'm happy to have him in my class. Great sense of humor—he's pure pleasure, that one—hmmm, has the same Latin name that Daniel had, Marcellus. Anyway, tell Daniel I said hello."

As Thanksgiving approached, Peter let me know that Daniel would be at the Martins' again. Warned, I braced for another possible invasion. Though Case Western had not yet officially closed, I was prepared, or so I thought, when the front door opened and Daniel seemed catapulted into the house.

I was stunned by the change in his appearance. He affected a heavy stride, wearing the boots Peter had bought him, and a black leather jacket with brass studs, looking like a Gestapo officer. He was personally clean, his long hair tied back, but his facial expression was hard. His speech was pressured

and nonstop, and he spoke in a monotonous husky growl, using poor grammar and street slang. I inferred that he was on drugs.

In contrast to my reaction, his arrival produced happy excitement in Jonathan and David, who immediately started chattering about their trip and showing him mementos. Again Peter did not confront him with how he had taken over our house three months earlier. Knowing that at any moment this caricature of a family reunion could end in the same kind of whirlwind in which it had begun—with Daniel there is never the luxury of time—I began by inquiring about some of the missing property. "Daniel, what do you know about my silver and turquoise jewelry?" I asked.

"Nothing. Why would anyone take your dumb jewelry?" he asked, too quickly.

"Yeah, Dan, and what about my tapes?" asked David.

Daniel went to the stereo, reached under a low-built speaker, drew out several cassettes, and handed them to David. "Here. I put them there so they'd be safe."

"What kind of people were here last summer that you'd have to hide things from to keep them safe?" It was a rhetorical question.

"Look," said Daniel with an angry glare in his eye, "I came here not mad at you or anyone, and just like always you start hassling me for no reason."

"You have no justification for being angry with me. I wish I could say the same for myself. I have a backlog of anger that long ago took the place of my love. Why do you want to look so tough and uncouth? Why do you want to live with and be like those punks? What gave you the right to move in here for five weeks of partying? And another thing: This is my house, and I'll say anything I like in it."

"I'd better be going," Daniel said, and vanished after Peter made arrangements to pick him up in the morning to go to Crown Point with his brothers to visit relatives and go shopping.

Predictably, Peter was angry with me for the confrontation, and I suffered my usual embitterment over his passive noninvolvement. I went upstairs to slow my racing heart, to cry, to lick my wounds, and to ponder again whether there was any way for me not to be at the mercy of a repetition of this encounter every day of my life. My home was not my castle, as long as it was also Peter's home. I called Peter's sister Vera in Crown Point, to ask her to hide any alcohol before her nephew's visit.

When Peter and the two younger boys returned from Crown Point, having dropped Daniel off at the Martins', Peter related that Daniel had behaved well around the relatives, but had admitted to not working in college. His grades had plummeted, and he had dropped first the honors math course, then the regular one replacing it. He was carrying a D in biology, his major.

His excuses were flimsy—six students in the suite, failure to use the study room, and bad study habits. But he was having fun, he told Peter. They had burned an effigy of the Ayatollah Khomeini. Typically, he made no mention to Peter of the disciplinary probation.

"As soon as Daniel flunks out," I told Peter, "our support should cease. He certainly isn't ready for college now, maybe never will be. Maybe being at the bottom of the economic ladder might make him see that there's more to life than a menial job and drinking beer. Maybe nothing will make him see the value of an education, even the mere economic value."

"You may be right," Peter admitted.

"I can't believe this is going on in a normal nervous system. Maybe it never was normal. Maybe it was normal once, but now he's killed his own brain."

Daniel stayed at Phil's over Thanksgiving, and we heard no more about him until one night in December when the phone rang at one in the morning. I jerked upright in fear of that crisis psychiatrists dread, a patient's suicide. At first the call seemed to be one of Peter's middle-of-the-night endocrinologic emergencies, but then I heard him use Daniel's name. "Why are you calling at this hour?...You say you didn't what?...Well, why do they think you did?...Well, why did he do a thing like that?"

Usually I can tell the caller's input from the redundancy at Peter's end, but not this time.

"What was all that?" I asked when he finally hung up. "Why can't he let us sleep?"

"He said he dialed our number by mistake. He meant to call his girlfriend."

"Did he sound drunk or, uh, abnormal that he might make a mistake like that?"

"I don't know."

The sleep vapors having evaporated from my brain, by then I realized that if there had been a point to the call, Peter was not volunteering what it was. "Anyway, what's all this that he did or didn't do?"

"He says he didn't set fire to the Canadian Consulate."

"'He didn't set fire to the Canadian Consulate!'" I mocked. "What kind of message is that? I didn't set fire to the Merchandise Mart, but I never called anybody at one in the morning to tell them that."

"He says—you're not going to believe this—"

"Just try me. I probably won't believe what he said, but I bet I'll believe he said it."

"—that his roommate *did* set fire to the Canadian Consulate."

"The roommate had a good reason, no doubt."

"Dan says the roommate is anti-Canadian."

"Of course. I believe *somebody* set fire to it, and if Dan was anywhere

within a country mile, I'll bet he was somehow involved. Was anybody hurt? Are there charges? There must not be charges or they would have just put him in jail and let us sleep."

"He didn't tell me. I don't think the fire got very far."

"You never ask the right next question. ...Well, if he goes to jail, we'll find out soon enough."

And so I called Carol Levine next morning.

"Did he tell you about the fire-setting?" she asked. "Oh, dear, now I'm trapped and feel I'm betraying a confidence."

"A *confidence?* He *confided* the fire-setting to you? I bet you didn't find out about it from him, so what do you mean by 'confidence'? With Daniel the only confidence is the game he's playing."

"You're right, of course. Daniel never established any kind of relationship with me. But I'm still in a bind concerning my obligations to students, their parents, and the school." She went on, regardless, to clarify that the "fire-setting" had not put anyone in jeopardy and had been, at worst, an unintended side effect of mindless behavior or a stupid prank. She explained that the building next to Rockefeller Hall happened to be the Canadian Consulate. The boys had jettisoned something that was burning from their window, and it was carried by the wind in such a way as to alight on the roof of the consulate. For whatever reason, Daniel's roommate was made to pay for the damage and was already on probation for the offense. Daniel was only under suspicion. There were no legal charges, since the authorities considered the incident an accident. I told her that Daniel had told his father it was intentional.

A few days later I called her for an update—she never called me back as she kept promising—and learned of fresh incidents. Daniel had thrown an entire decorated Christmas tree from a window. He had also been found drunk and unconscious, and had had to be carried to his room by the security guard. His language had been foul and abusive.

"So it sounds as if now we have to say he's alcoholic."

Miss Levine agreed, a switch from her reassurances several weeks earlier than many if not most college freshmen cut their teeth on alcohol and soon settle down.

"Probably other drugs, too," I said.

"It certainly looks that way," she admitted. "I've talked this over with my supervisor, and we're giving Daniel his last chance. If he gets out of line after Christmas, there's nothing left to do but transfer him to Hanna, that dorm I told you about with only a hundred fifty students and a male psychology graduate student in charge. Rockefeller can't contain him."

"Exactly where you should have put him in the first place," I growled. "I appreciate your efforts, but can't you see why I'm discouraged? With Daniel,

everyone always starts by being absurdly optimistic and assuming I'm exaggerating. They think that standard treatment will produce standard results, and he'll rise to meet expectations—until he starts showing his hand. Everyone always wants to help, to a point. It's not your fault or the fault of anybody before—but the problem always bounces back to me. I keep retreating to less-easily-held positions and never even win any skirmishes. I certainly have very little hope of winning the war, ever."

She could not deny the truth of anything I said.

I told Peter about the Christmas tree, the gross and abusive language, and the fact that our son was alcoholic. He sat on the bed, sobbing. "What do you want me to do?"

"Treat me with gentleness. And stop treating Daniel as if he were normal. Don't always act as if each new story of his is likely to be true. He's the liar; the rest of us aren't. You don't have a built-in shit-detector. Mine isn't built-in either, but I've at least been able to learn. And don't answer him when he starts manipulating. Bite your tongue before making any promises. Remember that everything sounds innocent to you. Talk to me. Not only am I better at this than you, but women in general have had to do this sort of thing to survive since the beginnings of recorded time."

Peter nodded and sighed.

"But what to do about the alcoholism at this point I don't know. Carol Levine tacitly admitted there're other drugs too, although she couldn't come right out and say so. Another thing, whatever you do, don't ever let his name be taken off the car insurance. He's not above driving a car, ours or someone else's, drunk or sober, with or without insurance."

As colored lights started to twinkle on trees, and wreaths appeared on doors, I too geared up for Christmas. I got out the ceramic crèche Aunt Lith, from whose traveler's tales I got my love of travel, had brought me from Provence twenty years before, with tiny doves on the red tile stable roof. That manger scene had appeared with little Jonathan's face in one of the Christmas cards past. Christmas is a time for memories.

Peter and Daniel arranged for another stay with Phil and his mother over Christmas. Peter said he'd need to get him a winter coat, since his last one had been left in Texas or lost somewhere. Then Peter's eyes filled with tears, and he added, "I'm going to help him."

"How?"

"I don't know. I'm just going to help him."

"How do you intend to help with the real problem?"

"I don't know. I just know I'm going to help him."

"This is the story of Daniel's tragedy. All of us wanting to help, endless talk, and all we can do is helplessly wring our hands. I bet he hasn't told you about the disciplinary probation."

"What?"

I changed my mind and explained, despite resenting being cast in the role of investigator to ferret out all these unhappy incidents, and message-bearer when Peter made no such efforts.

"No, he hasn't told me that either, but I still want to help him."

"He's likely to be kicked out of the dorm."

"I didn't know that either."

"Of course not, and you wouldn't if it weren't for me. You never do any fact-finding. So what would you suggest trying now?"

"I don't know," said Peter once again. "All I know is that I want to help him."

"So do I. And I haven't got a clue how to go about it."

Daniel always timed his calls to Peter for late in the evening, when both of their biorhythms soared but I would be asleep. He was usually out of money and always had something to ask from Peter. Sometimes the ring would waken me and I would tiptoe partway downstairs to eavesdrop on Peter's end of the conversation. On one call I heard Peter ask to see a grade card, because our insurance rate was predicated on a "good student discount". "But even if you *did* make two C's and two B's, that's not good enough for someone with your mind. And on four easy courses, after dropping your major. ...But I'm telling you, I haven't seen it either. ...No, when I send you money, it won't be so much. You and your pot-smoking friends and you lying in your vomit in the booze—you could go through any amount. ...No, I'm a respectable and respected member of the community, morally responsible for accidents. ...That's downright ridiculous! I'm telling you—he's senile. He wouldn't know you, and you'll never get anything from him. ...I know he stole what Grandma tried to leave you. ...That's right, he stole what she tried to leave me too! That doesn't matter. He's a psychopath, just like you, and nobody ever got a penny out of him. ...No, I wouldn't struggle for that. Life's too short. [He was referring to my mother's will that my father never probated.] You're not my son any more. You've broken my heart too many times."

He did not tell me about the call—he didn't have to—but the next morning his always-slow tread was slower still. His shoulders drooped and he looked a beaten old man. "I'm tired," was all he admitted, and later added, "I guess I'm depressed."

"Then do what you advise me to do—take an antidepressant. Drug yourself. Where is it written that, having sired Daniel, you should go through life drug-free?"

Daniel was back in town for Christmas and Peter invited him to our holiday dinner while the Martins attended their family festivities. He suggested that I might like to leave for the afternoon, and he was right—I would have preferred an afternoon in the library. But other needs took priority: I would be doubling as a security guard around our home. Still, even if I'd been given a guarantee that Daniel would leave everything, I knew I had to watch my son, like prey hypnotized by the eye of the predator about to strike. Even more, I needed an idea for my next attempted interception. Not watching Daniel at every opportunity was a luxury I couldn't afford.

I had bought Daniel a copy of Turgenev's *Fathers and Sons,* but Peter and Daniel hadn't bought the coat Daniel had asked for, and all we had on hand, besides the book, was a huge bottle of multivitamins Daniel had asked for. Therefore, I had the boys open their gifts before Daniel came. Bluebell was chewing her enormous rawhide bone when Daniel arrived, looking diametrically opposite from the picture he had presented in November, and smelling strongly only of tobacco smoke. This time he was not arrogant or swaggering. He was more than subdued. He was blank, without sparkle or spontaneity, maybe depressed, possibly drugged. He said little other than to question having the tree in the dining room instead of in its usual corner of the living room. I let him know that I had bought it from his old Scout troop.

Soon the three boys were in the basement playing Ping-Pong, Monopoly, and a new Christmas game. Though conflicted about pitting my sons against each other and loath to ask one to spy for me on another, I nevertheless called Jonathan aside to ask him not to let Daniel out of his sight. Yet Daniel looked as though it was farthest from his mind to take or destroy anything. But of course he had a long history of being both unpredictable and changeable from moment to moment.

Knowing Daniel would be there, I had already planned to treat the occasion as a festive holiday with a guest. I set the table with a purple tablecloth, my mother's china, silver candlesticks with violet candles, goblets with a thumbprint pattern reflecting in a thousand concavities the Christmas tree lights, and my

grandmother's cut crystal relish dish, filled with jelly the boys and I had made from elderberries we had gathered. I proposed a toast in V-8: "To a New Year that's better for all of us."

I was on tenterhooks through the quiet meal. Peter offered to take Daniel to pick out the coat and gave him the book and the vitamins. There was little reaction from Daniel. His attention was sparked only when David mentioned having seen a Lamborghini.

Gradually I grasped the fact of Daniel's impoverished mental life. He contributed nothing but the most concrete remarks. "This turkey is great." Daniel also praised the gravy, though I didn't recall gravy ever having been a favorite of his. In my role as hostess, I related how my favorite Aunt Lith would always jokingly evaluate her visits to us on the basis of my mother's wonderful gravy.

I had a strange and new but sad sensation. Providing my children's nutritional sustenance had never been a source of pleasure to me. I had found meal planning, grocery buying, and food preparation tiresome and a necessary evil. Watching the family enjoy what I'd prepared had never produced happy feedback for me as it does for some homemakers. But as I watched Daniel eat and eat and eat, at least his appreciation of good food seemed wholesome, except for his overuse of salt, a lifelong habit of my father's, and one I came to associate with "sensation-seeking". For the first time since his infancy when I had enjoyed nursing Daniel, I felt a *soupçon* of satisfaction in feeding him, the only form of nourishment he would accept from me.

During the afternoon I saw Daniel come down from the attic, apparently having been looking for ropes and camping equipment. "It looks like my things around here always vanish," he said.

"It looks as if ours do too," I reminded him, but the jab didn't penetrate his consciousness.

He complained about an aching wisdom tooth. "It has to be yanked," he said. Tough and conveying disregard for human flesh, his expression grated on the physician part of me.

Peter looked into his mouth, saw that the tooth was impacted, and told him to call Dr. Kennedy for an appointment.

"And tell him you have a tendency to bleed," I added.

"Oh, I'd forgotten about that," Peter sighed. "It may have to be done in a hospital."

On the six o'clock news we heard a reference to the upcoming Winter Olympics at Lake Placid. The younger boys were well aware of this, as was I despite my lack of interest in sports. Indeed, I'd have expected anyone to know of the event, particularly a university student, but Daniel acted as if he hadn't heard of it. A clammy feeling crept over me as I realized that he had become isolated from common knowledge, divorced from the world. Nor

did I like his reaction to finding out about it. "I should go up there to see it. I know somebody from school in the Catskills."

"You should do nothing of the kind," snapped Peter. "The Catskills are hundreds of miles from Lake Placid, but that's beside the point. You need to stay at school and study. A serious person your age shouldn't always be thinking about play."

When Daniel returned to the Martins' that night, he forgot the vitamins and the book, but he swaggered out with a coiled climbing rope over his shoulder. The day could have been worse. Depression was a real improvement over hyperexcitability. Or had he, perhaps, taken a 'downer'?

Over the next few days, Daniel kept calling Peter about the wisdom tooth, but they never coordinated a way to deal with a straightforward dental problem. This episode forced Peter to observe how incompetent Daniel was, in face of a simple problem. "He was crying from the pain," said Peter. He didn't even want to talk about looking for the coat, his tooth hurt so. I told him to start with some aspirin."

"You had to *tell* him to take aspirin for pain?"

"That's the funny part. I asked him, and he said he took one once for something and it hadn't helped, so he never tried it again."

"Doesn't it make your flesh crawl to think of a kid of nineteen who considers himself an adult able to handle everything, who isn't integrated enough to know that you take aspirin or maybe Tylenol for pain? And in a medical family? Can you see how deteriorated he is? When I was nineteen, I made my own dental appointments."

"Victoria, you were a girl. Boys take longer to grow up."

"If ever. Stop making excuses for our Peter Pan, who used to shock me by saying he never wanted to grow up."

"Let's not go into his immaturity just now."

"You're the one that brought up about the teeth. I'll give you a couple Darvons to give him but don't tell him what they are or he'll probably sell them on the street for ten or fifteen dollars. I'd also suggest Tylenol instead of aspirin for a potential bleeder."

Over the next few days Daniel's calls continued, followed by X-rays, an oral surgeon's consultation, and antibiotics for an abscess. Finally, our own dentist being out of town, Peter arranged for a dentist he had as a patient to extract the impacted tooth, and there were no bleeding complications. Peter's wish to help Daniel had been granted. Meanwhile, the time for normal registration had run out, and Daniel arrived back at school just in time for us to

pay another late fee.

After they had left for the bus station, in my frustration and despair, with no relatives of my own to turn to, and unable to think of any other way to cope, I called my sister-in-law Vera. She had seen Daniel over the holidays and reported no problems with him.

"I can't *stand* it," I shrieked over and over, hysterically. "I can't *stand* to see this caricature of a human being my child has become."

In early March I called Carol Levine again, since she, like others who promised to help with Daniel, had preferred to forget. She said that Daniel did pretty well in January, but in February there was more trouble. "Once we found a lot of furniture overturned, some smashed. Pillows were punctured and feathers all over. The housekeeper refused to clean in there. Dan also threw carts around that we use for moving luggage. And his language—I've heard a lot of college language but nothing like his. I'm afraid Rockefeller can't contain him any longer, and we've told him so. He'll have to go to Hanna."

"Of course. I told you so last fall. What's wrong with Hanna for him anyway? For that matter, what good will Hanna do?"

I called the psychology graduate student running Hanna Hall, to brief him on what was coming. He told me he was confident he could handle anything Daniel presented.

"You and everybody else," I told him, and explained.

There were more late-night calls from Daniel. Knowing that they would hear if I lifted the receiver, I would get my clipboard and sit on the stairs out of Peter's sight as I took notes. Once when I grabbed a chewed green pencil stub, I was jolted to see Daniel's name on it in gold, a *déjà vu* from days when stockings always needed stuffing with rulers, pens, whistles, and long, skinny toys.

By this sneaky device of mine I learned of another way Peter's and my marriage was being eroded. Peter was sending Daniel endorsed patient checks, thereby never passing them through our account, to deceive me, just as I was deceiving Peter with my costly legal surveillance of Daniel and my eavesdropping on their phone conversations.

Daniel called one evening when Peter was out, and I listened to his vituperation, ranting, and demanding that I keep out of his life. Then he dropped the line, "You threw me out of the house and the family."

"Wait a minute. You *left* the family when you threw in your lot with Scott Sawyer and when you wouldn't accept the help offered at Pleasant Valley, at

Nova, and at Alamo High School in Texas. It's true that I wouldn't tolerate your having your foot in both worlds, using our house as a base from which to exploit and rob us while you played with your punk friends."

"You said you didn't want to see me again when I went to Texas."

"I said I didn't want to see you *until you were cured,* and I tried six or seven ways to do that, all of which you sabotaged. You didn't want to be cured, to come back to the way of life you grew up in. All you wanted was to milk us for what you could get. And as for the way you are now, you're right. I have no use for you."

My call to Case Western Reserve was just three days too late. In early April I tried to reserve a room in Hanna for Daniel in the fall, in case he got back to school, and I was told the deadline was already past. The girl in the housing office asked me to have Daniel stop in to try to remedy this.

"You don't understand. He doesn't want to live in Hanna or any other dorm, but that's the only place that'll take him on campus, and his father and I won't pay for off-campus living." I was embroidering the truth about Peter.

"All right," said the voice, "I'll put him on the wait list, and you can call over the summer. I can't imagine that nothing will open up by fall."

Even for a family with a child like Daniel, life moves on. That spring I performed my annual volunteer job for the younger boys' Scout troop, organizing the award potluck. It was a special one for Jonathan because he was getting his Eagle. That night Fred Saroyan made a point of praising both of our boys still in his troop, but I detected—or thought I did, though maybe my pain had brought me to the brink of paranoia—a question in his eyes about Daniel. But this celebration of success for Jonathan was bittersweet, contrasting as it did with my disappointments in his older brother. I went through the same reluctance/inability to let myself fully enjoy the high school banquets honoring scholarship, which we attended with each younger boy, and another banquet taking Jonathan and others into Thespians. I cried, too, when Jonathan's debate team showed surprising strength, sufficient to let them compete in the state tournament. Where had my erstwhile ability to compartmentalize gone? How could I have let my festering wound with Daniel contaminate everything good? Daniel had poisoned the well of my parental pride.

The next call from Daniel was actually for me. The occasion was Mother's Day. Daniel volunteered to tell me why his grades had been so poor.

I had no reason to expect them to be anything else, but how poor they were I hadn't heard. His raising the matter of grades was like a red cape to a bull, because Peter and I had argued over the fact that we never saw a grade card, but Peter refused to withhold money until we received one.

For all these reasons I had no wish to hear about his grades, and I didn't ask for either the grades or an explanation. Nevertheless he plunged ahead, explaining that he had slept through a final or two. The reason for that was that he had been upset because his girlfriend had been raped.

"By you?" I did not believe the story of the "rape".

"That was a hostile remark."

"It was intended to be. I don't believe your story."

"I didn't expect you to understand. You don't care for anybody but yourself. I called because it was Mother's Day and to say hello—"

"I'm sorry about your girlfriend, if there's any truth to that. But even if there is, what about *before* the rape? If it's true, what good did it do her for you to lie in bed, cut finals, and waste your entire year at the university, not to mention your education fund? And what reason have I to believe this story, given your history of truth, lies, and a mixture to suit your convenience? I don't buy that 'rape' as an excuse for failure or bad grades or sleeping through finals or whatever you're using it as an excuse for."

At this point Daniel did one of the abrupt about-faces he was noted for: "Woman, you are off the wall! You are out of your fuckin' head. You took my education fund and—"

"Your fund! Just what do you mean by that? Your tuition has been paid—and more than once for some courses, not to mention late fees because of your screwing around. We've sent room and board money for two dorms—"

Daniel broke the connection. When my anger subsided, I remembered that he had called me, the reason being Mother's Day. But if his call had been intended as an olive branch, it was neither the right time nor the right branch. After the thousands of times Daniel had deceived or baited me with truth and half-lies, I did not intend to blame myself for missing what might have been a legitimate overture. I was too angry to care.

Thirty-seven

Meeting of
Two Sociopaths

CALLS FROM DANIEL CONTINUED IRREGULARLY, causing me to live always in dread of the next Molotov cocktail. Since the calls were usually between eleven and eleven-thirty at night, I began staying up until midnight, relaxing only when Daniel's witching hour had passed.

One such call came on Father's Day. Positioned at the head of the stairs with my clipboard, I heard Peter say, "But we discussed how you were going to summer school to make up those two courses. ...But if you're serious, why don't you get it done? We agreed you'd be in summer school by this time. You don't sound very keen on school at all! What about your naturalist goals?

"Yes, but how did Sharko have enough money to support you?...You shouldn't be living off him and his parents!...Sending money to you is sending it down a rat-hole [sigh], but I guess I'll send a little more. ...It'd be plenty if you gave up pot and alcohol. ...But you don't need any of that stuff....Because it isn't good for you, that's why not. Look at you—once you had a fine mind and showed promise. Now you can't make it through an average course at a good university. There are plenty that do make it through. Why don't you associate with *them*? Why don't you use *them* to compare yourself to?...I'm sorry to hear that you broke up with Michelle. I thought she was a nice girl. ...That's a pretty uncouth expression—that's no language to use about her. ...Well, I'm going to have to go, and I guess I'd rather hear from you than not, but I hate to argue

313

with you every time. ...Call me again, and let me know." Peter sounded more tired than usual as he dragged his bad leg up the stairs. I scuttled ahead of him to bed and pretended to be asleep so he wouldn't know I had been listening. But Peter never suspected anything like that.

The next call came ten days later. This time Peter was yelling. "I *sent* the money and the letter came back. What's *happening* out there? I sent four and two came back. They don't *know* you at that address. ... I can't send letters all over the world! Daniel, you can't go on living this chaotic life where nothing ever gets finished! Settle down somewhere where they'll recognize you as a person with an address. Then do something constructive; don't just drift. ...Daniel, wiring money doesn't pay; it's too expensive. ... All right [sigh], I'll wire it. Give me that address again. I know you need shoes. ... Get back into school, or they'll draft you. ...You mean you'd give an address that doesn't exist? You shouldn't do that. Don't you get tired of this chaotic life? Go back to school. Give up this craziness. ... I'm glad she likes you. I have no objection to that. ...All right, we'll try again with the money." And so on.

Later, when no checks made out to Daniel came back with the monthly statement, I confronted Peter, who admitted having endorsed patient checks. One such envelope of checks was "lost" and eventually cashed by someone else. Daniel had no job but had been to the horse races. He told his father that a friend who worked in a restaurant was giving him leftovers. He continued leading Peter around by the nose, with endless dust-in-the-eye half-descriptions of false starts and changed plans, nothing ever meshing.

"I repeat, you shouldn't be sending him money," I told Peter. "He's legally an adult, which means that we've lost the semblance of control we had when we asked the judge to send him to Nova. He's not working, and he's a caricature of a student. Apparently he's just freeloading off one kid or family after another, the way Applegate said he did that summer after Pleasant Valley. And your support makes all this possible. In fact, you're supporting his habit!"

"He says they didn't offer the courses he needed the first summer school session, so he's going to the second."

"Yeah, so's Bluebell."

"There you go again," he replied testily. "You never knew what it was like to be poor when you were in college. They all help each other. When I was a graduate student, people would let me spend the night on their couch, and I'd help my friends out, too, when they needed it."

"They helped you go to the races? I doubt it. No, you helped each other get through school. He and those so-called friends are helping each other get the next fix. You were working for the future. They live in an unbounded present."

"I tell him not to drink and that even pot is harmful."

"And what good does that do, your telling him? Pot or something else has

already produced his amotivational syndrome. Yet you go on subsidizing him."

"One good thing you have to say about Daniel is that reasonable people always turn up who seem willing and happy to take him in."

"So he says, and it seems to be true. But even assuming it is, and assuming they are the kind of people you'd like him to be with, unfortunately he doesn't do anything positive with what they have to offer. Aletheia says the same thing about Judith. She always was able to get the positive notice of decent, well-intentioned people. But sooner or later, when she didn't use their help constructively, they understandably became discouraged. As in the Chinese proverb, you keep giving these young people fish instead of insisting that they learn how to fish. Sending money does nothing but perpetuate this pattern of living so that tomorrow he'll be no more reliant than today."

"He's my son. I can't abandon him."

"He's your son but you haven't got guts enough to do the only thing that might help. Cut him adrift. If he were asking for a gun, would you give him that?"

"Don't be ridiculous."

"I'm not—*you* are." And so on.

The next word about Daniel came from Florida. Peter asked me to send a hundred dollars to Howard Butterworth, my father's stockbroker in Fort Lauderdale, because Daniel had arrived there penniless and asked for an advance. Peter, of course, had not asked Howard for any explanations.

As soon as Peter left in the morning, I called Howard, a man I had known since my mother's death six years earlier. He had not only handled my father's account but also helped with many errands for his aging, legally blind, hard-of-hearing, forgetful, irascible, generally impossible client. My father had come as close to feeling human warmth for Howard as for anyone else he had known in his lifetime. He even spoke fondly of him as the son he had always wanted. Still, as Howard and I cooperated in providing my father's increasing needs for care, I had had to help this intelligent financier with a doctorate in psychology learn what I'd had to learn as a child: whatever my father said was subject to change when the wind shifted. If you had made plans or taken action based on what he told you, he was never burdened by any scruples against changing his mind, having a tantrum, and veering off in another direction, regardless of what this would do to your plans and investment of money, time, and effort. When I called my father "unpredictable", this was what I meant.

I had helped Howard learn not to take my father's pronouncements at face

value and not to be manipulated by the crafty old man. Now I would have to teach him how to deal with the crafty grandson.

"Howard, what's this I hear about Daniel hitting you up for a hundred dollars?"

"Well, I couldn't get you at home yesterday, so—"

"Of course not. I was at the clinic."

"—so I got through to Peter at the hospital, who said to go ahead and give it to him. He's down here with some kid and ran out of money."

"Howard, I've never gone into this with you. I wish I didn't have to now, and I'm likely to cry any minute, but if Peter asks you one thing and I ask another, I'm asking you to honor my request, not Peter's. After all, you and I became friends before you ever knew Peter, and it's my father who's your client."

"What are you getting at, Victoria?"

"I'm asking you never again to advance money to Daniel, or to have anything to do with him without first clearing it with me, no matter how rational his request sounds, and no matter how long it takes to reach me."

"What're you saying?"

"I know it sounds strange. I've thought of telling you, over the years, but I've been ashamed. Daniel isn't normal. He doesn't have normal feelings for people, just manipulates and uses them, a mod version of my father. He's in the large group that confidence men fall into. He lacks some essential ingredient for humanity. I think I passed something horrible on to Daniel that I carried in my genes from my father. And now our alcohol and drug culture just makes everything worse."

"But why wouldn't you want him to have the money? The kid's down here broke."

"What business did he have down there in the first place? Who told him to go there without money?" I summarized how Daniel had been on probation in two states, had been drifting all summer, goldbricking, mooching, freeloading off classmates' families until they got fed up, probably pushing drugs, and even manipulating Peter, Hal, and Rose about living in the house the previous summer. "You never know where he'll strike next," I concluded. "I didn't expect to hear from him in Florida, although I should have because I overheard him tell Peter he was going down there."

"Last summer you say? That must have been when you were in Europe and he was staying in your house. He talked to me then, too."

"Why did he talk to you last summer?"

"I tried to reach you, but you'd already left for Europe. Daniel answered the phone, and we talked for a while. He didn't ask for money then, or anything else, except he asked me not to tell you we had talked."

"What reason did he give for such a strange request?"

316

"He didn't, exactly, but I got the impression it was because he wasn't supposed to be in the house."

"That's true, and I was enraged with Peter for letting him. Why did you agree not to tell me?"

"I didn't. I explained that you and I had been friends for a long time, and that even one lie would jeopardize our trust for each other. He seemed to understand that."

"He always seems to understand everything. So why didn't you tell me about his having moved in when we got home?"

"I thought I did. Are you sure I didn't?"

"This is the first I've heard of it. I don't know what I'd have done differently if I'd known, except to alert you to beware of him. Now what's the story about him in Florida?"

"Well, evidently the night before last he and another boy arrived about one in the morning at your father's. They woke him up and asked to stay but he wouldn't even let them into the house. Your father went outside and told Daniel to get his ass off the property or he'd call the police. He was so loud he woke up the whole neighborhood, I was told."

" That may have been a shrewd intuition on his part, recognizing Daniel as like himself. But I'd expect him to act that way anyway. He never loved or took any interest in his grandchildren, even as small children. Said it made him feel old to be a grandfather."

"So then the next morning Dan found me at the brokerage. He came in yesterday, and we chatted for half an hour. He says he's got to get his act together, intends to bring up his grades because he hasn't been doing very well."

"That's the understatement of the year. But you see how disarming he can be. He says the right things, admits to the least of the problems. How'd he look?"

"Oh, very presentable. He reminded me of a Dutch burgher, solid round chest."

"Of course you think of him as mine. Actually he looks more like Peter's side. How was he dressed?"

"Cutoffs and a T-shirt. His hair was long and tied back."

"Shoes?"

"Sneakers, and he wore one earring."

"I take it he wasn't drunk."

"Oh, no, and he spoke very intelligently. I enjoyed talking to him. Nice break in my day."

"Did he ever say what he had come to Florida for?"

"I asked that. He said to register for the draft and give an address where he

317

couldn't be traced. I told him I didn't think it was a good idea."

"You're about the thousandth in line to tell him that about his ideas, and not only about the draft, with identical results in all cases. Did you ever change my father's ideas on anything?"

"Can't say that I did. All right," Howard continued, "I won't give him the money if you don't want me to."

"I thought you already had."

"Only twenty dollars. I don't carry much, so I let him have that and told him to come back today for the rest."

"So I'm putting you in the position of having to renege?"

"That's O.K.—I'll have to tell Peter too."

"No, I'll tell Peter."

"Another thing you might be interested to hear. Dan told me last summer that Peter was pretty passive."

"You don't have to be a super-manipulator like Daniel to notice that. Peter's passivity makes it so he and I can't work together. It never mattered when life was normal, and it wouldn't have mattered if Daniel had been normal. Peter is easily worked by the little boys, too, but they haven't taken outrageous advantage of their father."

An hour later the next call came. "This is your son—"

"Jonathan, where are you?" Their telephone voices had become indistinguishable.

"—your son Dan. I want to know when you're going to get out of my life. Stop fucking me up, woman!" There was a pause while he waited for a retort. I reached for my clipboard. "Are you there?"

"Yes, I am here."

"I thought I made it clear on Mother's Day that you're to stay out of my life."

"You don't understand, punk. *You* don't make things clear to *me*."

"Woman, all the time you fuck me up. I might not have been the best son, but you're something else. You're really off the wall. You live in your fantasy world!"

"The fantasy that I might get you back on track, to live the kind of life you were brought up to live?"

"You're the one that ought to go to Nova! Maybe they'd put you in the ring and have some guerilla beat your face in!"

"I don't believe that happened at Nova."

"They showed you a model house. There were murderers and pimps and rapists and arsonists there. You weren't at the real place. Anyway, I'm not your little boy any more, and I'm not coming home, and Evanston forgot me a long time ago, so why don't you forget me too and let me get on with my life? Why?"

318

"I wish I could! But you have a terrible disorder, and I'll do anything I can to get it corrected."

"Another thing—I read those lies you sent my counselor. You certainly can twist the truth. Cory and I used to sit and read that rubbish and laugh. I'd say, 'Here's a good paragraph. Hey, I'll be a celebrity some day!' Any publisher that would want to publish that crap is out of his fuckin' mind because it's pure garbage. . . . What did you do anyway, ask the teachers what I did—sneak out of classes and come back stoned? All you did was make life miserable for me because you were miserable. Don't you remember how you would beat my hands with shoes when I was little? Aunt Vera said you did it till they were red and puffy."

"No, I'd use the high heel on your *bottom* when I could hold you, the wooden spoon on your hand when that was all I could reach."

"You and your high heel!"

"Yes, after you laughed at every other way I tried to control you."

"You really think you were a good mother, don't you? You're crazy! You're off the wall! You've made Jon and David mama's boys. They'll never live their own life. You've got them too scared. I think you're nuts. You called the Texas prosecutor on me. You had your own son kidnapped. What the hell explanation do you have for that?"

"I already gave you the explanation. It was intended to benefit you. It would have, if you hadn't gotten away."

"You think you're the fairy godmother! You think you're the greatest thing that ever walked the face of the earth. You've got a swelled head the size of a balloon that'll pop some day. You have no friends. Everyone hates you. You're nothing but a psychiatrist that doesn't even practice. Jon and Davey don't need you now. Why don't you go back to work full time? You don't accept the truth, do you? You don't have any habits but sitting around the house and keeping Jon and Davey scared."

There was a long pause, during which I heard an adult male voice in the background telling him to hang up. Then he added, "You'll be sorry when I get to Evanston."

"What's that supposed to mean? You intend to vandalize the house again?"

"That dump! No, I'll firebomb your car. . . . Your father is a crazy old man."

"Your father told you that months ago. You had no business trying to put the bite on him."

"I'm just going around looking for a place where I can live. After all, you threw me out of the house when I was sixteen."

"When you were seventeen, after you ran from Nova. The four of us couldn't survive with you as you were then, and still are. Sometimes, when the dust settles for a few days, I still cling to the hope that some day you'll come back."

"I'm never coming home."

"I don't mean to our address. I mean for you to take your place in the world as an intelligent and responsible adult who shares our values and standards, wherever you live. I guess that's a pretty wild dream. . . . We gave you everything truly beautiful, and you had to go for the cheap thrills. I despair for you. . . . I'll make you the same offer I made when I started my book: Write your chapter about what *really* happened, and I'll be delighted to include it at the end."

"You'd probably change what I wrote anyway."

"There's only one way for you to find out."

After a pause he went on, "There's a lot of rich houses down here" in that tone I hated, unctuous, menacing, and phony as a wooden nickel.

"If you're going to rob them, rob them. Don't try to blackmail me with threats."

"If I can afford a thing, I prefer to pay for it," he said in a grandiose tone. "But if not, I'll steal it. You just wish—"

"What difference does it make what I wish?"

"Won't you be satisfied until you see me dead?"

This produced its intended surge of guilt because I had reached a point where having Daniel dead would have been better than my terrible helplessness of being at his mercy. I replied, "Don't look at *me*. I'm not the one whose idea it is for you to hang around with that scum that's likely to bring you to some violent and premature end."

When he started covering the same ground for the third time, I told him I had to go unless he had something new to add. After hanging up, I tidied up my notes and pondered how, as always with Daniel, truth was inextricably woven with falsehood. It was true that I had been a less-than-perfect mother. What mother isn't? After years of having explanations and reasoning fail to control this child, and without any backup or support from Peter, my methods had escalated to include the high heel and the wooden spoon, which had certainly failed as well. By then society was in a stage of horror—absolute one hundred percent prohibition—of physical punishment (though the pendulum has now swung back, some experts favoring mild physical punishment in some cases). For the thousandth time I asked myself whether, if I could have set lower standards, Daniel might have come closer to meeting them, and avoided this egregious outcome.

The Daniel situation was put on hold while the four of us camped through eastern Canada and New England, visiting historic and literary sites. We also

stopped for nature—a rookery of ten thousand gannets—and to observe the Bay of Fundy, whose high tides Jonathan had studied. Our only disagreement on the trip was the route we should take home. Peter did not intuit my post-traumatic stress syndrome as my reason to wish to detour hundreds of miles around beautiful Maine. I gave in, and we drove through the state, thus reprobing my festering wound.

On our return I resumed my calls to the university housing office to ask about a place for Daniel at Hanna. Their answer was always the same: ordinarily they would have had a room by then; keep trying. I began to question whether they were reluctant to tell me that Hanna had blacklisted Daniel.

Then Daniel himself appeared. He stayed with us two days before Peter drove him back to Cleveland in time for the fall semester. I heard Daniel on our phone: "No! How'd he get caught? If the operator does that, all he has to do is hang up. That was my old trick."

"Get off the phone," I yelled. "You're not going to deal in drugs in my house!"

"Don't *worry*, Mom," he jeered. "Those girls can't get enough drugs to sell."

When I raised the question of what he had been living on, Daniel affected a man-about-town tone: "If I have the money, I'm partial to paying for things. But if not, I'll steal them."

During the forty hours Daniel was with us, a blond teenager I had never met came to the door. Daniel took him to the neighbor's driveway to talk. I tried to eavesdrop from a number of places—inside our garage, behind the garage, a second-story window—but the only phrase I could catch from Daniel was "ten percent". I asked Peter to go out to meet the boy and see what he could find out. Peter duly reported that this youth admitted having done poorly at the University of Illinois the past year. I could hardly expect them to confide to Peter their "ten percent plan".

The next morning Phil Martin called for Daniel before he got up. "I'm sorry to bother you, Dr. G, but do you know if Dan's still going to help me move? Yesterday he offered to help me get my things to DeKalb, and I wondered if he still intended to do it. I didn't ask him. It was his suggestion."

"I think it's a great idea, and I'm glad he offered. I'll get him up, and you stop by in fifteen minutes. . . . You know, Phil, in contrast to what you've doubtless heard about me, you'd be amazed at how reasonable I can be, if given half a chance. All anybody has to do is come up with some worthwhile idea. It doesn't have to benefit me; it doesn't even have to help the person who thought it up; it can be to some third party's advantage that I don't even know, and I'll do anything within reason to implement it. It's when behavior is either pointless, negative, or destructive that I start throwing monkey wrenches around, to the best of my limited ability."

"Dr. Greenleaf, I want you to know I just let Dan talk, and whatever he says about you goes in one ear and out the other. I pay no attention to it. He's too smart a kid to be living like he does. I worry about him too and wish I could help him get his act together."

Neither Phil nor I could anticipate what help would be asked from him, or how soon. Fifteen minutes later, Daniel went off with Phil for the day.

During that brief visit Daniel came to me once as I was working at my typewriter and made an overture in his own way by saying, "I know I haven't been a good son." I was so taken off balance by that admission that I didn't respond. I should have asked how I could help him let his life make amends. It was a lost opportunity. But how is it fair to me to berate myself for something so small and so unexpected, in the face of his rejection of all my other efforts?

Before they left for Cleveland, I reminded Peter that Daniel was on the list for a room at Hanna. "It'll probably come through in a few days, so don't listen to whatever he says about having to live off campus."

"Good. How did that work?"

"The same way that everything else that works works, by me being on the phone since April. Who else ever does anything to benefit him?"

"I do. I drive him back and forth. I buy him clothes. I try to talk to him."

"I apologize, and I hope what you're doing pays off some day."

After Peter returned from delivering Daniel to school, and I had mentally written off Hanna Hall, David took a message that Daniel was to report to the housing office by Monday noon. Neither they nor Peter nor I had an inkling of where to reach Daniel in Cleveland. The university office gave me his schedule and the department office number in which he had a class on Monday morning, but drew the line at giving me the professor's name and phone number. The class happened to be in the religion department, so I assumed that Daniel figured he needed an easy A.

I lied to the department secretary, telling her I was calling on behalf of my husband, who was himself giving a lecture to his students, about his son. I asked her to take Peter's message verbatim and hand it to Daniel. I dictated: "Get over to the Housing Office by noon for a room in Hanna Hall. That is the only rent I will pay this year. (signed) Dad."

"That sounds pretty forceful," said the secretary.

By evening, *mirabile dictu*, Peter related that Daniel had called to let him know that he had made the move. He had complained, however, that the professor had embarrassed him by delivering the message orally in front of all the students.

"Well, don't blame me! I specifically asked her to have the professor hand him the note. It wasn't my idea to have to deliver messages like that. I wish I had confidence in Hanna as the solution, but I'm sure it's only stopgap." I

sent off a check for room and meal tickets.

Within a week Daniel was on the line. I heard Peter say, "Be nice to him. It's not his fault he's a little guy. Don't make him move just by being mean to him....You're a hard-nosed character. [His tone conveyed that he meant 'contemptible'.]...You mean you've already dropped a course? Come on! What's the idea?"

I called Dale Altman at Hanna Hall the next day to alert him that Daniel was deliberately being obnoxious to get a roommate to move. "This reminds me," I told Dale, "of how I used to try to teach Dan to be kind to a lovely retarded boy of the kind we used to call 'idiot savants'. He would follow Daniel around and want him to play *school.* Isn't that ironic? Sometimes I could get Daniel to do it, but it took some concessions—bribes, you might say—on my part. He has no milk of human kindness. This roommate's 'fault' seems to lie in the fact that he's small. This is the thorn in Daniel's own side. He admitted once in therapy at Nova, that he, himself, felt inadequate being short."

Dale reacted by defending Daniel, indicating that the roommate had character traits that would make anyone negative. "But of course," he added, "that doesn't excuse Daniel's crass behavior. I'm telling him he has to behave with a minimum of civility."

He concluded with the standard refrain, "I'm sure that whatever comes up, I can handle it."

"I wish I shared your confidence. You're the thousandth one to think that."

Two weeks later Dale admitted that Daniel had been "a little rowdy" but assured me, again, "We're taking care of it." Pinned down, he used the word "partying" and conceded, finally, that he meant drugs. And the roommate? He had moved out.

By mid-November Daniel told Peter about a proposed dorm meeting to censure him for the party he "threw" on moving in. Peter also recounted that Daniel admitted to D work in chemistry and claimed that he "couldn't get any help from the instructor".

"Well, either he's made some effort and no longer has the mental equipment, or he makes no effort. He got high nineties in chemistry at Pleasant Valley. Most likely there's very little effort and maybe not much to work with any longer, either. One thing I don't buy is refusal of help from instructors."

The next day I had a long clinic without a minute free for private phoning, and the following day Altman wasn't available. By the morning after that, when I finally reached Dale, Daniel had already received his eviction notice. "No one thing was so terrible," said Dale. "It was chronic misbehavior. There was no way to intervene—he was never there. He would always come in very late, was never around during normal hours, and when I did talk to him, his condition was such that I couldn't reach him."

323

"You mean he was drunk?"

"Let's say 'an altered state of consciousness'."

"Drugs, maybe?"

"I can't be quoted on that. But the day I confronted him on this move, he wasn't polluted. He agreed with everything I complained about, even talked about going to A. A."

"I wish I had a dollar for every drunk who talks about going to A. A. What do you suggest?"

"I would cut off support. There's no point in keeping him in college this way."

"Exactly what I've been telling his father for a long time. If I get Peter on the phone tonight, will you tell him what you said to me just now, that we should stop this masquerade of Daniel as a student?"

"Sure thing! I also advised Dan not to live with his so-called friends in the boarding house. They're no good for him."

"If Dan were ready to take advice, he wouldn't be getting kicked out in the first place."

That night, after relating the conversation with Dale to Peter, I laid it on Peter. "I can't understand it. I know you're a loving and worried parent, yet after what you heard on Monday night, why weren't you on the phone to the dorm on Tuesday? You quoted Daniel as saying the dorm was calling a meeting about him. Did you think they were planning to honor him? A commemorative plaque, maybe? Why are you always so passive? Even Howard volunteered to me that Dan had told him how you never suspected anything and could be talked into everything." Peter was silent.

On the phone to Dale that night, after half an hour of 'uh-huh's, Peter began interposing. "We've been trying to deal with it for three or four years, and it's been agonizing seeing him poured down a rat-hole with these miserable people he associates with over and over again. . . .What would you recommend? . . .A residential treatment facility? We had him at Nova, he ran, and the judge refused to send him back. Now he's an adult! I can't put him anywhere. He refused to go to the psychiatrist, he refused to go to the psychologist, there's nothing we can do to make him go. I tell you it's been very painful. I've been powerless for a long time. It's heartbreaking. . . .You can't imagine how agonizing it is to want to help this child and not be able to. . . .Well, it's late. Thank you very much."

On Thanksgiving Day a call came from Daniel, which Peter and I picked up simultaneously downstairs and up. For once I could listen to both of them unbeknownst to either, while I scribbled on my clipboard. Daniel's speech was pressured, without pause for answers, and manic as if high on something.

For once, Peter demanded an explanation, this time for the eviction.

"That really pissed me off!" Daniel shouted irritably. "I just had a party when I moved in, and things got out of hand." He callously related that his roommate had succumbed to his obnoxiousness and moved. He acted pleased that this had freed up the ex-roommate's bed for a friend, a non-student, which was, of course, against the rules. By the time of the call, however, having no room at all, he was staying with yet another friend and that boy's girlfriend. He had also bounced to Massachusetts for a weekend visit to his own girlfriend's home. "I had a great time with Sally and her family. Her father let me drive his Cadillac into New York City. You're only young once, and my time is running out."

Asked by Peter to come home at Christmas, he replied, "I'd really love to see you and the boys, but your wife wouldn't want me."

Peter spluttered, choked, and told Daniel he would take the three brothers to Crown Point. Daniel asked that the money for the bus ticket home be sent to his old dorm, where he would pick it up, because of his endlessly moving and losing mail. Valiantly trying to act as if we were all still a family, Peter called David to the phone to say hello to his brother. Daniel's utterances to both younger brothers were scattered, inappropriate, and vulgar.

"How are you, cowboy? I have to go back to college and hopefully salvage my college education."

"Why'd they throw you out?"

"They didn't really want me there, so they looked for an excuse and I'm out. ...You got a girlfriend? You working on it or waiting for them to come to you?...I understand. Dad's around so you can't talk personal. ...I saw Black Sabbath and Blue Oyster."

David told him about being on the basketball team. "Jesus, it's not even basketball season yet. How's Jon treating you?"

"He goes through phases."

"*I'm* in a phase where Dad says I can come home for Christmas."

"You want a Christmas present?"

"I'll think of something for you to get me. Is Dick Cahoon [high school principal] still driving around at lunch looking for kids on the streets? How're you doing?"

"I got a 3.8 average."

"Lemme talk to Jon. Get 'im to the phone. ... Hey, Jick, how's school? How's

the ladies? You chasing them? What does your mother say about that?"

"What about you? You get kicked out of the dorm?"

"I'm going to be an old man pretty soon. Twenty. Maybe I'll let you drive my car."

"Mom's giving it away."

"Hey, what the fuck's she doing *that* for? I put eight hundred bucks into that car."

"It's junking up the driveway."

"It's a hell of a lot better than here rusting. Have you seen any of my buddies, Kurt Duncan or his little brother Chuckie? No? Well, if you hung out with them, I'd kick your ass. You a good driver?...Driver's Ed at Town and Country? Why?"

"Because I'm taking six and a half credit hours and can't fit it in."

"I'm takin' four and barely makin' it. You gonna graduate early?"

"No. I'm taking advance placement, for some college credit."

"I knew how to drive a car when I was fourteen. Only reason I took Driver's Ed was it cut insurance rates in half."

"I don't think it does any good any more. My debate partner Kelly ran into two trees, another car, and a hedge. Demoed their Cadillac."

"Drunk?"

"She didn't want to hit this kid."

"Pretty poor reason to total a Caddy. I was in Jay Boone's mother's Cadillac when he did a $2800 crack-up. His mother never let him drive it again."

"Kelly's family's Indianapolis pace car got ripped off. The insurance came to six digits."

"You just go out with that little lady if they've got that kind of money."

"I'm going to try out for *West Side Story.*"

"Hey, do they still sell drugs in the stairwells at Evanston High? They were cracking down the last year I was there. I would go off the school grounds every day, never got caught."

Peter returned, indicated that the call had gone on long enough, and said good-bye to Daniel.

"Peter, I don't want your son around my normal children," I said, admitting my eavesdropping and describing the nature of Daniel's input to his brothers. "There was a time I wouldn't have thought they'd be impressed by talk like that, but I no longer know what to think."

A few days later I asked Jonathan, "Were you in the car when Kelly totaled it?"

"No." He sounded convincing. "How'd you know?"

"If I disclosed my sources, they'd dry up."

One bright November morning, walking in the park, Aletheia and I were reminded of happier, nature-type things about our children when they were young. "Did I ever tell you how Judith would be an hour late for school on rainy days because of saving the drying earthworms by moving them off the sidewalk?"

"That's charming!"

"Let me tell you something I did that'll make you laugh. George and I were moving cartons in the basement, and we saw a mother mouse running along a beam carrying a baby in her mouth to a new safe place. I went upstairs and cried."

"Because you can't carry your baby to safety. So why should I laugh?"

"Because I put food out for her. You know, she has to make milk for all those pups."

"That's funny—not many people would feed mice in the basement."

I told her about the boys' and my adventures in the park when they were young. "I taught the children the names of all the wildflowers. Then, with a year in between bloomings, they'd forget. Once I pointed to a Dutchman's britches and asked Daniel to identify it. 'Wait a minute,' he said, screwing up his face in concentration. 'It's on the tip of my tongue. I've got it—English pants!'"

We laughed. "Even happy memories—especially happy memories—of Daniel make me cry."

"Maybe it's harder because we were once so proud. I may just have to accept that Judith will never go back to the Judith of promise. I can see her deterioration when she, who used to be an artist, sends pictures of the baby, not focused, not composed. George hates Mike for being the father of his grandchild, but I tell him that no Harvard man needs Judith."

As we talked about the role of upbringing in a person's character formation, I reversed my usual professional stance of passively listening eighty percent of the time. I opened the floodgates of my dammed-up anger over the wrongs I felt inflicted on me by nature, in contrast to what other parents had escaped, with or without justification. "We used to believe that a newborn was a blank slate, a *tabula rasa,* on which the environment, the family at first, had unlimited power to write, to create character. We still think—mental health specialists especially—that we can look back and say what produced the outcome we see in adults," I told her. "The cases that seem to validate our belief in what we want to believe—good upbringing seeming to produce a healthy, happy, independent adult—confirm our belief in the negative of the converse: bad outcome in a son or daughter must result from bad input from the parents. Often there is this kind of correlation—

many adults certainly show the scars of neglect or abuse in childhood. But we also have to deal with the exceptions to the rule. While some abused children grow into abusing adults, others, equally abused and neglected, do not. They have apparently looked around them and cut themselves loose from a bad start, thinking, 'I'm not going to live this way'—and don't. Then we have the opposite: lack of correlation between an average-to-good family and its 'black sheep', as they used to call them. Like Daniel, brought up with care and intelligence, who couldn't have turned out worse of he'd been neglected and battered. My experience with Daniel has made me observe other such examples more carefully. The result has knocked the foundation out from under my belief system, and given me newfound compassion for other parents. Finally, whatever the child, and whatever the parent, yet a third factor in the equation is the poison seeping through our society. While we used to think of 'nurture' in the 'nature-nurture controversy' as coming from the family, now the influence of teenaged nurture has leapfrogged over that of the family. As the twin study researchers have learned, about 70 percent of personality is genetic-based, and it functions by causing people to find the environment that matches. . . . What do you tell people about Judith?"

"I've been answering honestly for a long time," said Aletheia. "Still, sometimes the most casual mention of Judith is enough to unhinge me."

"It must be terrible to have all your eggs in one fragile basket. At least we have hopes for the younger ones."

"Yes, you have them to be thankful for. I usually say something like, 'Our child has been a disappointment.' It's such a common experience that people understand and don't pursue it."

We sat in the bright November sunshine for a few minutes. Finally I told her about a letter we had received from friends we met on our sabbatical in Australia, people in the diplomatic corps who had been both kind and hospitable to us. "Their son, also in the diplomatic service, had developed a malignant melanoma. It used to be the worst and most deadly of the malignancies, but now they can save some of them. Peter has worked on something that relates to the metabolism of the melanoma, and cooperated with his doctor there. Her letter reported no evidence of disease, and I'm glad Peter could help. But I can't help but feel bitter that no one ever comes forward to do anything like this for our child. Peter saved another one lately, had them fly the little grandson of Peter's college classmate up from Tallahassee just in time. Somehow it doesn't seem right that every now and then Peter can pull off a miracle for someone else's child, but nobody can do it for ours. It's not that we doctors don't all have stories like this—we all do. I'm nothing but a shrink, but even I diagnosed a rare endocrinologic disorder as a cause of insanity, treated the woman, and brought

328

her back from a living death. But no doctor's story of victory ever stars Daniel. Disorders like his make malignant melanoma, dermatomyositis, and idiopathic hypoparathyroidism look good. Sometimes I wish Daniel could have had leukemia. Now they save many of them."

"Victoria, don't say that."

"Even if they don't survive the malignancy, their death isn't the death of the human spirit. Our Daniel was invaded by an alien demon long ago, sickened and died, and now I have to bury my dream child."

Thirty-eight

Intervention

As I gathered credit hours on closed circuit television to keep my medical license fresh, quite by accident I learned about a then innovative device to reach alcoholics, called "intervention". Hoping it might offer yet another opportunity to reach Daniel, I made an appointment with Ione Barre, a social worker who had been on the program and specialized in interventions. She interviewed me with the help of Gerry Frackleford, a nurse, both unabashedly "recovering alcoholics". My initial impression was negative because, as I described the tango Daniel and I had been dancing, they kept responding with jargon that sounded canned and applied indiscriminately to alcoholics' family members, not specific to my experiences. "I can tell you love him very much" was one of these phrases, though it was obvious I was more desperate and angry than loving.

"It's been years since I loved him" was my response, "but that doesn't stop me from trying to save him."

"We feel only the pain we let ourselves feel." Another canned phrase.

"That's this year's pop psychology, and I consider it horse manure. How the hell can you love a child for many years and *not* feel pain when he turns out like this?" I asked. I'm sure I didn't sound appreciative, though their obvious concern touched me, no matter how banal their expressions. "I nourished that boy with my milk and my mind. I moved from love to worry to frustration and anger, and now at least I can cope with rage. What I can't stand is unrequited love.

"I've gone through stages in my relationship with Daniel. I began by considering

331

him a normal, healthy, reasonable individual who, if approached reasonably, given explanations, would listen and come partway. But he has shown himself not to be 'reasonable' but strong-willed and self-centered. After struggling for years, I realized that whenever we were in presumed agreement that I would do one thing, he another, both intended for his benefit, I would do mine and he would ignore his. More recently I have been compelled to recognize that he is not only not reasonable but not 'normal', if indeed he ever was. Someone 'normal' couldn't do this to himself.

"I've reached the point of questioning whether he's even 'human', in the sense of being able to receive and give love. I don't think he is and I can't forgive him for it, even though a part of me knows that this lack is no more under his control than our other sons' nearsightedness is under theirs.

"I'd rather see Daniel dead than this caricature of a human being. I end up powered not by love but by burdensome feelings of duty and obligation. When I say that I no longer love Daniel and wish he could drop through a time warp into a black hole, people conclude that I'm hostile, but 'hostile' means without a reason, and I'm angry with plenty of reason, not only with Daniel but with Peter. Through most of this Peter has done very little but cater to Daniel. Peter sometimes cries in pain over Daniel. But Peter was sitting right beside me at the telecast where we both learned about the potential of intervention, and you see who's here in your office."

Ione empathized. She told me that her husband, too, had reached the point of wishing she would just die in one of her binges and get it over with. Finally he made his point stick by giving her an ultimatum: enter treatment in a fairly new center in St. Paul, or be thrown out into the street. She chose St. Paul. She hoped to be able to facilitate the same for me with Daniel.

Ione and Gerry explained to me that alcoholism, like addiction to other drugs, is an addiction to the "highs" produced by that drug. The chemistry of some alcoholics is so finely tuned that their alcoholism is unmasked by a single first exposure to alcohol. Gerry claimed this had happened to her.

"I don't know how you can condone it," I said. "What business did a kid like this, bright and handsome and talented, have gravitating to chemicals, 'experimenting' as you call it? You could understand it in people with nothing else going for them, but Daniel had a good life. Peter and I gave him so many varied experiences. He has trod three continents and seen the beautiful, the esoteric, natural, cultural, and man-made phenomena they have to offer. I remember the last truly happy day I spent with him. It was during our sabbatical, and all of us were on the Great Barrier Reef. We saw living coral extending its polyps to feed on the ocean soup, cobalt-blue starfish, and an enormous 300-year-old clam. Why wasn't that good enough for him? Why did he have to go for the cheap thrills? You might make a case

332

for somebody without much else in life taking up drinking and drugs, then, through no fault of his own, getting 'hooked'. But how can you defend this for a gifted kid of fourteen?"

"We're not condoning it, just reminding you that the pressures on the young are enormous these days."

"Just what my friend Aletheia always says."

"And do you know," Ione went on, "that the siren song luring the young to their destruction is often reinforced by what families do to and for their children in their misguided efforts to 'love' them?"

"I get fed up with 'love' that's only verbal, with no muscle."

"It sounds as though Peter and his lack of controls over Daniel have made it very easy for Daniel to go his merry way. We call it 'enabling behavior', meaning support, financial and otherwise, that puts no obstacles in the way of drug-seeking behavior."

"I've tried to get Peter to stop subsidizing him. But I haven't been able to make him see that there comes a time when it's a mistake to continue being generous and tolerant and forgiving. Real love turns that stereotype inside out. Real love sometimes means saying "no" and making it stick. But Peter can't—or doesn't want to—see withdrawing support as giving love."

"When Peter comes in, I'll talk to him about the 'enabling behavior'," said Ione, in the same confident voice that Dale and all the others had used with reference to Daniel. "My husband had to tell me that he planned to take away my children and put me out in the snow unless I went for treatment, and that was a cold winter. It's the only language we alcoholics and drug abusers understand."

"When Peter starts making excuses for Daniel, ask him about the smashed furniture at the dorm, the fist through the wall, the fire set at the Canadian Consulate," I suggested.

"Oh, yes, I meant to tell you. We'd like to see your other sons too when you bring Peter in."

"You don't understand. I don't intend to bring him," I yelled. "I'm bone-tired! I just want to hand Peter and Daniel over and let somebody else work on them. I want to rest. I want *Peter* to take some responsibility, and I didn't plan to drag our normal sons through this."

"Will he come without you?"

"They'll all come if I ask them to. We'll call it a 'planned absence' from school for a 'medical appointment'. We don't have to say whose."

"Do you have any questions before you leave?"

"Yes, after the intervention," I pursued, "what if the subject refuses to go to the hospital? That's what I'd expect from Daniel. He's not in business to co-operate. What then?"

We discussed the possibility of probating Daniel and if so whether on my signature or that of another psychiatrist. I described my sad experiences with the unholy alliance between our judicial system and the forces of chaos as they pertain to the young and their 'rights' over the rights, if any, of their parents. "Since I'm a licensed physician it would be legal, but considering my history with the courts, they'd probably let him back out. I suggest a colleague, and maybe I'd better arrange to bring one to the intervention."

When I put the plan to Peter, he asked why Ione needed him.

"The assumption is that you also care that your son is—" I paused in frustration over the futility of explaining anything to Peter—"why should I have to tell you what he's doing? It boggles my mind that when we both sat at the therapeutics conference hearing about all this, I could feel your shoulder tensing beside mine, and I thought—hoped—it was because they were getting to a sensitive nerve about your child. Actually, you were probably falling asleep. You just get your ass over there!"

Peter and Jonathan and David and Ione and Gerry had the meeting, but Peter reported no return appointments, no intervention plans. "Nothing got settled," he said.

"Then why didn't you pin her down?" I asked, nonplussed, because at my meeting with Ione we had decided to use Daniel's intended trip home over Christmas for the intervention. I couldn't imagine this level of denial in someone as intelligent as Peter.

Ione Barre's story was different. "We set up the intervention for ten in the morning of December 22. Your husband said Daniel was expected home by then. We've already reserved a bed in St. Paul in Daniel's name for that afternoon."

"Fine! No time between the intervention and his going, if he goes, which I have grave doubts about. We should have the tickets and reservations for that afternoon."

"Of course. You mean Peter didn't order the tickets? We talked about that. I'll talk to him again to make sure he understands. He has to realize he must bring the tickets to the intervention and go straight to the airport. Has he called the treatment center with the Blue Cross number?"

"Not that I know of. I suppose I'll have to do it." I put both jobs on my own worksheet.

"Why are you so fucking incompetent?" I asked Peter, when confronting him with Ione's story.

He responded with his all-time prize-winning remark: "Well, then, I guess

there's nothing to do until Daniel gets home."

When Ione called, I heard Peter say, "Well, no, I haven't, but I've thought about it. …Uh-huh! O.K. Yes, indeed. Give me that phone number again and I'll call. …Yes, I'll have the tickets and the reservations."

And so, with a target date two weeks off, regardless of anything Peter might arrange, I started calling. Since it was close to Christmas, they put me on several wait lists. Finally I remembered the father of a friend of David's who did so much flying that they gave him special treatment. He put me in touch with a vice president, who told me he could not understand the difficulty because he knew there were flights with spaces. "I told them I needed two seats for my husband and a sick son, for whom a hospital bed was waiting on that day, and they said they were sorry. They sounded leery about an invalid, even though I assured them he could walk and would not bleed, convulse, or lose consciousness, but I declined to name the condition."

"Your mistake was to mention illness at all," he advised. He gave me a phone number for preferred customers and told me to mention him. "Call me back if you have any more problems."

The phone number and the vice president's name were the open sesame. Peter also followed through, with the result that we had two pairs of tickets and a total of four sets of reservations, all of which I kept, putting my sick son's needs ahead of strangers' holiday plans.

Then I turned to the nuts and bolts of the intervention. First I discussed with Dale Altman the possibility of my flying him out to Evanston to take part in our intervention. "That's a very unusual request," he said.

"Of course it's unusual! Everything about Daniel is unusual. If it were run-of-the-mill, I'd have solved it long ago."

"Yes, but even though it would be during vacation, I could be perceived as representing the university. I'd better check with my boss first."

"I can see that." One of my misfortunes in life is to be able to see the other fellow's side better than he can see mine. "Is this to say that you'd be willing if they go along with it? I could talk to your boss."

"I'm not sure. I have to give it a little thought."

But Dale's verdict was that he could not justify participating in anything fraught with duplicity such as our "gang-bang". He found it morally wrong to set an ambush for someone to whom, as he had told me, he could not talk seriously because his state of consciousness was like quicksilver—always "high" or "down" or "stoned" or "smashed" or polluted in some way. He concluded that his attendance would be counterproductive anyway by making Daniel all the more resentful. In Dale's final conversation, he suggested that I carefully reexamine my relationship with Daniel, my feelings for him, and my motives, including the question of whether I really loved him or was just hostile and punishing.

"You're right that I no longer love him, but neither am I hostile. I'm enraged. Daniel wantonly destroyed my beautiful and precious son, and for this I hate him, in a way I could never hate anyone I hadn't once loved dearly. The whole process has brought insult and humiliation down on me. As if that weren't enough, people like you, who enjoy the luxury of getting rid of him after a few weeks or months, have the effrontery to call me mean, hostile, and vindictive. Maybe I'm all that and worse, but I didn't start that way! I'm the only one trying consistently and rationally to save my child, and for this I get castigated! You make the same stupid mistake everyone else makes. You accept at face value the idea of "love" as something soft and gentle, basically weak, instead of something that sees beyond the immediate present to the ultimate good. When somebody like Peter talks about 'loving' Daniel, you believe it, but when I try my damnedest to *do* something for him, you call it hostile. If I were drowning and you gave me a choice between telling me how much you loved me or screaming and swearing about what a fool I was to have fallen in, but throwing me a life preserver, which 'love' do you think I'd pick?"

Dale declined to come, but offered to send an account of his interactions with Daniel leading to the need to evict him. He doubtless had second thoughts, because, despite a reminder call, I never received his written account. To Dale's credit, at least he didn't sabotage my efforts by warning Daniel.

Dale having disqualified himself, I began lining up other people for the intervention. My second attempt also failed, though I got through the protective telephone network. He answered the phone himself. "This is Dr. Perez."

I explained what we were up against and asked if he would come to our intervention prepared to commit Daniel if he refused to go voluntarily, as was likely.

"But Bill Hyatt works with that group. Why can't he go?"

"Not any more, he doesn't. He's severed connections. Not only that, but when I called his office, they said he no longer works with anybody under twenty-one."

"I'm sorry. I can't help you. The court won't take my papers even when I've seen the patient, like last time. I haven't seen Daniel for over three years." That was the truth.

I placed several more calls trying to clarify my legal rights in the matter, if any. One call was to Dr. Councillor, an expert in forensic psychiatry. His assessment was that Daniel would surely demand a hearing, and the commitment would not stick. And that was the truth. Furthermore, probate court would be likely to look unfavorably on commitment papers signed by someone with the same surname, even though I could sign legally. It was what the legal profession, with its magnificent lexicon of clichés, refers to in every other sentence as a "gray area". They have, it would appear, little other than "gray areas". On the

other hand, getting Daniel examined by another psychiatrist seemed even more hopeless than getting him to the intervention. I asked Dr. Councillor whether he would come to our intervention and, if Daniel refused the treatment center, then sign probate forms for him, having, in effect, examined him there.

"Oh, I'm sorry but I couldn't do that. You see, I'm a stickler for the law. What you propose certainly sounds as if it would be in the young man's best interest, but I couldn't do something that wouldn't hold up at the three-day hearing," he said sanctimoniously. The irony was that I had attended a presentation by Dr. Councillor in which his voice quavered as he related the case of a mother who had killed her children in the belief that she was saving them from the devil. He had tears in his eyes for that insane mother.

"It must be great to know the world is your oyster and you can bask in the luxury of respecting the law because it isn't screwing you personally. Maybe some day I'll get to join that elite."

I continued searching for options by contacting the clerk in probate court. He verified that the court would not and could not commit to another state, which of course included St. Paul, regardless of there being no comparable facility in Illinois. "Lady, you ain't got a case," our public representative concluded. And that, unfortunately, was the incontestable truth.

Unless I could get a feasible plan B, the day of intervention would be like the day we had airlifted Daniel to Nova, following a plan with a thousand potential leaks and no backup. I decided to circumvent these sticky legal angles by getting a different, non-Greenleaf, psychiatrist, a colleague and distant friend of mine, to come, observe (hence "examine") Daniel at the intervention itself, and commit him as a last resort.

"Look, Vaclav, I need help, and I'm likely to cry before you even hear the story," I said to my colleague and explained what I was asking.

"Of course you won't pay me. And of course I'll come. I'll do anything I can for you, just as I know you'd do it for me."

I explained the intervention procedure and asked him to be early so Ione Barre could explain how he would fit into the meeting.

I mulled over whom else to ask. Ideally, they should be people who had been, if not important, at least significant to Daniel recently. Other than Dale, the only other one I could think of was Sally, the girl he had visited on vacations and long weekends. But she was an unknown entity, and I had grave reservations about anyone who had been attracted to Daniel. I decided not to risk her selling Dr. Jekyll and me out to Mr. Hyde.

Peter's brother James, in Texas, was remarrying and unable to come. I invited Daniel's paternal aunts, Vera and Natalia, to the intervention. Vera had finally completed her driver's training and had her license but no car, and public transportation from Crown Point was abominable.

I reviewed the local possibilities for the intervention. Both Scoutmasters, the one who had denied the Eagle and the one who had granted it, would certainly do their part to help save a young person. I went first to Hank Toth, took him away from a happy, chatting group in his kitchen, and behind closed doors told the story of Daniel's fall.

"I knew there was something wrong the day he got the Eagle. He was slovenly, didn't have a neckerchief, hair long and unkempt, sloppy manner."

"Really? I'm amazed to hear you say that. He looked all right to me. He had just had a haircut the day before. It was long, of course, but a style I liked."

"Oh, yes, you'd been seeing him all along, but I hadn't seen him for several months since he went away to school for some reason."

"The court sent him. It was for breaking and entering."

A long pause. "See, I didn't know that."

"I should have told you, but I was in a difficult spot. I kept hoping that something, like the Eagle for instance, could make a difference."

"Yes, when I saw him that night, if it hadn't been for you, I would have sent him home without it."

"I guess you should have."

It was as Ione Barre had predicted. Even before the intervention, as family and friends start comparing notes, people discover what each other has already known. The insidious changes that Hank could see in Daniel after three months at Pleasant Valley, like the physical deterioration someone as remote as Heidi Cunningham at the Juvenile Division had commented on six months earlier, had escaped me completely the night I thought Daniel had looked handsome and behaved appropriately as he received his Eagle.

I explained to Hank what I needed for the intervention. Reaching for the telephone, he cleared a day's absence with his boss, who was happy to cooperate to try to help a young man.

With tears in his eyes, Hank patted me on the shoulder as we said goodbye. I promised to let him know if we should have to scrub the whole operation by Daniel's failure to appear.

The next day I visited Fred Saroyan, the Scoutmaster who had picked up Daniel's abnormality earlier than Hank and had refused the Eagle. "Of course I'll come. I knew there was something wrong. From one campout to the next he'd have the boys in factions fighting with one another. I'd never had so many boys drop out or move to another troop, and some of them even told me that Dan was the reason."

"I never heard about that, but whenever there's trouble, Dan's always in the thick of it."

"It had been going on for a long time. But I kept trying to work with him. He was always somebody I wanted for a friend, but it never worked. And

then he went to the other troop where they said they'd give him the Eagle. ... Of course I'll try to help."

"I must admit that at the time I thought you were being unreasonable. You told him to wait and to work at leadership, and he did, for a whole year, and you still put him off."

I had never heard anything about Daniel fomenting dissention in the Scout setting. And yet I should not have been surprised. I had tried, in a number of ways and with different ends in mind, to maintain a dialogue about my children with other adults. I had noticed that my overtures about Daniel usually elicited a chilly reaction, rarely any feelings of warmth or willingness to take the discussion any further. I can understand people finding it disagreeable to talk about your children unless they can say something good. But their reluctance cut me off from possible input that might have helped me with Daniel. And this was the opposite of what I tried to do for the parents of children about whom I had information or observations.

Another local possibility for the intervention was Phil Martin, the young man whom Daniel had known for twelve years since Indian Guides and had stayed with and had recently helped move. Phil's tone and evidence of concern made me happy that Daniel had him for a friend. I decided to risk trusting him with the plans for the intervention. It was my rotten luck that he was scheduled for a job interview on that very morning, though he promised to come if he could. Unfortunately for me, he needed the job and would have to stay for work if they offered it.

I tried to track down Joseph Vargo, the Evanston High School Counselor, but a tinny recorded voice told me that the number had been changed to unlisted. I gave up on both Vargo, who had offered to help before, and Jason White at Pleasant Valley, because both were in the official/unofficial position of being school employees on Christmas break, and being asked to do something on behalf of a former student that the student would resent. It was the same bind Dale had cited.

Finally it was time to prepare my own personal presentation for the intervention. I rummaged through photographs but could not find our family portrait taken four years earlier, just as Daniel's whole life was starting to crumble. But I did find a school picture of Daniel at fourteen, round-faced, rosy, and smiling. I asked my sister-in-law Natalia to lend me the family portrait I'd given her for Christmas that year. I got out my late mother's mirror that I had given to Daniel to hang in his basement study cubbyhole. As I cleaned the reflecting surface and waxed the maple frame to restore its beauty, I decided that

after the millions of ineffectual words between Daniel and me, I would try to get his attention with silence.

Unlike the wrenching days before the airlift to Nova, when I had no one on whom to test my thoughts, this time I had Ione Barre to listen to every idea and worry. She even suggested, if we should be unable to get Daniel to their office by our agreed-upon ruse about needing him to attend marital counseling, that we could transport her whole entourage to our house and hold the intervention there.

My plan was to schedule and attend holiday festivities normally because an intervention is not something to sit and wait for, with ever-mounting anxiety. Whenever Daniel should actually arrive, it was time enough to cancel everything subsequent.

When our countdown was sixty hours to the Monday morning intervention, with no sight of Daniel, I asked Peter if he had any idea about Daniel's E.T.A. Based on a late-night call I hadn't overheard, Peter guessed that Daniel would be in some time over the weekend. Peter had sent money for a bus ticket. Fortunately for our planning, it was not until later that that letter was returned unclaimed, addressee unknown, from the address Daniel had given Peter.

Saturday the 20th came and went without Daniel. While part of me worried about his showing up for the intervention on the 22nd, part of me felt reprieved and able to attend my psychiatry ward's staff Christmas party. But it wasn't festive for me. I envied my colleague, who had nothing worse to worry about than his daughter's having to come to terms with her first B in college calculus. A nurse told of her husband shooting an eight-point buck. I went to the bathroom and vomited. Peter usually called me a "last dogger", but that night we left early.

Sunday morning I asked Peter whether there might be any way to facilitate Daniel's arrival.

With no concern for my anxiety, Peter calmly said, "Oh, he called yesterday and said he was coming in today. He and Sally were going to her parents' on Friday night, and he was going to take the bus from New York City today."

"Why didn't you tell me? We ought to call Sally's and see if they've really left for her parents'."

"Do you know the number?"

"I can find it." Peter didn't question how I had it. He didn't know about my file of names, addresses, and phone numbers relative to Daniel, which I took down whenever I heard Peter repeating them over the phone.

Sally's roommate confirmed their departure. She had evidently not caught

Daniel's negativity about me and guilelessly gave me Sally's parents' number.

Peter reached Daniel there, who indicated that he would take one of two buses that afternoon. Another call from him in the late afternoon conveyed that he had missed the first but was waiting at the station for the second and would be in Evanston at 5:30 in the morning (just four and a half hours before the intervention). The four of us ate cold turkey, acknowledged Jonathan's birthday, and wrapped gifts.

"Daniel is more likely to cooperate tomorrow morning if I'm not around," I told Peter. "When you tell him our cover story about the family counseling, tell him I'll be coming straight from the clinic. That's actually true—not that I'd mind lying—because I promised to deliver some gifts for their distribution in the inner city. And remember, if you can't get him to come, call the number I gave you but don't ask us to come to you. We'll know that means to move the intervention to home."

At 5:30 Peter brought home from the bus station our dirty, unshaven son Daniel, the drifter. His long hair was tied at the nape. He wore ragged jeans and carried a heavy pack on his back, and looked like a sick, dissipated profligate of thirty. We exchanged no more than ten words as Peter urged him to get to bed for a while.

Hank Toth called to confirm Daniel's arrival. I felt like Joe Friday on the old crime show *Dragnet*. At 8:30, with the temperature registering five degrees, I found all my car doors frozen, finally managed to get one loose, and had to tie it shut lest it fly open as I turned corners on my way across town.

I met Gerry, the nurse, and Fred Saroyan in the parking lot of the beautiful gray stone church where the intervention would take place. Ione arrived next and decided where to seat us, her idea being to place the most meaningful people, namely Peter and me, opposite Daniel, flanking him with the least threatening, such as a young intern of the counseling service who had been brought along as a near-contemporary of Daniel's.

As Gerry arranged the chairs, I despaired over the hopelessness of this massive offensive. For me, outcome is not predicated on outlook. As I had done with the airlift to Nova, I had thought through the intervention and had taken every precaution I could think of, but I refused to feign optimism I did not feel. "I don't know what will go wrong, but I predict something will."

"What are you talking about? I plan to get Daniel to St. Paul today," said Gerry. "Lotsa luck, fella!"

As the various members arrived, Ione cautioned us all to be sure to include anything positive we could honestly say about Daniel. "He'll need all the support he can get. His self-esteem is pretty low right now," she said. I didn't believe that.

Hank Toth briskly announced that he had the entire day to help in any way

he could. Vaclav arrived next and was briefed on intervention and how we hoped to avoid commitment—actually had no local facility to which to commit Daniel specifically for substance abuse treatment—and that his role was to represent objective external psychiatric opinion. It would be an opinion for which Daniel was likely to have little regard, but in the worst outcome Vaclav would be asked to sign papers.

Ione said to Vaclav, "You don't remember me, but you treated me for a short while a long time ago. Like alcoholics everywhere, I lied to you, too."

Another chair was readied in case Phil should manage to come, but he evidently landed the job. The obstacles for this intervention were greater than in most. We had a subject who had been geographically distant, and whose bonds to his family had been loose for a long time. We were also lacking anyone he would perceive as a friend his own age, anyone representing his school with the sanctions it could impose, and any employer with threat of a job loss to hold over him. Worst of all, our son had a pernicious character disorder long anteceding drug use. He carried, in current terminology, a dual diagnosis.

We were still missing the principal player, his father, and his brothers. Had Daniel run? Had he outmaneuvered Peter? Finally at 10:15, fifteen minutes after the set time and still forty-five minutes away by car, Peter called to say that they were on their way. Assuming no slip between the house and the car or the parking lot and the counseling office, Peter had done his part. He had deceived the unwilling subject of all our preparations, a difficult job for Peter, to whom duplicity had never come easily.

Our deathwatch continued. Eons later I heard Daniel's voice on the stairs, and my four men entered. Mrs. Barre introduced herself to Daniel and explained that we were assembled because we all cared about the course his life had been taking. He made no effort to bolt or struggle and took his assigned seat without a word.

Ione began: "I know—we all know—that you are in a hot-seat. I know—I've been in it too. I am now the director of a counseling center for alcoholics and drug abusers. I'm an alcoholic myself, recovering, and I've been a drug abuser as well. Gerry over there is a nurse, also an alcoholic and abuser of drugs. She took Dexedrine, speed, by prescription. That's the easy and cheap way to get it, right?" A smile flickered across Daniel's face.

"A few weeks ago," she went on, "your mother came to me and—"

"Who else?" sneered Daniel, but so quietly that Ione didn't hear, or pretended to believe his reaction had been positive.

She continued, "That's right, your mother came to me about your problem, and I told her then that today we would have to change roles. Normally she's the doctor, but today I have to be the doctor because she has to be the

mother. This takes a lot of courage for me, and I wish there were someone to help, but there's no one else, so today I have to be the best doctor I can. Then your father and brothers came to me, and we talked about how broken-hearted they also are over you. You know most of the other people here today, and they've come to tell you what you mean to them and how they feel about the change in you."

She paused, softening as she looked at him. "That's a nice smile. When you're straight, I could sure use you in my aftercare group. Dan, I'm going to ask you to listen to what we all have to say. Later you'll have your own chance to talk, I promise." There being no objection from Daniel, she finished with "I think I'd like to begin with your mother."

I walked over to Daniel with my pictures and mirror. I held up the rosy-faced fourteen-year-old Daniel, then the family portrait. Then, flashing back in my mind to a picture I had taken nineteen years earlier of the toddler Daniel kissing his reflection in a mirror, I held up the maple-framed mirror within a foot of his face. He looked over the frame, and our eyes met, both brimming with tears.

"Will you please tell us what you're doing?" Ione asked.

"I'm showing Daniel a picture of himself, normal and healthy at fourteen, then a family portrait taken when he was sixteen and we were still a family, although he was already in trouble and drifting downhill. And in the mirror I have let him see the wreck he has become."

I sat down, and she called on David. Shy and inarticulate, he had to have it dragged out of him that he wanted Daniel for a big brother again, somebody he could talk to. His jerky, disjointed speech was eloquent.

Then Ione called on Jonathan, who without the help of having seen Daniel during his deterioration, nevertheless talked of wanting him back in the family "the way we were". Jonathan's eyes were full of tears, and occasionally he snuffled. I thought of handing him a tissue, a plentiful supply of which I had provided, but thought it more effective just to let him rub his nose on his sleeve.

Then the scoutmasters, one after another, repeated in essence what they had told me earlier. If we had been in court, however, what they had to say would have been hearsay. I wished we had someone who had actually witnessed Daniel's physical and mental, social and moral deterioration, someone like Dale Altman, who had remained away from our "gang-bang".

Next Ione called on the young man she had brought from the center. Not an ex-user himself, he compared himself with Jonathan and David as the grieving younger brother of a man whose long slide downward he had watched, paralyzed.

Peter's turn came next. He spoke of Daniel's once fine mind and promising future, now jeopardized by years of mental clouding, running here, bombing out there, asked not to return to one school, thrown out of two dormitories

in another. He told of Daniel's downward skid from having been invited to college after his sophomore year (on the basis of his PSAT), from the Dean's List at Pleasant Valley, from his having been recruited by fine colleges, to barely passing those courses he hadn't dropped at Case Western. "I want you back as my son, Daniel, but not like this." Peter choked and wiped his eyes. I thought the very stones would cry out.

And finally Ione asked Vaclav to speak to Daniel. His tack was to inquire about Daniel's hopes and plans and to point out that a future in conservation in the mountains was more a daydream than a plan if he didn't pick a goal and steer toward it.

Through everything that followed my confrontation, Daniel's face manifested a stony impassivity. He seemed to be unaffected by what was coming at him.

Finally Ione asked for his reactions.

"Well, hey, y'know, it's awful nice of you all to get together to try to help me, but I don't know whether I like this being lied to and brought here," he began sarcastically. "Like when my mother had me kidnapped and taken—"

Peter and Ione interrupted simultaneously. Ione said, "She was doing all she knew to help you, and besides, this is different."

Peter asserted, "Don't forget me. I was part of that Nova business too. It was intended to put a stop to all your craziness, but the bastards couldn't hold you."

Hank Toth came to Peter's support. "Dan, you thought they were sending you there to punish you, to get rid of you, but it wasn't that at all! They did it because they thought it was best for you. Maybe it was a mistake, but it wasn't because they don't love you. I've seen a lot of parents of my Scouts, and there aren't many that love their kids the way yours do."

"Bullshit!" said Daniel.

"You know, Dan," Hank continued, "you probably thought the little kids were getting all the attention and you weren't getting any. You got attention too, but it was a different kind. All the Scouting—"

"Yeah, another thing, I don't like to be locked up," Daniel interrupted without moving his lips, "like at that place my mother sent me."

"That wasn't just your mother, I told you," Peter insisted.

"Maybe that wasn't the right place for you at the time." (Ione was repeating her belief we had discussed in her office. She saw Daniel's disorder as entirely one of substance abuse, including alcohol, and therefore she denied that Nova was "treatment", aimed at insisting on becoming "sober" and never "using" again. By contrast, I saw—and still see—Daniel's character disorder as primary and Nova as the place where character-disordered late adolescents, manifesting their disorder with drugs and in other ways, are contained, when things go right, until they learn to live civilly. Although Nova would

344

have been my preference a thousand times over, our intervention was not the place to debate what I considered Ione's misguided opinion, since she was the only one offering any help with the chemical abuse manifestation of Daniel's disorder.)

"Anyway," she concluded to Daniel, "the place we're sending you doesn't have locked wards." Unfortunately she was speaking the truth. I wished it did.

" I was brought here without being told what was going on—"

Ione interrupted. "I told you I took over, and they were acting on my orders. You know you wouldn't have come if you'd known." She went on to explain that there was a reservation for him on a drug and alcohol abuse ward in St. Paul and that Peter would fly out with him that afternoon.

"I don't dig this. I was invited home for Christmas, and now you're asking me to go—"

"We're not asking you—we're telling you."

"No way am I going to a place like that today," he declared.

"Why not?"

"I got things to do."

"Like what?"

There was no reply.

"Getting your head back together is the most important. You need help and you need it *now!* You're alcoholic and you're drug-dependent!"

"I've been pickin' up on that too."

"What makes you say you've been 'pickin' up'?" she asked.

There was no answer.

"You have nothing more important to do than get your head straightened," Peter begged. "Come on! Let's go!"

"Maybe later," said Daniel.

"You need it now. We have a bed, and they're not always available. They're expecting you in St. Paul this afternoon."

"Why St. Paul?" After years of having considered all questions legitimate and deserving of a reply, I had come to recognize Daniel's type of question that was not for information but to stall. I had finally stopped answering these pseudo-questions, which I called "the contentious why".

It was therefore not surprising that Ione, like others over the years, attempted to answer this dodge cloaked as a legitimate question. "Because they happen to have the best center of this kind in the country, that's why. We're trying to get you the best."

"Why can't it be in the Virgin Islands?"

"Look, I'm getting tired of this argumentativeness," said the young man, quick to pick up Daniel's ploy. "If they had one in the Virgin Islands, I'd get a job there myself instead of here." General laughter.

345

"I'll take a walk and think about it."

"NO!" chorused Ione, Gerry, and all the rest of us simultaneously.

"Look, Daniel," began Hank, beseechingly. "I went to my mother's funeral three weeks ago, and at the funeral I saw my brother, a man of fifty-four and alcoholic. So help me God, he looked ninety! You don't want to age fast and die young!" Hank was really trying.

"That means nothing to him," said Ione.

"I'm not sure you're enough of a man to do this," said Fred Saroyan, in an effort to make Daniel respond with a who-says-I'm-not-a-man? protest.

"Daniel," begged Peter with tears in his eyes, "you have nothing on earth more important than to get your act together. We're willing to help you. We'll send you to the best unit in the country. You have no other option."

"I could always crash on a detox unit," the flippant Daniel retorted. I was enraged afresh for the same reason that Aletheia and I had discussed. It is the assumption on the part of the young that they are free to inflict whatever harm they wish on themselves or others because there will always be someone to jump to their rescue.

"Your problem is more than just the drugs in your body at this time," Ione insisted, "and you're not the only person in trouble. Your whole family is involved. And it isn't just you that'll be going to St. Paul. They have a twenty-eight-day program, and your family has agreed to go out there for a week to work this out as a family problem."

This was news to me. I had agreed to no such thing, nor did I intend to be sucked into something like that. I did not see Daniel's disorder as something the family had done to him, and I felt I had already done my absolute utmost for Daniel. But this was no time to argue.

Forty-five minutes later we found ourselves going over the same stale arguments. Vaclav, who had expected to finish and be gone an hour earlier, excused himself in time to get to a teaching commitment after missing lunch.

"I'm getting bored with this whole thing," said the young intern, "and hungry too. I'm leaving for lunch."

Peter said, "Dan, I love you, and I want what's best for you, always have. I've done a lot of things for you—remember the Indian Guides and Scouts? Now I'm asking you to do this for me because"—Peter was wiping his eyes—"I want you back as my son, and I can't have you like this."

I had been completely silent since being asked to explain my part in the intervention, having known long since that Daniel had never paid any attention to what I said nor done anything with a view to pleasing me. At that point, however, I added, "That, Daniel, is the best offer you're likely to get. I've known for a long time that you've never liked or loved me, and I guess that's all right. But doesn't it bother you to see your father crying over you,

not to mention your brothers? When you were baptized, your godmother, Aunt Dorothy, said she had never seen a new father as proud as Daddy was about you. Don't you owe anything to him? Doesn't it mean anything to you that your family still loves you?"

Still Daniel demurred.

Finally Ione said, "I've let this intervention go on longer than I've ever done before, and if you're not going, I have to talk with your family and help them with what needs to be done next. I have to urge them not to take you back and to cut off financial aid because that would only encourage this lethal behavior of yours."

"Do you understand what Ione is saying, Daniel?" Peter asked. "She's telling us to throw you out, and she's getting no argument from me. Do you know that that's what she means?"

"Oh, is that what she's talking about?" Daniel asked sarcastically.

"And who does that leave who does support this way of life?" Ione asked rhetorically.

"I guess I do," Peter admitted.

"And what will you give Daniel from now on, if he doesn't go?"

"I'll give him—nothing," said Peter reluctantly.

"Look," said Hank Toth, "if you want me to, I'll go out with you to the airport. Before the plane leaves, let's have milkshakes together."

"Well, what'll it be?" Ione asked.

"I'll go," said Daniel, wearily.

Within sixty seconds we had all dispersed, but only after Fred Saroyan had given me a hug, a pat, a moist eye, and a look of horrified comprehension on his normally impassive face, as he seemed to realize for the first time the enormity of the problem we faced. There was no other word or contact between Daniel and myself.

Thirty-nine

Drug Ward

Hᴀɴᴋ ᴀɴᴅ ᴅᴀɴɪᴇʟ ʟᴇᴅ ᴛʜᴇ ᴡᴀʏ ᴜᴘ from the church basement, followed by Peter, drawing himself up the stairs by the handrail, reminding me of Daniel's airlift to Nova, with Peter helping himself up into the plane to say good-bye. The difference was that Daniel was walking free out of the church with his father; in the Cessna he had been confined and surrounded by the people from Nova.

"Thank you, boys," I said as we got into the car. "I'll never forget what you did today. Maybe someday Daniel will thank you too." We drove home in silence. "Do you want me to let you off at the gym, David? You're late for practice."

"That's all right, Mom. I have to get my shoes. I'll run over."

Over the weekend we had moved from standby to confirmed status on four pairs of reservations, one of which had already passed. Though I knew which flight Peter and Daniel should be on, I dared not let any of the others go since I had no way of knowing what moment-to-moment complications might develop, such as overbooked flights.

I called LaVerne Eastbrook, the intake social worker in St. Paul. I related the events of the morning, the high points of Daniel's recent history, and my many foiled efforts to stop him and hold him in one place long enough to redirect constructively his natural and drug-stimulated excessive energy that never burned itself out.

"I can understand your pain, she said, when I paused for breath. I'm a

349

mother too."

"And so am I, but no longer to Daniel."

"You must be very angry."

"How can you tell? And why not? Bit by bit, he has squashed the humanity out of my child, and with that, part of me has died too."

"I hope we can help him."

"I hope so too, but I doubt it. I'm glad you're not trying to reassure me, the way everyone else does. I have come to the conclusion that his characterologic problems long anteceded drugs or alcohol."

"That's entirely possible. From what you tell me, they'll be calling a psychiatric consultation." She agreed to get me the name and number of the psychiatrist. Before hanging up she said, "I'll be looking forward to meeting you at 'Family Week'."

It was like a match in a haystack. "Ione sprang that 'Family Week' idea on us at the intervention, but I never agreed to it! I've done enough! I just want to hand him over to others and pay them to contain him for however long it takes, not just your twenty-eight days. He was supposed to spend a year at Nova, but he escaped. I don't think I deserved a life sentence for the crime I committed in bed almost twenty-one years ago."

"Think about Family Week anyway. We need everyone together. The disease developed within a family and afflicts the whole family. Alcoholism is a family disease."

That time it was more like a match in a munitions dump. "Bullshit! One thing I really appreciated about the people at the intervention was that they weren't implying 'you drink because you have troubles', but rather 'you have troubles because you drink'. I resent the implication that I'm part of these so-called family troubles from which Dan had to run because his life wasn't good enough or beautiful enough without chemical stimulation. I resent that term 'family disease'."

"Hold it a minute. That's not what we mean. We mean just what you've been telling me, about how Dan's drug abuse hurts the whole family. You are all in unbearable pain, you most of all."

"Well, I'll drink to that. If you mean he tears us all up, why don't you just say so? But this year's pop psychology—Ione was just quoting it—everybody says it—is that no one can hurt you unless you let them, and that's malarkey. If those you love or have loved in the past can't hurt you, you're not human. When you use a phrase like 'family disease', it sounds as if you're blaming us, and that rubs salt in the wound. ... For the better part of this century, Freud's beliefs about how important early experiences are in the development of neurosis has been twisted to mean, 'If there's anything wrong with the child, blame the parent—especially the mother.' That's why it's easy to get paranoid

when somebody starts talking about 'family disease'.

"If it's faults you want, you can find them. You don't need to be Sherlock Holmes—anyone looking for faults can find them in me and in all the other mothers, including the mothers of paragons. No doubt I made mistakes with Daniel, though at the time I always did what I thought best, like most parents, regardless of what I might have preferred for myself, like most parents. In retrospect I see and acknowledge some of my mistakes, and I plead *mea culpa* though I'm not Catholic, to faults I know about and to mistakes about which I'm in blessed ignorance. But I won't tolerate the implication that Daniel must be bad because he has an angry mother. What all you imaginative and creative thinkers out there don't credit is that Daniel has an angry mother because *I have a rotten kid.* And that came first. No, I don't intend to come to your 'Family Week'."

"Let's talk about that a little later, after you've had a chance to rest and recoup." She confirmed that the wards were open, as Ione had said, and I indicated that an open ward was not appropriate for Daniel. She assured me that they would station someone beside his bed to watch all night. She offered to call me in the morning.

I checked the flight they should have taken, which had left fifteen minutes late, but the airline personnel declined to disclose whether Peter and Daniel had been on it. "It's against our policy and regulations," the voice announced crisply.

"That figures. I wouldn't expect any regulations that would ever help me." I hung up angrily.

I gave Peter an hour to get home from the airport in case plans had fallen apart, then another half hour just in case, but there was no sign of him. And so I went to bed and slept as though dead.

After our turkey sandwiches the boys and I trimmed the tree, with the annual disagreement, Jonathan wanting the tree spare and elegant, David favoring it heavily laden. "It's David's turn this year." There was no word from St. Paul, but neither was there any sign of Peter. The only call came from Fred Saroyan.

"We can only pray for him," was Fred's comment. "There was nothing that boy set his mind to that he couldn't do, and he can leave the hospital too, if he has a mind to."

In the morning LaVerne Eastbrook kept her promise and called me. "He's here, and he's just fine!"

"Remember what I told you. That's what they all say, to begin with."

"Well, all I can say is that he arrived with nothing but a toothbrush, and I told the ward what you had said about his history of running, so they watched him all night. I gather he didn't sleep much."

"It was nice of you to call."

"I want you to know that I don't do this for all families. I'm going down to take a history from him pretty soon."

"And you're going to believe him?"

"Well—"

"Of course you have to talk to him, but remember, I gave you the true history."

"I can see that you're terribly angry."

"Who wouldn't be who wasn't in denial? I can cope with rage more easily than with pain. I'd like to kill Daniel with my own hands. If I ever commit suicide, he goes first. I wouldn't waste a suicide without taking that punk with me."

"Suppose he's not a punk?"

"Suppose he is. For four years I've been asking him to prove me wrong. He'd need at least another four of perfect conduct before he could con me again. The proof is up to him."

I repeated material we had covered the day before, since nothing I said about Daniel ever registered on the first telling. At least it never did when he looked well groomed. I hoped we had avoided the mistake we made when we got Daniel to court looking clean and well kempt. Perhaps his deteriorated appearance would convey to the staff his deteriorated state, as it had to Saroyan, but of course they had no earlier appearance of Daniel to which to compare this present portrait. LaVerne gave me Daniel's psychiatrist's name, Dr. Prinzmetal. She ended by urging me to be kind to myself.

Peter staggered in the next afternoon. "I warned the social worker and the director of the center that part of the trouble all along has been that Daniel has been smarter than those assigned to work with him."

"That's true, but people resent being told that. I hope you didn't insult them. Smarter, yes, but maybe we should add 'street-smart'." I told Peter about two letters to Daniel from Case Western, one with instructions about a new date for a final exam for which the professor didn't arrive, having had a heart attack, the other a notice of being on academic probation for barely passing grades.

"He knew about the probation, and he told me. ...Well, *that's* done," he sighed.

"At least he's there. It remains to be seen whether they can do anything with him."

On Christmas Eve day Peter and Jonathan wrapped a box of clothes for Daniel, including underwear and socks Jonathan had never worn, two shirts Peter had bought him, and a sweater, a robe, and pajamas I had picked up for him. I didn't intend to send or even look into the backpack Daniel had brought home. I spent the rest of the day wrapping presents since David still liked to open gifts, even those he had seen or even picked out for me to give him. On Christmas Day we unwrapped them all again, and I looked at the beautiful wildflower guide David gave me, while Bluebell chewed on her new rawhide bone.

Though the intervention had been less than a hundred hours earlier, it seemed to me infinitely longer than half a week. Critical time expands, just as it had done at the time of the airlift. Peter and I sat and talked. We didn't talk about Daniel. We didn't talk about anything important. We just chatted. We may have even begun to heal, a little.

Gradually, as my fatigue receded and I was able to think of Daniel as safe and maybe even being helped, I felt a surge of tenderness and pity for him, alone and in a hospital on the high point of our year. I even experienced a replay of my Christmas fantasy when he was in Texas, in which I imagined him calling home, asking for me, telling me he was sorry.

"I really can't call Daniel," I told Peter, "but maybe you ought to. It's Christmas." He finally got a line to St. Paul and told Daniel about the box on its way and about the trip he was planning, to take Jonathan and David to Florida to see Peter's college friend and her snorkeling daughter. I had already backed out, so as to be at a phone for late-breaking developments from St. Paul.

As Christmas wore on, however, a nagging worry beset me. One hole relative to Daniel that had not been plugged was Sally Lane's family, who had let him live with them for most of the summer. He could easily hitchhike there again, and from past experience they would be likely to take him in. Contemplating this, I could feel my anxiety titer rise, until in early evening I dialed Massachusetts, and asked for Mr. Lane on the assumption that, all else being equal, the father would be the likelier parent to take a harder line. I explained what we had done and asked him not to be an "enabler" by taking Daniel in, should he come.

Mr. Lane expressed astonishment, asked whether I was absolutely certain about this chemical dependence idea, indicated that he had seen Daniel drink only a little beer and not use any drugs. I was trapped into going further into the story, lest he consider Daniel railroaded into an inappropriate facility. I told about Dale Altman's statement that Daniel could never be reasoned with because of never being in a "normal state of consciousness". I reviewed how Daniel had been thrown out of "a school for middle-class delinquents" and had been on probation in two states.

Mr. Lane sounded bewildered. "Is Dan in St. Paul now? I wondered why he invited Sally out there."

"Yes, he's in St. Paul, but he has no place to put Sally, so I don't understand this 'inviting' her out there. Mr. Lane, I'm not telling you all this out of pride. Would you be willing to write me a letter confirming that you agreed not to facilitate his running from treatment by taking him in?"

"I don't think a letter from me would be appropriate, but I'm willing to tell him that over the phone."

"All right. I'm sure that if your daughter continues to be interested in him, it would be in everybody's best interest, including yours, for Daniel to get straightened out."

"I couldn't figure out why he was here so long last summer. My wife and Sally would go out and pick him up on the highway and bring him home."

"It's your house. Why did you let him stay?"

"Well, you know, my wife is so maternal—" and Mr. Lane trailed off into a mumble. Then he told me about his daughter's immaturity and how they were trying to get her to return to college, but she just sat home, refused to look for work, and professed herself in love with Daniel. "I know Dan's a bright fellow," he went on. "I've been telling him he should work at his studies, bring up his grades. I'd like to see him in law school. I'm a lawyer, you know."

"You're about the hundredth person to tell him that. Actually, I don't want Daniel back in school, the shape he's in. He won't study. First he must show motivation."

There was a click and the sound of shattering glass. Mr. Lane shouted, "Sally, no, get off that—"

"What was that?" I asked, although it was painfully obvious.

"My daughter was listening on the other line, got mad, and smashed something. She does that sometimes."

"I'd appreciate it if you'd get her not to tell Daniel about our conversation."

"I wish I could do that, but I have no control over her."

I hung up with a sinking feeling that once again things were out of control, and in a new, unexpected way. I was glad only that I hadn't invited Sally to the intervention.

Around midnight came the next cataclysm. Peter, livid, stormed into the bedroom and demanded, "Get on the phone to Daniel. I don't know why you've done what you've done. Now you've ruined everything we've worked for."

I grabbed my clipboard and picked up the receiver, to hear Daniel's voice, "Listen, woman, get out of my life. I say, GET OUT OF MY LIFE! Why did you tell Mr. Lane I was on a psych ward? You're the one that's crazy—out of your fuckin' gourd!"

"I told him you were on a drug abuse rehabilitation ward."

"And you implied he'd be in trouble with the law if he takes me in. Jesus Christ, what kind of bullshit is this?"

"I didn't say or think that."

"Dad, why did you let her do it? She gets your balls too."

"I didn't have anything to do with it. She leaves me out too. I have no control over her."

"You ought to knock her around!"

"Daniel, you know I don't 'knock people around', least of all my wife. But you're right, it wasn't fair of her, now that you're trying to get your act together. I'll do everything I can for you. I'll talk to Mr. Lane for you. ... No, stay there. Give it a chance. It's only four weeks. I'll do everything I can to help you. I'll be up for Family Week, and we'll talk it all over, where you should go. ... But don't you see? Nobody will pay you much. You haven't got any skills. You should *finish* first." And so on.

Daniel also told his father that he had arranged for Sally to bring out another airline ticket for him to return with her. By saying "I knew I could always cancel it if I changed my mind," he defined the level of his commitment to treatment.

When Peter asked me to get off the line so he could talk to Daniel alone, I hung up and waited upstairs until I presumed their conversation at an end. When I went down to talk to Peter, I found him looking ashen and drawn. "Peter, it was O.K. for you to come in on Daniel's side, because his treatment is at stake, which is more important than my feelings or the rights and wrongs of anything. I'm willing to be scapegoated when either of you finds it necessary. But between us you should acknowledge that I didn't do anything wrong. I think you should see that when you sided with Daniel against me, this time you did the right thing for the wrong reason.

"Nothing I did or said to Mr. Lane was untrue or unfair or unreasonable. As for why I go ahead without including you, it's because I learned long ago that when a problem arises, and I want input, either support or rational objection based on angles I haven't thought of, you don't make distinctions, sometimes elect the milder course, sometimes the more drastic. You always take the conservative, passive approach. For this reason I have to go ahead on my own. You wouldn't have seen the wisdom of calling the Lanes, to try to put my finger in the hole in the dike through which Daniel can escape this time. Like everything else with Daniel, we had rotten luck that Sally was listening and that Mr. Lane is ineffectual. But what kind of girl would Daniel find, and what kind would be attracted to him?

"Normally, one parent shouldn't support a child against the other, but in this case, your move was the right one, given the abnormal circumstances, but so was mine in calling the Lanes. In all this, 'fairness' has absolutely

nothing to do with anything. It's a luxury we can't afford. Only pragmatism counts. So far, nothing that either of us has done has worked. The tragedy is that neither of our diametrically opposite methods has accomplished anything. If anything ever does work, that's what will have been the 'right' thing."

Peter thoughtfully sipped his tea.

"With Daniel it's always this giant chess game, and he always has us in check. But the goal is not to let him checkmate us, even if we have to cheat. As I told him long ago, 'If I win, you win, but if you win, we both lose.'"

I took a breath and went on, "You heard Daniel on the phone. He admitted asking Sally to bring him an airline ticket. I may have missed the method, but I was right on target with his loophole."

Peter's eyes widened as this interlocking of facts sank in. "But Daniel complains that you keep calling his social worker. Why do you have to do that?"

"When I was young and green as a psychiatrist, sometimes I would listen to the family but really believe the patient's story, and sometimes the other way around. Either could turn out to have been a mistake, and sooner or later I'd find out I'd been hoodwinked. Among other things, I told LaVerne Eastbrook that if she has anything in her bag of tricks to reach Daniel, she shouldn't pussyfoot around because with Daniel there's never the luxury of time. Everything is always 'just fine', until without warning everything has fallen apart. I talked to Jason White at Pleasant Valley every Monday. Everything was at least 'okay', until just one week before we got the letter about their kicking him out."

"But at least he went to St. Paul willingly and we have his cooperation this time—or had until you called the Lanes."

"You call that 'willingly'? It's like that 'voluntary confession', every word of which had to be dragged out of him by the detective. This time Daniel has planned his escape hatch in the form of an air ticket to Sally's. That's not what I call 'having his cooperation'."

"Maybe the center will be the answer."

"Maybe, but it doesn't address the root problem, the antisocial personality disorder, as Nova is tailored to do."

"You know, he once told me that his feelings were hurt that we went to Colombia without him."

"We were in Colombia when he was at Nova, the one place in the world he really needed to be. And as I told him, Colombia is the *last* place in the world I'd take him. He probably would have brought back half the year's marijuana crop."

"It's true we couldn't have taken him there."

"I've taken a lot of hatred and scorn from Daniel, and it's finally getting to me. Back in the days when I would talk to the parents of other boys about Daniel, and they would be at least mildly positive about him, I'd think it wasn't

356

so bad if for some strange reason I was the only one who thought there was something wrong with him. As time passed, more and more people became more and more negative about Daniel. I've reached a point where I could live with his hating just me if he only loved the three of you and got along with the rest of the world. But his apparent preference for you is only because he can work you. I could also live with it if he hated me for some reason, justified or not, but lived a life of integrity somewhere else. But he doesn't. I think he holds it against me that my dreams for him didn't include his street life. . . . Do you know why he hates me?"

"Well, one thing he doesn't like is your black-and-white language. You're always calling Pleasant Valley 'a school for middle-class delinquents'. It isn't just that. It's also a school for boys with learning problems of various kinds and for normals."

"And for girls, now that you mention it. No one ever made this point to me before. I should have said something like 'a school that *takes* middle-class delinquents'. I can't edit every word that comes out of my mouth, but whenever somebody draws my attention to a consistent error, I try to correct it, and I will this one. Now that I've admitted the justification of that particular complaint, let's look at why I happened to perpetuate that error. That was the side of Pleasant Valley I saw. The only kids I had any contact with were court placements that Daniel gravitated to. He didn't look for their intelligent and motivated kids to hang around with, and I know they had them, entering the chess tournament, for example. . . . I'd like to remind you of something else while we're talking relatively calmly, for us. I've said it before and I'll say it again. No matter how we disagree about what we do regarding Daniel, you must know I've never impugned your motives."

"And *I* don't impugn yours."

"I didn't say you did. But I haven't finished. It's your methods that are so brainless and passive. We both sat side by side in the hospital conference room and watched the same closed circuit television regarding interventions. The next thing I heard was your proposal to help Daniel by taking him and his brothers to Florida over Christmas, while I was the one who went out to see Ione about an intervention. I'm appalled at how you manage to deny reality. You just keep on acting as if Daniel were normal! I think you really could do better in this regard. Then the next thing was that I got you and the boys out to see Ione, and you came home and said—your very words—'Nothing got settled.' Ione told me that the date had been picked. Still, if the date didn't register with you, why did you just say 'good-bye' rather than pin her down and ask, 'What do we do next? What do I do, and what do you do?' You're oblivious to all the hours I spent phoning and visiting people who came, and talking to others who didn't come. I wasn't keeping any of this a secret from

you. You don't credit me or even seem to notice all my thought, time, and effort that go into this Daniel problem. Over the years I've made hundreds of phone calls in my pathetic effort 'to stick out my foot and trip him', as Aletheia puts it. I'll never forget your absolutely classic remark when I told you the date for the intervention: 'Well, then, there's nothing to do until Dan gets home'—this after you'd seen the same sample intervention on video, with people assembled there to confront the alcoholic. How did you think they got there? Did you think they all just happened to drop in? I spent a total of about twenty hours—half a workweek—in these preparations, plus think-time. It's not that I'm expecting you to do these things. I know I'm the one with the flexibility and privacy to make the calls and see people as needed. It's your oblivion that I resent. . . . So, what now with Daniel?"

"He said he'd give it a chance."

"These 'chances' exhaust me. We're always left hanging from a cliff by our fingernails. With Daniel, whatever loopholes I foresee in the system, if I miss one, that's the one he finds. Still, I have to keep trying to anticipate and take evasive action, in this case trying to keep the Lanes from 'helping' him and sabotaging our efforts."

"I didn't think that was very likely."

"You never do, but you were obviously wrong. You heard Daniel say he could always cancel airline reservations if he changed his mind. Was that the speech of a person determined to make it this time? Well, was it?"

There was no reply from Peter.

By the next day Peter and Jonathan had the flu, and Peter decided that the trip to Florida would be too hard for just one tired driver.

That evening, the return call finally came from Daniel's psychiatrist, Dr. Prinzmetal. He was the first professional who, on hearing the high points of Daniel's *danse macabre,* agreed, "He's probably a classic sociopath."

I photocopied another set of reports, letters, and documents, and forwarded them to Dr. Prinzmetal. I even got Isidor Kalland to send his information directly that he would not give to me.

On New Year's Day Peter said he intended to call Daniel to wish him the season's best. I advised against any boat-rocking on grounds that Daniel could turn any loving overture into a nightmare. Peter said that in that case he would hold off calling until the next day.

"That's a dumb idea! What difference does a day make? He's not going to change in a day. At the moment everything is in a precarious balance. But once he has you on the line, he'll take control. I'd advise you that the next time he calls you, just tell him you tried on New Year's Day and couldn't get a line through to St. Paul."

But before he even tried, a call came from the office of the treatment center, asking Peter whether he planned to come for Family Week. "No, I didn't get the letter yet. Could I come Tuesday evening instead of Monday? I planned to call Daniel tonight," he told the secretary.

Peter ignored my advice and got a line through to Daniel at eleven. Peter's end of the conversation consisted of arguing, pleading, and trying to make Daniel see the wisdom of remaining in the drug program. He also told Daniel he had decided against Florida. Daniel's arguments were inappropriate to the point of being delusional—that other freshmen flunk out and that he was doing better than his friends who had done time in reform school. It went on for forty-five minutes and ended with Peter begging Daniel to stay until he got there for Family Week. "I want to help you, and if you're there in twelve days when I get there—YOU DON'T HAVE TO ARGUE WITH EVERYTHING I SAY!—I'd like to see you there. If you're not, I'm powerless. You have all the power. I want to help, O.K.? It's twelve here. I've been on the phone over an hour. If you let me know, fine. If you don't, that's the way you are. If other people don't give you any challenge, that's the way *they* are. . . . Good night."

Peter sat on the bed, trembling. "I told you not to call him," I said gently. "You're no match for him. But I respect and love you for trying. I don't know how you stood it. Is he really constantly on the verge of splitting? Or does he just take every opportunity to work you over by whatever device will steamroller you the most?"

"I don't know."

"Now do you see who's in control once you have him on the line?"

"I'm afraid I do."

"I want you to know that although I strongly advised against that call, I bled for you. It was a noble try. You know, practically, whatever name we give it, we have to consider Daniel insane. Anyone who would use an argument like 'I'm not as bad as people who've been in reform school' on a professional man, and think this would reassure the scientist, can't be anything but insane."

"I guess so. It's late, and I'm tired. I guess I'm feeling my age these days."

"Around Daniel, it's always late, and we're always tired."

Forty

Sociopath on a Drug Ward

By MONDAY, JANUARY 5, DANIEL HAD BEEN in St. Paul for two weeks, Jonathan and David had returned to school, and peace and quiet had resettled over the house. We received a form letter from the drug treatment center about the importance of reuniting the sick but recovering patient with the battered and wounded but loving family. April McQueen's name was inserted in the blank for counselor. I didn't want to attend Daniel's Family Week, but, having caught my second wind, I knew I could not boggle at that final investment of time and energy. I told Peter it was time to find out what was really going on with Daniel, listening to April's words and especially to her tone of voice, hearing between the words, so to speak.

But Peter had his own reservations. "I don't know about this Family Week," he said. "What good will it do to talk to all these strangers about our messed-up children?"

"Better strangers than friends. Whatever the pain and the shame, we'll know we won't have to see them again."

When Peter left, I dialed April McQueen. "Oh, I'm so glad you called," she responded cheerfully. "You were on my list to call today about coming out for Family Week."

"Daniel is still there? He hasn't split? He gave his father quite a tussle on the phone."

"Oh, he's here, or I would have heard."

"You surely have the list of weekend discharges AMA." [AMA is an acronym for "Against Medical Advice", which means that the doctor didn't approve the patient's leaving and is absolved of responsibility.] "When I talked to Mrs. Eastbrook, that's what she went by."

"Oh, they would have notified you automatically if he had run."

The word "automatic" is a red flag to me. "Don't tell me what happens automatically. The only thing you can really count on to happen 'automatically' is for somebody to screw up. The only automatic thing with Daniel is that nothing ever holds still. Would you check the AMA list?"

"All right, I'm looking on the bulletin board. ...He's not on the list. The last anybody knew, he was still here."

"Thank you. Now can you tell me how he's doing? I talked to Mrs. Eastbrook before."

"She's intake. I'm his counselor, but I haven't seen him yet."

"You mean not yet today."

"No, I haven't met him."

"Then what makes you his counselor?"

"I've been on vacation for the past two weeks, so he's had a substitute."

"Ms. McQueen, do you understand why I'm upset? Someone is in a four-week program and halfway through has to change counselors. Why?"

"He didn't change. He was on my caseload all along. They said he would be a tough nut to crack, and I have a reputation for being tough. They thought I could handle a case like his."

"Not if you're not there!" I wailed. "When the program is only four weeks long, why assign a patient to one counselor for the first half, then to another?"

"It may have to be more than four weeks. I'll have to assess him for that."

"Well, that's fine with me. I've known all along he would require more than four weeks, but I didn't know you people could adjust."

"As I said, they thought I'd be good for him. The counselor he had while I was away was Mrs. Sweigert. She wanted to talk to you but couldn't reach you because you were in Florida."

"What do you mean, 'couldn't reach us'? Did she try? Who said we were in Florida?"

"I guess Daniel did."

"And you who are experts on alcoholics just believe their stories?"

"Weren't you in Florida?"

"No. My husband had a half-assed idea to go with the younger boys, but then he was too tired and he told Daniel that. I was never going. I knew it wasn't a good idea with Daniel in treatment. Besides, we're too smart to put

362

Daniel into a four-week crash program with open wards and go away without notifying you and arranging how to be reached? We learned *that* when he escaped from a locked facility up in Maine, as my husband told LaVerne Eastbrook when he brought Daniel to you. Depending on when Daniel told Mrs. Sweigert about Florida, he may or may not have been telling the truth as he knew it, but if he had wished, he could have told her when he found out the trip was off. He always uses the truth as it suits his purpose. On the other hand, if Mrs. Sweigert wanted to talk to us, all she had to do was lift the telephone. Somebody was home almost all week."

April told me that she had gleaned from Mrs. Sweigert that Daniel daily threatened to leave but had not done so. He had been very disruptive in groups. "When I see him today, I'll tell him he can go if he wishes. This is not a prison. If he goes, will you take him back?"

"I won't, but his father will. I've been ready to cut him off for a year. It's his father who keeps subsidizing him."

"I don't like the term, 'enabling behavior', but I guess I'll have to work with his father if he's the enabler. "

"Even if his father refused to cooperate, Daniel has another out. He's been living with a nineteen-year-old girl whose parents, for reasons that escape me, keep him for weeks on end. I've gotten the father to agree not to take him if he runs from you—and I found out that that was his plan—but somebody ought to reinforce that her father agreed not to take him back."

I gave her the Lanes' phone number in case Daniel needed to hear it from Mr. Lane's mouth. "Daniel is, of course, enraged with me for talking to Mr. Lane in the first place. He talks about how I 'screw up his life'. It's true that I would just *love* to screw up his life. The most I could accomplish was to get the court in Texas to give him a short probation instead of just rapping his knuckles."

She pointed out that Daniel might be staying just to keep out of the cold St. Paul winter. "If this young man wants help—"

"Who said he did?"

"What I started to say was that he may really need more than four or five weeks. That's only an estimate, based on most patients. I hope the whole family will come out for Family Week to look at the options."

"Peter and I just talked about it. He dreads a week of exposing our raw pain to the gaze of strangers, as do I. Yet strangers are better than friends. I'm wavering for other reasons, not only my own pain but because Daniel can't stand me, partly because more than anyone else, I see through him and know what he's up to."

"Oh, it's not at all uncommon for alcoholics to pick one family member to blame everything on. Often it's the one they're really the closest to."

"I'd prefer to be excused from the Family Week. I'm tired. But I'm also fed up. I masterminded that whole 'Tet Offensive' that got him to St. Paul, and I didn't do much else for two weeks. When am I going to live *my* life? I didn't do anything criminal—but wait, you said 'whole family'. Surely you don't mean the boys? Daniel hasn't lived home for over three years, and they've seen very little of him."

"We'd like them, too. Family Week is very important, maybe the most important part of treatment. Often the families are reluctant, and often the patient discourages them from coming. But in the end they say that's what brought the family closer together than anything else. Believe me, I understand and sympathize with your being fed up, but Family Week is intended to help you, too, because the whole family is hurting. At Family Week the defenses are down, and Dan will be receptive to hearing about the pain he's caused."

"I doubt if that bastard's defenses are down. Remember, you're talking about someone you haven't met yet."

"I understand your resentment. I presume you're sending him here because we're the experts, and—"

"I sent him to you because I had nowhere else to turn. I really wanted him at Nova for eighteen months."

"I assure you, he needs to hear about your resentment in this setting. And you too need help with your pain. I hear the rage, but, as you know, love and hate are close together. What's worse is indifference. We can't work with people who don't care."

"I understand. Indifference is what I'm striving for. I keep trying not to care any more."

"Dr. Greenleaf, I have to go because I have a group to conduct, but before we hang up, I'd like your commitment to come out here next week. Well?"

I paused, gulped, and said, "All right, I'll be there."

"And the boys?"

"I'll talk to them about it. They'll do it if I ask." After hanging up, I dialed a number in Massachusetts and, when a young woman's voice answered, used a ruse to which I have occasionally resorted. "Mr. Lane, please. Long distance is calling." Asked by his daughter, I gave my name and birthplace as "Miss Gray in Eau Claire, Wisconsin". I explained to Mr. Lane that we would all go to St. Paul for Daniel's Family Week, and he again agreed not to take in Daniel if he ran from treatment.

Within fifteen minutes Daniel was on the line, screaming, "You told him I was mentally deranged! Woman, you're the one that's a nut case! Don't do anything like that again or I'll call up somebody I know on South State, and you won't like the results. You can take that as a threat or a promise. I know people all over the country who'll take me in and give me food and a warm

place to stay. I don't have to go to the Lanes' if I leave here. I have other places to go. I'm going to be living with Sally. We're in love."

"Do you plan to live off her father? Can I introduce you as 'my son the stud'?"

"You, woman, are nuts, out of your fuckin' gourd! I've had it with your fuckin' shit. You can't accept it that I'm twenty and not your little boy any more. Well, I'm not coming home again, ever."

"Great! I don't want you." A short pause served to echo my statement.

After it had sunk in, he continued in his quarrelsome tone, "I couldn't stand living with your fuckin' ass! You failed as a mother. Do you agree?"

"You failed as a human being."

"What did you do anyway? Drop me on my head when I was a baby? I haven't lived in your fuckin' dump for three and a half years. People take care of me. The Martins took me in, Uncle James, all sorts of people took me in. Nothing you can say will make up for it. I don't want to have nothin' to do with you any more. You make your little phone calls—call the counselor—but nothing you say is going to make any difference! I'm going to the Lanes' to live just to spite you! I'm going to be happy without you, and that's what you can't stand, that I don't need you. You try to ruin every place I go to. Well, what do you say?"

"I say that what you did to yourself you had no right to do. You threw away with both hands everything we gave you, and for that I'll never forgive you. And that comes from someone who once would have died to save you. I wouldn't die for you now; you're not worth it."

"What do you think I'm doing here?"

"Oh, messing around, eating three meals a day, stuff like that, nothing therapeutic."

After a few more minutes of this, I interrupted "Daniel, if you have anything new to say, I'll listen. I won't argue, but you're repeating yourself, and I have things to do. Anything else?" There was no answer, so I hung up.

I expected another explosion from Peter when he learned about my second call to Mr. Lane, so I saved that story for just before I left for the clinic. But he knew it all already, having been asked by Daniel to tell Mr. Lane that what I had allegedly said about the "psycho ward" wasn't so. Peter had reluctantly verified to Sally's father the basis for Daniel being on the drug ward.

"I didn't tell Mr. Lane anything he didn't force me to by his incredulity and obliviousness," I said. "I had to counteract a rescue fantasy in a man who was being persuaded—and believed—that I was railroading a healthy boy to a hospital. If I had been in Mr. Lane's place, I would have listened when someone said something serious was wrong with the young man his daughter was screwing around with. If they ever married, you would think Mr. Lane would prefer for

365

Sally to have the kind of husband who would support her than for both of them to live off him. Not to mention that the prospective son-in-law is failing in school, bumming around the country, and running from a drug rehabilitation ward. What kind of testimonial is that?"

The other part of my message to Peter, practically over my shoulder as I was on my way out the door, was about April McQueen expecting the boys for Family Week. This disconcerted him more than I anticipated. "They shouldn't just sit in St. Paul for a week. You don't understand—the accommodations for families are poor and cramped. There'd be nothing for them to do, and I can't see that they'd contribute anything."

"Well, considering the places we stay when we travel—like in Central America—I don't see why we can't stay on their unit. This isn't supposed to be a vacation. You talk to Ms. McQueen. She's very insistent. I already promised her I'd be there and that I'd ask the boys for their cooperation."

I skidded on new-fallen snow across town to my clinic. While taking my boots off, I told the secretary to call in the next week's appointments because a family emergency was taking me out of town. Within an hour these patients started filtering in, and I worked them through as fast as I could consistent with good care, continuing through my lunch break. The clinic director acerbically told me she would have liked more notice. "You got as much notice as I did," I snapped. "Besides, you'll be getting three days' patients done for two days' pay."

The following morning April McQueen called. While Peter was coming downstairs, I alerted her to his reluctance to include Daniel's brothers, although I had already reserved rooms for the four of us. I explained that the boys were willing to help despite David's basketball and Jonathan's debate.

She made several abortive efforts to cut me off, and finally began, "I've had several one-to-ones with Daniel in my office. When I told him I'd invited the whole family, he screamed that he wouldn't work with you here. I've done more intensive work with him since then, asked him to take time to think about it, and he did, but he stands firm, and of course I have to honor his wishes. He said he couldn't be in the same room with you."

"You didn't know this punk yesterday. And now you've let him bend and break your rules, your policy, your agenda. Much as I hate to come, and much as I promised myself that the time had finally arrived when somebody else would work with him, I can see that he needs to be confronted by me because I'm the one who has seen through him the longest and the clearest. I'm the one who choreographed getting him to you, I'm the one who has repeatedly tried to save him from himself, and I'm just about the world's last citizen who honors the word 'should' and does distasteful things out of obligation. You gave him a choice in this matter without knowing him. You blew it."

"This has been his first real chance to look at these issues."

"Bullshit! He's had chance after chance. He spent three weeks at Nova. He's had counselors of all stripes. We've spent hundreds of hours and thousands of dollars, but he always finds a way to wriggle through the lattice of the system."

"I gave him a chance to reconsider his decision, but he said that if you were in the room, he'd attack you physically. I believe him, and of course we can't have that. I told him the family meetings are a setting for coming to terms with all the pain and rage. After thinking about it again, he said he would physically remove himself from a room if you were there. Believe me, I'm sad about all this. I'd like to think that under all the pain there's a communality of blood."

"The only communality is DNA, not blood nor the fact that he once lived in my body. I understand your position. You have to worry about getting sued by Daniel because he's legally an adult. That's not my fault. I didn't vote for the Twenty-sixth Amendment or for anyone under twenty-one to be considered adult."

"You know, he doesn't see himself as chemically addicted, and I tend to agree with him. I heard from my substitute that he's been 'using' for a very long time."

"While I was trusting him. And that's what Ione says. But what is the operational difference?"

"I'm sure it's been very hard."

"Yes. As you must have heard, some experts think that sociopaths cannot be addicted because they don't have the emotional depth."

"I'm not sure about the 'sociopath' part either."

"Dr. Prinzmetal sees him that way."

"I've heard from the substitute that he's very disruptive here. Every day he says he's leaving but he's still here."

"I guess that's something." I remembered Diane at Nova. "Maybe it's because he doesn't have a warm parka."

"Yes, and he gets three squares a day. Anyway, I've asked him to write out an in-depth study of what drugs have done in his life. I want you to know that whatever happens, he will get my best expertise. One thing I hope for you is that you can get over the bitterness. For this reason I suggest you come out next week for the other parts of the program, the lectures and discussions that the families but not the addicted persons attend. I'd like you to come for help for yourself."

"I have things to do that do not include going where I'm not wanted." My battered self and self-worth suddenly perceived her request as overwhelmingly insulting—at this interval I have mellowed and appreciate her wish to heal my wounds—and my voice went up many decibels. "I wish I hadn't listened to you.

I *humbled* myself to agree to come, and HE HAS REJECTED ME AGAIN! Not only that—you have supported his contempt! People from uncaring homes in the slums have made it, but not Daniel. Until recently I haven't begrudged all the time and effort and, yes, even money we've spent, but now I see that it has all been down a rat-hole, taking an irreplaceable part of my life with it. I'm outraged that you treated him as my peer. You gave him a choice! I let myself become a sniveling marionette on his string, and you let him cut the string."

"May I tell him you said that?"

"Tell him anything you like! Tell him lies—I owe him a thousand lies. No, tell him the truth! Tell him I played Russian roulette in bed and lost. Tell him I hope he gets some of that potent new drug that kills right away, doesn't take years. Tell him I'll dance at his funeral. ... I know you don't give a damn about me, but—"

"That's not true. I *do* give a damn about you, but of course my first obligation and responsibility are to my client. I hope you'll think about all this and decide to come."

I made two more Daniel calls that morning before getting back to the fragments of normal Victoria living. I complained to Ione Barre about the unit in St. Paul having assigned Daniel to a counselor who was scheduled to be on vacation. And I complained about April McQueen's double whammy of playing on my sense of duty one day and then going over to Daniel's side and betraying me the next.

She said, "I understand your anger, but it's still a fine unit. I happen to be going out there next week. I intend to see Daniel and reinforce the halfway house idea, which I'm sure they're promoting. I'll talk to them and give you a call when I get back. There's been a misunderstanding somewhere." "Misunderstanding" is another word that enrages me, having come to be used for "not liking what I hear". No one had misunderstood anything.

My second call was to Aletheia. "You're not going to believe this," I began, and told her.

"This happened to you, and you're a professional person with clout?"

"I've got clout? You've got a sense of humor, and you've given me my laugh for today."

"If these things can happen to you, think what it must be like for the average parent—total impotence."

In the mail that day was the third, and final communication from Case Western Reserve University, an invitation, no longer applicable, to a parents' weekend.

As I thought about it, I decided that since I would not appear in St. Paul in person, I would represent myself in written form, in my own defense, so to speak. I realized that Ms. McQueen probably would not read anything I sent,

considering it disloyal to her charge. Still, I sent out copies of the fifteen pages that I had sent Nova, along with copies of his MMPI and the letter Dr. Kalland had sent me. I looked, also, for a lovely poem Daniel had written at nine, about throwing up a pebble and musing about the sky. I remembered the ending: "It flies high; no one has been there." I also looked for his retelling of *Moby Dick* in the form of a diary. While searching, I found a report on a parent-teacher conference Peter and I had attended with Daniel's third-grade teacher. She was so enthusiastic about Daniel's imagination and creativity that she arranged for him to be promoted to her friend who taught fourth grade. I sent photocopies of these to Ms. McQueen as evidence of how far Daniel had fallen and to demonstrate that I was not exaggerating the terrible things this child had done to himself. I enclosed also two poems I had written about good events in Daniel's life. God knows what he was telling them about me, and with what results in their efforts to work with him.

Peter finally talked to April McQueen on Friday afternoon, argued with her, and told me she had agreed that it was all right not to bring the boys.

Sunday afternoon I took Peter to the airport and wished him Godspeed. That night I awakened realizing that no one had ever searched the back-pack Daniel had brought home before Christmas. Jonathan and I went through it together the next day. We found a university court summons for a hearing on charges of "misconduct at the Rathskeller", dating from when I suspended Beauregard's docket scans because I thought Daniel was out of the state. There was an unsheathed camping knife, an address book going back to the Australia days, including one name, unfamiliar to me, with a notation—"jail, Joliet, out July, 1980". (Joliet is a penitentiary in Illinois.) In the address book there were two numbers for pay phones in Penn Central Station in New York City. Would Daniel or a friend loiter there for a call? There was also a ticket stub to the Metropolitan Museum of Art; I had heard that drug connections were made in its galleries. Finally, there was a folder of "cannabis papers". There were also keys to the car that Daniel had used in Texas, now standing in our driveway. Checking the trunk I found no weapons, only a jack, but in the trunk I found a grater—maybe for shredding that "buffalo chip" I'd found in my slipper.

When Peter called, I said, "Nobody thought to search Daniel's backpack, so—"

"The boys went through it."

"Why do you so casually make such dumb assertions about things you know nothing about? All they did was get out some clothes to send him." And I told him what I had found. "How's it going?"

"We're chugging along. We have another confrontation this afternoon."

"The school strike is settled here. I went to the Psychiatric Society dinner

369

last night, saw Vaclav, and let him know Daniel at least got to St. Paul. This must be an awful week for you. Hang in there."

That night I asked the boys to finish their assignments early so we could watch the movie *Dr. Jekyll and Mr. Hyde* together. "Notice," I told them, "the movie can be interpreted as a metaphor for the addictive nature of evil. Dinner's ready. We haven't had grace for a long time. I'm going to say one: Our Heavenly Father, we commend to You our absent family members and ask once again that You will see fit to reach the heart of our son and brother."

Forty-one

Family of Four

A‌T THE AIRPORT, I WAITED IN THE CAR with Bluebell, but Peter took so long that I went looking for him and found him at the baggage conveyor belt. He was slumped and haggard, and his hair looked thinner and whiter. It was obvious he had nothing good to relate.

Absentmindedly petting the delighted Bluebell, who was jumping all over him as we pulled out of the airport, he asked dully, "Well, do you want to hear it now or at home?"

"Get it over with. You see what it's like to get the shock waves."

"Everything was going well until yesterday. Dan seemed to be getting a lot out of the confrontations. He also looked good after four weeks on the ward, shaven and wearing clean new clothes. Coincidentally, at the same time Dan was admitted, so was the biggest cocaine pusher in St. Paul. He was also a pimp, and his girls brought him drugs, which he then distributed on the ward. Dan had just two marijuana cigarettes—"

"That you know of."

"That he admitted, and I believed him. Anyway, I don't think the administration handled things fairly. They got that pusher to put the finger on those he had supplied, and for this they gave the pusher immunity. He came out smelling like a rose. There was one patient, a girl of twenty-two, a cocaine addict, who, according to her parents, works as a model and earns $200,000 a year—"

"She earns that as a model?"

"—and spends $90,000 a year on cocaine. Her parents were nice people. I spent a lot of time with them because we were in the same group of five families. Anyway, the girl admitted her part in it, and they let her stay. Another girl denied it once, but the second time she admitted it, and they let her stay. Dan wouldn't admit it and ask to stay, so they threw him out. I don't think it was fair, and neither did April." Peter's voice vibrated with grief and pity.

"'La commedia è finita.' I guess, much as I tried to kill the demon hope, I kept imagining that the flint I'd been striking over and over would somehow light this time. What a fool I was! As I've said many times, everything else would follow if Daniel would only acknowledge, 'I did wrong, and I'm in trouble; help me.' Without that, nobody or nothing can touch him."

"But they weren't fair to him." His voice was one of despair.

Traffic was light, and I drove automatically. "What I think happens there is that they rank offenses. Drug use isn't the worst; refusing to admit it is. Daniel wasn't being 'upfront', in the language of today's youth. It wasn't that he defended or showed loyalty to the pusher but that he was saying, in effect, 'I'm a big man and can take care of myself, and a little grass now and then isn't going to hurt me.' They can't accept that, of course. One of my problems in life is that I can almost always see the other person's side."

"Anyway, even April didn't have control over the situation, and she has to work in the framework of administrative decisions. It wasn't fair that that pusher got to stay in treatment but not Dan!" Peter's voice spoke impotent rage.

"It was par for our course that the pusher was in Dan's cohort. I know that drugs often get taken to treatment units, and that sewage-maker was probably just there to reduce his so-called 'need'. Aletheia and I talked about this once, and we agreed that pushers should get the death penalty, even if it started with our own children." Peter could see this.

I explained, "In group treatment, administrative decisions help some and hurt others. Daniel is always atypical, so he's likely to get the shaft. They found Daniel's attitude, his refusal to admit guilt, worse than the amount or kind of drugs. It may sound punitive to you, but it makes sense to me. Most religions tolerate 'sin' as long as it's acknowledged as such and is accompanied by remorse and a willingness at least to say, 'I'll do better next time.' But the stiff-necked ones get thrown out."

"You're all so retributive. 'An eye for an eye', isn't it?" Peter was angry with me now, which was his way to divert his pain over Daniel.

"All I said is that I could see their side. You and I see our child's needs as primary, but I can understand their demand that he humble himself, admit guilt, crawl, jump through hoops, eat crow, or whatever you want to call it. When I was a child they called it 'breaking the child's will', an atrocious phrase, but there came a time when, had I been able, I would have broken

Daniel's will because it needs to be broken. They couldn't do it either, and Daniel's going to keep his will until it kills him. Nobody who works with him is perfect—I accept that—nor has anyone found a way to lure him into accepting rules. You can always point out where somebody might have treated him differently, but the bottom line is his determination to be arbiter of all things. The rest of us relinquish our omnipotence out of love, but there's nobody he loves, and maybe he can't. That's the one ineluctable fact. . . . So, where is he now?"

"Sally sent him a ticket. They're setting up an apartment in Cleveland, and Sally's father will get her a job."

"Get her a job? Isn't Daniel going to contribute anything to this?"

"He plans to sell the rest of that stock from Lith."

"That won't go far."

"That's what I told him."

"I wish I'd transferred it along with the stock we bought for him. Are you going to send money? Or do you agree not to? As everyone has said, we've got to cut him adrift. Supporting him just says, 'You can have your cake and eat it. You can have your drugs and at the same time be a Greenleaf.'"

"I agree. April doesn't want us to call the Lanes either."

"Believe me, I have nothing to say to them any more. They may live to regret buying that stud for their daughter."

"April says she'll take Daniel back if Sally gets tired of him and puts him on a bus or plane back to St. Paul."

"Meaning that he has to make the effort to get there and ask to be taken back. Of course he'll never do it."

"Another thing—he's asking for more of those minerals. Says he felt better on them."

"Well, he knows where he got them. Nothing stops him from asking Dr. Sylvester."

"One thing I learned in St. Paul is that this is a real illness—it's their metabolism that makes them alcoholic or addicts, and they can't help their metabolism."

"You could have learned that without going to St. Paul, if you'd paid attention to the video or to Ione. The bottom line is that they can help messing with the stuff. When Daniel was growing up, when I thought he listened to what I had to say, I warned him that drugs were very dangerous, even marijuana, more than was generally thought at the time, but of course he preferred to go along with his punk friends."

"I learned a lot. It started as curiosity with Dan. I wish you'd been there."

"I was ready to go until they let Daniel call the shot against me. You've been brainwashed. He could have chosen not to be an addict the same way we've chosen not to be addicts."

373

We drove on in silence. As we entered the driveway, I said, "Don't worry—it wasn't serious—but there was a small accident. David got hit in the mouth playing basketball. Dr. Pryor repaired his lip immediately, the way he fixed Dan after the car accident. What bothers David is that he can't play, probably for the rest of the season, because Dr. Pryor doesn't want the cut broken open."

"That's too bad. Basketball means a lot to Dave."

"On a brighter note, Jonathan's PSAT scores came back, very high, just like Daniel's. He was told he could probably get into an Ivy League school. I told him to go for it! If I have to, I'll work another clinic to help pay for it."

Epilogue

YEARS HAVE PASSED SINCE THE END of my story, but what story ever ends during the lifetime of the characters? Our lives plateau or trough out as the case may be, once we are beyond the age where each autumn brings its new set of classes, teachers, and friends. During this time I have become increasingly aware of my life trickling away. Sometimes I awaken in the night, jolted by awareness of the finite number of heartbeats remaining to me. Sometimes as I wake up, dream Daniels flee. Once, one such Daniel of my own creation said, "I do wish we could be friends." Another Daniel swam with me one night, and when we clung to swaying mossy pilings to rest, he laid back a wet lock of hair from my temple. And a waking fantasy that I strove to dispel back into the shadows from which it came was to rock Daniel in my arms until he would be well, because he is not well.

Although Daniel's life has leveled off from the jagged peaks of those energy-and-testosterone days of his twenties and early thirties, I've continued my surveillance in various ways. Yet my life is mercifully less entangled in his. This is as it must be, since no miracle can let me accept what has gone before. I can see the wisdom of a remark by George Bernard Shaw, to the effect that there comes a time when we must realize that no matter how beautiful and right the thing we crave, we must accept that fate has said "no". Still, as I type, I once again see my monitor through smeared glasses.

Within days of Peter's return from St. Paul, the cocaine-addicted model's father called to inquire after Daniel. Then the pusher's mother sent us a card notifying us that she included Daniel's name for a series of masses being said by the Carmelite nuns for her child and others. "Isn't that lovely? I've written to thank her," I told Peter.

But the Carmelites' prayers made no difference. With consistent and monotonous and heartbreaking regularity, as weeks, months, and years have passed, the answer to the nuns' prayers has remained: "Why should I care what happens to the Greenleafs' son? Screw their son."

Daniel and Sally worked at various minimum-wage jobs, including serving subpoenas in bad neighborhoods, with Sally waiting at the wheel while Daniel took them in.

For seven years Sally and Daniel cohabited, fought, separated, and tried again on numerous occasions. We are told that the course of true love never runs smoothly. Peter maintained contact, whenever it suited Daniel, and thereby learned more than I would have wished him to know about how it feels to receive the shock waves. Typical was a call from Sally, asking whether Peter had any idea where Daniel was, who had disappeared after a fight. Ingenuous Peter replied, "You say it was Thursday? But I talked to him since then, and he didn't say anything about a fight or leaving. I don't know what to say. He told me he was making plans to go back to school. Have you called Phil? Oh, Jeez, how can things get so bad so fast?" They promised to keep in touch, and Peter went to the bedroom and sobbed.

Several months after Daniel's return from St. Paul, it became apparent that Sally was pregnant; she'd stopped taking her oral contraceptives because "they made her sick". From what I heard on the phone, it became apparent they had killed my grandchild, with no objections from Peter. That was the more obvious case. Another time Sally left on a mysterious medical errand. These, plus the fiscal discrepancies in Texas made me conclude that my son has aborted one or more of my grandchildren, with Peter's passive acquiescence. Anything else from Daniel I could have tolerated with a view to his eventual rehabilitation, but not his killing his child, my grandchild, any child, for that matter. In *1984*, Big Brother ferrets out whatever you fear the most and uses it to torture you. In Orwell's novel, it was caging starving rats over your face. Daniel didn't even have to plan my suffering.

I could have tolerated anything else from Peter, but not his complicity in the destruction of those helpless children. At the time I planned to leave Peter as soon as David entered college. But I have not done so, partly because it's too much work. I have compromised my principles, and with them has been eroded my self-esteem.

These are terrible times to be a parent.

Others are joining the ranks of grieving grandparents. A physician I used to work with is raising his son's child, and trying to keep his own son, polluted with drugs, away from the child. Similarly, I would have raised Daniel's child if given a chance. Another grandfather at my hospital, who adopted his granddaughter when she was dropped on his doorstep, is battling in

court an ex-daughter-in-law whose new husband's whim it is to uproot the eleven-year-old from the only family she has ever known.

Daniel returned to the university, which took him to court several months later for drunk and disorderly conduct. The chief security officer told me that in his fourteen years at the school there had been five such arrests, and Daniel had been two of them. I learned of them through my surveillance lawyer, Alfred Beauregard, who had found them by his monthly scanning court dockets. He tried to get mandatory treatment for Daniel, spending a day and a half in court waiting for Daniel's case to be heard. Daniel perceived that Beau was several stripes above the seedy legal talent represented—and engaged him in conversation. Beau identified Daniel, talked to him without Daniel's knowing he was working for me, and sent a note to remind the prosecuting attorney of what he had gotten the judge to promise. But these arrangements fell apart because the director of the drug treatment center I'd found would not take someone as unmotivated as Daniel.

Having been expelled from Case Western, Daniel later matriculated at another prestigious university and, in time, graduated. Peter showed me a picture of Daniel in cap and gown.

Eighteen months after Daniel's departure I received an astonishing letter from a Paul Bledsoe, a young man I had never met face to face but had heard of from Daniel's Pleasant Valley days. He was, in fact, the boy whom Daniel followed to Case Western Reserve University in Cleveland. Paul claimed that he probably knew Daniel better than anyone else alive, since they had talked daily about their daily drug and alcohol use since age fourteen, thereby confirming Ione's belief that Daniel had an early start. Paul shared his experience of maintaining his grades despite daily drinking and had finally enrolled in Northwestern's Medill School of Journalism. He acknowledged that he'd had "problems with drugs from the very first time", called himself "heinously flagellating and self-destructive", and referred to the "morbid narcissism" in combination with "specious self-esteem" that characterized himself, Daniel, and other addicts. It wasn't until his father cut off support, and Paul tried to work two jobs and continue his studies, that he floundered, failed, "came to some conclusions", and found himself in Alcoholics Anonymous. He had been trying to get Daniel to do likewise. "But," he added, "it will have to be soon."

Bledsoe indicated that he had written to me because Daniel had told him about my writing efforts. I called Bledsoe and expressed my eagerness to underwrite any help he could give Daniel. I asked him also to contact any professors who might help my efforts to publish my Daniel account. I got him

to tell Peter how destructive to Daniel was the tsunami of money flowing from Peter, but this had the usual effect.

However I underestimated the maturity of the young letter-writer, for he soon called back and asked me not to contact him again, nor to quote his letter. (My explanation for this switch was that he had talked to some professor, who had frightened him about legalities.) I honored the former but not the latter, in line with my rule of causing no harm to him but possibly helping someone else.

Several years later, in an effort to take another look at Daniel and perhaps enlist his interest in alcoholism treatment, we took him and his new live-in friend on a trip to see a solar eclipse in the Sea of Cortez. I was astonished at how much he remembered from his childhood. In the ship's decor he drew my attention to a photograph of the Temple of the Sun outside Mexico City, where I'd taken him at eight. In the dining room he charmed elderly ladies, and his conversation sparkled. He reminded us that the flag of Australia features the Southern Cross, which we were about to see. When, on a shore excursion, we were taken to the decrepit cathedral, I found the contrast between the two of us significant: I dropped money into the box for the restoration fund, while he put coins into the clawed hand of a beggar woman sitting in the entrance, her baby in her shawl. But he drank every night, keeping it pretty well under wraps. To no one's surprise, he was uninterested in help with his alcoholism.

Over the years he has performed other isolated acts of charity, some of which we learned about, and some of those so tender as to break my heart over the Daniel that might have been. Once he arranged for used computers to be sent to an ill-equipped school on a Native American reservation, where a friend took him to visit his childhood home. He gave us an adopted manatee in Florida. Another time he asked our preference for a Christmas gift (to be given to the needy, as we had done at home in his childhood): a flowering cherry tree for Washington, D.C., or two cataract surgeries in Central America. "Tell him the tree," I told Peter, "and we'll do the surgeries in his name." Always changing plans in midstream (like my father), he settled on a goat for a woman in Honduras, to provide milk for her family.

Daniel has for years worked as a bartender, thus making his living on the disease and death of others, instead of turning that still-marvelous mind to anyone's advantage. He is part owner of the Marquis de Sade Lounge, where, I understand from another source, intellectuals gather for good conversation. With such a name, one can only ask what they do upstairs. I always wanted to introduce Daniel as, "My son, the bartender".

His behavior now is less flagrantly outrageous than it was. A friend of his started a hemp fabric-importing business, and Daniel travels often to Eastern Europe to arrange purchases. Peter has invested money in the enterprise; the young president would like more because he can't keep up with demand for the product, and orders are canceled. The young man understands my refusal to contribute: there is no way to pour money into an alcoholic (Daniel's current drug) without feeding the addiction. Another issue is that they would like to see the growth of hemp legalized domestically. This crop is much friendlier ecologically than, for example, cotton, but so far all our states are afraid of the close connection between hemp and marijuana, and fear that legalizing the former would move us closer to legalizing the latter, with its predictable effects on the green ethics of Madison Avenue. I told Daniel that it is my wish that any legislator who votes for such legalization lose a child to it, as I have.

At least I no longer rehearse a fantasy in which, having been given a fatal diagnosis with limited life expectancy, I kill first Judge Whittier, then Daniel and, finally, myself.

Sometimes I am even able to remember the real Daniel, the undamaged Daniel, with joy. Once, scrambling to take a phone message, I stumbled on a stub of chewed pencil with little Daniel's name in gold letters on the green paint, a reminder of the days when stockings needed to be stuffed with elongate paraphernalia—pencils, rulers, whistles—since baseballs never fit. Like Tennessee Williams' Bill, for whom bits of colored glass always brought back Laura, that pencil transported me to the good days of Daniel's childhood. And a shirt of Daniel's that I found in the attic, each piece of the pattern cut from a different color, making the wearer look like a happy-go-lucky gypsy, took me back to his early teen years. It made me ask myself whether that shirt had directed him toward the image of what Peter had called him, "a bum wandering around Evanston".

Then, when my brother-in-law James, in Texas, preparing to move to smaller quarters, returned memorabilia of our children, I felt the bittersweet pang of Daniel's oh-so-normal-sounding Christmas "thank you" note on cowboy stationery, written at his old-fashioned mother's insistence.

After graduating, Daniel took a few graduate courses, though without any defined goal. Tanya's and Sally's fathers—both lawyers—Peter, and Dan's advisor have encouraged him to go to law school, but he shows little interest in that.

Daniel was elected to his neighborhood council, and his "mitzvah" for that office was to run a club to keep teenagers off the streets. It sounded as though

he did a good job, and as though, when he wasn't reelected, the reason had been political. The suspicion crossed my mind that he might have used this activity as a way to traffic in drugs. I really don't think so, but I've been wrong before.

My life with Daniel has given me more compassion for others than I would otherwise have realized. It was a difficult way to learn compassion; if given the choice I would have foregone my own growth and development. I feel something else as I age, a feeling others approaching the ends of their lives have described, a sense of the inevitability of it all. We have to play the hand we're dealt. Any other life would not have been mine.

Voices are now being raised on behalf of the lost generation of parents. Illustrative of this shift of focus are remarks quoted in the *Miami Herald* that were made by Judge Alfonso Sepe as he sentenced a seventeen-year-old to a year in the stockade and four years' probation:

"Do you know who is going to serve that year? Not you; your mother and father will serve that year. That is what's wrong. They get sentenced. They get sentenced for a lifetime. You serve a year. Your body is in the stockade for a year, but their souls are tormented for the rest of their lives. Why? Because you are a selfish, spoiled boy, that's why. You think you're smarter than everyone else. There is no punishment in the world that I could inflict upon you that could in any way compensate for what you are doing to your mother and father.

"I have not spent five cents raising you. I didn't know you from Adam. But your mother and father have put their lives, their hearts, their sweat, their money and everything else they have into bringing you up. Now they have to sit in this courtroom and listen to a total stranger, who had nothing to do with your upbringing, scold you and put you in jail.

"This is at a time when phony kids your age are yelling, 'You adults have your alcohol, we want our drugs; and you have polluted our water and our air, and you have polluted this and that,' and all the rest of the garbage that comes out of your mouths. Meanwhile, you put yourselves above everybody else. I feel sorry for you.

"I want you to think of this for one year, and the reason why I say it:

"If you are sick, a doctor will treat you and he won't be on drugs. The lawyer who represents you won't be high on drugs, and the people in whose custody you'll be won't be on drugs. Your astronauts are not on drugs, and your President is not, and your legislators are not. And your engineers who build the bridges that you drive across and the tunnels that you drive through are not on drugs, and those who build the planes that you fly in and the cars

that you drive are not. Neither are those who build the bathrooms that you stink up with your lousy, rotten drugs. None of them have been on drugs, and this is because of people like your mother and father.

"But in the world of the future, the same may not be true. Teachers, doctors, lawyers, legislators—products of the new drug-oriented generation—may well be high as kites. You won't know whom to send your child to or whom to trust your life to. Let's see what kind of world you leave to your children before you talk about the world we left to ours."

I wish our world could return to a better balance between rights and responsibilities, between parents and children. I wish, also, that we could somehow put a moratorium on the damage being done by drugs to the bodies and minds of our species.

Postscript

I HAD THOUGHT THIS WORK COMPLETE when Daniel did something warm and wonderful, showing concern and caring—dare I say love?—for a friend. It made me hope that it might signal a change in Daniel.

His call reached me during a patient interview, and he was leaving a number as I interrupted, "But that's an international code. Are you in Europe?"

"Yes, I'm in Prague. Please hurry—it's urgent."

I cut the session short for Daniel's emergency. He was requesting help for Tom, his friend and co-worker, who was in a coma from a pedestrian accident he'd suffered in Prague. Four days had elapsed while authorities tracked down Tom's connections in America, during which time he was treated in a military hospital (an ideal arrangement for a trauma victim). When the authorities finally located Tom's grandmother, who had raised him, she turned to Daniel for help. In two days he had secured a passport for the grandmother, located Tom's girlfriend, Anne, a nurse, and transported all three to Prague.

The medical prognosis was dire: "If he opens his eyes, which is doubtful, he'll never be able to scratch his head—or talk. The concussion got his speech center." Still, the patient's life had been saved for a week, and Daniel had taken charge. He told me, "Grandma says there's a special place in heaven for me."

"*You* in *heaven?* That's a special place, all right!"

"About Tom—I want another opinion. I can't accept that it's this bad. They say that he has the body of an athlete and he could live another twenty-five years in a vegetative state. Maybe Dad knows somebody in West Germany we could ask to see him."

"Stay at the phone. Your father and I will put our heads together. Have you been to the embassy?"

"Yes, and they're no help. They have nothing else to suggest."

I caught Peter just before he left his lab at the university and told him the grim tale. "Do you know any doctor in that part of the world who could refer Daniel to a neurologist or a trauma specialist?"

"Let me think. There's that one in Ljubljana who found us a surgeon ready to take out little Jonathan's appendix until Jon vomited and we decided it was food poisoning. I'm coming home. I'll think on the way."

Peter arrived with a plan. In the parking garage he had met a surgeon who suggested our Life Flight. If our level one trauma center agreed to accept Tom after talking with the Czech trauma doctor, they would send their plane equipped as a hospital, with physician, nurse, and pharmacy aboard.

All this was accomplished, though our doctor confirmed the grave prognosis. "We'll play the long shot," we told Daniel. "I told them to start filling up the plane with gas."

Five days after Daniel's first call, Tom made the final lap of his 6000-mile trip, by helicopter, from our airport to the trauma center. With him came a photocopy of the hospital record, documenting his excellent care in the Czech Republic. His life had been saved thus far by their having removed a section of his skull, permitting his brain, as it swelled, to expand upward rather than downward. Our trauma doctor explained that this procedure, absolutely essential to saving the lives of patients like Tom, is standard practice in Europe but not in the United States, because it results in nursing homes full of patients whose hearts and lungs are operational but who have no higher brain functions. Had Tom's accident occurred here, his traumatized brain would have herniated its vital centers downward through the foramen magnum, and there would have been no further decisions.

When Tom was stable, though still in coma, he was moved to a step-down unit, then to a nursing home here, and later several hundred miles by ambulance to a nursing home near his grandmother and his nurse girlfriend. I expected him to remain there until pneumonia took his life. He did, in fact, develop pneumonia so severe that they had to clean abscesses out of his lungs, but his powerful heart and lungs, developed during five years of working out and healthful living, brought him through.

I even wrote a poem intended for his funeral, but we haven't needed it.

Two weeks later Daniel updated us on the phone. As I was phrasing a statement of condolence for the news I expected, Daniel related that Tom had opened his eyes, tracked movement around the room, and whispered single words and a few short sentences that made sense, such as "Don't go" and, when Daniel apologized for not being able to understand Tom's babytalk-like speech, "Don't worry about it."

The day when Tom asked for his grandmother to get him a drink of water,

384

the staff excitedly called in the grandmother.

Daniel and other friends spend time with Tom, and their stimulation is important for his improvement. Tom was transferred to a rehabilitation hospital for speech therapy and exercise for his arms and legs. His friends, coming for a birthday party, so filled Tom's room that a nurse finally had to empty it.

Like other accident victims, Tom can't remember the incident or the time just prior to it. For several weeks he believed he was being held in prison for a crime they wouldn't divulge (as in Kafka's *The Trial*), and asked his friends daily whether that was the day they would "spring me".

During all our phoning and planning, everyone kept reiterating what a truly outstanding person Tom is, and was, even in the drug years before he had gotten his life together five years earlier. "Even at his worst, he was always there to help people. He was the only pusher I ever knew who never stole from anyone," was Daniel's testimonial.

A beautiful note arrived for Peter and me from Tom's grandmother: "I want to thank you very much for getting my grandson to Chicago. I thank God every day he is alive and I hope he will get better every day. I care so much for him. I have known Dan for many years, and Tom would walk to the end of the world for him."

I have told Daniel and Tom's girlfriend several times that if her "red-headed giant" never recovers anything more, he is rewarded by knowing how much he is loved.

In May I was invited to the graduation of a friend of Daniel's, a young woman who was divorced and had two children to rear with the sometime help of her intermittently drug–abusing ex-husband. She had struggled through the university with the help of a loan that Daniel had requested from us. She majored in psychology and art therapy and was graduating with honors. To have a chance to meet the graduate and her children, I took them all out to dinner. Later, Daniel criticized: "She doesn't discipline those kids right. They were yelling and throwing bread! They don't raise them right anymore. You would never have let us do that."

About the high school shooting in Littleton he concluded, "Those parents should have known about those kids' websites."

"Maybe, but if I were the parent, I wouldn't know how to *find* a website."

"If it were now, you would have learned. You were the best snooper ever!"

When Daniel and I visited Tom in the hospital, I was astonished, having known him only as inert flesh, to see him respond to Daniel's introducing me. I spent half an hour with Tom's doctor, who confirmed that if the medical team doesn't give up prematurely, a few of these severe head trauma cases will really surprise you, as Tom was doing. They predicted that he'd always have trouble with names and other nouns, and with short-term memory, making

holding a regular job problematic, but Daniel can hire him to work under his supervision. He has had a metal plate surgically implanted to fill the gap in his skull bone that had been removed to save his life. He has also been discharged to live with his grandmother.

Daniel has made other efforts in Tom's behalf. He arranged two benefit performances by Rock musicians who knew Tom, and raised three thousand dollars. (My son, the impresario.)

Daniel also has another plan, involving the stepfather of one of his friends and the stepmother of another. The stepfather expressed himself tired of paying so much income tax and inclined to establish a charitable foundation. He agreed to formulate it so as to benefit brain-damaged citizens of the area, and make Tom the first beneficiary. The stepmother, a secretary in a legal firm one of whose partners does *pro bono* work of this kind, has arranged for one of their lawyers to set up the foundation. The project is now under way.

Lately, when Daniel leaves, he kisses me and says he loves me. Can I trust that?

"I love you too," I answer. "Sometimes I wish I didn't."

Recently Daniel remarked that he hoped someday to be able to do something for someone else comparable to what Peter and I did by bringing Tom home. I hope to be able to influence that proposal when the time is ripe, the beneficiary to be Daniel. Perhaps someday his life can be directed toward using that still-magnificent mind more systematically for others and himself. "I think I'm meant to do something important," he said.

"I hope so, even if after our deaths, but it would be nice if your father could see it."

He also said, "I don't want to be lonely in my old age, but I'd rather be lonely than fight the way Sheila and I do."

Antisocial Personality Disorder has been studied very little in the psychiatric arena. The best known study was first published more than sixty years ago by Hervey Cleckley, who included detailed case reports of subjects much more deeply troubled than Daniel. Cleckley reported no change in these men over time. Recently, however, a new long-term follow-up study by Donald Black reports less pessimistic findings. Black finds that antisocial personality in adults is always preceded by conduct disorder (like Daniel's) in childhood, but many children with conduct disorder do not go on to full-

blown antisocial personality disorder.

Recently, facilities on the order of Nova have been created on islands. They are too late to help Daniel, who needed to be confined in an escape-proof treatment center.

Whereas Cleckley's men (and one woman) never improved during the decades when he had access to their records, Black's study finds that after twenty or thirty years, nearly a third are improved, and about a tenth in complete remission. Almost none of his subjects are in trouble with the law except for occasional drunk and disorderly charges. Criminal behavior is largely confined to the teens and twenties, when young men have boundless energy, as had Daniel with his score of "9" on the MMPI. Black's reading of this book confirms my diagnosis of antisocial personality disorder in Daniel. In Black's experience, when such patients improve they do so mostly between the ages of thirty-five and the early forties. Thus the time is ripe for Daniel.

While I will gladly accept any improvement, I hope that the time and a treatment will soon arrive when preventive action can spare the families of antisocial personalities a score of years like the ones we have endured.

Suggested Readings

DURING THE WRITING OF MY EXPERIENCES with Daniel, I have noticed points of reference with other works of literature throughout the twentieth century.

I. Accounts of Illness, Mental or Physical, in Oneself or a Significant Other, Spouse, Child, or Sibling

Barbellion, W.N.P. *Journal of a Disappointed Man.* New York: Gordon Press, 1974. Originally written and published in England, this introspective view of the course of multiple sclerosis was recommended by our neurology professor as better than a textbook. He was right.

Beers, Clifford. *A Mind That Found Itself.* Garden City, NY: Doubleday, 1970. This account of bipolar disorder, originally written in 1908, has been reprinted several times. The author describes, from the patient's perspective, the insides of "asylums", private and public, before any effective treatment was known. He recovered and went on to generate public interest in the plight of the mentally ill and organized societies that advocated for their humane treatment.

Wilson, Louise. *This Stranger, My Son.* New York: New American Library, 1969. A mother's agonizing observations of ever-worsening symptoms of schizophrenia in her son, from pre-school age to young adulthood. Professional inability to help his condition was aggravated by the professional belief at the time in the "schizophrenogenic mother", adding spoken and unspoken

389

blame to the grief of the mother.

McDonnell, Jane Taylor. *News from the Border: A Mother's Memoir of Her Autistic Son.* New York: Tickner & Fields, 1993. Account of a mother fighting for appropriate treatment and schooling for her high-functioning autistic son (a condition now designated Asperger's syndrome), with sporadic help and opposition from the medical and educational establishments. More recently, I am told, this has been reissued in paperback, with comments by other parents of autistic children and by a classmate of the son.

Greenfeld, Josh. *The Noah Trilogy.* New York: Holt, Rinehart, and Winston. Consisting of:
 A Child Called Noah: A Family Journey. 1972.
 A Place for Noah: A Family Journey Continued. 1978.
 A Client Called Noah: A Family Journey Continued. 1987. A journalist's account of his autistic/retarded son's life from childhood to young adulthood, and the father's attempts to make it as rewarding as possible. Often it required battling the establishment.

Wideman, John Edgar. Brothers and Keepers. New York: Holt, Rinehart, and Winston, 1984. A black English professor's account of his life growing up in a good family, intact, with values and ambition for the children. Out of this setting one brother chose the low road, eventually receiving a life sentence for murder. Now the author tries to take the outside world to his brother by monthly visits, with talk, books, and family. Through it all the question is, "Why him and not me?" Since this book, the author's son has also been convicted of murder.

McGovern, George. *Terry: My Daughter's Life-and-Death Struggle with Alcoholism.* New York: Villard Books, 1996. A prominent politician's soul-searching account of his daughter's fatal alcoholism.

Djerassi, Carl. "A Scattering of Ashes." In *The Pill, Pygmy Chimps, and Degas' Horse.* New York: Basic Books, 1992, 284–97, ch. 18. A prominent chemist shares his pain, self-questioning and attempts to come to terms with his adult daughter's suicide. He established a philanthropy in her memory and lectured to the grieving parents of other offspring who took their own lives.

Neugeboren, Jay. *Imagining Robert: My Brother, Madness, and Survival.* New York: Morrow, 1997. An account of a man's lifelong, loving responsibility for his schizophrenic brother.

Simon, Clea. *Mad House: Growing Up in the Shadow of Mentally Ill Siblings.* New York: Doubleday, 1997. Experiences of the only non-schizophrenic of three children.

Moorman, Margaret. *My Sister's Keeper: Learning to Cope with a Sibling's Mental Illness.* New York: W. W. Norton, 1992. An account of the increasing responsibility of an only sibling for the care of a schizophrenic sister, escalating after the death of their parents.

Lear, Martha Weinman. *Heartsounds.* New York: Simon & Schuster, 1980. A journalist's angry and bitter account of her husband's heart trouble, and their problems coping with the medical and social work establishments.

II. Fiction Concerning Parent/Child Relationships, Some with a Mentally Disturbed Child

Ibsen, Henryk. *Peer Gynt.* Trans. Christopher Fry. Ed. James McFarlane. London, New York: Oxford University Press, 1976. A play based on Norwegian folk tales about the rascally, irresponsible Peer (now we would diagnose him as having antisocial personality disorder). Especially poignant is his return to his mother's deathbed.

Lawrence, D. H. *Sons and Lovers.* New York: Modern Library, 1997. Originally published in 1913, this mostly autobiographical novel based on a son's love for and difficulties emancipating from his mother shocked readers on both sides of the Atlantic.

Paton, Alan. *Cry, the Beloved Country.* New York: Charles Scribner's Sons, 1948. Written by a worker in a boys' reform school in South Africa, this novel deals with a black father's grief over his son's going wrong and killing a white man who worked to improve the lot of the blacks. The father's lament: "Why didn't anyone just tell me, so I could have gone to Johannesburg to bring him home and save him?"

March, William. *The Bad Seed.* Hopewell, NJ: Ecco Press, 1997. Originally published in 1954, this novel about a cold-blooded young killer suggested that the girl's lack of conscience derived from a natural grandmother who was electrocuted for multiple murders, including all her own children except for the mother of this child. At the height of the influence of Freud and belief in the environment/upbringing basis of personality, many readers would have been startled by the author's assumption on which this thriller was based.

Thompson, Thomas. *Richie*. New York: E. P. Dutton, 1981. In this novel a father's despair over what his son has become drives him to kill the youth.

III. Scientific Works Dealing with Aspects of Issues Raised in This Book (Accessible to Thoughtful Readers)

Aichorn, August. *Wayward Youth*. New York: Viking, 1935. Of historic interest as the first work on juvenile delinquency.

Binswanger, Ludwig, "The Case of Ellen West: An Anthropological-Clinical Study." Trans. Werner M. Mendel and Joseph Lyons. In *Existence: A New Dimension in Psychiatry and Psychology*. May, Rollo; Angel, Ernest; and Ellenberger, Henri F., eds. New York: Basic Books, 1958, ch. IX, 237–364. From mid-twentieth century, when existential psychiatry was an offshoot of existential philosophy, this case report suggested the possibility of more prolonged studies than professional journals print.

Cleckley, Hervey. *The Mask of Sanity*. 5th ed. Augusta, GA: Emily S. Cleckley, 1988. Classic work on "psychopathic personality disorder" (now antisocial personality disorder) with many vignettes showing how the disorder presented itself in the first half of twentieth century (mostly among the well-to-do). Extensive bibliography and many literary references.

Thomas, Alexander; Chess, Stella; and Birch, Herbert G. *Temperament and Behavior Disorders in Children*. New York: New York University Press, 1968. and Thomas, Alexander and Chess, Stella. *Temperament and Development*. New York: Bruner/Mazel, 1977. These books present the findings of extensive prospective studies from infancy through latency. Observations of mother/child interactions and later worker/child interactions through one-way mirrors and counts of various types of behavior permitted the researchers to delineate different personality types and their proneness to kinds of mental illness. In defining these types they recognize the innateness of traits and the fact that they are not caused by parental styles of child handling. These observations, scheduled at regular intervals (first monthly, later three-monthly) would be cost-prohibitive to repeat. I have suggested these books to many parents blaming themselves for "flaws" in their children.

Hamer, Dean and Copeland, Peter. *Living with Our Genes: Why They Matter More than You Think*. New York: Doubleday, 1998.
Bouchard, T. J.; Lykken, D. T.; McGue, M.; Segal, N. L.: and Tellegen, A. "Sources

of Human Psychological Differences: The Minnesota Study of Twins Reared Apart". *Science,* 1990, 250, 223–28. Review of extensive studies on traits of personality and intelligence in monozygotic twins reared separately, and the contributions of biology and environment.

Zuckerman, Marvin. *Behavioral Expressions and Biosocial Bases of Sensation Seeking.* Cambridge, New York: Cambridge University Press, 1994. A summary of this researcher's lifetime of study of sensation-seeking, a trait common in alcoholism, drug abuse, and antisocial personality disorder. It can be expressed in dangerous sports such as skydiving, but also in exploring, research, and the arts. In these persons, certain neurohormones are below normal, others above.

Zuckerman, Marvin. "Sensation Seeking." In *Personality Characteristics of the Personality Disordered.* Ed. Costello, Charles G. New York: Wiley-Interscience Publication, John Wiley and Sons, Inc., 1995, ch. 11, 289–316. In this chapter the psychologist researcher targets this trait in antisocial personality disorder and other personality disorders.

Black, Donald W. with Larson, C. Lindon. *Bad Boys, Bad Men: Confronting Antisocial Personality Disorder.* New York: Oxford University Press, 1999. A retrospective study of patients diagnosed with this disorder as young men, and then tracked down and interviewed thirty years later. More optimistic than Cleckley's, this study shows general amelioration of the condition, with retreat to petty crime, alcoholism, brawling, and, in a few cases, no longer evidence of the condition. Extensive bibliography.